P9-DWJ-343

Ancient Greece

SECOND EDITION

Ancient Greece

From Prehistoric to Hellenistic Times

THOMAS R. MARTIN

Yale UNIVERSITY PRESS

New Haven & London

Published with assistance from the Mary Cady Tew Memorial Fund.

First edition 1996. Updated in 2000 with new suggested readings and illustrations. Second edition 2013.

Copyright © 1996, 2013 by Yale University.
All rights reserved.
This book may not be reproduced, in whole or in part, including illustrations, in any form (beyond that copying permitted by Sections 107 and 108 of the U.S. Copyright Law and except by reviewers for the public press), without written permission from the publishers.

Yale University Press books may be purchased in quantity for educational, business, or promotional use. For information, please e-mail sales.press@yale.edu (U.S. office) or sales@yaleup.co.uk (U.K. office).

Set in Joanna type by Integrated Publishing Solutions.
Printed in the United States of America.

Library of Congress Cataloging-in-Publication Data

Martin, Thomas R., 1947–
Ancient Greece : from prehistoric to Hellenistic times / Thomas R. Martin.—Second Edition.
 pages cm.
Includes bibliographical refences and index.
ISBN 978-0-300-16005-5 (pbk. : alk. paper) 1. Greece—History—To 146 B.C. I. Title.
DF77.M3 2013
938—dc23 2012043154

A catalogue record for this book is available from the British Library.

This paper meets the requirements of ANSI/NISO Z39.48–1992 (Permanence of Paper).

10 9

This book is dedicated to the students who have over the years asked questions that continually kept me thinking anew about the history of ancient Greece, to the colleagues who have so often helped me work through the challenges of presenting that history in the classroom, to the readers who have sent me comments and suggestions, and to the people of Greece, past and present, whose *xenia* has always inspired and humbled me, in good times and bad.

CONTENTS

MAPS, PLANS, TABLES, AND FIGURES

Maps

Plans

Tables

Figures

PREFACE

The first edition of this book came out in 1996, as a companion and a supplement to the overview of ancient Greek history included in the Perseus Project. At that time, before the explosion of the Internet, Perseus was released on CD-ROM, which was the only medium then available that allowed the integration of narrative, illustrations, and access to the full texts in translation and the original languages of ancient sources. That original overview has now been online for more than a decade as part of the Perseus Digital Library (www.perseus.tufts.edu/hopper/) under the title *An Overview of Classical Greek History from Mycenae to Alexander* (www.perseus.tufts. edu/hopper/text?doc=Perseus:text:1999.04.0009). As best as can be estimated, it has been viewed online more than a million times from all around the world. I take heart from that figure that the history of ancient Greece retains its fascination for many, many people, myself included.

As a policy decision taken for multiple reasons, the overview in Perseus has remained unchanged over the years. This printed book has now been updated twice (though with the same coverage and arrangement of topics). It can no longer be said to be a companion to the Perseus overview, but its inspiration remains the spirit and dedication to the goal of the wide dissemination of knowledge that has motivated the Perseus team throughout the history of that groundbreaking project. For this and more, the world of those interested in ancient Greece in particular and digital libraries in general owe a boundless debt of gratitude to and admiration for Gregory Crane, Professor of Classics and Winnick Family Chair of Technology and Entrepreneurship at Tufts University and Alexander von Humboldt Professor at the University of Leipzig, scholar and friend and fellow Red Sox fan through thick and thin.

ACKNOWLEDGMENTS

Again, I want to express in the first place my abiding appreciation for the patience, encouragement, and guidance that Jennifer Banks (senior editor, Yale University Press) has repeatedly given me; her many contributions have been invaluable. Piyali Bhattacharya and Heather Gold (editorial assistants) were unstinting in their attention to the project, as was Suzie Tibor in her art research in locating the new images for this edition. Kate Davis (copy editor) earns warm thanks for her prompt and meticulous editing to improve the text, as does Margaret Otzel (senior editor, Yale University Press) for her unfailingly responsive and encouraging work to turn the manuscript into a book. The honest criticisms and thorough analysis of the anonymous reviewers aided me greatly in improving the narrative from beginning to end. My wife and fellow philhellene, Ivy Sui-yuen Sun, has supported me from the very beginning forty years ago, when we began our marriage and our love of things Hellenic during our first sojourn in Greece.

ABBREVIATIONS

CAF Theodorus Kock. *Comicorum Atticorum Fragmenta* (Leipzig, Germany: Teubner, 1880–1888; reprint, Utrecht, Netherlands: HES, 1976).

D.-K. Hermann Diels. *Die Fragmente der Vorsokratiker.* Ed. Walther Kranz. 11th ed. (Zurich: Weidmann, 1964).

FGrH Felix Jacoby. *Die Fragmente der griechischen Historiker* (Leiden, Netherlands: Brill, 1954–1964).

GHI Russell Meiggs and David Lewis, eds. *A Selection of Greek Historical Inscriptions to the End of the Fifth Century B.C.* (Oxford: Clarendon Press, 1988).

IG *Inscriptiones Graecae.* Vol. 4, 2nd ed.; vol. 1, 3rd ed. (Berlin: De Gruyter, 1929–; 1981–).

OGIS Wilhelm Dittenberger. *Orientis Graeci Inscriptiones Selectae* (Leipzig, Germany: S. Hirzel, 1903–1905; reprint, Hildesheim, Germany: Olms, 1970).

NOTE ON CITATIONS, SOURCES, AND DATES

The term *primary sources*, as used here (and commonly in classical studies), refers to ancient texts, whether literary, documentary, epigraphic, or numismatic. To help readers find the passages in primary sources that are embedded in the text of this book, citations will be presented wherever possible using the standard internal reference systems of those sources that are conventional in modern scholarly editions and that are used in many, but not all, modern translations. So, for example, the citation "Pausanias, *Guide to Greece* 4.2.3" means that the passage is book 4, section 2, subsection 3 of that work by Pausanias. This will enable readers to find the passage in question in any modern edition or translation that includes the internal reference system.

Secondary sources accordingly refers to postclassical or modern scholarship about these ancient sources and the history that they describe. The embedded citations of secondary sources contain the name of the author or a short title, with the relevant page numbers or, in the case of catalogued objects such as inscriptions or coins, the reference number of the object.

Full bibliographic information on modern translations of primary sources and on secondary sources can be found in the Suggested Readings at the end of this book.

Dates not marked as B.C. or A.D. should be assumed to be B.C. Dates given in parentheses following the name of a person indicate birth and death dates, respectively, unless preceded by "ruled," which indicates regnal dates.

Backgrounds of Ancient Greek History

"Most things in the history of Greece have become a subject of dispute" is how Pausanias, the second-century A.D. author of a famous guide to sites throughout Greece, summed up the challenge and the fascination of thinking about the significance of ancient Greek history (*Guide to Greece* 4.2.3). The subject was disputed then because Pausanias, a Greek, lived and wrote under the Roman Empire, when Greeks as subjects of the emperor in Rome no longer enjoyed the independence on which they once had prided themselves and had fought fiercely to protect. One dispute he focused on was why Greeks had lost their liberty and what it meant to live as the descendants of more-glorious ancestors. Today, the study of ancient Greek history still remains filled with disputes over how to evaluate the accomplishments and the failures that its story so dramatically presents. On the one hand, the accomplishments of the Greeks in innovative political organization, including democracy, history writing, literature, drama, philosophy, art, and architecture, deserve the description that the fifth-century B.C. historian Herodotus used to explain why he included the events and people that he did in his groundbreaking work: They were "wonders." On the other hand, the shortcomings of the ancient Greeks, including their perpetuation of slavery, the exclusion of women from politics, and their failure to unite to preserve their independence, seem equally striking and strongly disturbing. For me, after nearly forty years of studying, teaching, and writing about ancient Greece, the

subject in all its diversity remains fascinating—and often perplexing—because it is awe inspiring. *Awe*, a word in English derived from the ancient Greek noun *achos*, meaning "mental or physical pain," can, of course, have two opposite meanings: "wonder and approval" or "dread and rejection." I have both those reactions when thinking about ancient Greece and the disputes that its history continues to stimulate.

Ancient Greece is a vast subject, and this overview, written to be a concise introduction, necessarily compresses and even omits topics that others would emphasize. Whenever possible it tries to signal to readers when interesting disputes lie behind the presentation and interpretation of events or persons, but it cannot offer anything like a full treatment and still achieve the goal of brevity. My hope is that readers will be inspired, or at least provoked, to investigate the evidence for themselves, starting with the ancient sources. For this reason, those sources will be cited in the text from time to time to give a glimpse of the knowledge and delight to be gained from studying them. An extensive list of English translations of those sources is provided in the Suggested Readings, along with modern scholarly works that present fuller accounts and sometimes dueling inter-pretations of important topics, especially those that give rise to dispute.

The narrative of the overview covers the period from prehistory (so called because no written records exist to document those times) to the Hellenistic Age (the modern term for the centuries following the death of Alexander the Great in 323 B.C.). Geographically, it covers, as much as space allows in a book meant to be very brief, the locations in and around the Mediterranean Sea where Greeks lived. The majority of the narrative concerns the Archaic and Classical Ages (the modern terms for the spans of time from 750 to 500 and 500 to 323 B.C., respectively) and the settlements in the territory of mainland Greece, especially Athens. This coverage admittedly reflects a traditional emphasis on what remain the most famous events, personalities, writings, art, and architecture of ancient Greece. It also reflects the inescapable fact that the surviving an-cient sources for this four-hundred-year span are more copious and have been studied in greater depth by scholars than the sources for the earlier and later spans of Greek history, although that imbalance is being reduced by discoveries and modern scholarly work. Finally, that this book focuses above all on the Classical Age reflects my interest in the awe-inspiring (in both positive and negative senses) deeds and thoughts of Greeks over those few centuries.

Relatively small in population, endowed with only a limited amount of flat and fertile agricultural land, and never united as a single nation, ancient Greece eagerly adopted and adapted many ideas and technologies

from its more-numerous, prosperous, and less-factional neighbors in the Near East (the southwestern edge of Asia at the eastern end of the Mediterranean Sea). Building on these inspirations from others, Greeks incubated their own ideas and practices, some of which still resonate today, thousands of years later. It is also true that ancient Greeks, like other ancient peoples, believed and did things that many people today would regard as "awesome" in the sense of morally repugnant. In this context, I agree with those who regard the past as a conceptual "foreign country" largely populated by people who can seem strikingly "other" from what most people today believe, or at least proclaim that they believe, about what sort of persons they are and what moral standards they live by. I also think that admirers of modernity sometimes express a supercilious moral superiority in their judgments regarding antiquity, which recent history scarcely merits. In any case, writing history inevitably involves rendering judgments, if only in what the historian chooses to include and exclude, and I hope that my skepticism about the assertion that the present is far "better" than the past will not seem inconsistent or hypocritical when I occasionally offer critical evaluations in this history. These judgments are made with a deep sense of humility and a keen awareness of how they certainly may miss the mark. Those are the sentiments, along with awe, that studying ancient history constantly renews in me.

The Greek achievements that strike me as the most impressive, and the failures that seem the saddest, took place beginning in the eighth century B.C., when Greece gradually began to recover from its Dark Age—the centuries of economic devastation, population decline, and political vacuum from about 1000 to 750 B.C. Earlier, in the Bronze Age of the second millennium B.C., life had been stable and, relatively speaking, prosperous throughout Greece in tightly organized, independent communities ruled by powerful families through "top-down" political, social, and economic institutions. Spurred by growing trade and cultural interaction with especially the peoples in the lands bordering the eastern end of the Mediterranean Sea, Greeks slowly rebuilt their civilization, but in doing so they diverged both from their previous ways of life and also from those of everyone else in their world: Organizing themselves into city-states, they almost universally rejected the rule of royalty as the "default value" for structuring human society and politics. For them, the new normal became widespread participation in decision making by male citizens who earned that privilege by helping to defend the community. Most astonishing of all, some Greeks implemented this principle by establishing democracies, the first the world had ever seen (some scholars see roots of democracy in earlier communities in the eastern Mediterranean, but the evidence is un-

convincing because, for one thing, it shows no concept of citizenship). At Athens, the guiding principle of democratic government became "equality before the law" and "equality of speech," regardless of a male citizen's wealth, birth, or social status. These concepts of equality represented a radical departure from the usual expectations and norms of politics in the ancient world.

It is necessary to emphasize that Greeks stopped short of fully putting the principle of participation into practice: They did not extend it to female citizens or slaves. As their literature dramatically reveals, they were clearly aware of logical arguments refuting the assertions that women and the enslaved of both genders were by nature characterized by cognitive inferiority and ethical deficiencies, rendering them incapable of participating in the community alongside men. This failure to accept and live by the full implications of their reasoning about politics and law seems to me an inescapable demerit to ancient Greek society. As the nineteenth-century English historian known as Lord Acton remarked in commenting on the ruthless actions of popes and kings, "Power tends to corrupt, and absolute power corrupts absolutely" (Historical Essays and Studies, p. 504). Men held the majority of power in ancient Greece, and it corrupted them, as it eventually does everyone in every era who exercises it.

That ancient Greeks recognized the existence of ideas contradicting their practices is not as surprising as it might seem, because their philosophers, scientists, and literary authors displayed relentless insight in conducting what we might call "thought experiments" on the nature of the world and of human beings. The Greeks' expressions of their ideas in poetry, prose, and drama are deservedly famous for their brilliance—and their sometimes troubling implications. Other ancient civilizations, from the Near East to India to China, also developed impressively insightful scientific and philosophic theories, and the Greeks certainly belong to the first rank of this distinguished company. The same evaluation is justified for Greek literature, drama, history writing, art, and architecture. It is more difficult to evaluate ancient Greek values and practices concerning those two most controversial areas of human experience and belief—religion and sex. As will become clear from the discussions of those topics later in this book, significant differences exist between ancient Greek religious and sexual traditions and what the majority of people today believe and do.

For all these reasons, and more that form part of the narrative to follow, the history of ancient Greece offers fascinating insights into the possibilities and limitations of human existence and presents numerous opportunities for discovery and reflection about the past and the present; not only is it intrinsically interesting (it seems to me), it is also good to think with, as

the renowned French anthropologist Claude Lévi-Strauss said in interpreting why human beings have identified animal species as totems, meaning legendary ancestors whose characteristics their descendants were thought to have inherited and needed to keep in mind in defining their lives (*Totemism*, p. 89).

SOURCES AND EVIDENCE

The best way to learn about ancient Greek history and form one's own judgments is to study the ancient evidence first and then follow up on particular topics by consulting specialized works of modern scholarship. It is conventional to refer to ancient literature, inscriptions, documents written on papyrus, coins, and archaeological remains as "primary" sources, even when they were not contemporary with the history to which they refer. In fact, sources that scholars treat as primary can be considerably later in date than the events or persons for which they provide evidence, such as the inscription from Cyrene cited in the discussion of the founding of colonies in chapter 4. Other primary sources, such as fifth-century B.C. inscriptions about the finances of the so-called Athenian Empire (fig. 1.1), provide direct evidence about history at the time when they were produced. In any case, the surviving ancient sources are the first place to which we should turn to try to understand the past, and in that sense they are always primary. They can be hard to understand. Ancient documents were written for people who knew the full context to which they applied, not for us, who do not. Authors of literary works, including historians, were not aiming to present neutral, objective accounts of events and persons. Rather, they wanted to support a particular view of things and persuade their audiences to accept their interpretations of events and people's motives. Of course, modern writers often take this same approach, too, but those of us studying ancient Greece today must always stay on the lookout not only for what the ancient source was saying but why it was saying that.

The works of modern scholars are usually referred to as "secondary" sources, even when they prove essential in understanding, or even in correcting, the evidence derived from the primary sources. To try to help readers in consulting ancient sources, the citations to them in this overview will use, whenever possible, the internal reference systems that allow a passage to be located regardless of the translation being used (if that translation includes the reference system, which not all do, unfortunately). So, for example, a citation of Herodotus, *The Histories* 7.205, cited as evidence for the three hundred Spartans at the battle of Thermopylae in 480 B.C., means the passage is in book 7, section 205. (For poems, citations

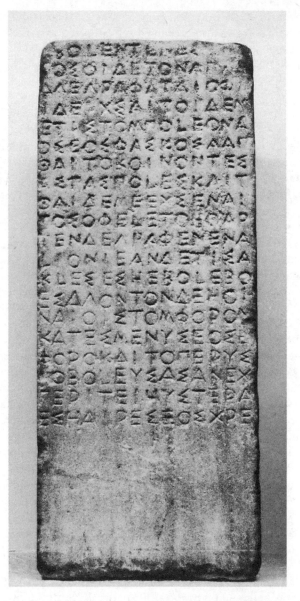

Fig. 1.1: Inscriptions on stone, like this one from the fifth century B.C., which concerns the finances of the naval alliance led by Athens, are "primary sources" for our reconstruction of ancient Greek history. In this period, Greeks wrote such documents with all capital letters and no separation between words. Marie-Lan Nguyen / Wikimedia Commons.

are to line numbers, preceded, if needed, by book number.) For secondary sources, the citations are to page numbers or catalogue item numbers.

The majority of the literary and documentary texts from Greek antiquity have not survived, but those that have are significant and provocative. The epics of Homer, The Iliad and The Odyssey, represent the most primary of the surviving primary sources from literature for the history of ancient Greece, for the Greeks then and for us today. Scholars debate how these long poems reached the form in which they have survived to this day. Some argue that they emerged from centuries and centuries of fluid and flexible oral performances by many bards, finally put down in a written version in the Archaic Age. Others believe that a single poet created the poems using the technology of writing in the eighth century B.C. However they came into existence, the stories in The Iliad and The Odyssey looked back to the Bronze Age while also reflecting the history of the Dark Age. Every ancient Greek valued these works for their artistic beauty and their life lessons. Above all, the Homeric epics encoded enduring values and traditions about the nature of the gods and human courage, self-control, loyalty, love, and sorrow. A thousand years later, people were still memorizing Homeric poetry. The (much-shorter) epic poems of Hesiod, The Theogony (Birth of the Gods) and Works and Days, composed arguably in the eighth century B.C., were meant to teach lessons about the role of the gods in human life, the nature of justice, and the problems created by the inequalities of power that arose as the Greeks slowly developed new forms of political and social life in their city-states. Seventh-century lyric and elegiac poets, such as Alcaeus, Alcman, Archilochus, Sappho, and Tyrtaeus, composed shorter works for choruses and for single voices that introduced communal and individual themes relevant to an era of social and political change. Bacchylides, Pindar, and Simonides in the late sixth century and the fifth century became famous for their elaborately artful poems intertwining mythology with current events, often composed in praise of victors in athletic competitions or battles and powerful rulers. The so-called "first philosophers"—who could just as well be called "scientific thinkers"—in the sixth century also wrote poems describing the underlying and invisible nature of reality as they reasoned it must be.

Soon after, Greeks began to write in prose, focusing on ethnography, geography, and myth (a Greek word, mythos, that means stories about the distant past that offered competing versions of the consequences of the often-difficult relationship between gods and human beings). The earliest of these works have not survived except in quotations and paraphrases by later authors. From the later fifth century B.C., however, we do have The Histories of Herodotus. Telling the complex story of the background and

events of the extended war between a coalition of Greek city-states and the powerful Persian Empire in the opening decades of the fifth century, Herodotus's unprecedented history generates a sense of wonder through its enormous length (50 percent longer than The Iliad), diverse reporting on a dizzying array of Greeks and non-Greeks alike, and its thematic complexity on human motivation. Thucydides' The Peloponnesian War, composed (though not finished) during that long conflict (431–404 B.C.), created the genre of contemporary history written by an eyewitness participant. His biting observations about the human desire for power and the unintended consequences of the violence of war also point to the beginnings of what today is called political science. In the next generation, Xenophon continued Thucydides' history by narrating events in Greece but also made a reputation by producing works about his exciting service as a mercenary soldier in a Persian civil war, the unique characteristics of society at Sparta, the idiosyncratic ideas and behavior of the famous philosopher Socrates (469–399 B.C.), and many other topics.

The fifth century also saw the creation of the primary sources that are perhaps best known today: the plays of the Athenian dramatists Aeschylus, Sophocles, and Euripides. These tragedies sometimes dealt with recent history, but mostly they based their plots on imaginative retellings of myths whose themes connected to life in contemporary Greek society. The characters and emotional conflicts portrayed in these dramas have a universality that keeps them fresh even for performance today. The comic plays of Aristophanes provide another fascinating, if sometimes perplexing, primary source for fifth-century B.C. Athenian society. Skewering his contemporaries with fantastic plots, merciless mockery, and vivid profanity, Aristophanes offers a revealing glimpse of what Greeks said about one another when they were unconcerned with being polite.

From the fourth century come the famous works of the philosophers Plato and Aristotle. Plato's philosophic dialogues, written as the scripts of imaginary conversations between Socrates and his contemporaries, have inspired and provoked thinkers ever since with their implications that the truth of reality is hidden, that the soul is the only worthwhile part of a human being, and that justice requires people to be stratified socially in layers of differing responsibilities and privileges. Aristotle, a student of Plato who argued for a more-practical approach to knowledge and conduct than his teacher did, astounded the world, then and later, with his encyclopedic interests and writings covering more topics in natural science, politics, and ethics than can be easily summarized. From this same century we have numerous surviving speeches from Athens concerning law cases and political crises, works that reveal many details of private and

public life. The orations of Demosthenes are especially vivid in portraying the military danger to Athens posed by the growing power of the kingdom of Macedonia under Philip II (382–336 B.C.) and his son Alexander the Great (356–323 B.C.), and the political split among Athens's citizens concerning whether to collaborate or to go to war to defend their political independence. The surviving primary sources for the world-changing career of Alexander as he fought his way to India and back are not contemporary, but their Roman-era authors (Diodorus, Curtius, Plutarch, Arrian, Justin) preserve vivid portrayals and interpretations of this conflict-filled era when monarchy began to return as the dominant political system of control in the Greek world. Plutarch's biographies of ancient Greeks are, for us, crucially important historical sources, even though he explicitly wrote them to explore individual character by pairing them with lives of Romans. He explicitly said that he was not writing history, but we have to use his biographies in that context to try to fill in the gaps left by our surviving primary sources. Reading Plutarch, therefore, is one of the most interesting challenges in constructing and interpreting ancient Greek history. The same is true of the amazing number of quotations from Greek sources of the Classical Age that are preserved in the long and discursive work called The Learned Banqueters (Deipnosophistae), composed by Athenaeus in the second century A.D.; the variety of topics ranges widely, from food to sex to jokes. Equally challenging to interpret and place in the right historical context are the quotations found in later sources from the writings, which have not survived on their own, of the early historians who wrote about Athens (the so-called Atthidographers).

The comedies of Menander of Athens reveal that, in the new world that was emerging at the time of Alexander in which the city-states of Greece were losing their political independence, audiences preferred soap-opera situation comedies about mistaken identities and romance in place of the biting political satire that had characterized comic plays in the earlier days of Greece's freedom from foreign domination. In studying the centuries following Alexander's death (the Hellenistic Age), it is difficult to reconstruct the story of Greek history with chronological precision because very few narrative sources have survived. The evidence of inscriptions, coins, and archaeological remains is of course crucially important in every period, but for the centuries of Greek history after Alexander these sorts of sources provide the overwhelming majority of what we know. Physical objects, like ancient texts, can of course be challenging to understand and interpret, especially when they were not created with the goal of directly communicating with people who would know nothing about them. Still, they help us puzzle out the significance of the changes in politics, soci-

ety, art, philosophy, and religion that took place in Greek culture as, first, Macedonian rulers constructed kingdoms in Greece, Egypt, and the Near East and, then, the Romans conquered these monarchies to become the dominant power in the Mediterranean world. Greek history and the Greek language lived on even after Rome had absorbed Greeks into its territorial empire, of course, but for the purposes of this book the story will end with a brief overview of Hellenistic Greek history.

THE PHYSICAL ENVIRONMENT OF GREECE

The deepest background of the history of ancient Greece lies in the physical environment and its effects on the opportunities and the constraints of life in this part of the Mediterranean region. The homeland of the ancient Greeks was located in the southern portion of the mountainous Balkan Peninsula (today the territory of the modern nation of Greece) and the hundreds and hundreds of islands in the Aegean Sea to the east and the Ionian Sea to the west. The islands in these sections of the Mediterranean Sea varied in size from large territories, such as Lesbos (630 square miles in area) and Corcyra (227 square miles), to small ones, such as Delos (1.3 square miles). Greeks also lived up and down the western coast of Anatolia (modern Turkey), far to the south on the very large island of Crete (3,219 square miles), on even larger Cyprus (3,572 square miles) far to the east, on the coast of North Africa, and in southern Italy and on Sicily (an area referred to by the Latin name "Magna Graecia"). Almost all the places where Greeks lived were subject to devastating earthquakes.

Chains of rugged mountains dominate the landscape of mainland Greece, fencing off plains and valleys in which communities could keep themselves politically separate from one another while still maintaining contacts for trade and diplomacy. These mountains mainly run from northwest to southeast along the Balkan Peninsula, with narrow passes connecting Greek territory to Macedonia in the north. The highest was Mount Olympus, at almost 10,000 feet high (fig. 1.2). The terrain of the many islands of the Aegean was also craggy. Only about 20 to 30 percent of the mainland was arable, but some islands, western Anatolia, Magna Graecia, and a few fortunate mainland regions, especially Thessaly in the northeast and Messenia in the southwest, included plains spacious enough to support bounteous crops and large grazing animals. The scarcity of level terrain ruled out the raising of cattle and horses on any large scale in many areas. When Greeks first domesticated animals in the late Stone Age, pigs, sheep, and goats became the most common livestock. By the seventh cen-

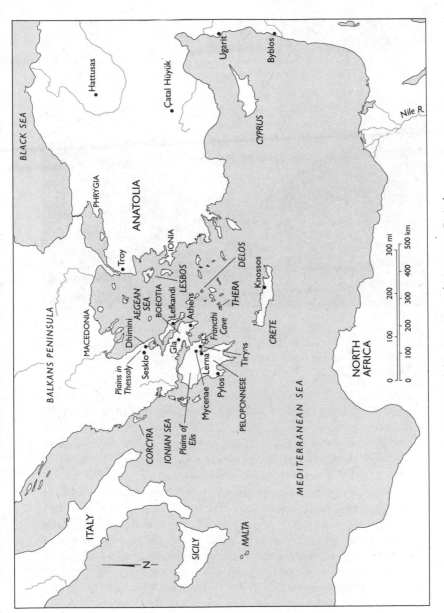

Map 1. Neolithic, Minoan, and Mycenaean Periods

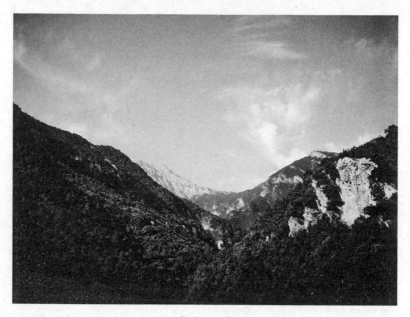

Fig. 1.2: This view through a gorge looks toward Mount Olympus, the highest mountain in Greece at nearly 10,000 feet / 3000 meters high. Greeks believed the gods made their home atop its peak. Mountainous terrain occupied much of the landscape of Greece. Wikimedia Commons.

tury B.C. the domestic chicken had been introduced into Greece from the Near East.

Once Greeks learned to farm, they grew mostly barley, which formed the staple of the Greek diet. The generally poor land supported crops of this grain far better than of wheat, which made tastier food but needed richer land to flourish. Root vegetables and some varieties of cereal grains could be grown even during the cooler winter months. Other major crops were wine grapes and olives. Wine diluted with water was the favorite beverage drunk by Greeks, while olive oil provided a principal source of dietary fat and also served, among many other uses, as a cleaning agent for bathing and a base for perfumes. Meat, which was expensive, appeared more rarely in Greek meals than in those of modern Western cultures. Fish was a popular food but could also be scarce.

So jagged was the Greek coastline that most settlements lay within forty miles of the sea, providing easy access for fishermen and seagoing merchants, though harbors large enough to protect ships during storms, such as the port of Piraeus at Athens, were rare. The ports of Egypt and

the eastern Mediterranean coast were favorite destinations. Going to sea with the limited marine technology of the time made bad weather a serious threat to life and limb, and prevailing winds and fierce gales greatly limited sailing during winter. Even in calm conditions sailors hugged the coast whenever possible and aimed to land every night for safety. Pirates were a menace, too. Nevertheless, driven by the desire for the profits to be made from international trade, Greek entrepreneurs risked the dangers of the sea to sail all over the Mediterranean. Summing up the situation, Hesiod remarked that merchants took to the sea "because an income means life to wretched mortals, but it is a terrible fate to die among the waves" (*Works and Days*, lines 686–687).

Most Greeks, even if they lived near the sea, never traveled very far from home. Commercial sea travel, however, played a central role in the development of Greek culture because traders and entrepreneurs voyaging between the Near East, Egypt, and Greece put Greeks into contact with the older civilizations of the eastern Mediterranean region, from which they learned new technologies; ideas about religion, philosophy, and science; and styles in art. Transporting people and goods overland instead of by sea was slow and expensive because rudimentary dirt paths were Greece's only roads. The rivers were practically useless for trade and communication because most of them, though perhaps not as many as today, slowed to a trickle during the many months each year when little or no rain fell. Timber for building houses and ships was the most plentiful natural resource of the mountainous terrain of the mainland, but deforestation had probably already affected many regions by the fifth century B.C. By that time mainland Greeks were importing lumber from northward regions and paying stiff prices for it. Some deposits of metal ore, especially iron, were scattered throughout Greek territory, as were clays useful for making pots and other containers. Quarries of fine stone, such as marble, furnished material for expensive buildings and sculpture. The irregular distribution of these resources made some areas considerably wealthier than others. The silver mines in Athenian territory, for example, provided an income that supported the exceptional prosperity of Athens's so-called Golden Age in the fifth century.

Modern meteorologists refer to the climate of Greece as Mediterranean, meaning winters drenched with intermittent heavy rain and summers baking with hot, dry weather. Rainfall varied significantly, with the heaviest (around 50 inches annually on average today) along the western side of the Balkan Peninsula, while the eastern region, where Athens is located, receives much less precipitation (16 inches per year). Greek farmers endured a precarious cycle of boom and bust, fearing both drought

and floods. Nevertheless, the Greeks believed their climate to be the best anywhere. Aristotle, who saw climate as determining political destiny, believed that "Greeks occupy a middle position [between hot and cold climates] and correspondingly enjoy both energy and intelligence. For this reason they retain their freedom and have the best of political institutions. In fact, if they could forge political unity among themselves, they could control the rest of the world" (Politics 7.7, 1327b29–33).

As Aristotle implied, throughout their history the ancient Greeks never constituted a nation in the modern sense because their various independent states never united politically. In fact, they often fought wars with one another. On the other hand, Greeks saw themselves as sharing a cultural identity because they spoke dialects of the same language, had similar customs, worshipped the same gods (with local variations in cults), and came together at international religious festivals, such as the celebration of the mysteries of the goddess Demeter at Athens or the athletic games at Olympia in the Peloponnese. Ancient Greece was thus a set of shared ideas and practices rather than a sharply demarcated territorial or national entity. How this sense of Greek cultural identity came to be and how it was maintained over the centuries are difficult questions that must be kept constantly in mind. That its mountainous topography contributed to the political fragmentation of Greece seems clear.

PREHISTORY BEFORE AGRICULTURE

The prehistoric background of Greek history belongs to the Stone Age, so named because the people of the time had mainly stone, in addition to bone and wood, from which to fashion tools and weapons; they had not yet developed the technology to make implements from metals. Most important, at this point human beings did not yet know how to cultivate crops. When people finally began to develop agricultural technology, they experienced tremendous changes in their lives and began to affect the natural environment in unprecedented ways.

The Stone Age is conventionally subdivided into the Paleolithic (Greek for "Old Stone") and Neolithic ("New Stone") Ages. During the hundreds of thousands of years of the Paleolithic period, human beings roamed throughout their lives, searching for food in the wild by hunting game, fishing, collecting shellfish, and gathering plants, fruits, and nuts. Living as hunter-gatherers, these early human beings sometimes migrated great distances, presumably following large game animals or searching for more abundant sources of nutritious wild plants. The first human beings in Greece probably migrated there long ago from the African continent via

c. 45,000–40,000 years ago: *Homo sapiens sapiens* first moves out of Africa into southwestern Asia and Europe.

c. 20,000 years ago: Human habitation begins in the Francthi Cave in southeastern Greece.

c. 10,000–8000 B.C.: Transition from Paleolithic to Neolithic Age marks the beginning of agriculture and permanent settlements.

c. 7000–6000 B.C.: Agriculture and domestication of animals under way in southern and eastern Europe, including Greece.

c. 7000–5000 B.C.: Settlements of permanent houses being built in fertile plains in Greece.

c. 4000–3000 B.C.: Copper metallurgy under way in Balkan region.

the eastern Mediterranean and Anatolia. A skull found at Petralona Cave in Greece has been dated to at least two hundred thousand years before the present. At least as early as fifty thousand years ago the type of Paleolithic human beings known as Neanderthals (from the finds of their remains in Germany's Neander Valley) spread over Macedonia and then into Greece as far south as the plain at Elis in the Peloponnese peninsula. People of modern type (*Homo sapiens sapiens*) began to migrate from Africa into Europe during the last part of the Paleolithic period. This new population eventually replaced completely the earlier populations, such as the Neanderthals; how this happened remains unknown. Perhaps the newcomers were better able to cope with natural disasters, such as the tremendous floods that covered the plains in Thessaly for many years beginning about thirty thousand years before the present.

Ancient hunter-gatherers probably lacked laws, judges, and political organization in the modern sense, which is not to say that they lacked forms of social organization, regulation, and control. Some Paleolithic graves containing weapons, tools, animal figurines, ivory beads, and bracelets suggest that hunter-gatherers recognized social differences among individuals and that an individual's special social status could by marked by the possession of more-expensive or elaborate goods. Just as the possession of a quantity of such goods in life had shown that individuals enjoyed superior wealth, power, or status in their groups, so too the burial of the goods with the corpse indicated the individual's prestige. Accordingly, it appears that some Paleolithic groups organized themselves not along egalitarian lines but rather in hierarchies, social systems that ranked certain people as more important and more dominant than others. Thus, already in this early period we find traces of social differentiation (the marking of

certain people as wealthier, more respected, or more powerful than others in their group), the feature of human life that characterized later Greek society, as it has every society in historical times.

TRANSFORMATION OF DAILY LIFE IN THE NEOLITHIC AGE

Daily life as the ancient Greeks knew it depended on agriculture and the domestication of animals, innovations that gradually took root starting some ten to twelve thousand years ago at the opening of the Neolithic Age. The process of gaining this knowledge, which was to change human life radically, extended over several thousand years. Excavations at the site of the Francthi Cave in Greece have revealed the gradual process of adapting to natural changes that prehistoric populations underwent as they learned to farm. Hunter-gatherers first showed up in this area near the southeastern Greek seacoast about twenty thousand years before the present. At that time the cave, used for shelter, lay some three to four miles from the coast and overlooked a plain verdant with vegetation. Wild horses and cattle grazed there, providing easy hunting. Over about the next twelve thousand years, the sea level gradually rose, perhaps as a result of climatic changes, until only a narrow ribbon of marsh and beach about one kilometer wide separated the cave from the shoreline. With large game animals no longer available nearby, the residents of the Francthi Cave now based their diet on seafood and especially wild plants, such as lentils, oats, barley, bitter vetch, and pear, gathered from nearby valleys and hillsides.

As hunter-gatherer populations came to depend increasingly on plants for their survival, the problem became to develop a reliable supply. The answer, which took thousands of years of repeated trial and error to learn, was to plant part of the seeds from one crop to produce another crop. Knowledge of this revolutionary technology—agriculture—first emerged not in Greece but in the Near East and slowly spread outward. Evidence from the Francthi Cave and the plains in Thessaly shows the new technology had reached Greece by around 7000 B.C. How it made its way there is an intriguing puzzle still to be solved. One of perhaps many contributing factors may have been the contact between different regions that resulted from the travels of merchants and entrepreneurs, who sailed throughout the Mediterranean in search of materials and markets by which to make a profit.

Whatever the ways through which knowledge of agriculture spread, Neolithic women had probably played the major role in inventing the technology and the tools needed to practice it, such as digging sticks and grinding stones. After all, women in hunter-gatherer society had devel-

oped the greatest knowledge of plants because they were the principal gatherers of this food. In the earliest history of farming, women did most of the agricultural labor, while men continued to hunt, although women hunted smaller game, too, using nets. During this same transitional period, people also learned to breed and herd animals for food, thus helping replace the meat formerly supplied by the hunting of large mammals, many of which had become extinct. The first animal to be domesticated as a source of meat was the sheep, from about 8500 B.C. in the Near East. (Dogs had been domesticated much earlier but were not commonly eaten.) Domesticated sheep and goats had become widespread throughout the Near East and southern Europe, including Greece, by about 7000. In this early stage of domestication, small herds kept close to home were the rule. They could therefore be tended by men, women, and children alike.

The production, instead of just the gathering, of food laid the foundation for other changes that we take for granted today. For example, to farm successfully, people had to live in settled locations, and farming villages formed in the Near East as early as 10,000 B.C. Permanent communities of farmers, comprising a built environment with a densely settled population, constituted a new stage in human history. Neolithic villages sprang up in Macedonia and further south in Greece in Thessaly and Boeotia during the period 7000–5000, concentrating in plains suitable for agriculture. The houses of these early settlements were mostly one-room, freestanding dwellings in a rectangular shape up to about forty feet long. At Sesklo in Thessaly, some Neolithic houses had basements and a second story. Greek houses in this period were usually built with a wood frame covered with clay, but some had stone foundations supporting mud bricks (a common building material in the Near East). The inhabitants entered through a single door and baked food in a clay oven. Settlements like those at Sesklo or Dhimini in Thessaly housed populations of perhaps several hundred. At Dhimini a series of low walls encircled the settlement. By the third millennium, large dwellings were being built in Greece, as at Lerna in the Argolid region, where the so-called House of Tiles had a roof of baked tiles covering a multistory building. There are no documents to tell us about the beliefs of the people who lived in these communities: The technology of writing was not yet known in Greece. Sculptures such as a male statue with exposed genitals (fig. 1.3) suggest that rituals meant to ensure human reproduction were important to the villagers, whose existence literally depended on having a high birthrate to replace the many people who died as babies or while still young. Expanding its population was the way for the community to become stronger.

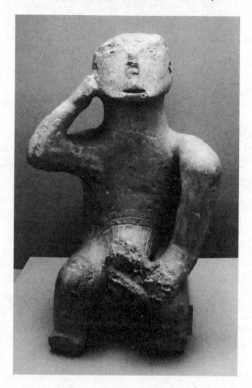

Fig. 1.3: Greeks in the Neolithic ("New Stone") Age created art including statues such as this seated male figure. That this statue had its genitals exposed, with an erect penis (now broken off), leads some scholars to speculate that it concerned reproduction and human fertility, which were sources of anxiety in a world in which many people died young. Wikimedia Commons.

The remarkable changes of the late Neolithic period took place as innovative human adaptations to what in anthropological terms would be called the feedback between environmental change and population growth. That is, as agriculture developed (perhaps in a period when the climate became wetter), populations increased, thus further raising the need for production of food, thus leading to further population growth, and so on. The process that led to the innovation of humans producing their food through agriculture instead of simply finding it in the wild clearly underlines the importance of demography—the study of the size, growth, density, distribution, and vital statistics of the human population—in understanding historical change.

Physical evidence for the new patterns of life emerging in the Neolithic

Age is still emerging at a site in Anatolia (modern Turkey) being explored by an international team of archaeologists; it is known to us only by its modern name, Çatal Hüyük (pronounced "Chatal Hooyook," meaning "Fork Mound"). Large for its time (housing perhaps six thousand people by around 6000 B.C.) but otherwise comparable to Greek Neolithic communities, Çatal Hüyük subsisted by raising grains and vegetables in irrigated fields and domesticating animals, along with hunting some game.

Since the community could produce enough food without everyone having to work in the fields or herd cattle, some workers could become crafts specialists, producing goods for those producing the food. These artisans not only fashioned tools, containers, and ornaments from the traditional materials of wood, bone, hide, and stone but also developed new technological skills by experimenting with the material of the future: metal. Metalworkers at Çatal Hüyük certainly knew how to fashion lead into pendants and to hammer naturally occurring lumps of copper into beads and tubes to make jewelry, but traces of slag (the residue from the process of smelting mineral ores) found on the site further suggest that they were beginning to learn the technique of extracting metal from the rock with which it is usually mixed in its natural state. The tricky process of smelting—the basis of true metallurgy and the foundation of much modern technology—required temperatures of 700 degrees centigrade. Melting copper took temperatures almost twice that high. Achieving this extraordinary heat required building clay furnaces fired by charcoal and stoked by blowing air into them with bellows, perhaps through tubes punched through the furnace walls. This was exhausting, sometimes dangerous work that required great skill and care. Other workers at Çatal Hüyük specialized in weaving textiles, and the scraps of cloth discovered there are the oldest examples of this craft ever found. Like other early technological innovations, metallurgy and the production of cloth apparently also developed independently in other places where agriculture and settled communities provided a context for such creative divisions of labor.

The increasing specialization of labor characteristic of Neolithic settlements such as Çatal Hüyük promoted the development of social and political hierarchies. The need to plan and regulate irrigation, trade, and the exchange of food and goods between farmers and crafts specialists in turn created a need for leaders with greater authority than had been required to maintain peace and order in hunter-gatherer bands. In addition, households that found success in farming, herding, crafts production, or trade made themselves wealthier and thus different from less successful villagers. The greater social equality between men and women that prob-

ably characterized hunter-gatherer society also grew weaker by the late Neolithic period. Gradual changes in agriculture and herding over many centuries perhaps contributed to a shift in the relative power of women and men. Sometime after about 4000 B.C. farmers began to employ plows dragged by animals to cultivate land that was more difficult to sow than the areas cultivated in the earliest period of agriculture. Men apparently operated this new technology because plowing required greater physical strength than digging with sticks and hoes, and men were generally stronger than women. Men also took over the tending of the larger herds that had now become more common, with cattle being kept for milk and sheep for wool. Large herds tended to be grazed at a distance from the village because new grasslands had to be found continually. Men, free from the responsibility of nursing babies, were able to stay away from home to tend to the herds. Women, by contrast, became tied down in the central settlement because they had to raise more children to support agriculture, which was becoming more intensive and therefore required more laborers than had foraging for food or carrying out the earliest forms of farming. Women also had to shoulder the responsibility for new labor-intensive tasks, processing the secondary products of larger herds. For example, they now processed milk into cheese and yogurt and produced cloth by spinning and weaving wool. It seems possible that men's tasks in this new specialization of labor were assigned greater prestige and thus contributed to the growth of inequality between genders. This form of social differentiation, which became a fundamental ingredient in later Greek culture, thus apparently emerged as a contingency of the fundamental changes in human life taking place in the late Neolithic Age.

EXPLAINING TECHNOLOGICAL CHANGE

The issue of how the prehistoric inhabitants of Greece learned to use the transformative technologies of the late Stone Age has become more complex as modern scientific technology has provided new information on the chronology of the changes in different areas. In the broadest form, the question is to what extent the prehistoric inhabitants of Europe derived their knowledge of the new technologies from the populations of Mesopotamia and Egypt, who clearly came first in inventing writing, building cities, and forming complex civilizations. For a long time scholars regarded European developments as, for all practical purposes, wholly derived from the Near East through a process of diffusion. That is, traders, farmers, herders, metalworkers, and architects were theorized to have slowly made their ways to Europe from the Near East, either peacefully or

as violent invaders. They brought with them, on this model, technologies hitherto unknown in the lands they entered, such as agriculture, monumental stone construction, and copper metallurgy. In this way, technological knowledge was gradually diffused from the Near East over Europe.

This explanation of technological change in prehistoric Europe has had to be revised, however, in the light of scientific analytic techniques refined only as recently as the late 1960s. Radiocarbon dating forced the revision by permitting scientists to give close estimates of the age of prehistoric organic materials from archaeological excavations. Laboratory analysis of the amount of radioactive carbon-14 remaining in materials such as bones, seeds, hides, and wood can now determine with an acceptable margin of error the length of time since the death of the material submitted for testing. Dendrochronology, the chronological evidence obtained from counting the internal rings of long-lived trees, has helped refine the accuracy of radiocarbon dating. These techniques applied to archaeological material from Neolithic Europe have suggested a more complex process of change than previously imagined. It now seems established that farming communities had already developed in Greece and the Balkan Mountains immediately to the north as early as the seventh millennium B.C. On this chronology, it is still possible to believe that traders and migrating farmers from the Near East introduced domesticated cereal grains into Greece, but it is also not ruled out that Greek agriculture developed as the result of independent innovation. As for the domestication of cattle, the evidence suggests that this important development in how human beings acquired meat to eat took place in this region of Europe at least as early as in the Near East. In this case, a European population apparently introduced change on its own, by independent local innovation rather than through diffusion.

Radiocarbon dates further suggest that European metalworkers developed copper metallurgy independently from Near Eastern metalsmiths because they show this technology developing in various European locations around the same time as in the Near East. By the fourth millennium, for instance, smiths in the Balkans were casting copper ax heads with the hole for the ax handle in the correct position. The smiths of southeastern Europe started alloying bronze in the same period in the third millennium as their Near Eastern counterparts, learning to add 10 percent of tin to the copper that they were firing. The European Bronze Age (to use the terminology in which periods of history are labeled according to the metal most in use) therefore commenced at approximately the same date as the Near Eastern Bronze Age. This chronology suggests contemporary but independent local innovation, because otherwise we would expect to find

evidence that metallurgy had begun much earlier in the Near East than in Europe, to allow the necessary time for the diffusion of the technology all the way from the Near East to Europe.

Thus, the explanation of important changes in prehistoric European history has become more complicated than it was when diffusion alone seemed sufficient to explain these developments. It no longer seems possible to think that the Neolithic population of Greece was wholly dependent on Near Easterners for knowledge of innovative technologies such as megalithic architecture and metallurgy, even if they did learn agriculture from them. Like their neighbors in Europe, the inhabitants of prehistoric Greece participated in the complex process of diffusion and in independent invention, which brought such remarkable technological and social changes in this period through the interacting effects of contact with others, sometimes very distant others, and local innovation.

TWO
From Indo-Europeans to Mycenaeans

When did the people living in and around the central Medi-
terranean Sea in the locations that make up Greece become
Greeks? No simple answer is possible, because the concept of
identity includes not just the social and material conditions
of life but also ethnic, cultural, religious, and linguistic tradi-
tions. So far as the available evidence shows, the Mycenaeans
of the second millennium B.C. were the first population in
Greece that spoke Greek. By that date, then, groups of people
clearly existed whom we can call Greeks. No records tell us
what the Mycenaeans called themselves; in Greek, as it devel-
oped in the historical period, they referred to their country
as "Hellas" and themselves as "Hellenes," from the name of a
legendary chief from central Greece, Hellen (Thucydides, *The
Peloponnesian War* 1.3.2). Those terms remain the proper usage
in Greek today. "Greece" and "Greek," in fact, come from
Latin, the language of the Romans.

The deepest origins of the language of the Greeks and the
other components of their identity lie deeper in the past than
Mycenaean times, but tracing those origins remains a chal-
lenge because written records do not exist from such early
times. Scholarly investigation of the fundamental components
of ancient Greek ethnic and cultural identity has centered
on two major issues: the significance of the Indo-European
heritage of ancient Greeks in the period c. 4500–2000 B.C.,
and the consequences for Greeks of their interactions with
the older civilizations of the Near East, Egypt in particular,

23

in the second millennium. Even though the details of these processes of cultural formation remain exceptionally controversial, on a general level it is clear that both these sources of influence affected the construction of Greek identity in lasting ways.

There are definite sources of influence on early Greek culture to be found in the history of the second millennium, for which we have significant archaeological evidence and even some written documents. Before the rise of Mycenaean civilization in mainland Greece, Minoan civilization flourished on the large island of Crete. The Minoans, who did not speak Greek, had grown rich through complex agriculture and seaborne trade with the peoples of the eastern Mediterranean and Egypt. The Minoans passed on this tradition of intercultural contact to the civilization of the Mycenaeans, whom they greatly influenced before losing their power after the middle of the millennium. The centers of Mycenaean civilization were destroyed in the period from about 1200 to 1000 B.C. as part of widespread turmoil throughout the eastern Mediterranean region. The descendants of the Greeks who survived these catastrophes eventually revived Greek civilization after the Dark Age (1000–750).

INDO-EUROPEAN AND NEAR EASTERN ROOTS

The central issue concerning the Indo-European background of Greek identity and culture is whether groups of peoples whom we call Indo-Europeans migrated into prehistoric Europe over many centuries and radically changed the nature of the lives of people already there, including the indigenous inhabitants of Greece. Debate continues over the location of the homeland of the earliest Indo-Europeans, but the most likely suggestion seems to be either central Asia or Anatolia. Recent though controversial research in computer analysis of linguistic evidence seems to tip the balance in favor of Anatolia. The final phase of Indo-European migration caused devastation across Europe around 2000 B.C., according to the also controversial hypothesis that aggressive peoples at that time moved in large groups across vast distances. The Greeks of the historical period are then seen as the descendants of this group of invaders.

The concept of an original Indo-European identity is constructed from the later history of language. Linguists long ago recognized that a single language had been the earliest ancestor of most of the major ancient and modern groups of languages of western Europe (including, among others, Greek, Latin, and English), of the Slavic languages, of Persian (Iranian), and of various languages such as Sanskrit spoken on the Indian subcontinent. They therefore bestowed the name "Indo-Europeans" on the

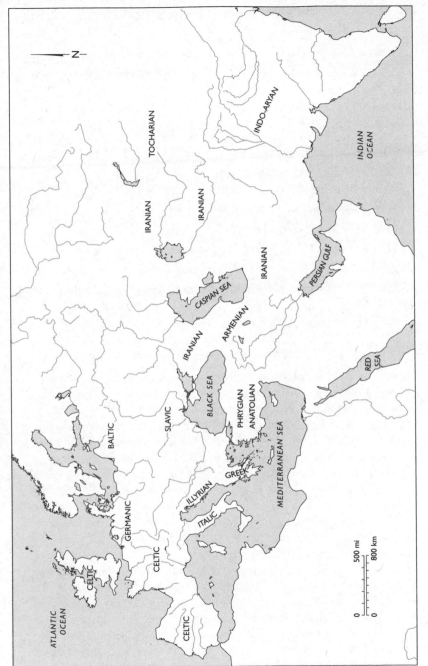

Map 2. Areas of Indo-European Language Groups

c. 4500–2000 B.C.: Movements of Indo-European peoples into Europe?

c. 3000–2500 B.C.: Bronze metallurgy under way in the Balkans and on the island of Crete.

c. 3000–2000 B.C.: Development of Mediterranean polyculture.

c. 2200 B.C.: Earliest Cretan palaces of Minoan civilization.

c. 2000 B.C.: Violent destruction of many European sites.

c. 1700 B.C.: Earthquakes destroy early Cretan palaces.

c. 1600–1500 B.C.: Shaft graves at Mycenae on Greek mainland.

c. 1500–1450 B.C.: Earliest Mycenaean *tholos* tombs.

c. 1400 B.C.: Earliest Mycenaean palaces.

c. 1370 B.C.: Palace of Knossos on Crete destroyed.

c. 1300–1200 B.C.: Highpoint of Mycenaean palace culture.

c. 1200–1000 B.C.: Violent disturbances across the Aegean region in the era of the Sea Peoples.

c. 1000 B.C.: Mycenaean palace society no longer functioning.

original speakers of this ancestral language. Since the original language had disappeared by evolving into its different descendant languages well before the invention of writing, its only traces survive in the words of the later languages derived from it. Early Indo-European, for example, had a single word for night, which passed down as Greek nux (nuktos in the genitive case), Latin nox or noctis, Vedic (the type of Sanskrit used in the ancient epic poetry of India) nakt-, English night, Spanish noche, French nuit, German Nacht, Russian noch, and so on. To give another example: that English speakers have the words I and me, two completely dissimilar pronouns, to refer to themselves in different grammatical contexts is a feature inherited from the pronouns of Indo-European.

Scholars of linguistics think that words in later languages that descended from the original language of the earliest Indo-Europeans can offer hints about important characteristics of that group's original society. For example, the name of the chief Indo-European divinity, a male god, survives in the similar sounds of Zeus pater and Jupiter, the names given to the chief god in Greek and Latin, respectively. This evidence leads to the conclusion that Indo-European society was patriarchal, with fathers being not just parents but rather the authority figure controlling the household. Other words suggest that Indo-European society was also patrilocal (the

wife moving to live with the husband's family group) and patrilineal (the line of descent of children being reckoned through their father). Indo-European language also included references to kings, a detail suggesting a hierarchical and differentiated society rather than an egalitarian one. Finally, both linguistic and archaeological evidence was taken to mean that Indo-European males were warlike and competitive. Since the language of the Greeks, the fundamental component of their identity, indisputably came from Indo-European origins, they represented one linguistically identifiable group descended from Indo-European ancestors.

The most controversial interpretation of the significance of the early Indo-Europeans argues that they invaded Europe in waves and imposed patriarchal, hierarchical, and violent values on the peoples they found there. On this hypothesis, the indigenous populations of prehistoric Europe had been generally egalitarian, peaceful, and matrifocal (centered on women as mothers), and the Indo-European invasions destroyed these qualities. This argument further asserts that these earlier Europeans had originally worshipped female gods as their principal divinities, but the Indo-Europeans forcibly degraded these goddesses in favor of their male deities, such as Zeus, the king of the gods for the Greeks. This brutal transformation would have begun about 4500 B.C., with different groups of Indo-Europeans moving into Europe over the following centuries, eventually sacking and ruining many pre–Indo-European sites in Europe around 2000 B.C.

Opponents of the theory of the Indo-European origin of other aspects of the Greeks' culture except for language argue that no evidence clearly shows Indo-Europeans migrating into Europe as distinct groups powerful enough to abolish already-existing social structures and beliefs and force their own practices on the people already there. It may even be that Indo-European social traditions had never differed significantly from those originally evolved by the non–Indo-European societies of prehistoric Europe. Therefore, characteristics of later, historical Greek society, such as patriarchy and social inequality for women, might in truth have already existed among the indigenous inhabitants of Greece. For example, another theory proposes that Stone Age male hunter-gatherers had pushed human society down the road toward patriarchy by kidnapping women from each other's bands in an attempt to improve their own band's ability to reproduce itself and thus survive. Since men as hunters had experience traveling far from base camp, they were the ones to raid other bands. In this way, men would have acquired dominance over women long before the date when early Indo-Europeans are supposed to have initiated their invasions of Europe.

On this view, the indigenous society of Europe became patriarchal without outside influence, even though its religion paid great respect to female divinities, as evidenced by the thousands of Venus figurines (female statuettes with large breasts and hips) uncovered in European archaeological excavations of prehistoric sites, and by the many goddesses prominent in Greek religion. Alternatively, the growth of social inequality between men and women may have been a consequence of the changes accompanying the development of plow agriculture and large-scale herding in late Stone Age Europe (see chapter 1). Scholars who deemphasize the significance of the Indo-Europeans as a source of cultural change argue further against blaming them for the widespread destruction of European sites around 2000 B.C. Instead, they suggest, exhaustion of the soil, leading to intense competition for land, and internal political turmoil could have motivated the violent clashes that devastated various European settlements at the end of the third millennium.

One aspect of the question of Greek identity that has aroused fierce controversy is the relation between Greece and the Near East, especially Egypt. Some nineteenth-century scholars downplayed or even denied any significant cultural influence of the Near East on Greece, despite the clear evidence that the ancient Greeks acknowledged with appreciation that they had learned a great deal from those peoples outside Greece who, they fully recognized, represented more-ancient civilizations. Greeks with knowledge of the past proclaimed that they had taken a lot in particular from the older civilization of Egypt, especially in religion. Herodotus reported that priests in Egypt told him that as well as being the first people to create altars, festivals, statues, and temples of the gods, the Egyptians had initiated the tradition of bestowing epithets or titles on divinities, and that the Greeks had adopted this tradition from Egypt—and, Herodotus adds, the evidence the priests provided him proved that "these claims were valid" (*The Histories* 2.4.2).

Modern research agrees with the view of the ancient Greeks that they had learned much from Egypt. The clearest evidence of the deep influence of Egyptian culture on Greek is the store of fundamental religious ideas that flowed from Egypt to Greece, such as the geography of the underworld, the weighing of the souls of the dead in scales, and the life-giving properties of fire, as commemorated in the initiation ceremonies of the international cult of the goddess Demeter of Eleusis (a famous site in Athenian territory). Greek mythology, the stories that Greeks told themselves about their deepest origins and their relations to the gods, was infused with stories and motifs with roots in Egypt and the Near East. But the influence was not limited to religion. For one thing, Greek sculptors

in the Archaic Age chiseled their statues according to a set of proportions established by Egyptian artists.

Archaeology reveals that people living in Greece had trade and diplomatic contacts with the Near East at least as early as the middle of the second millennium B.C. What cannot be true, however, is the modern theory that Egyptians invaded and colonized mainland Greece in this period. Egyptian records refer to Greeks as foreigners, not as colonists. Furthermore, much of the contact between Greece and the Near East in this early period took place through intermediaries, above all the seafaring traders from the island of Crete. In any case, in thinking about the "cultural debt" of one group to another, it is crucial not to fall into the trap of seeing one group as the passive recipient of ideas or skills or traditions transmitted by a superior group. What one group takes over from another is always adapted and reinterpreted according to the system of values of the group doing the receiving. Everything they receive from others they transform so as to give the innovations functions and meanings suited to their own purposes and cultural traditions. When the Greeks learned from the peoples of the Near East and Egypt, they made what they learned their own. This is how cultural identity is forged, not by mindless imitation or passive reception. The Greeks themselves constructed their own identity, based above all on shared religious practices and a common language. In the aspects of their culture that they originally took from others, they put their own stamp on what they learned from foreigners. The construction of Greek identity took a long time. It would be pointless to try to fix the beginning of this complex process at any single moment in history. Rather than look for a nonexistent single origin of Greek identity, we should try to identify the multiple sources of cultural influence that flowed together over the long run to produce Greek culture as we find it in later times.

BRONZE AGE CIVILIZATIONS OF EUROPE

The late Bronze Age (the second millennium B.C.) provides crucial evidence for understanding how Greeks became Greeks. The "first civilizations of Europe" belong to this period: Minoan civilization on the large island of Crete (southeast of the mainland peninsula of Greece) and on other smaller Mediterranean islands, and Mycenaean civilization on the mainland and on some of the islands and coast of the Aegean. The Minoans, who spoke a still-unidentified language, built a prosperous civilization before the Greek-speaking Mycenaeans. Both populations had extensive trading contacts with the Near East, complex agricultural and metallurgical technologies, elaborate architecture, striking art, and a marked taste

for luxury. They also inhabited a dangerous world whose perils ultimately overwhelmed all their civilized sophistication.

The forerunners of these civilizations in the third millennium B.C. had developed advanced metallurgy in bronze, lead, silver, and gold—a technology that had deep effects on Minoan and Mycenaean life, from war to farming to the creation of new objects of wealth and status. These metallurgical advances apparently took place independent of similar developments in the Balkans and the Near East. Devising innovative ways to alloy metals at high temperatures, Aegean smiths created more-lethal weapons for warfare, new luxury goods, and more-durable and effective tools for agriculture and construction. This new technology made metal weaponry more effective in dealing death. A copper weapon had offered relatively few advantages over a stone one, because this soft metal easily lost its shape and edge. Bronze, an alloy of copper and tin, was much stronger and able to hold a razor edge; its invention made possible the production of durable metal daggers, swords, and spearheads. The earliest Aegean daggers have been found at third-millennium Troy in western Anatolia. The dagger soon became standard equipment for warriors in the Bronze Age and an early entry in the catalogue of weapons that fueled the arms races familiar in human history. Daggers gradually lengthened into swords, increasing the killing efficiency of these new weapons.

Bronze Age smiths could also add expensive decorations to weapons and jewelry to make them objects for display and ostentation, serving as highly visible symbols of their owners' wealth and rank in society. Since human beings seem by nature to be status-seeking organisms, new and more-expensive metal objects gave people yet another way to set themselves apart, if they could afford it. For example, elaborately decorated weapons helped mark the division between men and women in society because they signified the masculine roles of hunter and warrior that had emerged long ago in the division of labor of hunter-gatherers. Since the desire to accumulate wealth in the form of metal objects and to possess costly examples as status symbols stimulated demand for metals and for the skilled workers who could fashion them, the creation of a new kind of wealth and status represented one of the most important social consequences of the development of metallurgy. Greater availability of such objects made even more people desire them, further stimulating demand across society. This process in turn affected people's expectations about what constituted rewards appropriate for their labor or for displaying their status. Now they expected to be able to acquire goods made of metal— utilitarian objects, such as tools, and luxury goods, such as jewelry. The elite also prized the products of other specialized crafts perfected in the

Near East, such as decorative pieces carved from imported ivory. Growing numbers of crafts specialists in turn swelled Bronze Age Aegean settlements, though the communities remained quite small by modern urban standards. Some of these specialists were itinerant Near Easterners who had traveled west looking for new markets for their skills. They brought with them not only their technological expertise but also a repertoire of myths that influenced the peoples with whom they interacted. In this way they became indirect agents of cultural change.

Mediterranean polyculture—the cultivation of olives, grapes, and grain together in one agricultural system—also grew common in the third millennium, as people began to make use of sharper and better metal tools and to exploit new plants to expand their diet. The emergence of this system, which still dominates Mediterranean agriculture, had two important consequences: an increase in the food supply, which stimulated population growth, and further diversification and specialization of agriculture. This newly diversified agriculture in turn produced valuable new products: olive oil and wine, both of which required new storage techniques for local use and for trade. The manufacture of giant storage jars therefore gained momentum, adding another specialization to the crafts of the period. Specialization in the production of food and goods also meant that the specialists in these fields had no time to grow their own food or fashion the variety of things they needed for everyday life. They had to acquire their food and other goods through exchange.

Society therefore became increasingly interdependent, both economically and socially. In the smaller villages of early Stone Age Greece, reciprocity had probably governed exchanges among the population of self-sufficient farmers. Reciprocal exchange did not aim at economic gain but rather promoted a social value: I give you some of what I produce, and you in return give me some of what you produce. We exchange not because either of us necessarily needs what the other produces, but to reaffirm our social alliances in a small group. Bronze Age society in the Aegean region eventually reached a level of economic interdependence that went far beyond reciprocity and far surpassed in its complexity the economies that had been characteristic of even larger Neolithic villages such as Çatal Hüyük.

THE PALACE SOCIETY OF MINOAN CRETE

People had inhabited the large, fertile island of Crete for several thousand years before the emergence about 2200–2000 B.C. of the system that has earned the title of the earliest Aegean civilization. This civilization,

which was characterized by large architectural complexes today usually labeled "palaces," relied on an interdependent economy based primarily on redistribution controlled by the rulers. The first, "pre-palace," settlers in Crete presumably immigrated across the sea from nearby Anatolia about 6000 B.C. These Neolithic farming families originally lived in small settlements nestled close to fertile agricultural land, like their contemporaries elsewhere in Europe. In the third millennium B.C., however, the new technological developments in metallurgy and agriculture began to affect society on Crete dramatically. By about 2200 or somewhat later, huge many-chambered buildings (the so-called palaces) began to appear on Crete, usually near but not on the coast. The palaces were multistoried and sprawling, their walls decorated with colorful paintings of ships on the sea, leaping dolphins, and gorgeous women. Today this Cretan society is called Minoan after King Minos, the legendary ruler of the island. The palaces housed the rulers and their servants and served as central storage facilities, while the general population clustered around the palaces in houses built one right next to the other, in smaller towns nearby, and in country houses in outlying areas.

Earthquakes leveled the first Cretan palaces about 1700 B.C., but the Minoans rebuilt on an even grander scale in the following centuries. Accounting records preserved on clay tablets reveal how these large structures served as the hubs of the island's top-down, redistributive economy. Probably influenced by Egyptian hieroglyphs, the Minoans at first developed a pictographic script to symbolize objects, for the purpose of keeping such records. This system evolved into a more linear form of writing to express phonetic sounds. Unlike cuneiform or hieroglyphics, this system of writing was a true syllabary, in which characters stood for the sound of the syllables of words. This script, used during the first half of the second millennium B.C., is today called Linear A. The identity of the language that it recorded remains unknown, and linguistic specialists can decipher only some of the words; recent scholarship suggesting that the language of Linear A belonged to the Indo-European family has not convinced the majority of scholars. In other ways, such as their religious architecture, the Minoans certainly differed from the population on the Greek mainland. Since Minoan civilization had direct contact with and great influence on the mainland inhabitants, however, it is appropriate to treat it as part of the early history of Greece.

Linear A is sufficiently well understood to see that it was used for records in the form of lists: records of goods received and goods paid out, inventories of stored goods, livestock, landholdings, and personnel. With their emphasis on accounting, the Minoans kept records of everything from

chariots to perfumes. The receipts record payments owed, with careful notation of any deficits in the amount actually paid in. The records of disbursements from the palace storerooms cover ritual offerings to the gods, rations to personnel, and raw materials for crafts production, such as metal issued to bronze smiths. None of the tablets records any exchange rate between different categories of goods, such as, for example, a ratio to state how much grain counted as the equivalent of a sheep. Nor do the tablets reveal any use of bullion as money in exchanges. (The invention of coinage lay a thousand years in the future.)

The palace society of Minoan Crete therefore appears to have operated primarily on a redistributive economic system: The central authority told producers how much they had to contribute to the central collection facility and also decided what each member of the society would receive for subsistence and reward. In other words, the palaces did not support a market economy, in which agricultural products and manufactured goods are exchanged through buying and selling. Similar redistributive economic systems based on official monopolies had existed in Mesopotamia for some time, and, like them, the Cretan redistributive arrangement required both ingenuity and a complicated administration. To handle receipt and disbursement of olive oil and wine, for example, the palaces had vast storage areas filled with hundreds of gigantic jars next to storerooms crammed with bowls, cups, and dippers. Scribes meticulously recorded what came in and what went out by writing on clay tablets kept in the palace. Specific administrators had the job of collecting quotas of the most valuable items—animals and textiles—from the various districts into which the palace's territory was divided. The process of collection and redistribution applied to crafts specialists as well as to food producers, and the palace's administrative officials set specifications for crafts producers' contributions, which amounted to work quotas. Although not everyone is likely to have participated in the redistribution system, it apparently dominated the Cretan economy, minimizing the exchange of goods through markets. People out in the countryside perhaps occasionally sold goods to one another, but the volume of exchange in these small markets never remotely rivaled the scope of the redistributive economic system of the palaces.

Overseas trade probably operated as a monopoly through the palace system, too, with little role for independent merchants and traders. The Minoan palaces conducted a great deal of commerce by sea, seeking raw materials and luxury goods. Copper could be obtained on Cyprus, but the tin needed to make bronze was only found in a few very distant locations. Therefore, trade for this essential metal connected Crete, if indirectly, to places as far away as Britain and even Afghanistan. Egypt was a favorite des-

tination for Minoan seafarers, who are depicted in Egyptian tomb reliefs as bringing gifts or tribute to Egypt's rulers. Some Minoans evidently stayed on in Egypt as mercenary soldiers or artists, and Minoan-style frescoes (wall paintings on plaster) have been found at Avaris (Tel el-Dab'a) there. Minoan Crete was also in contact with the Near East and the island of Cyprus in the eastern Mediterranean, with traders and crafts specialists from those areas probably voyaging westward to Crete as often as the Minoans went eastward.

Archaeological evidence suggests that Minoan civilization operated smoothly and peacefully for centuries. The absence of fortification walls around the palaces, towns, and isolated country houses of Minoan Crete imply that Minoan settlements saw no need to defend themselves against one other. By contrast, contemporary settlements elsewhere around the Aegean Sea and in Anatolia had elaborate defensive walls. The remains of the newer Minoan palaces, such as the famous one at Knossos on the north side of the island (fig. 2.1)—with its hundreds of rooms in five stories, storage jars holding 240,000 gallons, indoor plumbing, and brightly colored scenes painted on the walls—have led many to see Minoan society as especially prosperous, peaceful, and happy. The prominence of women in palace frescoes and the numerous figurines of bosomy goddesses found on Cretan sites have even prompted speculation that Minoan society continued to be a female-dominated culture of the kind that, as discussed earlier, has sometimes been postulated as the indigenous society of prehistoric Europe. But the wealth of weaponry found in the graves of Cretan men shows that expertise in combat and martial display bestowed special status in Minoan society. The weapons strongly suggest that men dominated in the palace society of Minoan Crete, and it is common to speak of "princes" or "kings" as the leaders in this society of palaces.

MINOAN CONTACT WITH MYCENAEAN GREECE

The long-distance international trade of Minoan Crete established extensive overseas contacts for the residents of the palaces, and this network of trade gained strength as the Minoans learned to build still larger ships that could carry more cargo and survive better in Mediterranean storms. Their daring sailors voyaged long distances not only to Egypt and the other civilizations of the Near East, but also to the islands of the Aegean and southern Greece. On the Greek mainland they encountered another civilization today called Mycenaean, after its most famous archaeological site. Inspired by the Greek poet Homer's tale of the Trojan War, archaeologists have uncovered the Bronze Age site of Mycenae in the Peloponnese

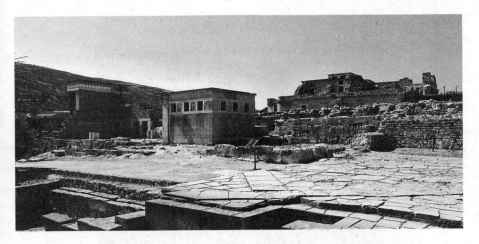

Fig. 2.1: The Minoan-era palace at Knossos on Crete was a sprawling, multistory building with extensive areas for storage of goods and large public gatherings. Centers such as this were the hubs of the "top-down," redistributive economic systems of the Minoans. © iStockphoto.com / Ralf Siemieniec.

(the large peninsula that is southern Greece), with its elaborate citadel on multiple terraces and fortification walls built of large stones meticulously fitted together (fig. 2.3 on p. 44). The discoveries at Mycenae gained such renown that "Mycenaean" has become the general term for the Bronze Age civilization of mainland Greece in the second millennium B.C., although neither Mycenae nor any other of the settlements of Mycenaean Greece ever ruled Bronze Age Greece as a united state.

The discovery in the nineteenth century A.D. of treasure-filled graves at Mycenae thrilled the European world. Constructed as stone-lined shafts, these graves entombed corpses buried with golden jewelry, including heavy necklaces festooned with pendants, gold and silver vessels, bronze weapons decorated with scenes of wild animals inlaid in precious metals, and delicately painted pottery. The first excavator of Mycenae, the businessman-turned-archaeologist Heinrich Schliemann, thought that he had found the grave of King Agamemnon (fig. 2.2), who commanded the Greeks at Troy in Homer's poem *The Iliad*. In truth, however, the shaft graves date to the sixteenth century B.C., long before the Trojan War of the twelfth century. The artifacts from the shaft graves point to a warrior culture organized in independent settlements ruled by powerful commanders, who enriched themselves by conducting raiding expeditions near and far, as well as by dominating local farmers. The retrospective story of the Trojan War told in *The Iliad* refers, at least in part, to the aims of Mycenaean

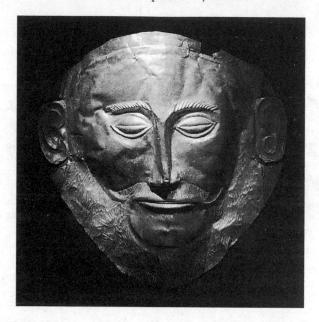

Fig. 2.2: This gold mask was discovered in a grave at Mycenae. Sometimes called the "Death Mask" of Agamemnon, the commander of the Greek army in the Trojan War, its identity and function remain mysteries. It does reveal, however, how rich the rulers of Mycenae became: They could afford to demonstrate their superior social status by burying such valuable objects. Wikimedia Commons.

society as they passed down to later ages in oral literature. The aggressive heroes of Homer's poem sail far from their homes in Greece to attack the citadel of the Trojans in western Anatolia. Their announced mission is to rescue Helen, the Greek queen whom the son of the king of Troy had lured away from her husband, but they were intensely focused on gathering booty by sacking Troy and other places in the neighborhood. The precious objects and symbols of wealth and power found in the graves dating long before the Trojan War show that a society of warriors with goals similar to those of the male heroes of *The Iliad* was in place at least four centuries earlier than the setting of the poem's story.

The construction of another kind of burial chamber, called *tholos* tombs—spectacular underground domed chambers built in beehive shapes from closely fitted stones—marks the next period in Mycenaean society, beginning in the fifteenth century B.C. The architectural details of the *tholos* tombs and the Near-Eastern-art-inspired styles of the burial goods found in them testify to the far-flung contacts that Mycenaean rul-

ers maintained throughout the eastern Mediterranean. Reference to Mycenaean soldiers in Egyptian records indicates that mainland warriors could take up service far from home.

Contact with the civilization of Minoan Crete was tremendously influential for Mycenaean civilization; Minoan artifacts and artistic motifs turn up on the mainland in profusion. The evidence for contact between Minoans and Mycenaeans raises a thorny problem in the explanation of cultural change. Since the art and goods of the Mycenaeans in the middle of the second millennium B.C. display many features clearly reminiscent of Cretan design, the archaeologist who excavated Knossos, Arthur Evans, argued that the Minoans had inspired Mycenaean civilization by sending colonists to the mainland, as they undeniably had to various Aegean islands, such as Thera. This demotion of Mycenaean civilization to secondary status offended the excavators of Mycenae, and a continuing debate among scholars raged over the relationship between the two cultures. They were certainly not identical; they spoke different languages. The Mycenaeans made burnt offerings to the gods; the Minoans did not. The Minoans constructed sanctuaries across the landscape in caves, on mountaintops, and in country villas; the mainlanders built no shrines separate from their central dwellings. When in the fourteenth century B.C. the mainlanders started to build palace complexes reminiscent of those on Crete, the Mycenaeans designed their palaces around megarons, spacious reception halls with huge ceremonial hearths and thrones for the rulers; the Minoans had not done that in their palaces. Some Mycenaean palaces had more than one megaron, which could soar two stories high with columns to support a roof above the second-floor balconies of the palace.

The mystery surrounding the relationship between the Minoans and the Mycenaeans deepened with the startling discovery in the palace at Knossos of tablets written in an adaptation of Linear A. This same hybrid script had also been found on tablets excavated at Mycenaean sites on the mainland, where scholars called it Linear B. Michael Ventris, a young English architect interested in codes, startled the scholarly world in the 1950s by demonstrating that the language being written with Linear B was in fact Greek and not the Minoan language of Linear A. Because the Linear B tablets from Crete dated from before the final destruction of the Knossos palace in about 1370 B.C., they meant that the palace administration had for some time been keeping its records in a foreign language—Greek—rather than in Cretan. Presumably this change in the language used for official record keeping means that Greek-speaking Mycenaeans from the mainland had come to dominate the palaces of Crete, but whether by violent invasion or some kind of peaceful accommodation remains unknown.

TABLE 1. EXAMPLES OF WORDS IN LINEAR B SCRIPT

1.	⊕?	‡⊕Ṭ	ʌʔ٦	ⵟⵊⵞⵐ	ⵟⵊⵞⵐ	ⵟⵊⵞⵐ	ⵟⵊⵞⵐ
2.	ka-ko	pa-ka-na	ti-ri-po	i-je-re-ja	qa-si-re-u	tu-ka-te	ko-wo
3.	kha(l)ko(s)	pha(s)gana	tripo(s)	(h)iereia	gwasileu(s)	thugatē(r)	ko(r)wo(s)
4.	khalkos	phasgana	tripous	hiereia	basileus	thugater	kouros
5.	'bronze'	'swords'	'tripod'	'priestess'	'chief'	'daughter'	'boy'

1. The words written in Linear B characters.
2. The words transcribed into syllables (separated by hyphens) using the English alphabet.
3. The words reconstructed into phonetic form (with letters in parentheses that must be supplied by the speaker reading the words).
4. The words as they appear in classical Greek (transliterated into the English alphabet).
5. The words translated into English.

Certainly the Linear B tablets imply that the mainland had not long, if ever, remained a secondary power to Minoan Crete.

THE HIGHPOINT OF MYCENAEAN SOCIETY

Archaeology helps us uncover the basis of the power of Mycenaean society from about 1500 to 1250 B.C. Archaeologists love cemeteries, not because of morbid fascination with death but because ancient peoples so often buried their dead with goods that tell us about life in the society. Bronze Age tombs in Greece reveal that no wealthy Mycenaean male went to the grave without his fighting equipment. The complete suit of Mycenaean bronze armor found in a fourteenth-century B.C. tomb from Dendra in the northeastern Peloponnese shows how extensive first-class individual equipment could be. This dead warrior had worn a complete bronze cuirass (torso guard) protecting his front and back, an adjustable skirt of bronze plates, bronze greaves (shin guards), shoulder plates, and a collar. On his head had rested a boar's-tusk helmet with metal cheek pieces. Next to his body in the grave lay his leather shield, bronze and clay vessels, and a bronze comb with gold teeth. Originally his bronze swords had lain beside him, but tomb robbers had stolen them before the archaeologists found his resting place. This warrior had spared no cost in equipping himself with the best technology in armor and weaponry, and his family thought it worthwhile as a demonstration of status to shoulder the expense of consigning this costly equipment to the ground forever rather than pass it on to the next generation. His relatives expected

other people to see them making this expensive demonstration as proof of their superior wealth and status.

Mycenaean warriors outfitted like this man could ride into battle in the latest military hardware—the lightweight, two-wheeled chariot pulled by horses. These revolutionary vehicles, which some scholars think were introduced by Indo-Europeans migrating from central Asia, first appeared in various Mediterranean and Near Eastern societies not long after 2000 B.C. The first Aegean depiction of such a chariot occurs on a Mycenaean grave marker from about 1500 B.C. Wealthy people evidently craved this dashing new invention not only for war but also as proof of their social status, much like modern people rushing to replace their horse-drawn wagons with cars after the invention of the automobile. It has been suggested that the Dendra armor was for a warrior fighting from a chariot, not for an infantryman, on the grounds that a foot soldier would not be able to move freely enough in the metal casing of such a suit. On this argument, chariots carrying archers provided the principal arm of Mycenaean armies, supplemented by skirmishers fighting on foot, not unlike the tank battles of World War II, in which infantrymen crept along into battle in the shadow of a force of tanks as mobile artillery. These supplementary infantrymen escorted the chariot forces, guarded the camps at the rear of the action, chased fugitive enemies after the main clash of battle, and served as attack troops on terrain inaccessible to chariots. Many of these Mycenaean-era foot soldiers may have been hired mercenaries from abroad.

The Mycenaeans in mainland Greece had reached their pinnacle of prosperity between about 1300 and 1200 B.C., the period during which the enormous domed tomb at Mycenae, called the Treasury of Atreus, was constructed. Its elaborately decorated facade and soaring roof testify to the confidence of Mycenae's warrior princes. The last phase of the extensive palace at Pylos on the west coast of the Peloponnese also dates to this time. It was outfitted with everything that wealthy people of the Greek Bronze Age required for comfortable living, including elaborate and colorful wall paintings, storerooms crammed with food, and even a royal bathroom fitted with a built-in tub and intricate plumbing.

War was clearly a principal concern of those Mycenaean men who could afford its expensive equipment. The Mycenaeans spent nothing, by contrast, on the construction of large religious buildings, as Near Easterners did on their giant temples. The nature of religion in mainland Bronze Age Greece remains largely obscure, although the usual view is that the Mycenaeans worshipped primarily the male-dominated pantheon traditionally associated with the idea of an Indo-European warrior culture. The names

of numerous deities known from later Greek religion occur in the Linear B tablets, such as Hera, Zeus, Poseidon, and Dionysus, as well as the names of divinities unknown in later times. The name or title *potnia*, referring to a female divinity as "mistress" or "ruler," is very common in the tablets, emphasizing the importance of goddesses in Bronze Age religion.

The development of extensive sea travel in the Bronze Age enabled not only traders but also warriors to journey far from home. Traders, crafts specialists, and entrepreneurs seeking metals sailed from Egypt and the Near East to Greece and beyond, taking great risks in search of great rewards. Mycenaeans established colonies at various locations along the coast of the Mediterranean, leaving the security of home to struggle for better opportunities in new locations. Seaborne Mycenaean warriors also dominated and probably put an end to the palace society of Minoan Crete in the fifteenth and fourteenth centuries B.C., perhaps in wars for conquest or commercial rivalry in Mediterranean international trade. By the middle of the fourteenth century, the Mycenaeans had displaced the Minoans as the most powerful civilization of the Aegean.

THE END OF MYCENAEAN CIVILIZATION

The emergence in the Bronze Age of extensive sea travel for trading and raiding had put the cultures of the Aegean and the Near East in closer contact than ever before. The wealth that could be won by traders and entrepreneurs, especially those seeking metals, promoted contacts between the older civilizations at the Mediterranean's eastern end and the younger ones farther west. The civilizations of Mesopotamia and Anatolia overshadowed those of Crete and Greece in the size of their cities and the development of extensive written legal codes. Egypt remained an especially favored destination of Mycenaean voyagers throughout the late Bronze Age because these Greeks valued the exchange of goods and ideas with the prosperous and complex civilization of that ancient civilization. By around 1250–1200 B.C., however, the Mediterranean network of long-established states and trading partners was weakening. The New Kingdom in Egypt was losing its cohesion; foreign invaders destroyed the powerful Hittite kingdom in Anatolia; Mesopotamia underwent a period of political turmoil; and the rich palace societies of the Aegean disintegrated. The causes of these disruptions are poorly documented, but the most likely reasons are internal strife between local powers and overexploitation of natural resources in overspecialized and centralized economies. These troubles, whose duration we cannot accurately gauge, apparently caused numerous groups of people to leave their homes, seeking new places to live, or at

least weaker victims to plunder. These movements of peoples through-out the eastern Mediterranean and the Near East further damaged or even destroyed the political stability, economic prosperity, and international contacts of the civilizations of most of these lands, including that of the Mycenaeans. This period of violent turmoil certainly lasted for decades; in some regions it may have gone on much longer. As a rough generalization, it seems accurate to say that the period from about 1200 to 1000 B.C. saw numerous catastrophes for Mediterranean civilizations. The consequences for Greeks were disastrous.

Egyptian and Hittite documents record the impact these disturbances inflicted. They speak of foreign invasions, some from the sea. According to his own account of attacks by warriors landing from the sea, the pharaoh Ramesses III around 1182 B.C. defeated a fearsome coalition of invaders from the north who had fought their way to the edge of Egypt: "All at once the peoples were on the move, dispersed in war. . . . No land could repulse their attacks. . . . They extended their grasp over territories as far as the circuit of the earth, their spirits brimming with confidence and believ-ing: 'Our plans will succeed!' . . . The ones who came as far as my border, their seed is no more, their heart and their soul are done for forever and ever. . . . They were dragged in, surrounded, and laid prostrate on the shore, killed, and thrown into piles from tail to head" (Pritchard, *Ancient Near Eastern Texts*, pp. 262–263).

The Egyptian records indicate that many different groups made up these Sea Peoples, as the attackers are called today. We can guess that these raiders originated from Mycenaean Greece, the Aegean islands, Anatolia, Cyprus, and various points in the Near East. They did not constitute a united or uniform population; rather, they should be thought of as in-dependent bands displaced and set in motion by the local political and economic troubles of their homelands. Some had previously been merce-nary soldiers in the armies of once-powerful rulers, whom they eventually turned against in a grab for power and booty. Some came from far away to conduct raids in foreign lands. One scholarly hypothesis explaining, at least in part, the origin of these catastrophes theorizes that this period saw a reconceptualization of military tactics. Previously, the key to success in battle had been to deploy chariots carrying archers. Bronze Age kings wag-ing war had supplemented their chariot forces with infantrymen, mostly foreign mercenaries. By around 1200 B.C., the argument goes, these hired foot soldiers had realized that they could use their long swords and jav-elins to defeat the chariot forces on the battlefield by swarming in a mass against their vehicle-mounted overlords. Emboldened by this realization of their power and motivated by a lust for booty, spontaneously formed

bands of mercenaries rebelled against their former employers, plundering and looting. They conducted raids on treasure-packed settlements, which were no longer able to defend themselves with their old tactics that depended on chariots. Lacking any firm organization or long-term planning, the rebels fatally weakened the civilizations they betrayed and raided, but they were incapable of or uninterested in putting any new political systems into place to fill the void created by their destruction of the Mycenaean world.

Whether this explanation for the downfall of the civilization of the Greek Bronze Age will prove correct remains to be seen, if only because we have to ask why it took the mercenary infantrymen so long to grasp their advantage over chariots, if they truly had one, and then to put it into effect to crush their opponents. But one important assumption of this scenario does ring true: What archaeological evidence we have for the history of the Sea Peoples points not to one group spreading destruction across the eastern Mediterranean in a single tidal wave of violence, but rather to many separate bands and varied conflicts. The initial attacks and spreading destruction spurred a chain reaction of violence that put even more bands of raiders on the move over time.

These various groups most likely had different characteristics and different goals. Some bands of Sea Peoples were probably made up only of men conducting raids, who expected to return to their homeland eventually. Other groups of warriors may have brought their families along, searching for a new place in which to win a more-prosperous and secure existence than in the disturbed area from which they had voluntarily departed or had been violently driven by other raiders. Regardless of its composition, no band on the move could expect a friendly welcome on foreign shores; those looking to settle down had to be prepared to fight for new homes. The material damage such marauding bands of raiders would have inflicted would have been made worse by the social disruption their arrival in a new area would also have caused to the societies already in place. However common such migrations may have been—that they were widespread has been both affirmed and denied in modern scholarship—destruction and disruption were widespread in the Mediterranean in this period of the Sea Peoples. In the end, all this fighting and motion redrew the political map of the region, and perhaps its population map as well, although it is unclear how many groups actually resettled permanently at great distances from their original sites.

Even if the reasons for all the violent commotion of the period of the Sea Peoples must still be regarded as mysterious in our present state of knowledge, its dire consequences for Near Eastern and Greek civilization

are undeniable. The once-mighty Hittite kingdom in Anatolia fell about 1200 B.C., when invaders penetrated its borders and incessant raids cut its supply lines of raw materials. Its capital city, Hattusas, was burned to the ground and never re-inhabited, although smaller Neo-Hittite principalities survived for another five hundred years before falling to the armies of the Neo-Assyrian kingdom. The appearance of the Sea Peoples weakened Egypt's New Kingdom by requiring a great military effort to repel them and by ruining Egypt's international trade in the Mediterranean. Struggles for power between the pharaoh and the priests undermined the centralized authority of the monarchy as well, and by the middle of the eleventh century B.C., Egypt had shrunk to its old territorial core along the banks of the Nile. Egypt's credit was ruined along with its international stature. When an eleventh-century Theban temple official named Wen-Amon traveled to Byblos in Phoenicia to buy cedar for a ceremonial boat, the city's ruler insultingly demanded cash in advance. The Egyptian monarchy continued for centuries after the New Kingdom, but internal struggles for power between pharaohs and priests, combined with frequent attacks from abroad, prevented the reestablishment of centralized authority. Egypt never again assumed the role of an active and aggressive international power that it had enjoyed during much of the Old and New Kingdoms.

The calamities of this time also affected the copper-rich island of Cyprus and the flourishing cities along the eastern coast of the Mediterranean. The Greeks later called these coastal peoples the Phoenicians, apparently from the name of the valuable reddish-purple dye that they extracted from shellfish; they apparently called themselves Canaanites. The inhabitants of cities such as Ugarit on the coast of Syria thrived on international maritime commerce and enjoyed a lively polyglot culture. A catastrophic attack of the Sea Peoples overwhelmed Ugarit, but one of its most brilliant accomplishments lived on: the first alphabet. The letters representing the sounds of a phonetic alphabet offered a simpler and more flexible system of writing than the other writing systems of the ancient Near East or the syllabary of Linear A and B. This invention had emerged from about 1700 to 1500 B.C. in this eastern Mediterranean crossroads of cultures; its later form eventually became the base of the ancient Greek and Roman alphabets and, from there, modern Western alphabets.

The Mycenaeans' wealth failed to protect them from the spreading violence of the late Bronze Age. Ominous signs of the dangers of this period occur in Linear B tablets from Pylos, which record the disposition of troops to guard this unwalled site around 1200 B.C. The rulers of most palaces had constructed walls for defense built from stones so large that later Greeks thought that Cyclopes, one-eyed giants, must have built these

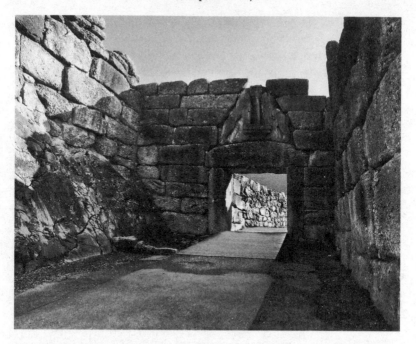

Fig. 2.3: Like the Minoans, the Mycenaeans in the Peloponnese and central Greece lived in politically centralized states with redistributive economies. Their centers, however, had massive stone fortification walls and gates like this one at Mycenae, a feature not found in Minoan civilization. Andreas Trepte, www.photo-natur.de.

massive fortifications (fig. 2.3). The defensive walls at locations such as Mycenae and Tiryns in the eastern Peloponnese could have served to protect these palaces situated near the coast against raiders attacking from the sea. The palace at Gla in central Greece, however, was located far enough from the coast that foreign pirates presented no threat, but it too erected a huge stone wall to defend against enemy attacks. The wall at Gla reveals, then, that Mycenaeans had above all to defend themselves against other Mycenaeans, or perhaps their own mercenaries, not against seaborne raiders. Never united in one state, the rival "princes" of Mycenaean Greece by the late thirteenth century B.C. were fighting each other at least as much as they were fighting foreigners.

Internal wars among the rulers of Mycenaean Greece, not foreign invasions, offer the most plausible explanation of the destruction of the palaces of the mainland in the period from about 1200 to 1000 B.C. Earthquakes probably increased the destructive consequences of these local wars; Greece is a seismically active region, and devastating quakes that killed

many people are documented from later historical periods. Near-constant warfare placed great stress on the administration of the closely managed redistributive economies of the palaces and hindered recovery from earthquake damage. The eventual failure of the palace economies had a devastating effect on the large part of the Mycenaean population that depended on this system for its subsistence. Peasant farmers, who knew how to grow their own food, had a chance to go on supporting themselves even when the redistributive system for foodstuffs and goods broke down, if they were not killed in the violent disruptions. The inhabitants of the palaces, however, who depended on others to provide them food, starved when the system disappeared. Warriors left unattached by the disintegration of the rulers' power set off to find new places to live, or at least to plunder others, forming roving bands of the kind remembered by the Egyptians as Sea Peoples. The later Greeks remembered an invasion of Dorians (speakers of the form of Greek characteristic of the northwest mainland) as the reason for the disasters that struck Bronze Age Greece, but archaeology suggests that the Dorians who did move into southern Greece most likely came in groups too small to cause such damage by themselves. Indeed, relatively small-scale movements of people, not massive invasions, probably characterized this era, as bands of warriors with no prospects at home emigrated from lands all around the eastern Mediterranean to become pirates for themselves or mercenaries for foreign potentates.

The damage done by the dissolution of the redistributive economies of Mycenaean Greece after 1200 B.C. took centuries to repair. Only Athens seems to have escaped wholesale disaster. In fact, the Athenians of the fifth century B.C. prided themselves on their unique status among the peoples of Classical Greece: "Sprung from the soil" of their homeland, as they called themselves, they had not been forced to emigrate in the turmoil that engulfed the rest of Greece in the twelfth and eleventh centuries B.C. The nature of the Athenians' boast gives some indication of the sorry fate of many other Greeks in the period c. 1200–1000 B.C. Uprooted from their homes, they wandered abroad in search of new territory to settle. The Ionian Greeks, who in later times inhabited the central coast of western Anatolia, dated their emigration from the mainland to the end of this period. Luxuries of Mycenaean civilization, like fine jewelry, knives inlaid with gold, and built-in bathtubs, disappeared. To an outside observer, Greek society at the end of the Mycenaean Age might have seemed destined for irreversible economic and social decline, even oblivion. As it happened, however, great changes were in the making that would eventually create the civilization and the cultural accomplishments that we today think of as the Golden Age of Greece.

THREE

The Dark Age

The local wars, economic disruptions, and movements of peoples in the period 1200–1000 B.C. destroyed Mycenaean civilization in Greece and weakened or obliterated cities, kingdoms, and civilizations across the Near East. This extended period of violence brought grinding poverty to many of the people who managed to physically survive the widespread upheavals of these centuries. Enormous difficulties impede our understanding of the history of this troubled period and of the recovery that followed, because few literary or documentary sources exist to supplement the sometimes ambiguous and incomplete evidence provided by archaeology. Both because conditions were so grueling for many people and, perhaps more than anything, because the absence of written records from Greece limits us to a dim view of what happened there in those years, it is customary to refer to the era beginning around 1000 B.C. as the "Dark Age": The fortunes of the people of the time seem generally dark, as does our understanding of the period.

The Near East recovered its strength much sooner than did Greece, ending its Dark Age by around 900 B.C. That region continued its vigorous international export trade in luxury items as well as raw materials, such as timber for large-scale buildings (fig. 3.1). The end of the Greek Dark Age is traditionally placed some 150 years after that, at about 750 B.C. No enormous break separated the culture of Bronze Age Greece from that of the Dark Age. Above all, the continuing contact in

c. 1000 B.C.: Almost all important Mycenaean sites except Athens destroyed by now.

c. 1000–900 B.C.: Period of most severe depopulation and reduced agriculture.

c. 950–750 B.C.: Greeks adopt Phoenician alphabet.

c. 900–800 B.C.: Early revival of population and agriculture; iron beginning to be used for tools and weapons.

776 B.C.: Traditional date of First Olympic Games.

c. 750 B.C.: The end of the Greek Dark Age.

c. 750–700 B.C.: Homeric poetry recorded in writing after Greeks learn to write again, using a Phoenician alphabet modified with vowels; Hesiod composes his poetry.

the Dark Age between Greece, the Near East, and Egypt meant that the survivors of the fall of Mycenaean Greece never lost touch with the technology and the ideas, especially religious traditions, of the older civilizations to the east. The details of Greek history in the Dark Age remain difficult to discover, but there is no doubt that in these centuries Greeks laid the foundations for the values, traditions, and new forms of social and political organization that would characterize them in later ages.

ECONOMY AND SOCIETY IN THE EARLY DARK AGE

The harsh economic decline in Greece after the disintegration of Mycenaean civilization severely increased the difficulty and precariousness of life for many people during the worst years of the Dark Age. Mycenaean palace society had collapsed because the violence of the period after about 1200 B.C. had destroyed the complex redistributive economic systems on which most Mycenaeans' survival had depended. The most startling indication of the dire state of existence in the early Dark Age is that the Greeks apparently lost their knowledge of writing when Mycenaean civilization ended, although it has been suggested that the loss was not total. In any case, the total or near-total loss of the common use of a technology as vital as writing is explicable because the Linear B script that Mycenaeans used was difficult to master and probably known only by the palace scribes, whose job was to keep the many records required for the palaces' centralized economies. These scribes employed writing as a technical skill for recording the flow of goods into the palaces and then out again for redistribution. Once the rulers had lost their power and nothing was com-

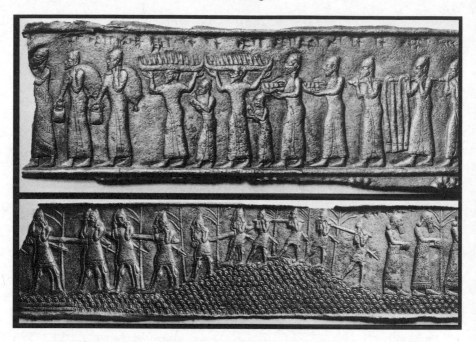

Fig. 3.1: These metal bands come from the gate of a ninth-century B.C. temple in Nimrud, Iraq. They show goods of various kinds, including timber, being transported. This part of the world experienced less disruption than Greece did during the Dark Age, and the Greeks' continuing trade and contact with this region helped them gradually recover economically and culturally. The Walters Art Museum, Baltimore.

ing in to their storehouses to be recorded and then redistributed, there was no longer any need to keep written records or to pay for the technical expertise of scribes. Remarkably, however, the oral transmission of the traditions of the past in poetry and song allowed Greek culture to survive this loss because its people remembered its stories and legends as valuable possessions to be passed down through time out loud. Oral performances of poetry, music, singing, and informal storytelling, all of which had been a part of Greek life for longer than we can trace, kept alive the Greeks' fundamental cultural ideas about themselves from generation to generation even during the worst of times.

In terms of accurate knowledge of the events of their past, however, the Greeks of later periods suffered from nearly total amnesia about the now-long-ago Bronze Age. They knew very little about Mycenaean civilization and its fall, and some of the major things that they thought they

knew seem not to have been true. As mentioned earlier, they believed, for example, that Dorians, a Greek-speaking group from the north, began to invade central and southern Greece following the collapse of Mycenaean civilization. Dorians were famed as the ancestors of the Spartans, the most powerful city-state on the mainland before the spectacular rise to prominence of Athens in the fifth century B.C. Strikingly, however, modern archaeology has not discovered any distinctive remains attesting to a Dorian invasion, and many scholars reject this ancient idea as a fiction, at least if it is taken to mean a large-scale movement of people all at once. The lack of written records or literature dating from the Greek Dark Age, when Greeks were probably ignorant of how to write, means that the mute evidence uncovered by archaeologists must provide the foundation for reconstructing the history of this transitional period. Therefore, we have no choice but to put greater trust in the results of archaeological excavations than in what the Greeks themselves believed about Dorians.

Archaeological research has shown that the Greeks cultivated much less land and had many fewer settlements in the early Dark Age than during the height of Mycenaean prosperity. No longer did powerful rulers protected by fortresses of stone control palaces, towns, and countryside, relying on their carefully structured redistributive economies to ensure a tolerable standard of living for farmers, herders, and workers in many different crafts. The number of ships filled with Greek adventurers, raiders, and traders sailing back and forth on the Mediterranean Sea was now minuscule compared to the numerous Mycenaean fleets that had conducted so many commercial, diplomatic, and military missions during the late Bronze Age. Large political states no longer existed in Greece in the early Dark Age, and most people scratched out an existence as herders, shepherds, and subsistence farmers bunched in tiny settlements as small as twenty people. The populations of prosperous Mycenaean communities had been many times larger. Indeed, the entire Greek population was far smaller in the early Dark Age than it had been in the second millennium B.C. It is possible that the violence that destroyed the palaces killed so many people that for a considerable period there were not enough agricultural workers available to produce the surplus of food that was needed to increase the birth rate to grow the population. People were always the scarcest resource in antiquity because life was hard and many died very young, and the difficult conditions of the Dark Age meant that it was harder than ever to develop human resources.

The withering away of agriculture in this period led more Greeks than ever before to herd animals to sustain their families. This increasingly pastoral way of life meant that people became more mobile because they had

to be prepared to move their herds to new pastures once the animals had overgrazed their current location. If pastoralists were lucky, they might find a new spot that allowed them to grow a crop of grain to supplement the food they were raising in their herds. As a result of this less-settled life-style, the majority of the population built only simple huts as their houses and got along with few possessions. Unlike their Mycenaean forerunners, Greeks in the early Dark Age no longer had monumental architecture—no palaces with scores of rooms, no fortresses defended by mammoth stone walls. Art also experienced a kind of impoverishment, as Greek potters no longer included pictures of people and animals in the decoration on their painted pottery.

The general level of poverty in the early Greek Dark Age might lead us to think that communities were relatively egalitarian in this period, at least as compared with the strong hierarchy of Mycenaean society. Archaeological evidence reveals, however, that a hierarchical social system survived in some locations in any case, or perhaps that it had revived as early as the late eleventh century B.C. By the middle of the tenth century B.C., indications of social hierarchy in Dark Age Greece are unmistakable at the sites of Lefkandi on the island of Euboea, off the eastern coast of the Greek mainland, and of Nichoria in Messenia in the Peloponnese. Excavation at Lefkandi has revealed the richly furnished burials of a man and woman who died about 950 B.C. Their graves contained expensive luxury items, some characteristic of Near Eastern manufacture. The dead woman wore elaborate gold ornaments, including breast coverings that testify to her exceptional wealth. The couple was buried under a building more than 150 feet long with wooden columns on the exterior. The striking architecture and riches of their graves suggest that these individuals enjoyed high social status during their lives and perhaps received a form of ancestor worship after their death. At Nichoria, archaeologists have discovered the remains of a mud-brick building with a thatched roof that was larger than the other structures in the settlement. It included a space that seems to have been a megaron, like those known from Mycenaean palaces. Though this building was no palace, its design does suggest that a locally prominent family lived there; most likely, it was the house of a leader who operated as a chief because he had a higher social status than his neighbors and was wealthier.

Although there were probably relatively few people with significantly greater wealth and status than others in tenth-century B.C. Greece, the excavations at Lefkandi and Nichoria reveal that social differentiation had either persisted or once again emerged, even in the generally poor and depopulated Greek world of the time. Stresses in this hierarchical orga-

nization of Greek society, as we shall see, were to set the stage for the emergence of Greece's influential new political form, the self-governing city-state of free citizens.

ECONOMIC RECOVERY AND TECHNOLOGY

In the earlier part of the Dark Age, the vast majority of dying people could afford no better grave offerings than a few plain clay pots. The evidence of archaeology reveals, however, that by about 900 B.C. a limited number of Greeks in diverse locations had become wealthy enough to have their families bury valuable objects alongside their bodies. This accumulation of conspicuous wealth indicates that a hierarchical arrangement of society was evidently (again) spreading throughout Greece by this time; the relatives of the men and women rich enough to have expensive material goods laid beside their mortal remains at their funerals were using this display to mark their status at the pinnacle of society. This social differentiation marked by wealth, which endured even into the grave as a dramatic signal to those still alive, corresponded to significant economic changes based on technology that were clearly under way by the ninth century B.C.

Two burials from Athens illustrate the changes taking place during this period in metallurgical and agricultural technology, advances that would eventually help bring about the end of the Greek Dark Age. The earlier of the two burials, that of a male about 900 B.C., consisted of a pit into which a clay pot was placed to hold the dead man's cremated remains. Surrounding the pot were metal weapons, including a long sword, spearheads, and knives. The inclusion of weapons of war in a male grave continued the burial traditions of the Mycenaean Age, but these arms were forged from iron, not bronze, the primary metal of the earlier period. This difference reflects a significant shift in metallurgy that took place throughout the Mediterranean region during the early centuries of the first millennium B.C.: Iron took the place of bronze as the principal metal used to make weapons and tools. For this reason, following the custom of characterizing periods of history from the name of the metal most used at the time, we refer to the Dark Age as the "early Iron Age" in Greece.

Greeks probably learned the special metallurgical techniques needed to work iron, such as a very high smelting temperature, from foreign traders searching for metal ores and from itinerant metalworkers from Cyprus, Anatolia, and the Near East. Iron eventually replaced bronze in many uses, above all in the production of swords, spears, and farming tools, although bronze remained in use for shields and body armor. The use of iron spread

because it offered practical advantages over bronze. Iron implements kept their sharp edges longer because properly worked iron was harder than bronze. Also, iron ore was relatively common in Greece (and other regions of Europe), which made iron weapons and tools less expensive than ones of bronze, which required imported metals to make. The popularity of iron was accelerated in particular by difficulties in obtaining the tin needed for alloying with copper to produce bronze. International trading routes, which had once brought tin to Greece and the Near East from this metal's few and distant sources, had been disrupted by the widespread turmoil that had affected the eastern Mediterranean region beginning around 1200 B.C. However, iron ore could be mined and smelted by Greeks in their own territory, ensuring a reliable supply.

The technology that also produced more-durable and affordable farming tools eventually helped to increase the production of food, a development reflected by the evidence of a second significant Dark Age burial at Athens. This grave, from about 850 B.C., held the remains of a woman and her treasures, including gold rings and earrings, a necklace of glass beads, and an unusual object made from baked clay. The necklace had been imported from Egypt or Syria or perhaps had been made locally by an itinerant metalworker from there. The technique of the gold jewelry was also that of the Near East. These valuable objects reflected the ongoing contact between Greece and the more-prosperous civilizations of that region. The most intriguing object from the burial is the clay object, which was a small-scale model of storage containers for grain (fig. 3.2). It was painted with characteristically intricate and regular designs, whose precision has led modern art historians to give the name "Geometric" to this style of art in the late Dark Age. On its top were sculpted five beehivelike urns that are miniature representations of granaries (containers for storing cereal grains). If this model was important enough to be buried as an object of special value, then actual granaries and the grain they held were obviously valuable commodities in real life. After all, grain provided the staple food for the Greek diet; it was the nutritional basis of life.

The model suggests that the woman and her family derived substantial wealth from their farmlands growing grain, which in turn hints that agriculture was recovering from the devastation in the early Dark Age, when the cultivation of crops had decreased while herding animals had become more prevalent. The woman's burial clearly witnesses the significance of farming for her and her contemporaries. The most important consequence of increased agricultural production in this period was a growth in the population. On present evidence, it is impossible to rule out the possibility that, for unknown reasons, a rise in population somehow preceded the

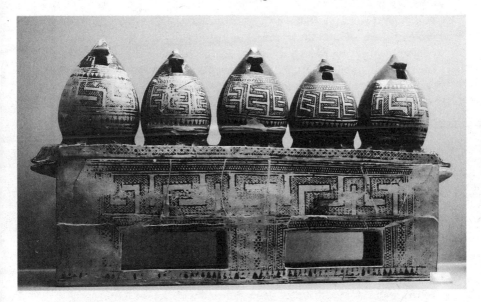

Fig. 3.2: This small-scale model of storage containers for grain, the staple food in antiquity, comes from the grave of a woman buried at Athens in the late Dark Age. It represented the wealth she had enjoyed in life, during an era when economic contraction had left many poorer Greeks hungry. Giovanni Dall'Orto / Wikimedia Commons.

recovery in agriculture and then promoted the raising of more grain, with more workers now available to labor in the fields. It seems more likely, however, that improvements in agricultural technology that allowed more food to be grown with less effort spurred a consequent growth in the population by increasing the number of people the land could support. In any case, these two developments reinforced one another: As the Greeks produced more food, the better-fed population reproduced faster, and as the population grew, more people could produce more food. The increase in population in Greece in the late Dark Age established the demography under which the new political forms of Greece were to emerge.

THE SOCIAL VALUES OF THE GREEK ELITE

People like the rich couple from Lefkandi and the wealthy woman buried at Athens came from the small layer of society that constituted the wealthiest, most prestigious, and most powerful level of the hierarchy that clearly had become widespread in Greece by the later part of the Greek

Dark Age. Historians often use the term *aristocracy*, a Greek word meaning "rule of the best," to refer to this elite social group, but that term can be misleading because of its varying meanings. In other times and places, such as early modern Europe, aristocracy has meant a legally constituted and formally recognized nobility, the members of which inherited their status by being born into a family officially designated as aristocratic. Greece never had a widespread system of official nobility. When the word *aristocracy* and its relatives, such as *aristocrat*, do appear in discussions of Greek history, it is imperative to remember that they do not mean what they often mean in, for example, French or English history. Some Greek families inherited privileges that set them apart, especially in conducting religious rituals, but there were few such people. For this reason, it is more accurate to refer to the leading members of Greek society as an elite rather than as an aristocracy, and that is the term used in this book. A social and political elite can acquire its status in various ways, but fundamental to the concept of an elite is the idea that its members must merit their status in the judgment of others and that they must continually prove by their behavior and actions that they deserve their superior position in society.

Members of the Greek social elite in this period merited their status based on a combination of interrelated factors, including above all conduct and wealth. Of course, being born into a family that already enjoyed wealth and prestige obviously represented the fundamental basis for membership in the social elite, but by itself one's lineage did not guarantee general acknowledgment as a member of the "best" in the society. It was essential to meet, and to be seen to meet, the demanding standards of the competitive code of behavior expected of this group, and to remain wealthy. Furthermore, it was crucial to employ one's wealth appropriately in public contexts: to compete with other members of the elite in making displays of status by acquiring fine goods and financing celebrations; to cement relationships with social equals by exchanging gifts and with inferiors by doing them favors; to pay public honor to the gods by providing expensive sacrifices, especially of large animals; and to benefit the community by paying for public celebrations and construction projects. Therefore, to gain recognition from others as a dutiful and therefore admirable member of the elite of the society, one had to behave in certain ways. Losing one's wealth or failing to observe the code of behavior expected of the elite could catapult one into social disgrace and oblivion, regardless of the past glory of one's family.

We can only speculate about the various ways in which families in Greece originally gained their designation as elite and thereby became entitled to pass on this status (and wealth) to those descendants able to maintain

TABLE 2. EXAMPLES OF LETTERS FROM EARLY ALPHABETS

1. Proto- Canaanite	2. Early Letter Names and Meanings		3. Phoenician	4. Early Greek	5. Modern English Capitals
⌀	*alp*	oxhead	✗	⌃	A
⌐	*bēt*	house	9	8	B
L	*gaml*	throwstick	⌐	⌐	C
⋈	*digg*	fish	⌐	△	D

1. The letters in the Proto-Canaanite alphabet of the second millennium B.C., as written at sites such as Serabit al-Khadim in Sinai.
2. The names of the letters and the words from which they were taken; for example, the letter *bēt* was written to indicate the sound of the letter *b*, which was the first sound in the Canaanite word for "house," *bēt*.
3. The same letters as taken over by the Phoenicians for their alphabet.
4. The same letters as taken over by the Greeks for their alphabet.
5. The same letters as written in modern English capitals.

the ancestral standard. Some families in the Dark Age might have inherited elite status as survivors of prominent families of the Mycenaean Age who had somehow managed to hold on to wealth or land during the early Dark Age; some certainly could have made their way into the elite during the Dark Age by amassing wealth and befriending less-fortunate people who were willing to acknowledge their benefactors' superior status in return for material help; and some did acquire superior social status by monopolizing control of essential religious rituals that they perpetuated for other members of the community to participate in.

The ideas and traditions of this social elite concerning the organization of their communities and proper behavior for everyone in them—that is, their code of values—constituted basic components of Greece's emerging new political forms. The social values of the Dark Age elite underlie the stories told in Homer's The Iliad and The Odyssey. The Greeks had relearned the technology of writing as a result of contact with the literate civilizations of the Near East and the alphabet developed there earlier. Sometime between about 950 and 750 B.C. the Greeks adopted a Phoenician alphabet to represent the sounds of their own language, introducing important changes to the script by representing the vowels of their own language as

letters. The Greek version of the alphabet eventually formed the basis of the alphabet used for English today. Greeks of the Archaic Age (roughly 750–500 B.C.) swiftly applied their newly acquired skill to write down oral literature, such as Homer's two famous epics. Near Eastern poetic tales influenced this oral poetry, which for centuries helped to transmit cultural values from one generation of Greeks to the next. Despite the ancient origins of Homeric poetry, the behavioral code portrayed in its verses primarily reflected values established in the society of Greece of the Dark Age before the rise of the political systems of the city-state based on citizenship.

The main characters in the Homeric poems are leading members of the social elite, who are expected to live up to a demanding code of values in competing with one another. The men live as warriors, of whom the most famous is the incomparable Achilles of The Iliad. This poem tells part of the story of the attack by a Greek army on the city of Troy, a stronghold in northwestern Anatolia. Although it is commonly assumed that the Trojans were a different people from the Greeks, the poems themselves provide no definitive answer to the question of the Trojans' ethnic identity. In The Iliad's representation of the Trojan War, which the Greeks believed occurred about four hundred years before Homer's time, Achilles is "the best of the Greeks" (for instance, Iliad 1, line 244) because he is a "doer of deeds and speaker of words" without equal (Iliad 9, line 443). Achilles' overriding concern in word and action is with the glorious reputation (kleos) that he can win with his "excellence" (the best available translation for Greek aretē, a word with a range of meanings, sometimes translated as "virtue"). Like all members of the Homeric social elite, Achilles feared the disgrace that he would experience before others if he were seen to fail to live up to the code of excellence. Under this code, failure and wrongdoing produced public shame. He lived—and died—always to be the best.

Excellence as a competitive moral value also carried with it a strong notion of obligation and duty. The strongest of this type of responsibilities for the elite was the requirement that ties of guest-host friendship (xenia) be respected no matter what the situation. In The Iliad, for example, the Greek Diomedes is preparing to battle an enemy warrior, Glaucus, when he discovers that Glaucus's grandfather once hosted his own grandfather as a guest while he was traveling abroad in Glaucus's land. This long-past act of hospitality had established ties of friendship and made the men "guest-host friends" of one another, a relationship that still remained valid for the two descendants and had to be respected even in the heat of battle. "Therefore," says Diomedes in the story, "let us not use our spears against

each other. . . . There are many other Trojans and their allies for me to kill, the gods willing, and many other Greeks for you to slay if you can" (Iliad 6, lines 226–229). To show their excellence in this case, these fighters were obliged to respect morally binding commitments they themselves had no original part in making but still had to respect. In this way, the notion of excellence could serve both as a competitive social value and as a cooperative one. That is, in the context of warfare among people with no obligations toward one another, excellence demanded that warriors compete to defeat their enemies and to outshine their friends and allies in their ability to win battles. In the context of relationships such as guest-host friendship, however, excellence required that even enemies put aside martial competitiveness to cooperate in respecting moral obligation established among individuals from their families.

The concentration on excellence as a personal quality distinguishes the code of values not just of warriors in the Homeric poems but also of socially elite women. This essential feature of the elite society portrayed in The Iliad and The Odyssey appears most prominently in the character and actions of Penelope, the wife of Odysseus, the hero of The Odyssey, and his partner in the most important household of their home community of Ithaca, on an island off the west coast of the Peloponnese. Penelope's excellence requires her to preserve her household and property during her husband's long absence, by relying on her intelligence, social status, and intense fidelity to her husband. She is obliged to display great stamina and ingenuity in resisting the attempted depredations of her husband's rivals at home while Odysseus is away for twenty years fighting the Trojan War and then sailing home in a long series of dangerous adventures.

When Odysseus finally returns to Ithaca, he assumes the disguise of a wandering beggar to observe conditions in his household in secret before revealing his true identity and reclaiming his leading position. Penelope displays her commitment to excellence by treating the ragged stranger with the kindness and dignity owed to any and all visitors, according to Greek custom, in contrast to the rude treatment that he receives from the female head of the servants in his household. Odysseus, still in disguise, therefore greets Penelope with the words of praise that were due a woman who understood the demands of her elite status and could carry them through: "My Lady, no mortal on this boundless earth could find any fault with you; your glorious reputation [kleos] reaches to the broad heavens, like that of a king without blame, who respects the gods and upholds justice in his rule over many strong men, and whose dark land sprouts wheat and barley, whose trees bend with the weight of their fruit, whose sheep

bear lambs every season, whose sea teems with fish, all the result of his good leadership, and thus his people flourish under his rule" (*Odyssey* 19, lines 107–114).

After Odysseus and his son manage with a clever ruse to kill off the rivals that were plaguing their household, the hero then executes the servants who had disrespected him as a stranger deserving hospitality. In the Homeric code of values, these actions are just because *justice* means "retribution; appropriate and proportional payback for one's actions." Scholars sometimes say that this code was based on *vengeance*, but that term can be misleading if it is understood to imply the necessity of violence and coercion in punishing wrongdoers. For Greeks, acting justly in keeping with the concept of excellence required what today might be called retributive justice. As depicted in *The Iliad* (18, lines 478–608) in the scenes carved on the new, divinely made shield of Achilles, retribution even for a crime as serious as a homicide can be satisfied with the payment of money, rather than violent punishment, if the family of the victim agrees. It is therefore important to remember that Greek ideas of what constituted justice stemmed from a focus on reestablishing and maintaining appropriate and agreed-upon social relations among people in the community.

Similarly, although it is certainly true that Greek society after the Dark Age was patriarchal, it must also be remembered that the code of excellence had high standards for women as well as for men, and that women who met those standards earned high status in return, and that those who fell short risked disgrace for their social failures. Penelope clearly counts as an exceptional figure of literature, but nevertheless it is significant that *The Odyssey*, in praising her, employs a description also fitting for a man. Indeed, her praise suits a ruler, one of surpassing virtue and achievement. In real life, women of the social elite, like men of the same status, regarded their proper role in life as a duty to develop an exceptional excellence to set themselves apart in the competition with others, whether members of the elite or those of more ordinary character and status. Under this code, any life—for a woman as for a man—was contemptible unless its goal was the competitive pursuit of excellence and the fame that it brought. Of course, this demanding code of values in a competition for the highest recognition both from one's contemporaries and also from posterity relegated the great majority of the population to secondary status, from which they had little if any hope of escaping, unless they could somehow manage to gain public prominence and the wealth that would allow them to participate in the competition for excellence that defined the lives of the elite in Greek society.

THE OLYMPIC GAMES AND PANHELLENISM

Excellence as a competitive value of the social elite showed up clearly in the Olympic Games, a religious festival associated with a large sanctuary of Zeus, king of the gods of the Greeks. The sanctuary was located at Olympia, in the northwestern Peloponnese, where the games were held every four years beginning in 776 B.C., according to the date that tradition has preserved. During these great celebrations, men wealthy enough to spend the time to become outstanding athletes competed in running events and wrestling as individuals, not as national representatives on teams as in the modern Olympic Games. The athletes' emphasis on competition, physical fitness and beauty, and public recognition as winners corresponded to the ideal of Greek masculine identity as it developed in this period. In a rare departure from the ancient Mediterranean tradition against public nakedness, Greek athletes competed without clothing (hence the word *gymnasium*, from the Greek word meaning "naked," *gymnos*). Other competitions, such as horse and chariot racing, were added to the Olympic Games later, but the principal event remained a sprint of about two hundred yards called the *stadion* (hence our word *stadium*). Winners originally received no financial prizes, only a garland made from wild olive leaves, but the prestige of victory could bring other rewards as well. Prizes with material value were often awarded in later Greek athletic competitions. Admission to the Olympic Games was free to men; married women were not allowed to attend, on pain of death, but women not yet married could be spectators. Women athletes competed in their own separate festival at Olympia on a different date in honor of Zeus's wife, Hera. Although less is known about the Heraean Games, Pausanias (*Guide to Greece* 5.16.2) reports that young unmarried women competed on the Olympic track in a footrace five-sixths as long as the men's *stadion*.

In later times, professional athletes starred in international sports competitions, including the Olympics. The successful competitors made good livings from appearance fees and prizes won at events held all over Greece. The most famous athlete of all was Milo, from Croton in southern Italy. Winner of the Olympic wrestling crown six times beginning in 536 B.C., he was renowned for showy stunts, such as holding his breath until his blood expanded his veins so much that they would snap a cord tied around his head. Milo became so internationally famous that the king of the Persians, whose land lay thousands of miles to the east, knew his reputation as a spectacular athlete.

The Olympic Games centered on contests among individuals, who

prided themselves on their demonstrated distinctiveness from ordinary
people, as the fifth-century B.C. lyric poet Pindar made clear in praising a
family of victors: "Hiding the nature you are born with is impossible. The
seasons rich in their flowers have many times bestowed on you, sons of Ala-
tas [of Corinth], the brightness that victory brings, when you achieved the
heights of excellence in the sacred games" (*Olympian Ode* 13). Despite the
emphasis on winning and individual achievement, the organization of
the festival as an event for all of Greece nevertheless indicates that a trend
toward communal activity was under way in Greek society and politics
by the mid-eighth century B.C. First of all, constructing a special sanctu-
ary for the worship of Zeus at Olympia provided an architectural focus
for public gatherings with a surrounding space for large, international
crowds to assemble. The social complement to the creation of this physi-
cal environment was the tradition that the Games of Zeus and Hera were
"Panhellenic," that is, open to all Greeks. Finally, an international truce of
several weeks was declared to guarantee safe passage for competitors and
spectators traveling to and from Olympia, even if wars were in progress
along their way. In short, the arrangements for the Olympic Games dem-
onstrate that in eighth-century Greece the values of excellence demon-
strated by one's individual activities were beginning to be channeled into
a new context appropriate for a changing society, one that needed new
ways for its developing communities to interact with one another peace-
fully. This assertion of communal as well as individual interests was, like
demography, another important precondition for the creation of Greece's
new political forms in the city-state.

RELIGION AND MYTH

Religion provided the context for almost all communal activities
throughout the history of ancient Greece. Competitions in sport, such as
in the Olympic Games that honored Zeus, took place in the religious con-
text of festivals honoring specific gods. War was conducted according to
the signs of divine will that civil and military leaders identified in the sac-
rifice of animals and in omens derived from occurrences in nature, such as
unusual weather. Sacrifices themselves, the central event of Greek religious
rituals, were performed before crowds in the open air on public occa-
sions that involved communal feasting afterward on the sacrificed meat.
The conceptual basis of Greek religion was transmitted in myth, whose
stories of the past depicted the conflict-filled relationships of gods, people,
and creatures such as satyrs and centaurs (see, for example, the statuette
from Dark Age Lefkandi, fig. 3.3), beings whose mixed animal/human

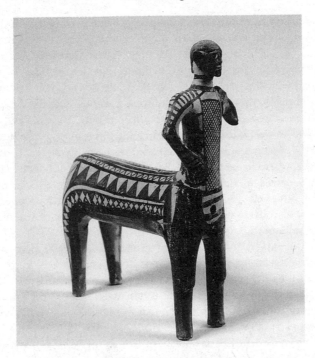

Fig. 3.3: This figurine from Lefkandi on the island of Euboea, painted with the bold geometric designs characteristic of the Greek Dark Age (compare fig. 3.2), depicts a centaur, a mythological creature with a man's head and torso on the body of a horse. Myths told stories featuring such half-human / half-animal beings to explore the boundaries between culture and nature. Marie Mauzy / Art Resource, NY.

physical form expressed anxieties about what human nature was truly like. Greek myth was, as said before, deeply influenced by Near Eastern myth in the Dark Age, as Greeks heard stories from Near Eastern traders passing through in search of metals and markets, and tried to understand the drawings and carvings of Near Eastern mythological figures found on objects they imported, such as furniture, pots, seals, and jewelry.

In the eighth century B.C., the Greeks began to record their own versions of these myths in writing. The poetry of Hesiod reveals how religious myth, as well as the economic changes and social values of the time, contributed to the feeling of community that underlay the gradual emergence of new political structures in Greece. Living in the region of Boeotia in central Greece, Hesiod employed myth to reveal the divine origin of justice. His *Theogony* details the birth of the race of gods over sev-

eral generations from primordial Chaos ("void" or "vacuum") and Earth, the mother of Sky and numerous other children. Hesiod explained that when Sky began to imprison his siblings, Earth persuaded her fiercest male offspring, Kronos, to overthrow him by violence because "[Sky] first contrived to do shameful things" (*Theogony*, line 166). When Kronos later began to swallow up all his own children, Kronos's wife Rhea had their son Zeus overthrow his father by force in retribution for his evil deeds. These vivid stories, which had their origins in Near Eastern myths, like those of the Mesopotamian *Epic of Creation* (Pritchard, *Ancient Near Eastern Texts*, pp. 60–99), carried the message that existence, even for gods, entailed struggle, sorrow, and violence. Even more significantly for social and political developments in Greece, however, they showed that a concern for justice had also been a component of the divine order of the universe from the beginning.

Hesiod identified Zeus as the source of justice in all human affairs, a marked contrast to the portrayal of Zeus in Homeric poetry as primarily concerned only with the fate of his favorite warriors in battle. Hesiod presents justice as a divine quality that will assert itself to punish evildoers: "Zeus ordained this law for men, that fishes and wild beasts and birds should eat each other, for they have no justice; but to human beings he has given justice, which is far the best" (*Works and Days*, lines 276–280). In the Dark Age society of Hesiod's day, men dominated the distribution of justice, exercising direct control over their family members and household servants. Others outside their immediate households would become their followers by acknowledging their status as leaders. A powerful man's followers would grant him a certain amount of authority because, as the followers were roughly equal in wealth and status among themselves, they needed a figure invested with authority to settle disputes and organize defense against raids or other military threats. In anthropological terms, such leaders operated as chiefs of bands. A chief had authority to settle arguments over property and duties, oversaw the distribution of rewards and punishments in a system of retributive justice, and often headed the religious rituals deemed essential to the security of the group.

At the same time, a chief had only limited power to coerce recalcitrant or rebellious members of his band to respect his decisions and commands. When choices affecting the entire group had to be made, his leadership depended on being capable of forging a consensus by persuading members of the band about what to do. Hesiod describes how an effective chief exercised leadership: "When wise leaders see their people in the assembly get on the wrong track, they gently set matters right, persuading them with soft words" (*Theogony*, lines 88–90). In short, a chief could only

lead his followers where they were willing to go, and only by the use of persuasion, not compulsion. The followers expected to gather in an assembly of them all to settle important matters by implementing what they regarded as just retribution. These expectations of persuasion and justice lived on after the Dark Age as fundamental principles contributing to the creation of the political structures undergirding the organization of Greek city-states composed of free citizens, not subjects.

Chiefs were of course not immune to misuse of their status and ability to persuade others to do their will, and it seems likely that friction became increasingly common between leaders and their poorer followers in the late Dark Age. A story from Homer provides a fictional illustration of the kind of behavior that could have generated such friction in the period during which the city-state began to emerge. When Agamemnon, the arrogantly self-important leader of the Greek army besieging Troy, summoned the troops to announce a decision to prolong the war, then in its tenth year, an ordinary soldier named Thersites spoke up in opposition, fiercely criticizing Agamemnon for his greedy and unjust behavior. Thersites had the right and the opportunity to express his opinion because Agamemnon led the Greeks as a Dark Age chief led a band, which required that all men's opinions be heard with respect in a common assembly. It was thus in front of Agamemnon's assembled followers that Thersites excoriated the leader as inexcusably selfish. "Let's leave him here to digest his booty," Thersites shouted to his fellow soldiers in the ranks. In response, Odysseus, another chief, immediately rose to support Agamemnon, saying to Thersites, "If I ever find you being so foolish again, may my head not remain on my body if I don't strip you naked and send you back to your ship crying from the blows I give you." Odysseus thereupon beat down Thersites with a blow to his back, which drew blood (Iliad 2, lines 211–277).

At the conclusion of this episode, The Iliad describes the assembled soldiers as approving Odysseus's violent suppression of Thersites, who is portrayed as an unattractive personality and ugly man (these two characteristics went together in Greek thought). For the city-state to be created as a political institution in which all free men had a share, this complacent attitude of the mass of men had to change in the real world. Ordinary men had to insist that they deserved equitable treatment, according to the definition of equity valid in their society, even if members of the social elite were to remain in leadership positions, while the rank and file themselves remained as subordinates to the elite leaders in war and their social inferiors in peace.

Hesiod reveals that by the eighth century B.C. a state of heightened tension concerning the implementation of justice in the affairs of every-

day life had indeed developed between chiefs and peasants (the free proprietors of small farms, who might own a slave or two, oxen to work their fields, and other movable property of value). Peasants' ownership of property made them the most influential group among the men, ranging from poor to moderately well-off, who made up the bands of followers of elite chiefs in late Dark Age Greece. Assuming the perspective of a peasant farming a smallholding, the poet insisted that the divine origin of justice should be a warning to "bribe-devouring chiefs" who settled disputes among their followers and neighbors "with crooked judgments" (*Works and Days*, lines 263–264). The outrage evidently felt by peasants at receiving unfair treatment in the settlement of disputes served as yet another stimulus for the gradual movement toward new forms of political organization, those of the city-state.

The Archaic Age

During the Archaic Age the Greeks fully developed the most widespread and influential of their new political forms, the city-state (*polis*). The term *archaic*, meaning "old-fashioned" and designating Greek history from approximately 750 to 500 B.C., stems from art history. Scholars of Greek art, employing criteria about what is beautiful, which today are no longer seen as absolute, judged the style of works from this period as looking more old-fashioned than the more-naturalistic art of the fifth and fourth centuries B.C. Art historians judged the sculpture and architecture from the following time period as setting what they saw as the classic standard of beauty and therefore named it the Classical Age. They thought that Archaic Age sculptors, for example, who created freestanding figures that stood stiffly, staring straight ahead in imitation of Egyptian statuary, were less developed than the artists of the Classical Age, who depicted their subjects in more-varied and active poses.

The question of the merits of its statues aside, the Archaic Age saw the gradual culmination of developments in social and political organization in ancient Greece that had begun much earlier in the Dark Age and that led to the emergence of the Greek city-state. Organized on the principle of citizenship, the city-state included in its population free male citizens, free female citizens, and their children, alongside noncitizen but free resident foreigners and nonfree slaves. Individuals and the community as a state both owned slaves. The Greek city-

c. 800 B.C.: Greek trading contacts with Al Mina in Syria.

c. 775 B.C.: Euboeans found trading post on the island of Ischia in the Bay of Naples.

Before 750 B.C.: Phoenicians found colonies in western Mediterranean, such as at Cadiz (in modern Spain).

c. 750–700 B.C.: Oracle of Apollo at Delphi already famous.

c. 750–500 B.C.: The Greek Archaic Age.

c. 750 B.C.: Greek city-states beginning to organize spatially, socially, and religiously.

c. 750–550 B.C.: Greek colonies founded all around the Mediterranean region.

c. 700–650 B.C.: Hoplite armor for infantry becoming much more common in Greece.

c. 600 and after: Chattel slavery becomes increasingly common in Greece.

state was thus a complex community made up of people of very different legal and social statuses. Certainly one of its most remarkable characteristics was the extension of citizenship and a certain share of political rights to even the poorest freeborn local members of the community. Explaining how this remarkable development happened remains a central challenge for historians. Since these principles are taken for granted in many contemporary democracies, it can be easy to overlook how unusual—and frankly astonishing—they were in antiquity. Although poverty could make the lives of poor citizens as physically deprived as those of slaves, their having the status of citizen was a distinction that gave an extra meaning to the personal freedom that set them apart from the enslaved inhabitants of the city-state and the foreign residents there. In my judgment, the importance of citizenship in the city-state ranks as a wonder of the history of ancient Greece.

THE CHARACTERISTICS OF THE CITY-STATE

Polis, the Greek term from which we take the modern term politics, is usually translated as "city-state" to emphasize its difference from what we today normally think of as a city. As in many earlier states in the ancient Near East, the polis, territorially speaking, included not just an urban center, often protected by stout walls, but also countryside for some miles around, inhabited by residents living in villages from large to small. Mem-

bers of a polis, then, could live in the town at its center and also in com-
munities or single farmhouses scattered throughout its rural territory. In
Greece, these people made up a community of citizens embodying a po-
litical state, and it was this partnership among citizens that represented the
distinctive political characteristic of the polis. Only men had the right to
political participation, but women still counted as members of the com-
munity legally, socially, and religiously.

The members of a polis constituted a religious association obliged to
honor the state's patron god as well as the other gods of Greece's polythe-
istic religion. Each polis identified a particular god as its special protector,
for example, Athena at Athens. Different communities could choose the
same deity as their protector: Sparta, Athens's chief rival in the Classical
period, also had Athena as its patron divinity. The community expressed
official obedience and respect to the gods through cults, which were regu-
lar systems of religious sacrifices, rituals, and festivals paid for by public
funds and overseen by citizens serving as priests and priestesses. The cen-
tral activity in a city-state's cult was the sacrifice of animals to demonstrate
to the gods as divine protectors the respect and piety of the members of the
polis and to celebrate communal solidarity by sharing the roasted meat.

A polis had political unity among its urban and rural settlements
of citizens and was independent as a state. Scholars disagree about the
deepest origins of the Greek polis as a community whose members self-
consciously assumed a common and shared political identity. Since by
the Archaic Age the peoples of Greece had absorbed many innovations in
technology, religious thought, and literature from other peoples through-
out the eastern Mediterranean region and the Near East, it has been sug-
gested that Greeks might have been influenced also by earlier political
developments elsewhere, for example, as in the city-kingdoms on Cyprus
or the cities of Phoenicia. It is difficult to imagine, however, how political,
as opposed to cultural, precedents might have been transmitted to Greece
from the East. The stream of Near Eastern traders, crafts specialists, and
travelers to Greece in the Dark Age could more easily bring technological,
religious, and artistic ideas with them than political systems. One Dark
Age condition that certainly did affect the formation of the city-state was
the absence of powerful imperial states in Greece. The political extinction
of Mycenaean civilization had left a vacuum of power that made it possible
for small, independent city-states to emerge without being overwhelmed
by large states.

What matters most is that the Greek city-state was organized politically
on the concept of citizenship for all its indigenous free inhabitants. This
concept did not come from the Near East, where rulers ruled subjects;

prudent rulers took advice from their subjects and delegated responsibilities to them in the state, but their people were not citizens in the Greek sense. The distinctiveness of citizenship as the organizing principle for the reinvention of politics in this period in Greece was that it assumed in theory certain basic levels of legal equality, especially the expectation of equal treatment under the law and the right to speak one's mind freely on political matters, with the exception that different regulations could apply to women in certain areas of life, such as acceptable sexual behavior and the control of property. The general legal (though not social) equality that the Greek city-state provided was not dependent on a citizen's wealth. Since pronounced social differentiation between rich and poor had characterized the history of the ancient Near East and Greece of the Mycenaean Age and had once again become common in Greece by the late Dark Age, it is remarkable that a notion of some sort of legal equality, no matter how incomplete it may have been in practice, came to serve as the basis for the reorganization of Greek society in the Archaic Age. The polis based on citizenship remained the preeminent form of political and social organization in Greece from its earliest definite appearance about 750 B.C., when public sanctuaries serving a community were first attested archaeologically, until the beginning of the Roman Empire eight centuries later. The other most common new form of political organization in Greece was the "league" or "federation" (ethnos), a flexible form of association over a broad territory that was itself sometimes composed of city-states.

The most famous ancient analyst of Greek politics and society, the fourth-century B.C. philosopher Aristotle, insisted that the emergence of the polis had been the inevitable result of the forces of nature at work. "Humans," he said, "are beings who by nature live in a polis" (Politics 1253a2–3). Anyone who existed self-sufficiently outside the community of a polis, Aristotle only half-jokingly maintained, must be either a beast or a god (Politics 1253a29). In referring to nature, Aristotle meant the combined effect of social and economic forces. But the geography of Greece also influenced the process by which this novel way of organizing human communities came about. The severely mountainous terrain of the mainland meant that city-states were often physically separated by significant barriers to easy communication, thus reinforcing their tendency to develop politically in isolation and not to cooperate with one another despite their common language and gods, the main components of the identity that Greeks in different places believed they all shared.

City-states could also exist next to one another with no great impediments to travel between them, as in the plains of Boeotia. A single Greek island could be home to multiple city-states maintaining their indepen-

dence from one another: The large island of Lesbos in the eastern Aegean Sea was home to five different city-states. Since few city-states controlled enough arable land to grow food sufficient to feed a large body of citizens, polis communities no larger than several hundred to a couple of thousand people were normal even after the population of Greece rose dramatically at the end of the Dark Age. By the fifth century B.C., Athens had grown to perhaps forty thousand adult male citizens and a total population, including slaves and other noncitizens, of several hundred thousand people, but this was a rare exception to the generally small size of Greek city-states. A population as large as that of Classical Athens at its height could be supported only by the regular importation of food from abroad, which had to be financed by trade and other revenues.

EARLY GREEK COLONIZATION

Some Greeks had emigrated from the mainland eastward across the Aegean Sea to settle in Ionia (the western coast of Anatolia and islands close offshore) as early as the ninth century B.C. Starting around 750 B.C., however, Greeks began to settle even farther outside the Greek homeland. Within two hundred years of this date, Greeks had established "colonies" in areas that are today southern France, Spain, Sicily, southern Italy, and along North Africa and the coast of the Black Sea. It is important to remember that the contemporary word *colonization* implies "colonialism," meaning the imposition of political and social control by an imperial power on subject populations. Early Greek "colonization" was not the result of imperialism in the modern sense, as there were no empires in Greece in this period. Greek colonies were founded by private entrepreneurs seeking new commercial opportunities for trade and by city-states hoping to solve social problems or improve their economic influence incrementally by establishing new communities of citizens in foreign locations.

Eventually the Greek world included hundreds of newly founded trading settlements and emerging city-states. The desire to own farmland and the revival of international trade in the Mediterranean in the Archaic Age probably provided the most important incentives for Greeks to leave their homeland. That is, the drive to improve one's life financially was most likely the first and most powerful inducement motivating Greeks to make the difficult choice to emigrate, despite the clear and serious dangers in relocating to unfamiliar and often-hostile places. In any case, greater numbers of Greeks began to move abroad permanently beginning in the mid-eighth century B.C. By this date, the population explosion in the late Dark Age had caused a scarcity of land available for farming, the most

desirable form of wealth in Greek culture. The disruptions and depopulation of the Dark Age originally had left much good land unoccupied, and families could send their offspring out to take possession of unclaimed fields. Eventually, however, this supply of free land was exhausted, producing tensions in some city-states through competition for land to farm. Emigration helped solve this problem by sending men without land to foreign regions, where they could acquire their own fields in the territory of colonies founded as new city-states.

Aiming to make one's fortune in international commerce was clearly a motivation for many Greeks to leave the security of home behind. Some Greeks with commercial interests took up residence in foreign settlements, such as those founded in Spain in this period by the Phoenicians from Palestine. The Phoenicians were active in building commercially motivated settlements throughout the western Mediterranean, usually at spots where they could most easily trade for metals. For example, within a century of its foundation sometime before 750 B.C., the Phoenician settlement on the site of modern Cadiz in Spain had become a city thriving on economic and cultural interaction with the indigenous Iberian population. The natural resources of Spain included rich veins of metals.

Greeks also founded numerous trading posts abroad on their own as private enterprises. Traders from the island of Euboea, for instance, had already established commercial contacts by 800 B.C., with a community located on the Syrian coast at a site now called Al Mina. Men wealthy enough to finance risky expeditions by sea ranged far from home in search of metals. Homeric poetry testifies to the basic strategy of this entrepreneurial commodity trading. In *The Odyssey,* the goddess Athena once appears disguised as a metal trader to hide her identity from the son of the poem's hero: "I am here at present," she says to him, "with my ship and crew on our way across the wine-dark sea to foreign lands in search of copper; I am carrying iron now" (1, lines 178–188). By about 775, Euboeans, who seem to have been particularly active explorers, had also established a settlement for purposes of trade on the island of Ischia, in the Bay of Naples off southern Italy. There they processed iron ore imported from the Etruscans, a thriving population inhabiting central Italy. Archaeologists have documented the expanding overseas communication of the eighth century by finding Greek pottery at more than eighty sites outside the Greek homeland; by contrast, almost no pots have been found that were carried abroad in the tenth century. Patterns of trade in the Archaic Age reveal interdependent markets for which highly mobile merchants were focused on satisfying demand by supplying goods of all kinds, from raw materials to luxury items.

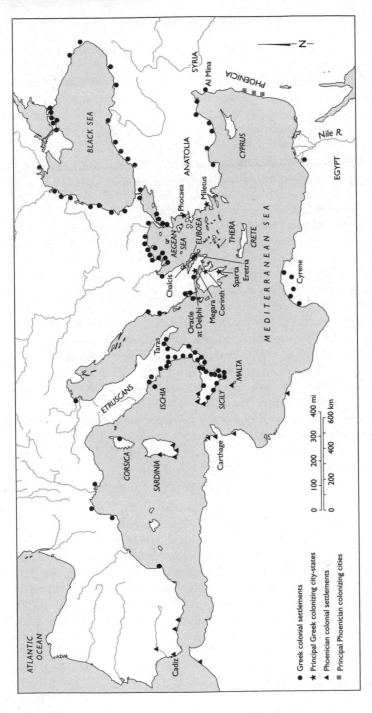

Map 3. Phoenician and Greek Colonization, c. 800–c. 500 B.C.

Hearing from overseas traders about places in which to relocate in search of a better life, Greek colonists sometimes went abroad as members of a group organized by their "mother city" (mētropolis), which would designate a group leader called the "founder" (ktistēs). Even though they were going to establish an independent city-state at their new location, colonists who left home on these publicly arranged expeditions were expected to retain ties with their metropolis. A colony that sided with its metropolis's enemy in a war, for example, was regarded as disloyal. Sometimes colonists, whether private merchants setting up a trading spot on their own initiative or a group sent out by a mother city, enjoyed a friendly welcome from the local inhabitants where they settled; sometimes they had to fight to win land and a harbor for their new community. Since colonizing expeditions seem to have been usually all male, wives for the colonists had to be found among the locals, either through peaceful negotiation or by violent kidnappings. A colony with a founder expected him to lay out the settlement properly and parcel out the land, as Homer describes in speaking of the foundation of a fictional colony: "So [the founder] led them away, settling them in [a place called] Scheria, far from the bustle of men. He had a wall constructed around the town center, built houses, erected temples for the gods, and divided the land" (Odyssey 6, lines 7–10).

The foundation of Cyrene (in what is now Libya in North Africa) in about 630 B.C. reveals how contentious the process of colonization could be in some circumstances. The people of the polis of Thera, on an island north of Crete, apparently were unable to support their population. Sending out colonists therefore made sense as a solution to population pressures. A much later inscription (put up in the fourth century B.C.) found at Cyrene claims to record how the expedition was organized under the leadership of the founder Battus, as this excerpt from the longer text shows:

Since [the god] Apollo of Delphi spontaneously instructed Battus and the Therans to send a colony to Cyrene, the Therans decided to send Battus to North Africa as leader and king and for the Therans to sail as his companions. They are to go on the expedition on equal and fair terms according to their household and one adult son [from each family] is to be conscripted [and those who are to be chosen are to be those who are the adults, and of the other Therans only those who are free men are to sail]. And if the colonists succeed in establishing the settlement, men who sail to North Africa later on to join it shall share in citizenship and magistracies and shall be given portions from the land that no one owns. But if they fail to establish the settlement and the Therans are unable to send assistance and the colonists suffer hardship

for five years, they shall depart from the land to Thera without fear of punishment, they can return to their own property, and they shall be citizens. And if any man is unwilling to depart for the colony once the polis decides to send him, he shall be liable to the death penalty and his property shall be confiscated. Any man who shelters or hides such a one, whether he is a father helping his son, or a brother aiding his brother, is to suffer the same penalty as the man who refuses to sail. An agreement was sworn on these conditions by those who remained in Thera and those who sailed to found the colony in Cyrene, and they invoked curses against those who break the agreement or fail to keep it, whether they were those who settled in North Africa or those who stayed behind.

—(Crawford and Whitehead, *Archaic and Classical Greece,*. no. 16 = GHI, no. 5)

If this retrospective inscription accurately reports the original circumstances of the expedition—and some scholars think that it was an imaginary reconstruction of the original oath—then the young men of Thera were reluctant to leave their home for the new colony. Regardless of whether this particular text is reliable in its detail, it seems undeniable that Greek colonization was not always a matter of individual choice and initiative. The possibility of acquiring land in a colony on which a man could perhaps grow wealthy had to be weighed carefully against the terrors of being torn from family and friends to voyage over treacherous seas to regions posing a level of risk to the immigrants that was hard to calculate but never small. Greek colonists always had good reasons to be anxious about their future.

In some cases, a shortage of land to farm or a desire to found a trading post were not the principal spurs to colonization. Occasionally, founding colonies could serve as a mechanism for a city-state to rid itself of undesirable people whose presence at home was causing social unrest. The Spartans, for example, colonized Taras (modern Taranto) in southern Italy in 706 B.C. with a group of illegitimate sons whom they could not successfully integrate into their citizen body. Like the young men of Thera, these unfortunate outcasts certainly did not go out as colonists by their own choice.

THE EFFECTS OF CONTACT WITH OTHER PEOPLES

Greeks participating in international trade by sea in the Archaic Age increased their homeland's contact with other peoples, especially in Anatolia

and the Near East, and these interactions led to changes in life in Greece in this period. Greeks admired and envied these older civilizations for their wealth, such as the famous gold treasures of the Phrygian kingdom of Midas, and for their cultural accomplishments, such as the lively pictures of animals on Near Eastern ceramics, the magnificent temples of Egypt, and the alphabet from Phoenicia. During the early Dark Age, Greek artists had stopped portraying people or other living creatures in their designs. The pictures they saw on pottery imported from the Near East in the late Dark Age and early Archaic Age influenced them to begin once again to depict figures in their paintings on pots. The style of Near Eastern reliefs and freestanding sculptures also inspired creative imitation in Greek art of the period. When the improving economy of the later Archaic Age allowed Greeks to revive monumental architecture in stone, temples for the worship of the gods inspired by Egyptian sanctuaries represented the most prominent examples of this new trend in erecting large, expensive buildings. In addition, the Greeks began to mint coins in the sixth century B.C., a technology they learned from the Lydians of Anatolia, who had invented coinage as a form of money in the previous century. Long after this innovation, however, much economic exchange continued to be made through barter, especially in the Near East. Economies that relied primarily on currency for commerce and payments took centuries to develop.

Knowledge of the technology of writing was the most dramatic contribution of the ancient Near East to Greece as the latter region emerged from its Dark Age. As mentioned previously, Greeks probably learned the alphabet from the Phoenicians to use it for record keeping in business and trade, as the Phoenicians did, but they soon started to employ it to record literature, above all Homeric poetry. Since the ability to read and write remained unnecessary for most purposes in the predominately agricultural economy of Archaic Greece, and since there were no public schools, few people at first learned the new technology of letters as the representations of sounds and linguistic meaning.

Competition for international markets significantly affected the fortunes of larger Greek city-states during this period. Corinth, for example, grew prosperous from its geographical location controlling the narrow isthmus of land connecting northern and southern Greece. Since ships plying the east–west sea-lanes of the Mediterranean preferred to avoid the stormy passage around the tip of southern Greece, they commonly offloaded their cargoes for transshipment on a special roadbed built across the isthmus and then reloaded onto different ships on the other side of the strip of land. Small ships may even have been dragged over the roadbed from one side of the isthmus to the other. Corinth became a bustling cen-

ter for shipping and earned a large income from sales and harbor taxes. It also earned a reputation and income as the foremost shipbuilding center of Archaic Greece. In addition, by taking advantage of its deposits of fine clay and the expertise of a growing number of potters, Corinth developed a thriving export trade in pottery painted in vivid colors. It is not certain whether the people overseas who obtained these objects in large numbers, such as the Etruscans in central Italy, prized the pots themselves as foreign luxury items or were more interested in whatever may have been shipped inside the pots, such as wine or olive oil. It is clear that Greek painted pots were regularly transported far from their point of manufacture. By the late sixth century B.C., however, Athens began to displace Corinth as the leading Greek exporter of fancy painted pottery, evidently because consumers came to prefer designs featuring the red color for which the chemical composition of Athens's clay was better suited than Corinth's.

The Greeks were always careful to solicit approval from the gods before setting out from home, whether for commercial voyages or formal colonization. The god most frequently consulted about sending out a colony, as in the case of Cyrene, was Apollo, in his sanctuary at Delphi, a hauntingly scenic spot in the mountains of central Greece (fig. 4.1). The Delphic sanctuary began to be internationally renowned in the eighth century B.C. because it housed an oracular shrine in which a prophetess, the Pythia, spoke the will of Apollo in response to questions from visiting petitioners. The Delphic oracle operated for a limited number of days over nine months of the year, and demand for its services was so high that the operators of the sanctuary rewarded generous contributors with the privilege of jumping to the head of the line. The great majority of visitors to Delphi consulted the oracle about personal matters, such as marriage, having children, and other personal issues, but city-states could also send representatives to ask about crucial decisions, such as whether to go to war. That Greeks hoping to found a colony felt they had to secure the approval of Apollo of Delphi demonstrates that the oracle was held in high esteem as early as the 700s B.C., a reputation that continued to make the oracle a force in Greek international affairs in the centuries to come.

STRUCTURING THE CITY-STATE

Identifying the reasons for the changes in Greek politics that led to the gradual emergence of the city-state in the Archaic Age remains a challenge. The surviving evidence mainly concerns Athens, which was not a typical city-state in significant aspects, particularly in the large size of its population. Much of what we can say about the structuring of the early Greek

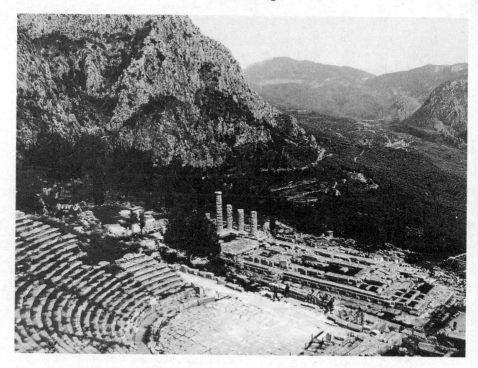

Fig. 4.1: This view shows the theater and the remains of the temple of Apollo
at Delphi, below a looming cliff and overlooking a deep valley. This dramatic
landscape was a sacred location, home to the internationally famous oracle of the
god, which private individuals and political states alike consulted when making
important decisions, from getting married to going to war. Wikimedia Commons.

city-state as a kind of social, political, and religious organization therefore
applies solely to Athens. Other city-states certainly emerged under vary-
ing conditions and with different results. Nevertheless, it seems possible
to draw some general conclusions about the slow process through which
city-states began to emerge starting around the middle of the eighth cen-
tury B.C.

The economic revival of the Archaic Age and the growth in the popula-
tion of Greece that were taking place by this time certainly gave momen-
tum to the process. Men who managed to acquire fortunes from success
in commerce and agriculture could now demand a greater say in political
affairs from the social elite, who claimed preeminence based on their cur-
rent prestige and riches and, if these first two markers of status seemed
insufficient, the past glory of their families. Theognis of Megara, a sixth-

century B.C. poet whose verses also reflect earlier conditions, gave voice to the distress of members of the elite who felt threatened by the ability of members of the non-elite to use their newly made riches to force their way into the highest level of society: "Men today honor possessions, and elite men marry into 'bad' [that is, non-elite] families and 'bad' men into elite families. Riches have mixed up lines of breeding . . . and the good breeding of the citizens is becoming obscured" (Theognidea, lines 189–190). This complaint bordered on dishonesty because it obscured the traditional interest of the elite in amassing wealth, but it did reveal the growing tension between those elite members of society who were accustomed to enjoying prominence from the status of their family and those in the non-elite who wanted to gain social status through upward mobility based on the material success they had built for themselves through their own efforts.

The great increase in population in this era probably came mostly in the ranks of the non-elite, especially the relatively poor. Their families raised more children, who could help to farm more land, so long as it was available for the taking in the aftermath of the depopulation of the early Dark Age. Like the Zeus in Hesiod's Theogony, who acted in response to the injustice of his ruthless father Kronos in swallowing his own children, the growing number of people now owning some property apparently reacted against what they saw as unacceptable inequity in the leadership of the elite, whose members evidently tended to behave as if they were petty kings in their local territory. In Hesiod's words, they were "swallowing bribes" to inflict what seemed like "crooked" justice on oppressed people with less wealth and power (Works and Days, lines 38–39, 220–221). This concern for equity and fairness on the part of those hoping to improve their lot in life gave a direction to the social and political pressures created by the growth of the population and the general improvement in economic conditions.

For the city-state to be created as a political institution in which all free men had a share, members below the level of the social elite had to insist that they deserved equitable treatment, even if members of the elite were to retain leadership positions and direct the implementation of policies agreed on by the group. The implementation of the concept of citizenship as the basis for the city-state and the extension of citizen status to all freeborn members of the community responded to that demand. Citizenship above all carried certain legal rights, such as being able to exercise freedom of speech and to vote in political and legislative assemblies, to elect officials, to have access to courts to resolve disputes, to have legal protection against enslavement by kidnapping, and to participate in the

religious and cultural life of the city-state. The degree of participation in politics open to the poorest men varied among different city-states. The ability to hold public office, for example, could be limited in some cases to owners of a certain amount of property or wealth. Most prominently, citizen status distinguished free men and women from slaves and metics (freeborn foreigners who were officially granted limited legal rights and permission to reside and work in a city-state that was not their homeland). Thus, even poor citizens had a distinction setting themselves apart from these groups not endowed with citizenship, a status in which they could take pride despite their poverty.

It is of course true that social and economic inequality among male citizens persisted as part of life in the Greek city-state despite the legal guarantees of citizenship. The incompleteness of the equality that under-lay the political structure of the city-state also revealed itself in the status of citizen women, despite the value that their citizenship represented for them. Women became citizens of the city-states in the absolutely crucial sense that they had an identity, social status, and local rights denied met-ics and slaves. The important difference between citizen and noncitizen women was made clear in the Greek language, which included a term meaning "female citizen" (*politis*, the feminine of *politēs*, "male citizen"), in the existence of certain religious cults reserved for citizen women only, and in legal protection for female citizens against being kidnapped and sold into slavery. Citizen women also could defend their interests in court in disputes over property and other legal wrangles, although they could not represent themselves at trial and had to have men speak for their in-terests, a requirement that, however, reveals their inequality under the law. The traditional paternalism of Greek society—men acting as "fathers" to regulate the lives of women and safeguard their interests as defined by men—demanded that every woman have an official male guardian (*kyrios*) to protect her physically and legally. In line with this assumption about the need of women for regulation and protection by men, women were granted no rights to participate in politics. They never attended political assemblies, nor could they vote. They did hold certain civic priesthoods, however, and they had access along with men to the initiation rights of the popular cult of the goddess Demeter at Eleusis near Athens. This in-ternationally renowned cult, about which more will be said later, served in some sense as a safety valve for the pressures created by the remaining inequalities of life in Greek city-states, because it offered to all regardless of class its promised benefits of protection from evil and a better fate in the afterworld.

THE POOR AND CITIZENSHIP

Despite the limited equality characteristic of the Greek city-state, the creation of this new form of political organization nevertheless represented a significant break with the past, and the extension of at least some political rights to the poor deserves recognition as a truly remarkable development. It took a long time for poor male citizens to gain all the political access and influence that they wanted, and there was always resistance from a faction of the elite. Still, no matter how slow or incomplete this change was, it was unprecedented in the ancient world. In my opinion, despite the limitations and despite how long it took for this change to reach its full development, it would be unfair to the ancient Greeks to deny them the credit for working to implement this principle that is so widely praised—if not always honored—in our world.

Unfortunately, we cannot identify with certainty the forces that led to the emergence of the city-state as a political institution in which even poor men had a vote on political matters. The explanation long favored by many scholars made a set of military and social developments, called the "hoplite revolution," responsible for the general widening of political rights in the city-state, but more recent research on military history has undermined the plausibility of this theory. Hoplites were infantrymen clad in metal body armor and helmets (fig. 4.2), and they constituted the heavy strike force of the citizen militias that had the main responsibility of defending Greek city-states in this period; professional armies were as yet unknown, and mercenaries were uncommon in Greece. Hoplites marched into combat shoulder to shoulder in a rectangular formation called a phalanx, which bristled with the spears of its soldiers positioned in ranks and files. Staying in line and working as part of the group was the secret to successful phalanx tactics. A good hoplite, in the words of the seventh-century B.C. poet Archilochus, was "a short man firmly placed upon his legs, with a courageous heart, not to be uprooted from the spot where he plants his feet" (Fragment 114). As Homer's *Iliad* shows, Greeks had been fighting in formation for a long time before the Archaic Age, but until the eighth century, only leaders and a relatively small number of their followers could afford to buy metal weapons, which the use of iron was now making more affordable; militiamen provided their own arms and armor. Presumably these new hoplites, since they paid for their own equipment and trained hard to learn phalanx tactics to defend their community, felt they—and not just the members of the elite—were entitled to political rights in return for their contribution to "national defense." According to

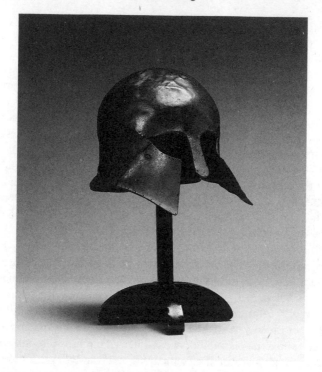

Fig. 4.2: Heavily armed infantrymen (hoplites) in the citizen-militias of Greek city-states wore metal helmets like these, which protected their heads but restricted their vision and hearing. The holes along the edges were to attach a lining to cushion the rigid headgear. The Walters Art Museum, Baltimore.

the theory of a hoplite revolution, these new hoplite-level men forced the elite to share political power by threatening to refuse to fight and thereby cripple the community's military defense.

The theory of a hoplite revolution correctly assumes that new hoplites had the power to demand an increased political say for themselves, a development of great significance for the development of the city-state as an institution not solely under the power of a small circle of the most prominent male citizens. The theory of a hoplite revolution cannot explain, however, one crucial question: Why were poor men and not only hoplites given (admittedly sometimes only gradually) the political right of voting on policy in the city-state? Most men in the new city-states were too poor to qualify as hoplites. Nor had the Greeks yet developed navies, the military service for which poor men would provide the manpower in later times, when a fleet was a city-state's most effective weapon. If being

able to make a contribution to the city-state's defense as a hoplite was the only way to earn the political rights of citizenship, the elites and the "hoplite class" had no obvious reason to grant poor men the right to vote on important matters. And history shows that dominant political groups do not like to split their power with those whom they consider their inferiors. Anthropologists and psychologists today may debate, as they do, to what extent, if any, human nature includes an innate tendency for us to share with others, but politics is barren ground on which to search for examples of power sharing happening spontaneously.

Yet poor men nevertheless did become politically empowered citizens in many Greek city-states, with local variations on whether a man had to own a certain amount of land to have full political rights, whether eligibility for higher public offices required a certain level of income, and how long it took for changes to be made to empower poor men politically. In general, however, all male citizens, regardless of their level of wealth, eventually were entitled to attend, speak in, and cast a vote in the communal assemblies in which policy decisions for city-states were made and officials were elected. That poor men gradually came to participate in the assemblies of the city-states means that they were citizens possessing the basic component of political equality. The hoplite revolution fails as a complete explanation of the development of the city-state above all because it cannot account for the elite's sharing this right with poorer citizens. Furthermore, the emergence of large numbers of men wealthy enough to afford hoplite armor seems to belong to the middle of the seventh century B.C., well after the period when the city-state as an innovative form of political organization was first coming into existence.

No thoroughly satisfactory alternative or complement to the theory of hoplite revolution has yet emerged to explain the origins of the political structure of the Greek city-state. The laboring free poor—the workers in agriculture, trade, and crafts—contributed much to the economic strength of the city-state, but it is hard to see how their value as laborers could have been translated into political rights. The better-off elements in society certainly did not extend the rights of citizenship to the poor out of any romanticized vision of poverty as spiritually noble. As the contemporary lyric poet Alcaeus phrased what Aristodemus of Sparta reportedly said, "Money is the man; no poor man ever counts as good or honorable" (Fragment 360).

It seems likely that placing too much emphasis on the development of hoplite armor and tactics in the Archaic Age misrepresents the reality of Greek warfare in this early period. In the Dark Age, few men could have afforded metal body armor, and military tactics presumably reflected this

fact, with most soldiers accustomed to gear fashioned from leather or even thick cloth as the best protection available to them. Since the numbers of poorer men far exceeded those of the wealthy, any leader wishing to assemble a significant force would have had to rely on the ranks of poor men. Even poorly armed men could form a formidable force against better-armed opponents if their numbers were great enough. Lightly armed combatants in the eighth century B.C.—even those only throwing rocks, wielding staves, and brandishing farming implements as weapons—could have helped their city-state's contingent of hoplites to sway the tide of battle against an opposing force. The battle scenes in Homer's *Iliad* frequently depict fighters throwing rocks at the enemy, and with effect; even the great heroes pick up stones to hurl at their armored foes, expecting to knock them out with the blow and often succeeding. In short, light-armed citizens could significantly shore up the defense of their city-state.

If it is true that poor, lightly armed men were a significant factor in Dark Age warfare, this importance could have persisted until well into the Archaic Age and the time of the development of the city-state, as it took a long time for hoplite armor and weapons to become common. And even after more men had become sufficiently prosperous to afford hoplite equipment, they still would have been well outnumbered by those poorer than they. Early hoplite forces, therefore, may have been only the "fighters in the front" (*promachoi*), spearheading larger forces of less heavily armed troops assembled from poorer men. In this way, the contribution of the poor to the defense of the city-state as part of its only military force at this date—a citizen militia—would have been essential and worthy of citizenship.

Another significant boost to extending political rights to the poor sometimes came from the sole rulers, called tyrants, who seized power for a time in some city-states and whose history will be discussed in the next chapter. Tyrants could have used grants of citizenship to poor or disenfranchised men as a means of increasing popular support for their regimes.

Furthermore, it seems possible that the elite in Greek society had become less cohesive as a political group in this period of dramatic change, splintering deeply as its members competed more and more fiercely with one another for status and wealth. Their lack of unity then weakened the effectiveness of their opposition to the growing idea bubbling up from the ranks of the poor that it was unjust to exclude them from political participation. When the poor agitated for power in the citizen community, on this view, there would have been no united front of members of the elite and hoplites to oppose them, making compromise necessary to prevent destructive civil unrest.

In this context, it makes sense to think that this unprecedented change

in the nature of politics in ancient Greece was fueled by the concern for justice and equality that Hesiod's poems express. The majority of people evidently agreed that it was no longer acceptable for others to tell them what to do without their consent, because, at some fundamental level, they were all equal or at least similar in their contributions to the community and therefore deserved a more-equal or at least a more-similar say in how things were run. This communal tendency toward greater egalitarianism in politics corresponded, on the local level, to the Panhellenism found in the emergence of the Olympic Games and rejected the attitude portrayed in the episode in Homer's *Iliad* when Odysseus beat Thersites for publicly criticizing Agamemnon (as mentioned in chapter 3).

Whatever the precise interplay of its different causes may have been, the hallmark of the politics of the developed Greek city-states certainly became the practice of male citizens making decisions communally. Members of the social elite continued to be powerfully influential in Greek politics even after city-states had come into existence, but the unprecedented political sway that non-elite citizens over time came to exercise in city-states constituted the most remarkable feature of the change in the political organization of Greek society in the Archaic Age. This entire process was gradual, as city-states certainly did not suddenly emerge fully formed around 750 B.C. Three hundred years after that date, for example, the male citizens of Athens were still making major changes in their political institutions to disperse political power more widely among the male citizen body and to give more rights to poorer male citizens. What is worth remembering is that this change happened at all.

CHATTEL SLAVERY

As already mentioned, freedom remained only an elusive dream for many in ancient Greece even after the emergence of the city-state in the Archaic Age. The evidence for slavery in the earlier Dark Age already reveals complex relationships of dependency among free and unfree people. The language of the epics of Homer and Hesiod mentions people called *dmōs*, *doulē*, and *douleios*, all of whom were dependent and unfree to a greater or lesser degree. Some dependent people featured in the poems seem more like inferior members of the owners' households than living, breathing possessions. They live under virtually the same conditions as their superiors and enjoy a family life of their own. Others who were taken prisoner in war apparently were reduced to the status of complete slavery, meaning they were wholly under the domination of their owners, who benefited from the captives' labor. These slaves counted as property—chattel—not as

people. If the descriptions in these poems reflect actual conditions in the Dark Age, chattel slavery was not, however, the primary form of dependency in Greece during that period.

The creation of citizenship as a category to define membership in the exclusive group of people constituting a Greek city-state inevitably highlighted the contrast between those included in the category of citizens and those outside it. Freedom from control by others was a necessary precondition to becoming a citizen with full political rights, which in the city-states meant above all being a freeborn adult male. The strongest contrast citizenship produced, therefore, was that between free (*eleutheros*) and unfree or slave (*doulos*). In this way, the development of a clear idea of personal freedom in the formation of the city-state as a new political form may paradoxically have encouraged the complementary development of widespread chattel slavery in the Archaic Age. The rise in economic activity in this period probably also encouraged the importation of slaves by increasing the demand for labor. In any case, slavery as it developed in the Archaic Age reduced most unfree persons to a state of absolute dependence; they were the property of their owners. As Aristotle later categorized slaves, they were a "sort of living possession" (*Politics* 1253b32). He concluded that slavery was natural because there were people who lacked the capacity for reason that was necessary for a person to be a free agent, although he reluctantly had to grant the power of arguments rejecting the assertion that some people by their nature did not deserve to be free.

Captives taken in war presented a problem for Aristotle's analysis of natural slavery, because they had been free before the accident of defeat in battle subjected them to the loss of their previous liberty; it was not a deficiency in reasoning that had turned them into chattel. Nevertheless, all Greek city-states accepted that prisoners of war could be sold as slaves (if they were not ransomed by their families). Relatively few slaves seem to have been born and raised in the households of those for whom they worked in Greece. Most slaves were bought on the international market. Slave traders imported chattel slaves to Greece from the rough regions to the north and east, where foreign raiders and pirates captured non-Greeks. The local bands in these areas would also raid their neighbors and drag off captives to sell to slave dealers. The dealers would then sell their purchases in Greece at a profit. Herodotus reported that some of the Thracians, a group of peoples living to the north of mainland Greece, "sold their children for export" (*The Histories* 5.6). This report probably meant that one band of Thracians sold children captured from other bands of Thracians, whom the first group considered different from themselves. The Greeks lumped together all foreigners who did not speak Greek as "barbarians"

(*barbaroi*)—people whose speech sounded to Greeks like the repetition of the meaningless sounds "bar, bar." Barbarians, the Greeks thought, were not all alike; they could be brave or cowardly, intelligent or dim-witted. But they were not, by Greek standards, civilized. Greeks, like Thracians and other slaveholding peoples, found it easier to enslave people whom they considered different from themselves and whose ethnic and cultural otherness made it easier to disregard their shared humanity. Greeks also enslaved fellow Greeks, however, especially those defeated in war, but these Greek slaves were not members of the same city-state as their masters. Rich families prized Greek slaves with some education because they could be made to serve as tutors for children, for whom there were no publicly financed schools in this period.

It took until about 600 B.C. for chattel slavery to become the norm in Greece. Eventually, slaves became cheap enough that families of moderate means could afford one or two. Nevertheless, even wealthy Greek landowners never acquired gangs of hundreds of slaves comparable in size to those that maintained Rome's water system under the Roman Empire or that worked large plantations in the southern United States before the American Civil War. For one thing, maintaining a large number of slaves year-round in ancient Greece would have been uneconomical because the cultivation of the crops grown there generally called for short periods of intense labor punctuated by long stretches of inactivity, during which slaves would have to be fed even while they had no work to do.

By the fifth century B.C., however, the number of slaves in some city-states had swollen to as much as one-third of the total population. This percentage means that, of course, small landowners, their families, and hired free workers still performed the majority of work in Greek city-states. The special system of slavery in Sparta, as will be explained later, provides a rare exception to this situation. Rich Greeks everywhere regarded working for someone else for wages as disgraceful, but their attitude did not correspond to the realities of life for many poor people, who had to earn a living at any work they could find.

Like free workers, chattel slaves did all kinds of labor. Household slaves, often women, had the physically least dangerous existence. They cleaned, cooked, fetched water from public fountains, helped the wife with the weaving, watched the children, accompanied the husband as he did the marketing (as was the Greek custom), and performed other domestic chores. Yet they could not refuse if their masters demanded sexual favors. Slaves who worked in small manufacturing businesses, like those of potters or metalworkers, and slaves working on farms often labored alongside their masters. Rich landowners, however, might appoint a slave supervisor

to oversee the work of their other slaves in their fields while they remained in town. The worst conditions of life for slaves obtained for those men leased out to work in the narrow, landslide-prone tunnels of Greece's few silver and gold mines. The conditions of their painful and dangerous jobs were dark, confined, and backbreaking. Owners could punish their slaves whenever they felt like it, even kill them without fear of meaningful sanctions. (A master's murder of a slave was regarded as at least improper and perhaps even illegal in Athens of the Classical period, but the penalty may have been no more than ritual purification.) Beatings severe enough to cripple a working slave and executions of able-bodied slaves were probably infrequent because destroying such useful pieces of property made no economic sense for an owner.

Some slaves enjoyed a measure of independence by working as public slaves (dēmosioi, "belonging to the people") owned by the city-state instead of an individual. They lived on their own and performed specialized tasks. In Athens, for example, public slaves later had the responsibility for certifying the genuineness of the city-state's coinage. They also performed distasteful tasks that required the application of force to citizens, such as serving as the assistants to the citizen magistrates responsible for arresting criminals. The city's official executioner was also a public slave in Athens. Slaves attached to temples also lived without individual owners because temple slaves belonged to the god of the sanctuary, for which they worked as servants, as depicted, for example, in the drama Ion written by the Athenian playwright Euripides and performed on stage in the late fifth century B.C.

Under the best conditions, household slaves with humane masters might live lives free of violent punishment. They might even be allowed to join their owners' families on excursions and attend religious rituals, such as sacrifices. Without the right to a family of their own, however, without being able to own property, without legal or political rights, they lived an existence alienated from regular society. In the words of an ancient commentator, chattel slaves lived lives of "work, punishment, and food" (Pseudo-Aristotle, Oeconomica 1344a35). Their labor helped maintain the economy of Greek society, but their work rarely benefited themselves. Yet despite the misery of their condition, Greek chattel slaves—outside Sparta—almost never revolted on a large scale, perhaps because they were of too many different nationalities and languages and too far from their homelands to organize themselves for rebellion and escape from their households to return to their lands of origin. Sometimes owners freed their slaves voluntarily, and some owners promised freedom at a future date to encourage their slaves to work hard in the meantime. Freed slaves

did not become citizens in Greek city-states, however, but instead became members of the population of resident foreigners, the metics. They were expected to continue to help out their former masters when called upon.

HOUSEHOLDS AND MARRIAGE

The emergence of slavery on a large scale in the Greek city-state made households bigger and added new responsibilities for women, especially rich women, whose lives were circumscribed by the responsibility of managing their households. As partners in the maintenance of the family with their husbands, who spent their time outside farming, participating in politics, and meeting their male friends, wives were entrusted with the management of the household (*oikonomia*, whence comes our word *economics*). They were expected to raise the children, supervise the preservation and preparation of food, keep the family's financial accounts, direct the work of the household slaves, and nurse them when they were ill. A major task was to weave textiles for clothing, which was expensive, especially the colorfully patterned clothes that women wore, when their families could afford such finery (fig. 4.3). Households thus depended on women, whose work permitted the family to be economically self-reliant and the male citizens to participate in the public life of the polis.

Poor women worked outside the home, often as small-scale merchants in the public market (*agora*) that occupied the center of every settlement. Only at Sparta did women have the freedom to participate in athletic training along with men. Women played their major role in the public life of the city-state by participating in religious rituals, state festivals, and funerals. Certain festivals were reserved for women only, especially in the cult of the goddess Demeter, whom the Greeks credited with teaching them the indispensable technology of agriculture. As priestesses, women also fulfilled public duties in various official cults; for example, women officiated as priestesses in more than forty such cults in Athens by the fifth century B.C. Women holding these posts often enjoyed considerable prestige, practical benefits such as a salary paid by the state, and greater freedom of movement in public.

· Upon marriage, women became the legal wards of their husbands, as they previously had been of their fathers while still unmarried. Marriages were arranged by men. A woman's guardian—her father, or if he were dead, her uncle or her brother—would commonly betroth her to another man's son while she was still a child, perhaps as young as five. The engagement was an important public event conducted in the presence of witnesses. The guardian on this occasion repeated the phrase that expressed

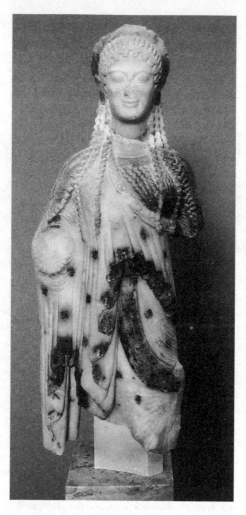

Fig. 4.3: This Archaic Age marble statue from Athens depicting an unmarried girl (korē) was displayed in public, as was customary for art at the time, probably as a gift to a divinity. The traces of paint on her hair and carefully draped clothing hint at the bright coloring of ancient Greek statues; the colors usually fade or disappear over the centuries. Wikimedia Commons.

the primary aim of marriage: "I give you this woman for the plowing [procreation] of legitimate children" (Lucian, Timon 17). The marriage itself customarily took place when the girl was in her early teens and the groom ten to fifteen years older. Hesiod advised a man to marry a virgin in the fifth year after her puberty, when he himself was "not much younger than thirty and not much older" (Works and Days, lines 697–705). A legal marriage consisted of the bride's going to live in the house of her husband. The procession to his house was as close to the modern idea of a wedding ceremony as Greek marriage offered. The woman brought with her a dowry of property (perhaps land yielding an income, if she were wealthy) and personal possessions that formed part of the new household's assets and could be inherited by her children. Her husband was legally obliged to preserve the dowry and to return it in case of a divorce. Procedures for divorce were more concerned with power than law: A husband could expel his wife from his home, while a wife, in theory, could on her own initiative leave her husband to return to the guardianship of her male relatives. Her freedom of action could be constricted, however, if her husband used force to keep her from leaving. Monogamy was the rule in ancient Greece, and a nuclear family structure (that is, husband, wife, and children living together without other relatives in the same house) was common, except at Sparta, although at different stages of life a married couple might have other relatives living with them. Citizen men could have sexual relations without penalty with slaves, foreign concubines, female prostitutes, or (in many city-states) willing preadult citizen males. Citizen women had no such sexual freedom, and adultery carried harsh penalties for wives as well as their illicit male partners. Sparta, as often in Greek social norms, was an exception: There, a woman who was childless could have sex for reproduction with another man, so long as her husband agreed.

More than anything else, a dual concern to regulate marriage and procreation and to maintain family property underlay the placing of the legal rights of Greek women and the conditions of their citizenship under the guardianship of men. The paternalistic attitude of Greek men toward women was rooted in the desire to control human reproduction and, consequently, the distribution of property, a concern that had gained special urgency in the reduced economic circumstances of the Dark Age. Hesiod, for instance, makes this point explicitly in relating the myth of the first woman, named Pandora (Theogony, lines 507–616; Works and Days, lines 42–105). According to the legend, Zeus, the king of the gods, created Pandora as a punishment for men when Prometheus, a divine being hostile to Zeus, stole fire from Zeus to give it to human beings, who had previously lacked that technology. Pandora subsequently loosed "evils and diseases"

into the previously trouble-free world of men by removing the lid from the jar or box the gods had filled for her. Hesiod then refers to Pandora's descendants, the female sex, as a "beautiful evil" for men ever after, comparing them to drones who live off the toil of other bees while devising mischief at home. But, he goes on to say, any man who refuses to marry to escape the "troublesome deeds of women" will come to "destructive old age" without any children to care for him (*Theogony*, lines 603–605). After his death, moreover, his relatives will divide his property among themselves. A man must marry, in other words, so that he can sire children to serve as his support system in his old age and to preserve his holdings after his death by inheriting them. Women, according to Greek mythology, were for men a necessary evil, but the reality of women's lives in the city-state incorporated social and religious roles of enormous importance.

Oligarchy, Tyranny, and Democracy

Although the Greek city-states differed in size and natural resources, over the course of the Archaic Age they came to share certain fundamental political institutions and social traditions: citizenship, slavery, the legal disadvantages and political exclusion of women, and the continuing predominance of wealthy elites in public life. But city-states developed these shared characteristics in strikingly different ways. Monarchy had mostly died out in Greece with the end of Mycenaean civilization, as the limited evidence for the time seems to show. In any case, the dual kingship that existed in Sparta formed part of its complex oligarchic system rather than functioning as a monarchy in the ordinary sense, which has only one ruler at a time and does not impose the complex and strict requirements for power sharing under which the Spartan "kings" operated. In Sparta and some other Greek city-states, a limited number of men from the citizen body exercised meaningful political power, thus creating a political system called an oligarchy (*oligarchia* in Greek, meaning "rule by the few"). Other city-states experienced periods of domination by the kind of sole ruler who seized power in some irregular, even violent way and whom the Greeks called a tyrant (from the Greek *tyrannos*). Tyranny, passed down from father to son, existed at various times across the breadth of the Greek world, from city-states on the island of Sicily in the west, to Samos off the coast of Ionia in the east, though most of these regimes failed to stay in control for more than a couple of generations.

c. 800–600 b.c.: Spartans develop their society's distinctive laws and traditions.

c. 730–710 b.c.: Spartans invade Messenia in First Messenian War.

c. 657 b.c.: Cypselus, of the Bacchiad family, becomes tyrant at Corinth.

c. 640–630 b.c.: Spartans invade Messenia in Second Messenian War. Athenians begin to develop the initial stages of democratic government.

c. 632 b.c.: In Athens, Cylon attempts to take over the government by force.

c. 630 b.c.: Sappho of Lesbos born.

625 b.c.: Cypselus dies and is succeeded by his son, Periander, as tyrant of Corinth.

621 b.c.: Draco creates code of law for Athens.

594 b.c.: Athenians appoint Solon to recodify their laws in an attempt to put an end to social and economic conflict.

546 b.c.: Pisistratus becomes tyrant at Athens on his third attempt.

c. 540 b.c.: Tyranny begins on Samos.

c. 530 b.c.: Pythagoras emigrates from Samos to southern Italy.

527 b.c.: Pisistratus dies; his son Hippias takes over as tyrant of Athens.

510 b.c.: Athens freed from tyranny by Alcmaeonid family and Spartan military force.

508 b.c.: Cleisthenes begins to reform Athenian democracy; Spartan invasion turned back by "the people."

Still other city-states created early forms of democracy (*dēmocratia*, "rule by the people") by giving all male citizens the power to participate in governing. This was an extraordinary new form of government; its creation has a significance that modern people can miss if they assume from their own experience that democracy is the "default value" of human political organization. Assemblies of men with some influence on the king had existed in some early states in the ancient Near East, as a wise king always sought out good advisors and kept his finger on the pulse of his people in general, but Greek democracy broke unprecedented new ground with the amount of political power that it invested in its male citizen body. The Athenians established Greece's most renowned democracy, in which the individual freedom of male citizens flourished to a degree never before seen in the ancient world and rarely since. These diverging paths of political and social development in the city-state reveal the extent of the challenges that Greeks faced as they struggled to construct a new way of life during the Archaic Age, reinventing their politics to support a grow-

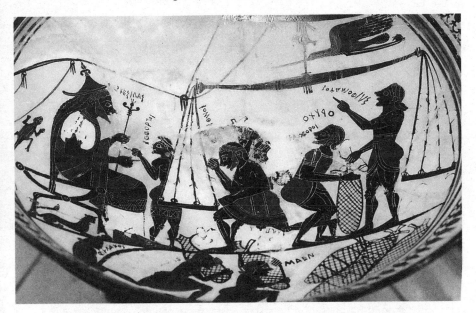

Fig. 5.1: This sixth-century B.C. Spartan vase shows Arkesilas, ruler of the Greek settlement of Cyrene in North Africa, overseeing the weighing of goods for export/import trade by sea. This sort of international commerce helped stimulate the growth of Greek city-states in the Archaic Age, especially those with good harbors to accommodate freight-carrying ships. Marie-Lan Nguyen / Wikimedia Commons.

ing population through agriculture and trade (fig. 5.1). In the course of this struggle, innovative thinkers also began to formulate new ways of understanding the physical world, their relations to it, and their relationships with each other; the novelty of their ideas in philosophy and natural science echoed the newness of the developments in politics.

EARLY SPARTA

The Spartans made oligarchy the political base for a society devoted to military readiness. The Spartan way of life became internationally famous for its discipline, which showed most prominently in the Spartan infantry, the most powerful military force in Greece during the Archaic Age. Sparta's easily defended location gave it a secure base for developing its might, as it was nestled on a narrow north–south plain between rugged mountain ranges in the southeastern Peloponnese, in a region called Laconia (hence the regional designation of Spartans as Laconians; as Spar-

tans, they could also be called Lacedaimonians, from the alternative name
Lacedaimon applied to Sparta).The city-state had access to the sea through
Gytheon, a harbor situated some twenty-five miles south of its urban cen-
ter, but this port opened onto a dangerous stretch of the Mediterranean
whipped by treacherous currents and winds. As a consequence, enemies
could not threaten the Spartans by sea, but their relative isolation from the
sea also kept the Spartans from becoming adept sailors.Their strength and
their interests remained tied to the land.

The Greeks believed the ancestors of the Spartans were Dorians who
had invaded the Peloponnese from central Greece and defeated the origi-
nal inhabitants of Laconia around 950 B.C., but, as said before, archaeol-
ogy indicates that no single "Dorian invasion" took place.The inhabitants
of Laconia in historical times spoke the Dorian dialect of Greek, but no
secure evidence exists to identify their earliest origins. At first the Spar-
tans settled in at least four small villages, two of which apparently domi-
nated the others.These early settlements later cooperated to form the core
of what would in the Archaic Age become the polis of the Spartans. The
Greeks gave the name "synoecism" ("union of households") to this pro-
cess of political unification. In a synoecism, most people continued to live
in their original villages even after one settlement began to serve as the main
urban center of the new city-state. (Synoecism could also take place by
everyone moving to a central location.) Over time, this unification turned
Sparta into the most powerful community in Laconia; the Spartans then
used this power to conquer the other Greeks in the region.We cannot de-
termine the chronology of this extension of Spartan power over Laconia
and then to Messenia to the west in the Peloponnese, but its consequences
for Spartan life were grave and enduring, as will be explained below.

One apparent result of the compromises required to forge Spartan unity
was that the Spartans retained not one but two hereditary military leaders
of high prestige, whom they called kings. These kings, who had perhaps
originally been the chiefs of the two dominant villages, served as the re-
ligious heads of Sparta and commanders of its army. The kings did not
hold unrestricted power to make decisions or set policy, however, because
they operated not as pure monarchs but rather as leaders of the oligarchic
institutions governing the Spartan city-state. Rivalry between the two royal
families periodically led to fierce disputes, and the initial custom of having
two supreme military commanders also paralyzed the Spartan army when
the kings disagreed on strategy in the middle of a military campaign. The
Spartans therefore eventually decided that only one king at a time would
command the army when the troops marched out to war.

The "few" who made policy in Sparta were a group of twenty-eight

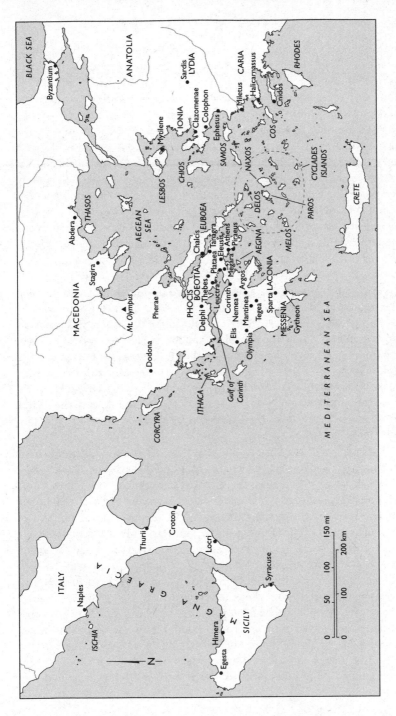

Map 4. Magna Graecia, Greece, and Anatolia

men over sixty years old, joined by the two kings. This group of thirty, called the "council of elders" (gerousia) formulated proposals that were submitted to an assembly of all free adult males. This assembly had only limited power to amend the proposals put before it; mostly it was expected to approve the council's plans. Rejections were rare because the council retained the right to withdraw a proposal when the reaction to it by the male citizens in the assembly indicated that a negative vote was likely. "If the people speak crookedly," Spartan tradition stated, "the elders and the leaders of the people shall be withdrawers [of the proposal]" (Plutarch, Lycurgus 6). The council could then bring the proposal back on another occasion after there had been time to rally support for its passage.

A board of five annually elected "overseers" (ephors) counterbalanced the influence of the kings and the gerousia. Chosen from the adult male citizens at large, the ephors convened the gerousia and the assembly; they exercised considerable judicial powers of judgment and punishment. They could even bring charges against a king and imprison him until his trial. The creation of the board of ephors diluted the political power of the oligarchic gerousia and the kings because the job of the ephors was to ensure the supremacy of law. The Athenian Xenophon later reported: "All men rise from their seats in the presence of the king, except for the ephors. The ephors on behalf of the polis and the king on his own behalf swear an oath to each other every month: the king swears that he will exercise his office according to the established laws of the polis, and the polis swears that it will preserve his kingship undisturbed if he abides by his oath" (Constitution of the Spartans 15.6–7).

The Spartans insisted that obedience to the law was the requirement for meeting their society's rigid standards of proper behavior on matters large and small. When the ephors entered office, for example, they issued an official proclamation to the men of Sparta: "Shave your mustache and obey the laws" (Plutarch, Agis and Cleomenes 9). The depth of Spartans' respect for their system of government under law was symbolized by their tradition that Apollo of Delphi had sanctioned it with an oracle called the Rhetra. A legendary Spartan leader named Lycurgus, they said, had instituted the reforms that the Rhetra institutionalized. Even in antiquity, historians had no firm information about the dates of Lycurgus's leadership or precisely how he changed Spartan laws. All we can say today is that the Spartans evolved their law-based political and social system during the period from about 800 to 600 B.C. Unlike other Greeks, the Spartans never had their laws written down. Instead, they preserved their system from generation to generation with a distinctive, highly structured way

of life based on a special economic foundation that exploited the coerced labor of others.

SPARTAN NEIGHBORS AND SLAVES

The distinctiveness of the Spartan way of life was fundamentally a reaction to their living surrounded by people whom they had conquered in war and enslaved to exploit economically but who outnumbered them greatly. To maintain their superiority over their conquered and hostile neighbors, from whom they extracted food and labor, Spartan men had to turn themselves into a society of soldiers constantly on guard. They accomplished this transformation by a radical restructuring of traditional family life enforced by strict adherence to the laws and customs governing practically all aspects of behavior. Art, literature, and entertainment became restricted to the reinforcement of communal values of loyalty to the group and obedience to the laws. Through constant daily reinforcement of their strict code of values, the Spartans ensured their survival against the enemies they had created by subjugating their fellow Greeks in the southern Peloponnese. The seventh-century B.C. poet Tyrtaeus, whose verses spill over with mythological references showing the literary refinement of the poetry produced in early Sparta before its military culture began to exclude such accomplishments, expressed that code in his ranking of courage in battle as the supreme male value: "I would never remember or mention in my work any man for his speed as a runner or his wrestling skill, not if he was as huge and strong as a Cyclops or could run faster than the North Wind, or more handsome than Tithonus or richer than Midas or Cinyras, or more kingly than Pelops, or had speech more honeyed than Adrastus, not even if he possessed every glory—not unless he had the strength of a warrior in full combat mode" (Fragment 12).

Some of the conquered inhabitants of Laconia did not become slaves and were allowed to continue to live in self-governing communities. Called literally "those who live round about" (perioikoi), which might also be translated as "neighbors," these Laconians were required to serve in the Spartan army and pay taxes; they were included under the name "Lacedaimonians." Still, they lacked citizen rights at Sparta. Perhaps because they retained their personal freedom and property, however, the perioikoi almost never rebelled against Spartan control. Far different was the fate of the large number of conquered people in the Peloponnese who had to endure enslavement as helots, a term derived from the Greek for "being captured." Later ancient commentators described the helots as "between

slave and free" (Pollux, *Onomasticon* 3.83) because they were not the personal property of individual Spartans but rather slaves belonging to the whole community, which alone could free them. Helots had a semblance of family life because they were expected to produce children to maintain the size of their population, which was compelled to labor as farmers and household slaves as a way of freeing Spartan citizens from any need to do such work. Spartan men in fact wore their hair very long to show they were warriors of high status rather than laborers, for whom long hair was an inconvenience.

When the arable land of Laconia proved too small to support the full citizen population of Sparta, the Spartans attacked their Greek neighbors in the southwestern part of the Peloponnesian peninsula, the Messenians. In the First Messenian War (c. 730–710 B.C.) and then in the Second (c. 640–630 B.C.), the Spartan army captured the territory of Messenia, which amounted to 40 percent of the Peloponnese, and reduced the Messenians to the status of helots. With the addition of those tens of thousands of people in Messenia, the total helot population now far outnumbered that of Sparta, whose male citizens at the time amounted to perhaps between eight and ten thousand. The Messenian legend of King Aristodemus dramatically portrayed the terrible sense of loss felt by the Messenians at their fate. They remembered Aristodemus as having sacrificed his beloved daughter to the gods of the underworld in an attempt to win their aid against the invading Spartans. When his campaign of guerrilla warfare at last failed, Aristodemus is said to have slain himself in despair on her grave. Deprived of their freedom and their polis, the Messenian helots were forever after on the lookout for a chance to revolt against their Spartan overlords and regain their ancient freedom.

In their private lives, helots could keep some personal possessions and practice their religion, as slaves in Greece could generally. Publicly, however, helots lived under the constant threat of officially sanctioned violence. Every year the ephors formally declared a state of war to exist between Sparta and the helots, thereby allowing any Spartan to kill a helot without any civil penalty or fear of offending the gods by unsanctioned murder. By beating the helots frequently, forcing them to get drunk in public as an object lesson to young Spartans, setting them apart visually by having them wear dog-skin caps, and generally treating them with scorn, the Spartans consistently emphasized the otherness of the helots compared to themselves. In this way, the Spartans erected a moral barrier between themselves and the helots to justify their harsh treatment of fellow Greeks. For all these reasons, the helots hated the Spartans bitterly.

Their labor made helots valuable to the Spartans. Laconian and Mes-

senian helots alike primarily farmed plots of land belonging to Spartan households, and they were tied to that land in perpetuity. Some helots also worked as household servants. By the fifth century B.C., helots would also accompany Spartan warriors on the march to war, serving as porters for the hoplites' heavy gear and armor. In major conflicts, the Spartans would even arm the helots to use them as soldiers, with the promise of possible freedom as an inducement to valor. The few helots who escaped enslavement in this way were classified as less than full citizens (*neodamodeis*) and existed in a state of social and political limbo, whose details remain obscure. Most helots, however, had no hope of freedom, and their hatred of their masters induced them to revolt whenever they saw a chance for freedom by driving the Spartans out of their land. The historian Xenophon, who knew Sparta well, recorded the feelings of rebellious helots toward the Spartans: "They said they would be glad to eat them raw" (*Hellenica* 3.3.6).

It was the labor of this hostile population, compelled to work as slave farmers to produce food for free Spartans, that allowed Spartan men to devote themselves to full-time training for hoplite warfare in order to protect their city-state from external enemies and to suppress helot rebellions, especially in Messenia. In the words of Tyrtaeus, helots worked "like donkeys exhausted under heavy loads; they lived under the painful necessity of having to give their masters half the food their plowed land bore" (Fragment 6). This compulsory rent of 50 percent of everything produced by the helots working on each free family's land was supposed to amount to seventy measures of barley each year to the male master of the household, and twelve to his wife, along with an equivalent amount of fruit and other produce. In all, this food was enough to support six or seven people. Helots were supposed to exist at a subsistence level; Spartans could be punished if they allowed helots under their control to eat enough to get fat. Contrasting the freedom of Spartan citizens from ordinary work to the awful life of the helots, the Athenian Critias commented, "In Laconia [the territory of Sparta] are the freest of the Greeks, and the most enslaved" (Libanius, *Orations* 25.63 = D.-K. 88B37; cf. Plutarch, *Lycurgus* 28).

THE SPARTAN WAY OF LIFE

The entire Spartan way of life was strictly regimented to keep the Spartan army at tip-top strength; individual choice in how to live was not an option. Boys lived at home until only their seventh year, when they were taken away to live in communal barracks with other males until they were thirty. They spent most of their time exercising, hunting, training with

weapons, and being acculturated to Spartan values by listening to tales of bravery and heroism at common meals presided over by older men. The standard of discipline was harsh, with physical and verbal punishment for failure to obey the trainers. The unrelenting pressure to perform and to obey prepared young males for the hard life of a soldier in war. For example, they were not allowed to speak at will. (Our word *laconic*, meaning "of few words," comes from the Greek name for Sparta's territory and the people who lived there.) Boys were also purposely underfed so that they would have to develop the skills of stealth by pilfering food. Yet if they were caught stealing anything, punishment and disgrace followed immediately. One famous Spartan tale taught how seriously boys were supposed to fear such failure: Having successfully stolen a fox, which he was hiding under his clothing, a Spartan youth died because he let the panicked animal rip out his insides rather than be detected in the theft. By the Classical period, older boys would be dispatched for a time to live in the wilds as members of the "Secret Service" (*Krypteia*), whose job was to murder any helots who seemed dangerous enough to murder Spartans or start a rebellion. Spartan men who could not survive the tough conditions of their childhood training fell into social disgrace and did not earn the status of "Those Who are Like One Another; Peers" (*Homoioi*, sometimes translated as "Equals"), the official name for adult males entitled to the full citizen rights of participation in politics and to the respect of the community. Only the sons of the royal family were exempted from this long and harsh education, called the *agogē* ("guidance, training"), to avoid a potential social crisis if a king's son failed to complete the course and therefore fell into disgrace. Dread of failure and the terror of public humiliation were constants in the Spartan way of life; the Spartans built a temple to Fear as a god because they believed that its power held their society together.

Each male citizen who finished the *agogē* had to win admission to a group that dined together at common meals, in a "common mess" (*sussition*), each of which had about fifteen members. Applicants were scrutinized by current members of the group, any of whom could blackball the prospective member and force him to look for another common mess to join. Once he passed scrutiny, the new member was admitted on the condition that he contribute a regular amount of barley, cheese, figs, condiments, and wine to the group's meals, taken from the produce provided by the helots working on his family plot. Some meat was apparently contributed, too, because Spartan cuisine was infamous for a black, bloody pork stew condemned as practically inedible by other Greeks. Perhaps it was made from the wild boars Spartan men loved to hunt, an activity for which messmates were formally excused from the compulsory communal

meals. If any member failed to keep up his contributions, he was expelled from the mess and lost his full citizen rights.

The experience of spending so much time in these common messes schooled Sparta's young men in the values of their society. There they learned to call all older men "Father" to emphasize that citizens' primary loyalty was to the community as a whole and not to their genetic families. In the dining groups, young men were chosen to be the special favorites of males older than themselves to build bonds of affection, including physical love, for others at whose side they would have to march into deadly battle. Sparta was one of the Greek city-states that allowed or even encouraged this kind of male homosexual bonding and love between adult and adolescent males; other places prohibited it. There was no single or uniform standard in the Greek world defining appropriate male-on-male sexual behavior, and modern terminology and normative assumptions about sexual behavior often fail to match the complicated reality and diversity of ancient Greek practice, especially in terms of gendered norms. At Sparta, for example, it was acceptable for "fine and good" older women to have same-sex unions with younger women (Plutarch, *Lycurgus* 18); other city-states rejected such relationships. In the messes, Spartan youths also learned to endure the rough joking, even mockery, characteristic of army life in their city-state. In short, a young man's common mess in many ways served both as his long-term school and also as his alternate family while he was growing up. This group of males remained his main social environment even once he had reached adulthood and married. Its function was to mold and maintain his values consistent with the demands of the one honorable occupation for Spartan men: as soldiers obedient to orders and unflinching in the face of danger. Tyrtaeus enshrined the Spartan male ideal in his poetry: "Know that it is good for the polis and the whole people when a man takes his place in the front row of warriors and stands his ground without flinching" (Fragment 12).

Spartan women were renowned throughout the Greek world for their relative freedom. Other Greeks regarded it as scandalous that Spartan girls exercised with boys and did so wearing minimal clothing. Women at Sparta were supposed to use the freedom from labor provided by the helot system to keep themselves physically fit to bear healthy children and raise them to be strict upholders of Spartan values. Their fitness was their beauty, so they wore no makeup. A metaphorical formulation of the male ideal for Spartan women appears, for example, in the late seventh century B.C. in the poetry of Alcman, who wrote songs for the performances of female and male choruses that were common on Spartan civic and religious occasions. The dazzlingly talented and attractive leader of a women's

chorus, he writes, "stands out as if, among a herd of grazing cows, some-
one placed a firmly-built horse with ringing hooves, a prize winner from
winged dreams" (Fragment 1). Although Sparta deliberately banned or-
dinary coined money to discourage the accumulation of material goods,
women, like men, could own land privately. Daughters probably inherited
portions of land and property equal to one-half of what their brothers
would get, but they received their portion earlier, at marriage rather than
only upon a parent's death. More and more land came into the hands
of women in later Spartan history because the male population declined
through losses in war, especially during the Classical Age.

With their husbands so rarely at home, Spartan women directed the
households, which included servants, daughters, and sons until they left
for their communal training. As a result, women at Sparta exercised more
power in the household than did women elsewhere in Greece. Until he
was thirty, a Spartan husband was not allowed to live with his family, and
even newly wed men were expected to pay only short visits to their brides
by sneaking into their houses at night. Spartans believed that this would
make their intercourse more energetic and therefore their babies stronger.
This tradition was only one of the Spartan customs of heterosexual be-
havior that other Greeks found bizarre. As already mentioned, if all parties
agreed, a married woman with an infertile husband could have children
by a man other than her husband, so pressing was the need to reproduce
in this strictly ordered society. Other Greeks regarded this arrangement as
immoral. Men were legally required to get married, with bachelors sub-
jected to fines and public ridicule. The freedom of Spartan women from
some of the restrictions imposed on them in other Greek city-states had
the same purpose as this law: the production of manpower for the Spartan
army. By the Classical Age, the ongoing problem had become acute of pro-
ducing enough children to prevent a precipitous decline in the size of the
Spartan citizen body. In the end, however, sex at Sparta was not a success.
When a giant earthquake in 465 B.C. and then the helot revolt that fol-
lowed killed an enormous number of Spartans, the population was never
able to return to its previous level, because the birth rate remained too low
to repair the loss to the city-state's most precious resource, its supply of
human beings. Eventually, Spartans failed to bear enough children to keep
their once supremely powerful state from shrinking to such a small popu-
lation that by the later fourth century B.C. their city-state had become in-
consequential in international affairs. This change—Sparta falling from its
position as the most powerful state in Archaic Age Greece to a bit player in
international affairs by the time of Alexander the Great—is perhaps the

clearest evidence from antiquity of the crucial importance of demography to history.

All Spartan citizens were expected to put aside their individual desires and make devotion to their city-state, including having children, their life goal. The situation was pressure filled because Sparta's survival was continually threatened by its own economic foundation, the great mass of helots. Since Sparta's well-being depended on the systematic and violent exploitation of these enslaved Greeks, its entire political and social system by necessity focused like a laser on fierce militarism and conservative values. Change meant danger at Sparta. The Spartans simultaneously institutionalized a form of equality as the basis for their male social unit, the common mess, while denying true social and political equality to ordinary male citizens by making their government a highly limited oligarchy. Other Greeks, though they did not want to live like Spartans, recognized with admiration the Spartans' high respect for their laws as a guide to life in hostile surroundings, a hostility of their own making.

THE RISE OF TYRANTS

A desire to avoid the domination of oligarchies brought the first Greek tyrants to power in various Greek states. The most famous early tyranny arose at Corinth around 657 B.C. in opposition to the rule of an oligarchy led by a family called the Bacchiads. Under Bacchiad domination in the eighth and early seventh centuries B.C., Corinth had blossomed into the most economically advanced city in Archaic Greece. The Corinthians had forged so far ahead in naval engineering, for instance, that other Greeks contracted with them to have ships built. Corinth's strong fleet helped the Bacchiads in founding overseas colonies at Corcyra off the northwest coast of Greece and at Syracuse on Sicily, city-states that would themselves become major naval powers.

Despite their role in promoting Corinth's prosperity, the Bacchiads made themselves unpopular because they ruled violently. Cypselus, a member of the social elite whose mother was a Bacchiad, built up support to seize power by becoming popular with the masses: "He became one of the most admired of Corinth's citizens because he was courageous, prudent, and helpful to the people, unlike the oligarchs in power, who were insolent and violent," according to the later historian Nicolaus of Damascus (*Excerpta de insidiis*, p. 20.6 = FGrH 90 F57.4–5). Cypselus engineered the overthrow of Bacchiad rule by rallying support among the non-elite at Corinth and securing an oracle from Delphi favoring his rebellion. After

seizing power, he ruthlessly suppressed rivals, but his popularity with the people remained so high that he could govern without the protection of a bodyguard. Corinth added to its economic strength during Cypselus's rule by exporting large quantities of fine pottery, especially to Italy and Sicily. Cypselus founded additional colonies along the sailing route to the western Mediterranean to promote Corinthian trade in those regions.

When Cypselus died in 625 B.C., his son Periander succeeded him. Periander aggressively continued Corinth's economic expansion by founding colonies on the coasts both northwest and northeast of central Greece to increase trade with the interior regions there, which were rich in timber and precious metals. He also pursued commercial contacts with Egypt for Corinth, an interest commemorated in the Egyptian name Psammetichus, which was given to Periander's nephew. The city's prosperity encouraged flourishing development in crafts, art, and architecture. Remains of the great stone temple to Apollo begun in this period can still be seen today (fig. 5.2). Unlike his father, however, Periander lost the support of Corinth's people by ruling harshly. He kept his power until his death in 585 B.C., but the persisting hostility toward his rule soon led to the overthrow of his successor, Psammetichus. The opponents of tyranny at Corinth thereupon installed a government based on a board of eight magistrates and a council of eighty men.

Greek tyranny represented a distinctive type of rule for several reasons. Although tyrants were by definition rulers who usurped power by force or the threat of force rather than by inheriting it like legitimate kings, they then established family dynasties to maintain their tyranny; they wanted their sons or nephews to inherit their position as the head of state. Also, the men who became tyrants were usually members of the social elite, or at least nearly so, who nevertheless rallied support from ordinary citizens for their coups. In places where men with no property may have lacked citizenship or at least felt substantially disenfranchised in the political life of the city-state, tyrants perhaps won adherents by extending citizenship and other privileges to these poorer parts of the population. Tyrants, moreover, sometimes preserved the existing laws and political institutions of their city-states as part of their rule, thus promoting social stability.

As at Corinth, most tyrannies needed to cultivate support among the masses of their city-states to remain in power because those were the men making up the majority of their armies. The dynasty of tyrants on the island of Samos in the eastern Aegean Sea, for example, who came to power about 540 B.C., built enormous public works to benefit their city-state and provide employment. They began construction of a temple to Hera meant to be the largest in the Greek world, and they dramatically improved the

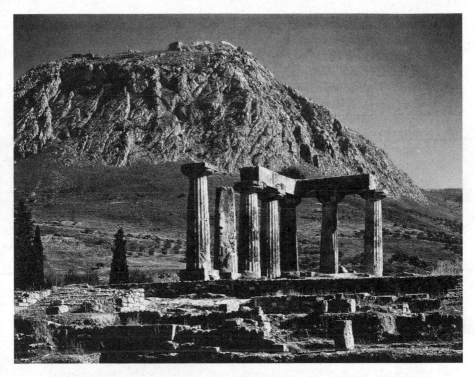

Fig. 5.2: The city-state of Corinth prospered because it had busy harbors on both sides of the isthmus connecting the Peloponnese peninsula to central Greece. The Corinthians expressed thanks to their patron god Apollo for their good fortune by building him this Doric-style temple with thirty-eight columns in the sixth century B.C. Gianni Dagli Orti / The Art Archive at Art Resource, NY.

water supply of their urban center by excavating a great tunnel connected to a distant spring, whose impressive dimensions can still be seen today. This marvel of engineering, with a channel 8 feet high, ran for nearly a mile through a 900-foot-high mountain. The later tyrannies that emerged in city-states on Sicily similarly graced their cities with beautiful temples and public buildings.

In short, the title "tyrant" in Archaic Greece did not automatically label a ruler as brutal or unwelcome, as the use of the same word in English implies. Greeks evaluated tyrants as good or bad depending on their behavior as rulers. By working in the interests of their peoples, some tyrannies maintained their popularity for decades. Other tyrants quickly experienced bitter opposition from rivals jealous of the tyrant's power, or

they themselves provoked civil war by ruling brutally and inequitably. The poet Alcaeus of the city-state of Mytilene on the island of Lesbos in the northeastern Aegean, himself an opponent of the tyrant of his homeland, described such strife around 600 B.C.: "Let's forget our anger; let's quit our heart-devouring strife and civil war, which some god has stirred up among us, ruining the people but bestowing the glory on Pittacus, our tyrant, for which he prays" (Fragment 70). Since the rulers of tyrannies in Greek city-states exercised great power, and since great power can corrupt even the best of intentions, over time this kind of negative judgment about the quality of the justice imposed by tyrants became common. In this way, tyrants increasingly became seen as "tyrannical" in the modern sense.

THE POLITICAL DEVELOPMENT OF ATHENS

It was a traditional Greek practice to explain significant historical changes, such as the founding of communities or the codification of laws, as the work of an individual "inventor" from the distant past. Just like the Spartans, who remembered the legendary Lycurgus as the founder of their city-state, the Athenians also believed their polis owed its start to a single man. Athenian legends made Theseus responsible for founding the polis of Athens by the synoecism of villages in Attica, the name given to the peninsula at the southeastern corner of the mainland of Greece, which formed the territory of the Athenian polis. Since Attica had several good ports along its coast, the Athenians were much more oriented to seafaring and communication with other peoples than were the almost landlocked Spartans.

Myth described Theseus as a traveling adventurer, whose most spectacular feat was volunteering to sail as a hostage to the island of Crete so that he could defeat the Minotaur, a cannibalistic monster with the body of a man and the head of a bull, to whom young Athenian men and women were fed as expiation of the city-state's killing of the son of King Minos. Like Theseus's other legendary adventures, this exploit became a favorite subject matter for artists. Theseus's "labors," as they are called in imitation of the deeds performed by the most famous Greek hero, Heracles (Hercules to the Romans), were mainly successful fights against monsters and criminals threatening civilized life. They therefore elevated him to the status of a culture hero laboring to promote the social and moral institutions of the city-state. Heracles, by contrast, the hero of Dorian Greeks, was renowned for overcoming monsters and criminals as a demonstration of his supreme physical strength and ability. The legend of Theseus made him a particularly appropriate choice as the founder of a city like Athens

that prided itself on its claim to have taught the most important aspects of civilized life, agriculture and the initiation ceremonies of Demeter, to the rest of the Greek world. The choice of Theseus as the legendary founder of the city-state thus expressed an Athenian feeling of superiority through its claim of having successfully conducted a "civilizing mission" for the early Greek world.

Unlike most other important sites inhabited in the Mycenaean period, Athens had apparently not suffered any catastrophic destruction at the end of the Bronze Age, although it seems unlikely that the settlement entirely escaped the violent disruptions so widespread at that time. In any case, the population of Attica shrank in the early Dark Age, just like the populations of the rest of Greece. By around 850 B.C., however, archaeological evidence, such as the model of grain storage containers from a woman's burial mentioned in chapter 3, implies that the Athenian agricultural economy was reviving. When the population of Attica apparently expanded at a phenomenal rate during the century from about 800 to 700, the free peasants constituted the fastest-growing segment of the population as economic conditions improved in the early Archaic Age. These small agricultural producers apparently began to insist on having a say in making decisions in Athenian policies because they felt that justice demanded at least a limited form of political equality for themselves as citizens. Some of these modest landowners became wealthy enough to afford hoplite armor, and these men, like similarly prosperous men elsewhere, probably made strong demands on the elite, who had up to this time ruled Athens as what amounted to a relatively broad oligarchy. Rivalries among the oligarchs for status and material wealth prevented them from presenting a united front, and they had to respond to these pressures to insure the participation of the hoplites in the citizen militia, on which depended Athenian military strength. The poor were also enfranchised as citizens in early Athens, but we are in no better position in this case than in that of the rest of Greece to explain the precise mechanism powering this significant development. It seems very likely that poorer citizens earned their right to participate politically on the grounds of their service as light-armed troops in the city-state's militia.

Was Athens already on the road toward democracy at this early stage in its political development as a city-state? Scholars disagree strongly on this question, but the evidence, admittedly scarce and obscure as it is, seems to me to indicate that by the late seventh century B.C., Athens's male citizens—rich, hoplite level, and poor together—had established the first form of government in Greece (and therefore in the world) about which we have enough information rightly to call a democracy, or at least the

first major step toward a democracy that admittedly reached its full form only after a long period of change and strife between richer and poorer citizens. It was also admittedly a limited and incomplete form of democratic government. Finally, it was not Greece's only democracy; other Greek city-states (about which we have much less information) also created democracies.

Still, the city-state of Athens as it developed after the Dark Age broke new ground in the organization of politics and society. It remains a difficult problem to understand why, on this interpretation, Athenians moved toward democracy instead of, for example, toward a narrow oligarchy like that of Sparta. Two factors perhaps encouraging the emergence of the Athenian polis as an incipient democracy were rapid population growth and a rough sense of egalitarianism among male citizens surviving from the frontierlike conditions of the early Dark Age, when most people had shared the same meager existence. These same factors, however, do not necessarily differentiate Athens from other city-states that did not evolve into democracies, because the same conditions generally pertained across the Greek world in the late Dark Age and early Archaic Age. Perhaps population growth was so rapid among Athenian peasants that they had greater opportunity than at other places to demand a share in governing. Their power and political cohesion were evident, for example, in about 632 B.C., when they rallied "from the fields in a body" to foil the attempted coup of an Athenian nobleman named Cylon (Thucydides, *The Peloponnesian War* 1.126.7). A former champion in the Olympics and married to a daughter of Theagenes, tyrant of Megara, Cylon and some of his friends had planned to use force to install a tyranny.

The scanty evidence seems to indicate that by the seventh century B.C. all freeborn adult male citizens of Athens had the right to attend open meetings, in a body called the assembly (*ecclesia*, "a gathering of those who have been called out"), which elected nine magistrates called archons ("rulers") each year. The archons headed the government and rendered verdicts in disputes and criminal accusations. As earlier, the social elite still dominated Athenian political life and exploited their status to secure election for themselves as archons, perhaps by organizing their bands of followers as voters and by making alliances with others of their socioeconomic level. The right of poorer men to serve as members of the assembly as yet had only limited significance because little business besides the election of archons was conducted in its gatherings, which in this period probably took place only rarely, when the current archons decided the time was right.

Political alliances among members of the elite often proved temporary,

however, and rivalries among men jealous of each other's status could become violent. In the aftermath of Cylon's attempted tyranny, an Athenian named Draco was appointed in 621 B.C., perhaps after pressure by the hoplites, to establish a code of laws promoting stability and equity. He infamously made death the penalty for most crimes. The Athenians later remembered his laws as having been as harsh as the meaning of his name (*drakōn*, the Greek word for "dragon, snake"). Athenians, like other Greeks, maintained the death penalty for murder and other serious crimes such as treason, but, for reasons that we cannot recover, Draco's reforms only increased the tension and instability of the political situation at Athens. Deterioration in the economic situation of Athens's peasants, which had been slowly building for a long time, further undermined social peace; hungry farmers were willing to do desperate things to try to feed their families. Later Athenians did not know what had caused this economic crisis that looked likely to flare up into a bloody rebellion, only that it had pitted the rich against the peasants and the poor.

One cause of the trouble may have been that the precariousness of agriculture in this period led to the gradual accumulation of the available farmland in the hands of fewer and fewer people. In subsistence agriculture, the level at which many Athenian farmers operated, a lean year could mean starvation. Moreover, farmers lacked any easy method to convert the surplus of a good year into imperishable capital, such as coined money, which then could be stored up to offset bad years in the future, because coinage was not yet in common use; Athens had yet to mint any currency. Failed farmers had to borrow food and seed from the rich to survive. When they could borrow no more, they had to leave their land to find a job to support their families, most likely by laboring for successful farmers. Under these conditions, farmers who became more effective, or simply more fortunate, than others could acquire the use and even the ownership of the land of failed farmers. Whatever the reasons may have been, many poor Athenians had apparently lost control of their land to wealthier proprietors by around 600 B.C. The crisis became so desperate that impoverished peasants became slaves when they could not pay their debts; economic failure had brought politics to the breaking point.

THE REFORMS OF SOLON

Within twenty-five years after Draco's legislation, the conditions of life had become so awful for many poorer Athenians that a civil war threatened to break out. In desperation, the Athenians in 594 B.C. gave Solon special authority to revise the laws on his own to deal with the crisis.

Putting this power in the hands of one man was an extraordinary decision for a city-state whose government was now based on the principle that policies and laws were to be determined by shared decisions made in the assembly. As Solon explains in his autobiographical poetry, he tried to steer a middle course between the demands of the rich to preserve their financial advantages, and the call of the poor for a redistribution of land to themselves from fields that would be seized from the holdings of the large landowners. His famous "shaking off of obligations," as the Athenians called it, somehow (we do not know the details) freed those farms whose ownership had become formally encumbered by debt but did not, however, actually redistribute any land. Solon also prohibited the selling of Athenians into slavery for debt and secured the liberation of citizens who had become slaves in this way, commemorating his success in the verses he wrote about his reforms: "To Athens, their home established by the gods, I brought back many who had been sold into slavery, some justly, some not. . . ." (Fragment 36).

Attempting to balance political power between rich and poor, Solon also instituted a reform that ranked male citizens into four levels according to their income: "five-hundred-measure men" (*pentakosiomedimnoi*, those with an annual income equivalent to that much agricultural produce); "horsemen" (*hippeis*, income of three hundred measures), "yoked men" (*zeugitai*, two hundred measures); and "laborers" (*thetes*, less than two hundred measures). The higher a man's income level, the higher the governmental office for which he was eligible, with *thetes* barred from all posts. Solon did reaffirm the right of this large group of poor men to participate in the assembly, however. Crucially important was Solon's creation of a council (*boulē*) of four hundred men to prepare an agenda for the discussions in the assembly (some scholars date this innovation after Solon's time). Council members were chosen by lottery, probably only from the top three income levels. Still, this innovation mattered because it meant that the elite could not dominate the council's deliberations by setting the agenda ahead of time in ways that privileged matters supporting their own interests to the detriment of the needs of poorer citizens. Solon also probably initiated a schedule of regular meetings for the assembly. All these reforms gave added impact to the assembly's legislative role in the city-state and thus indirectly laid a foundation for the political influence that the *thetes* would gradually acquire at Athens over the next century and a half.

Despite the restriction on officeholding by the lowest income class that he imposed, Solon's classification scheme supported further development of conditions leading to democracy because it allowed for upward social mobility, and the absence of direct taxes on income made it easier for

entrepreneurial citizens to better their lot. If a man managed to increase his income, he could move up the scale of eligibility for office. One man who did so had an inscription erected in the center of Athens along with a statue of a horse to commemorate his elevation from the fourth to the second income level: "Anthemion son of Diphilus set up this dedication to the gods when he exchanged his ranking in the laborer class for one in the horsemen class" (Aristotle, *Constitution of the Athenians* 7). Solon's reforms empowered Athenian male citizens to create, over time, a political and social system far more open to individual initiative and change than that of Sparta.

Equally important to restoring social stability and peace in a time of near–civil war were Solon's judicial reforms. He instituted as a legal right that any male citizen could bring charges on a wide variety of offenses against wrongdoers on behalf of any victim of a crime. Perhaps most importantly, he specified a right of appeal to the assembly by persons who believed a magistrate had rendered unjust legal decisions or verdicts against them. With these two measures, Solon made the administration of justice the concern of all citizens, and not just of the upper-income-level men who filled the official positions of government. He balanced these judicial reforms that favored ordinary people, however, by also granting broader powers to the "Council which meets on the Hill of the god of war, Ares," (Demosthenes *Orations* 20.157); this council is usually just called "The Areopagus" ("Ares' hill"). Archons became members of the Areopagus after their year in office. This body of ex-archons could, if the members chose, exercise great power because at this period it judged the most serious judicial cases, in particular accusations against archons themselves. Solon probably also expected the Areopagus to use its power to protect his reforms.

For its place and time, Athens's political system was remarkable, even at this early stage in its development toward greater democracy, because it granted all male citizens the possibility of participating meaningfully in the making of laws and the administration of justice. But not everyone found the system admirable. A visiting foreign king in the time of Solon reportedly remarked scornfully that he found Athenian democratic government ludicrous. Observing the procedure in the Athenian assembly, he expressed his amazement that leading politicians could only recommend policy in their speeches, while the male citizens as a whole voted on what to do: "I find it astonishing that here wise men speak on public affairs, while fools decide them" (Plutarch, *Solon* 5). Some Athenians who agreed with the king that the wealthy should count as wise and the poor as foolish continued to scheme to undermine Solon's reforms, and such oligar-

chic sympathizers continued to challenge Athenian democracy at intervals throughout its history.

FROM TYRANNY TO DEMOCRATIC REORGANIZATION

Solon also made reforms that he hoped would improve economic life, such as prohibiting exports of agricultural products except for olive oil and requiring fathers to train their sons in ways to make a living. Despite his best efforts, however, fierce conflict flared up again at Athens following his reforms, lasting for decades into the mid-sixth century B.C. The conflict sprang from rivalries for office and status among the members of the elite and the continuing discontent of the poorest Athenians. The outcome of this protracted unrest was a tyranny, when a prominent Athenian named Pisistratus began a long and violent effort to make himself sole ruler with the help of wealthy friends and also the poor, whose interests he championed. On his third try in 546 B.C., he finally established himself as tyrant at Athens, protected by a bodyguard. Pisistratus courted poor supporters by providing funds to help peasants acquire needed farm equipment and by offering employment for poorer men on public-works projects, such as road improvements, a huge temple to Zeus, and fountains to increase the supply of drinking water in the city. The tax that he imposed on agricultural production, one of the rare instances of direct taxation in Athenian history, financed the loans to farmers and the construction projects. He also arranged for judicial officials to travel on circuits through the outlying villages of Attica to hear cases, thereby saving farmers the trouble of having to leave their fields to seek justice in the city courts. He left in place Solon's laws and the by-now-traditional institutions of government. Like the earlier tyrants of Corinth, he promoted the economic, cultural, and architectural development of Athens. Athenian pottery, for example, now increasingly crowded out Corinthian wares in the international export trade.

Hippias, the eldest son of Pisistratus, inherited the position of tyrant of Athens after his father's death in 527 B.C. He governed by making certain that his relatives and friends occupied magistracies, but for a time he also allowed rivals from the social elite to serve as archons, thereby defusing some of the tension created by their jealousy of his superior status. Eventually, however, the wealthy family of the Alcmaeonids arranged to have the Spartans send an army to expel Hippias. This startling decision reflected the Spartans' view of themselves that, as Greece's most powerful city-state, they had the duty of protecting the freedom of other Greeks (at least those who were not helots). In the ensuing vacuum of power, the

leading Alcmaeonid, a man named Cleisthenes, sought support among the masses by promising dramatic democratic reforms when his bitterest rival, Isagoras, from another elite family, became archon in 508 B.C. Isagoras tried to block Cleisthenes' reforms by calling on the Spartans to make another military intervention at Athens, this time as his supporters. They responded, evidently having decided that Isagoras was the man to ensure Athens's freedom, given that they regarded democracy not as true liberty but rather as unbridled license propelled by the whim of the masses. In response to this second invasion, the majority of the Athenians united to force Isagoras and his foreign allies out. This remarkable demonstration of resistance by the bulk of the Athenian population put a quick end to the conflict between Athens and Sparta, but the repulse of the proud Spartans by, as they saw it, the Athenian rabble sowed seeds of mutual distrust between the two city-states, which would bear bitter fruit in the wars with one another that broke out two generations later in the mid-fifth century B.C.

The ordinary people's willingness to put their bodies on the battle line to support Cleisthenes' plans for Athenian government gave him the authority to begin to install the even more strongly democratic system for which Athens became famous. The enduring importance of his reforms led later Athenians to think of him as a principal founder of the democracy of the Classical Age. First, he made the preexisting villages of the countryside and the neighborhoods of the city of Athens (both called "demes," dēmoi) the constituent units of Athenian political organization. Organized according to deme, male citizens participated directly in the running of their government. To begin with, they kept track in deme registers of which males were citizens and therefore eligible beginning at the age of eighteen to attend the assembly to vote on laws and public policies. Each deme was also assigned according to its location to one of thirty different intermediate groupings called "thirds" (trittyes), which were drawn up to represent three territorial areas of Attica (ten thirds each for coast, plain, and city, respectively). Finally, ten administrative divisions called "tribes" (phylai) were created by assigning one third from each of the three regional categories to each tribe; these were not kinship groups, despite that implication of the term tribe.

This complex system of dividing up the voting population, which replaced an earlier division into four tribes, thus created ten groups whose members did not all necessarily live near one another. Cleisthenes' rearrangement of the political map of Athenian government meant that local notables no longer could easily control election results just by exercising influence on the poorer people in their immediate area. This effect may have been especially directed at the political power of his oligarchic en-

emies. In any case, the system of ten tribes, each made up of demes from all over Attica, provided an administrative basis for spreading service in Athenian government widely throughout the male citizen body. Especially significant was his reform by which fifty representatives were chosen by lottery from each tribe to serve for one year on a new Council of Five Hundred (replacing Solon's Council of Four Hundred). The number of representatives from each deme was proportional to its population. Most importantly, the ten men who served each year as "generals" (stratēgoi), the officials with the highest civil and military authority in the city-state, were elected one from each tribe. The citizen militia was also organized by tribes. Cleisthenes' reorganization was administratively complicated, but its overall goal was to promote less conflict among citizens in the sharing of political power. His full motives for the changes are not easy to discern, but his undermining of existing political alliances among the elite had the undeniable effect of promoting the interests of greater democracy and political stability.

By about 500 B.C., then, Cleisthenes had succeeded in devising a system of government based on direct participation by as many adult male citizens as possible. That he could put such a system in place successfully in a time of turmoil and have it endure and over time become even more democratic, as it did, means that he must have been building on preexisting conditions favorable to direct rather than representative democracy. Certainly, as a member of the social elite looking for popular support, Cleisthenes had good reason to invent the kind of system he thought ordinary people wanted. That he based his system on the demes, the great majority of which were country villages, suggests that some conditions favoring democracy may have stemmed from the traditions of village life. Possibly, the concept of widespread participation in government gained support from the custom that village residents often have of dealing with each other on relatively egalitarian terms. Each man is entitled to his say in running local affairs and must persuade others of the wisdom of his recommendations rather than resorting to compulsion. In the daily affairs of life in a small community, especially the organization and accomplishment of religious festivals and sacrifices, villagers of all statuses, from the poorest peasant to the richest landowner, must for practical reasons deal with each other through negotiation and compromise more often than not, at least if they want to accomplish anything for the group.

Furthermore, since many wealthy Athenian landowners in this period increasingly seem to have preferred to reside primarily in the city (even if they maintained a house in the country as well), they could no longer dominate discussions and affairs in the rural demes as they had when they

lived outside the urban center. In any case, the idea that persuasion, rather than force or status, should constitute the mechanism for political decision making in the emerging Athenian democracy fit well with the spirit of the intellectual changes that were taking place during the late Archaic Age. That is, the idea that people had to present plausible and persuasive reasons for their recommendations corresponded to one of the period's new ways of thought. This development has proved to be one of the most influential legacies of Greek civilization.

NEW LITERATURE AND NEW THINKING

Poetry represented the only form of Greek literature until the late Archaic Age. The earliest Greek poetry, that of Homer and Hesiod, had been confined to a single rhythm. A much greater rhythmic diversity characterized the new form of poetry, called lyric, that emerged during the Archaic Age. Lyric poems were far shorter than the narrative epics of Homer or the didactic poetry of Hesiod, and they encompassed many forms and subjects, but they were always performed with musical accompaniment, especially the lyre (a kind of harp that gives its name to the poetry) and a reed instrument called the *aulos*. Choral poets, such as Alcman of Sparta, wrote songs to be performed by groups on public occasions to honor the gods, to celebrate famous events in a city-state's history, to praise victors in athletic contests and wars, and to accompany wedding processions (fig 5.3). Lyric poets writing songs for solo performance on social occasions stressed a personal level of expression on a variety of topics.

The most personal of those topics was the passion of love, and the most famous poet on this topic was Sappho. Born about 630 B.C. on the island of Lesbos, she was already renowned for her poems by the time she was thirty years old. She was forced into exile in faraway Sicily, perhaps because she and her family had opposed the tyrant of her home city-state of Mytilene. Her poems are passionate in describing the psychological effects of love but reticent about physical love, as in this artful lyric about her feelings for another woman:

> Equal to the gods appears that one,
> the man sitting close by you now,
> who hears the sound of your sweet voice
> from so close by
> and drinks in your charming laugh. That sight,
> I swear, sets my heart racing;
> the briefest glance at you renders me

speechless!
My tongue loses its moorings, a delicate
flame burns all over under my skin,
My eyes no longer see, they are blinded, my ears
ring, pulsate,
a cold sweat overcomes me, fear
grips my heart. Paler
than grass in a meadow, I feel myself
nearly dead.
—(Sappho, Fragment 31)

Archilochus of Paros, whose lifetime probably fell in the early seventh century B.C., became famous for his range of poems on themes as diverse as friends lost at sea, mockery of wartime valor, and love gone astray. The bitter power of his poetic invective reportedly caused a father and his two daughters to commit suicide when Archilochus ridiculed them in anger after the father had put an end to Archilochus's affair with his daughter Neobule. Some modern literary critics think the poems about Neobule and her family are fictional rather than autobiographical and were meant only to display Archilochus's dazzling talent for "blame poetry," the mirror image of lyric as the poetry of praise. Mimnermus of Colophon, another seventh-century B.C. lyric poet, rhapsodized about the glory of youth and lamented its brevity, "no longer than the time the sun shines on the plain" (Fragment 2).

Lyric poets also wrote poems focused on contemporary events and politics; Solon and Alcaeus were particularly known for poems on such topics. Simonides, his nephew Bacchylides, and Pindar in the sixth and fifth centuries B.C. continued this emphasis, commemorating heroic achievements in war as well as victories in the international sports festivals of Greece, which attracted rich competitors who were ready to reward poets who were expert at crafting elegant poems of praise for them. Sometimes lyric poets self-consciously adopted a critical attitude toward traditional values, such as strength in war. Sappho, for instance, once wrote, "Some would say the most beautiful thing on our dark earth is an army of cavalry, others of infantry, others of ships, but I say it's whatever a person loves" (Fragment 16). The focus on the individual's feelings chosen by lyric poets such as Sappho represented a new stage in Greek literary sensibilities, one that continues to inspire poets to this day.

Greece's earliest prose literature also belongs to the late Archaic Age. Thinkers usually referred to today as philosophers, but who could equally well be described as theoretical scientists studying the physical world, cre-

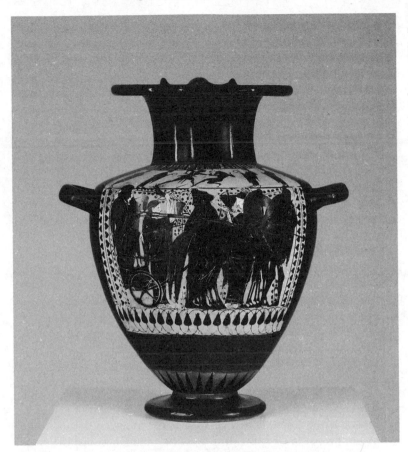

Fig. 5.3: This vase, painted in the "black-figure" style of the Archaic Age, shows the procession at the center of an ancient Greek wedding. Marriage was a private arrangement between families in which the bride moved from her house to the groom's. The smaller picture on the rim shows the hero Theseus killing the Minotaur. The Walters Art Museum, Baltimore.

ated prose in Greek to express their new ways of thought; some of them, however, also composed poetry to convey their ideas. These thinkers, who mostly came from the city-states of Ionia, were developing radically new explanations of the world of human beings and its relation to the world of the gods. In this way began the study of philosophy in Greece. Ionia's geographical location next to the non-Greek civilizations of Anatolia, which were in contact with the older civilizations of Egypt and the Near

East, meant that Ionian thinkers were in a position to acquire knowledge and intellectual inspiration from their neighbors in the eastern Mediterranean area. Since Greece in this period had no formal schools at any level, thinkers like those from Ionia had to make their ideas known by teaching pupils privately and giving public lectures, as well as composing works in prose and poetry and reciting from them to interested groups. People who studied with these thinkers or heard their presentations would then help to spread knowledge of the new ideas.

Knowledge from the ancient Near East influenced the Ionian thinkers, just as it had influenced Greek artists of the Archaic Age. Greek vase painters and specialists in decorating metal vessels imitated Near Eastern designs depicting animals and luxuriant plants; Greek sculptors produced narrative reliefs like those of Assyria, as well as statues with the formal, frontal poses familiar from Egyptian precedents; Egypt also gave inspiration to Greek architects to employ stone for columns, ornamental details, and eventually entire buildings. In a similar process of the transfer of knowledge from East to West, information about the regular movements of the stars and planets developed by astronomers in Babylonia proved especially important in helping Ionian thinkers reach their conclusions about the nature of the physical world. The first of the Ionian theorists, Thales (c. 625–545 B.C.), from the city-state of Miletus, was said to have predicted a solar eclipse in 585, an accomplishment implying he had been influenced by Babylonian learning. Modern astronomers doubt that Thales actually could have predicted an eclipse, but the story shows how influential Eastern scientific and mathematical knowledge was to the thinkers of Ionia. Working from knowledge such as the observed fact that celestial bodies moved in a regular pattern, scientific thinkers like Thales and Anaximander (c. 610–540 B.C.), also from Miletus, drew the revolutionary conclusion that the physical world was regulated by a set of laws of nature rather than by the arbitrary intervention of divine beings. Pythagoras, who emigrated from Samos to south Italy about 530, taught that the entire world was explicable through numbers. His doctrines inspired systematic study of mathematics and the numerical aspects of musical harmony, as well as devotion to the idea of transmigration of the human soul as a form of immortality.

These thinkers were proposing a dramatic new way of understanding reality: They were arguing that human beings could investigate and explain the ways in which the universe works because the phenomena of nature were neither random nor arbitrary. This insistence that natural laws governed how reality operated was a crucially significant development for later philosophical and scientific thought. The universe, the totality of

things, they named cosmos because this word meant an orderly arrangement that is beautiful (hence our word cosmetic). The order postulated as characteristic of the cosmos was perceived as lovely because it was not random. The universe's regularity encompassed not only the motions of the heavenly bodies but also everything else: the weather, the growth of plants and animals, human health and psychology, and so on. Since the universe was ordered, it was intelligible; since it was intelligible, human beings could achieve explanations of events by thought and research. The thinkers who conceived this view believed it necessary to give reasons for their conclusions and to be able to persuade others by arguments based on evidence. In other words, they believed in logic (a word derived from the Greek term logos, meaning, among other things, a "reasoned explanation"). This way of thought based on reason represented a crucial first step toward philosophy and science as these disciplines endure today. The rule-based view of the causes of events and physical phenomena developed by these thinkers contrasted sharply with the traditional mythological view of causation. Naturally, many people had difficulty accepting such a startling change in their understanding of the world, and the older tradition of explaining events as the work of gods lived on alongside the new ideas.

The ideas of the Ionian thinkers probably spread slowly because no means of mass communication existed, and few men could afford to spend the time to become followers of these thinkers and then return home to explain these new ways of thought to others. Magic remained an important preoccupation in the lives of the majority of ordinary people, who retained their notions that demons and spirits, as well as gods and goddesses, frequently and directly affected their fortunes and health as well as the events of nature. Despite the Ionian thinkers' relatively limited immediate effect on the ancient world at large, they initiated a tremendously important development in intellectual history: the separation of scientific thinking from myth and religion. Demonstrating the independence of mind that characterized this new direction in thinking, Xenophanes of Colophon (c. 580–480 B.C.) severely criticized traditional ideas about the gods that made them seem like nothing more than deeply flawed human beings who just happened to be immortal. For example, he decried the portrayal of gods in the poetry of Homer and Hesiod because those deities were shown to be prey to human moral failures, such as theft, adultery, and fraud. Xenophanes also rejected the common view that gods resemble human beings in their appearance: "There is one god, greatest among gods and men, who bears no similarity to humans either in shape or in thought. . . . But humans believe that the gods are born like themselves, and that the gods wear clothes and have bodies like humans and speak

in the same way. . . . But if cows and horses or lions had hands or could draw with their hands and manufacture the things humans can make, then horses would draw the forms of gods like horses, cows like cows, and they would make the gods' bodies resemble those which each kind of animal had itself" (Clement, *Miscellanies* 5.109.1–3 = D.-K. 21B23, 14, 15).

Some modern scholars call these changes in Greek thinking the birth of rationalism, but it would be unfair to label myths and religious ways of thought as "irrational" if that term is taken to mean "unthinking" or "silly." Ancient people realized that their lives were constantly subject to forces beyond their control and understanding, and it was not unreasonable to attribute supernatural origins to the powers of nature or the ravages of disease. The new scientific ways of thought insisted, however, that observable evidence had to be presented and that theories of explanation had to be logical. Just being old or popular no longer automatically bestowed the status of truth on a story that claimed to explain natural phenomena. In this way, the Ionian thinkers parted company with the traditional ways of thinking of the ancient Near East as found in its rich mythology and repeated in the myths of early Greece.

Developing the view that people must give reasons to explain what they believe to be true and persuade others of the validity of their conclusions, rather than simply make assertions that they expect others to believe without evidence, was the most important achievement of the early Ionian thinkers. This insistence on rationality, coupled with the belief that the world could be understood as something other than the plaything of a largely hidden and incomprehensible divine will, gave human beings who accepted this view the hope that they could improve their lives through their own efforts. As Xenophanes put it, "The gods have not revealed all things from the beginning to mortals, but, by seeking, human beings discover, in time, what is better" (Stobaeus, *Anthology* 1.8.2 = D.-K. 21B18). Xenophanes, like other Ionian thinkers, believed in the existence of gods, but he nevertheless assigned the opportunity and the responsibility for improving human life squarely to human beings on their own. Human beings themselves had the job of discovering what is better and how to make it happen.

From Persian Wars to Athenian Empire

An Athenian blunder in international diplomacy set in motion the greatest military threat that the ancient Greeks had ever faced and put the freedom of Greece at desperate risk from invasions by enormous forces of the Persian Empire. In 507 B.C. the Athenians were afraid that the Spartans would again try to intervene to support the oligarchic faction that was resisting the new democratic reforms of Cleisthenes. Looking for help against Greece's number-one power, the Athenians sent ambassadors to ask for a protective alliance with the king of Persia, Darius I (ruled 522–486 B.C.). The Persian Empire was by far the largest, richest, and most militarily powerful state in the entire ancient world. At Sardis, the Persian headquarters in western Anatolia, the Athenian emissaries met with a representative of the king, his local governor in the region (a satrap, in Persian terminology). When the satrap heard their plea for an alliance to help protect them against the Spartans, he replied, "But who in the world are you and where do you live?" (Herodotus, *The Histories* 5.73). From the Persian perspective, the Athenians were so insignificant that this major Persian imperial administrator had never heard of them. Yet within two generations Athens would be in control of what today we call the Athenian Empire. The transformation of Athens from insignificance to international power was startlingly unexpected: It came about over a generation-long period of desperate war that marked the beginning of the Classical Age (500–323 B.C.).

The dynamics of this incident between Athens and Persia expose the forces motivating the conflicts that would dominate the military and political history of mainland Greece throughout the fifth century B.C. First, the two major powers in mainland Greece—Sparta and Athens—remained suspicious of each other. As described in the previous chapter, the Spartans had sent an army to Athens to intervene against Cleisthenes and his democratic reforms in the last decade of the sixth century B.C.; on their mission in defense of freedom (as they would have justified it), they had forced seven hundred Athenian families into exile. But then they had experienced the humiliation of seeing the men of Athens band together to expel their forces, doing public damage to the Spartans' reputation for invincibility on the battlefield. From then on, the Spartans saw Athens as a hostile state, a feeling naturally reciprocated at Athens. Second, the kingdom of Persia had expanded westward all the way to Anatolia and had become the master of Greek city-states along its coast, installing tyrants as puppet rulers of the conquered Greeks there. With Persians now controlling the eastern end of the Aegean Sea, the Greeks of the mainland had good reason to worry about Persian intentions concerning their own territories. Since neither the Persians nor the mainland Greeks yet knew much about each other, their mutual ignorance opened the door to explosive misunderstandings.

CONFLICT BETWEEN UNEQUALS

The Athenian ambassadors dispatched to Sardis naively assumed that Athens was going to become more or less an equal partner with the Persian king in a defensive alliance because Greeks were accustomed to making treaties on those sorts of terms. When the satrap demanded that, to conclude the agreement, Athens's representatives must offer tokens of earth and water, the Athenians in their ignorance of the Persians at first did not understand the significance of these symbolic gestures. From the Persian perspective, they indicated an official recognition of the superiority of the king. Since Persian royal ideology maintained that the king was preeminent above everyone else in the world, he did not make alliances on equal terms with anyone. When the Athenian emissaries realized what the gestures meant, they reluctantly went ahead with this public admission of their state's inferiority because they were unwilling to return to their countrymen without an agreement in hand. Once they had returned home, however, they discovered that the citizens in the Athenian assembly were outraged at their envoys' symbolic submission to a foreign power. Despite this angry reaction, the assembly never sent another embassy to the satrap in Sardis to announce that Athens was unilaterally dissolving the

507 B.C.: Athenians send ambassadors to ask for an alliance with Persia.

500–323 B.C.: The Greek Classical Age.

499 B.C.: Beginning of the Ionian revolt.

494 B.C.: Final crushing of the Ionian revolt by the Persians.

490 B.C.: Darius sends Persian force to punish Athenians, who win the battle of Marathon.

483 B.C.: Discovery of large deposits of silver in Attica; Athenians begin to build large navy at instigation of Themistocles.

482 B.C.: Ostracism of Aristides (recalled in 480 B.C.).

480 B.C.: Xerxes leads massive Persian invasion of Greece; Persian victory at the battle of Thermopylae and Greek victory at the battle of Salamis.

479 B.C.: Battle of Plataea in Greece and battle of Mycale in Anatolia.

478 B.C.: Spartans send Pausanias to lead Greek alliance against Persians.

477 B.C.: Athens assumes leadership of the Greek alliance (Delian League).

475 B.C.: Cimon returns the bones of the hero Theseus to Athens.

465 B.C.: Devastating earthquake in Laconia leads to helot revolt in Messenia.

465–463 B.C.: Attempt of the island of Thasos to revolt from the Delian League.

462 B.C.: Cimon leads Athenian troops to help Spartans, who reject them.

461 B.C.: Ephialtes' reforms to increase the direct democracy of Athenian government.

450s B.C.: Hostilities between Athens and Sparta; institution of stipends paid to jurors and other magistrates at Athens.

454 B.C.: Enormous losses of Delian League forces against Persians in Egypt; transfer of league's treasury from island of Delos to Athens.

451 B.C.: Passage of Pericles' law on citizenship.

450 B.C.: End of overseas expeditions by Delian League forces against Persian Empire.

447 B.C.: Athenian building program begins.

446–445 B.C.: Athens and Sparta make a peace treaty meant to last thirty years.

443 B.C.: Pericles' main political opponent ostracized.

441–439 B.C.: Island of Samos attempts to revolt from Delian League.

430s B.C.: Increasing political tension at Athens as Sparta threatens war.

pact with the king. Darius therefore had no indication that the relationship had changed; as far as he knew, the Athenians remained voluntarily allied to him as inferiors and still owed him the deference and loyalty that he expected all mere mortals everywhere to pay to his royal status. The Athenians, on the other hand, continued to think of themselves as independent and unencumbered by any obligation to the Persian king.

This fiasco in diplomacy propelled a sequence of explosive events culminating in destructive invasions of mainland Greece by the enormous army and navy of the Persian Empire. That vast kingdom outstripped mainland Greece in every category of material resources, from precious metals to soldiers. The Greeks by this point could field citizen-militia forces of heavily armed and lightly armed infantry, archers and javelin throwers, cavalry, and warships, and the frequent conflicts between city-states had trained them in effective tactics (fig. 6.1). At the same time, the disparity in numbers between the Persian Empire and the Greeks meant that war between them pitted the equivalent of an elephant against a small swarm of mosquitoes. In such a mismatched conflict of unequals, a Greek victory seemed improbable, even impossible. Equally improbable, given the independent Greek city-states' propensity toward disunity and even mutual hostility, was that a coalition of thirty-one Greek city-states—a small minority of the Greeks—would band together to resist the enormous forces of the enemy and stay united despite their fear and disagreements over the years of struggle against a monstrously stronger enemy.

The Persian Empire was a relatively recent creation. The ancestral homeland of the Persians lay in southern Iran, and their language stemmed from the Indo-European family of tongues; the language of today's Iran is a descendant of ancient Persian. Cyrus (ruled 560–530 B.C.) became the founder of the empire by overthrowing the monarchy of the Medes. The Median kingdom, centered in what is today northern Iran, had emerged in the late eighth century B.C., and the army of the Medes had joined that of the Babylonians in destroying the Assyrian kingdom in 612 B.C. The Median kingdom had then extended its power as far as the border of Lydia in central Anatolia. By taking over Lydia in 546, Cyrus also acquired dominion over the Greek city-states on the western coast of Anatolia that the Lydian king Croesus (ruled c. 560–546 B.C.) had previously subdued.

By the reign of Darius I, the Persian kingdom covered thousands of miles in every direction, stretching from west to east from Egypt and Turkey through Mesopotamia and Iran to Afghanistan and the western border of India, and from north to south from the southern borders of central Asia to the Indian Ocean. Numbering in the tens of millions, its diverse population spoke countless different languages. The empire took its ad-

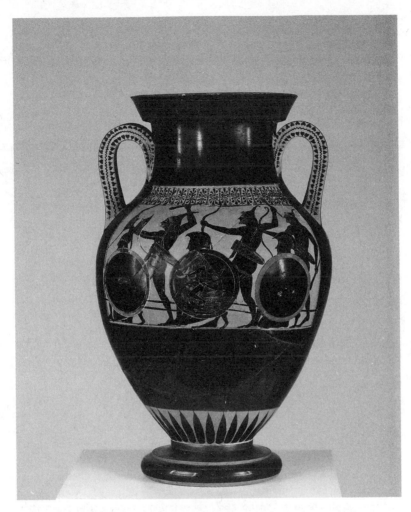

Fig. 6.1: This "black-figure" vase depicts a battle line in which the heavily armed infantrymen in metal helmets crouch behind their shields while unarmored archers shoot arrows at the enemy. This combined-arms form of attack meant that men who could not afford expensive metal body armor could still contribute to their city-state's defense by learning to use less costly missile weapons. The Walters Art Museum, Baltimore.

ministrative structure from Assyrian precedents, and its satraps ruled enormous territories with little direct attention from the king as to how they treated his subjects. The satraps' duties were to keep order, enroll troops when needed, and send revenues to the royal treasury. The imperial system exacted taxes in food, precious metals, and other valuable commodities from the various regions of the empire; the soldiers that it assembled from far and wide came with an enormous variety of different equipment, training, and languages of command, making the generalship of the army a daunting challenge in devising tactical cooperation and communications among troops with little or no experience working together.

The revenues extracted from its many subject peoples made the Persian monarchy wealthy beyond comparison. Everything about the king was meant to emphasize his grandeur and superiority to everyone else in the world: His purple robes were more splendid than anyone's; the red carpets spread for him to walk upon could not be stepped on by anyone else; his servants held their hands before their mouths in his presence to muffle their breath so that he would not have to breathe the same air as they did; in the sculpture adorning his palace, he was depicted as larger than any other human being. To display his concern for his loyal subjects, as well as the gargantuan scale of his resources, the king provided meals for some fifteen thousand nobles, courtiers, and other followers every day, although he himself ate behind a curtain hidden from the view of his guests. The Greeks, in awe of the Persian monarch's power and lavishness, simply referred to him as "the Great King."

The Persian kings did not regard themselves as gods but rather as the agents of the supreme god of Persian religion, Ahura Mazda. Persian religion, based on the teachings of the prophet Zoroaster, was dualistic, conceptualizing the world as the arena for a constant battle between good and evil. Unlike other peoples of the ancient Near East and the Greeks, the Persians shunned animal sacrifice. Fire, kindled on special altars, formed an important part of their religious rituals. The religion of ancient Persia survives in the modern world as Zoroastrianism, whose adherents have preserved the central role of fire in its practice. Despite their autocratic rule, the ancient Persian kings usually did not interfere with the religious worship or everyday customs of their subjects; they realized that this sort of interference with people's traditional beliefs and practices could only lead to instability, the dread of imperial rulers.

THE OUTBREAK OF WAR

The most famous series of wars in ancient Greek history—the so-called Persian Wars, which took place in the 490s and in 480–479 B.C.—broke

out with a revolt against Persian control by the Greek city-states of Ionia (the region and the islands on the western coast of Anatolia). As alluded to earlier, the Ionian Greeks had originally lost their independence not to the Persians but to King Croesus of Lydia in the mid-sixth century B.C. As colorfully described by Herodotus in the first book of his *Histories*, Croesus had been buoyed by this success and his legendary great wealth; the saying "rich as Croesus" still gets used to this day. He next tried to conquer territory in Anatolia that had previously been in the Median kingdom. Before initiating the attack, however, Croesus had requested advice from Apollo's oracle at Delphi about the advisability of invading a region that the new Persian monarchy was also claiming. The oracle gave the famous response that if Croesus attacked the Persians, he would destroy a great kingdom. Encouraged, Croesus sent his army eastward in 546, but he was defeated and lost his territory, including Ionia, to Cyrus, the Persian king. When Cyrus later allowed Croesus to complain to the Delphic oracle that its advice had been disastrously wrong, the oracle pointedly replied that if Croesus had been truly wise, he would have asked a second question: Whose kingdom was he going to destroy, his enemy's or his own? Croesus shamefacedly had to admit that the oracle was right.

By 499 B.C., the city-states in Ionia had begun a revolt against the Greek tyrants that the Persian kings, after conquering the area, had installed as collaborators to maintain control over their conquests there. An Ionian leader traveled to mainland Greece seeking military aid for the rebellion. The Spartan king Cleomenes ruled out any chance of help from his city-state after he saw the map that the Ionian had brought and learned that an attack on the heartland of Persia (today in modern Iran) would require a march of three months inland from the Ionian coast. He, like the other Spartans and most Greeks in general, had previously had no accurate idea of the geography and dimensions of the Near East. The men of the Athenian assembly, in contrast to the Spartan leaders, voted to join the city-state of Eretria on the neighboring island of Euboea in sending troops to fight alongside the Ionians in their revolt. The Athenian militiamen proceeded as far as Sardis, Croesus's old capital and current Persian headquarters for Ionia. Their attack ended with the city in flames, including a famous religious sanctuary. However, the Athenians and Eretrians soon returned home when a Persian counterattack made the Ionian allies lose their coordination and effectiveness as a fighting force. Subsequent campaigns by the Persian king's commanders crushed the Ionian revolt entirely by 494. King Darius then sent his general Mardonius to reorganize Ionia, where he now surprised the locals by installing democratic governments to replace the unpopular tyrannies. Since the Persian king was only interested in

loyalty from his subjects, he was willing to learn from his mistakes and let the Ionians be governed locally as they pleased if they would then remain loyal and stop rebelling against overall Persian control.

King Darius flew into a rage when he was informed that the Athenians had aided the Ionian revolt: It was bad enough that they had dared attack his kingdom, but they had done it after having indicated their submission and loyalty to him by offering the tokens of earth and water to his satrap. Insignificant though the Greeks were in his eyes, he vowed to avenge their disloyalty as a matter of justice, to set things right in the world that by nature he was supposed to rule. The Greeks later claimed that, to keep himself from forgetting his vow of punishment in the press of his many other concerns as the ruler of a huge kingdom, Darius ordered one of his slaves to say to him three times at every meal, "Lord, remember the Athenians" (Herodotus, The Histories 5.105). In 490 B.C. Darius dispatched a flotilla of ships carrying troops to punish the Athenians and the Eretrians. His men burned Eretria and then landed on the nearby northeastern coast of Attica near a village called Marathon. The Persians had brought with them the elderly Hippias, the exiled son of the Athenian tyrant Pisistratus, expecting to reinstall him as ruler of Athens as their puppet. Since the Persian soldiers vastly outnumbered the citizen-militia of Athens, the Athenians asked the Spartans and other Greek city-states for military help. The Athenian courier dispatched to Sparta became famous because he ran the 140 miles from Athens to Sparta in less than two days. But by the time the battle of Marathon took place, the only troops to arrive were a contingent from the small city-state of Plataea in Boeotia, the region just north of Athenian territory. The Plataeans felt that they owed the Athenians a debt of gratitude for having protected them from their hostile neighbors the Thebans thirty years earlier, and they had the great courage to try to pay that debt even when the price of their moral integrity looked likely to be destruction at the hands of the Persians.

Everyone expected the Persians to win. The Greek soldiers, who had never seen Persians in battle array before, grew afraid just gazing at their (to Greek eyes) frighteningly outlandish outfits, which included pants; Greek men wore only tunics, going barelegged. Moreover, the number of Persian troops at the battle of Marathon was huge compared to the size of the combined Athenian and Plataean contingents. The Athenian commanders—a board of ten generals elected each year as the civil and military leaders of Athens plus one other military official—felt enormous pressure to act, because they feared that the disparity in forces might induce the assembly to surrender rather than fight, or that the oligarchic

sympathizers among the Athenian elite might try to strike a treacherous deal with the Persian king, whose recent arrangements to install local democracies in Ionia demonstrated that he was always ready to come to terms with anyone who could guarantee peaceful subjects. The Athenians and Plataeans therefore prepared for an attack on the wider line of the Persians by thinning out the center of their own line of soldiers while putting more men on the wings. Carefully planning their tactics to minimize the time their soldiers would be exposed to the fire of Persian archers, the generals, led by Miltiades of Athens (c. 550–489 B.C.), sent their hoplites against the Persian line at a dead run. Mastering the natural urge to panic and run away as they approached the killing zone, the Greek hoplites clanked across the Marathon plain in their metal armor under a hail of arrows. Once engaged in hand-to-hand combat with the Persians, the Greek infantrymen overcame their opponents thanks to their longer weapons and superior armor. In a furious struggle, the strengthened wings of the Greek army slaughtered the Persians opposite them and then turned inward to crush the Persian center from the flanks. They then drove the Persians back into a swamp, where any invaders unable to escape to their ships could be picked off one by one.

The Athenian army then hurried on foot the more than twenty miles from the battlefield at Marathon to the fortification wall of Athens to guard the city against a naval attack by the Persian fleet. Today's long footraces called marathons commemorate in their name and distance this famous trek by Greek soldiers in 490 B.C. When the Persians sailed home without taking Athens, the Athenians (at least those who favored democracy) rejoiced in disbelief. The Persians, whom they had feared like no others, had withdrawn. For decades afterward, the greatest honor an Athenian man could claim was to say he had been a "Marathon fighter."

The symbolic importance of the battle of Marathon far outweighed its military significance. The defeat of his punitive expedition enraged Darius because it insulted his prestige, not because it represented any threat to the security of his kingdom. The ordinary Athenian citizens who made up the city-state's army, on the other hand, had dramatically demonstrated their commitment to preserving their freedom by refusing to capitulate to an enemy whose reputation for power and wealth had made a disastrous Athenian defeat appear certain. The unexpected victory at Marathon gave an unparalleled boost to Athenian self-confidence, and the city-state's soldiers and leaders thereafter always boasted that they had stood resolute before the feared barbarians even though the Spartans had not come in time to help them. They also forever after celebrated the Plataeans as noble allies.

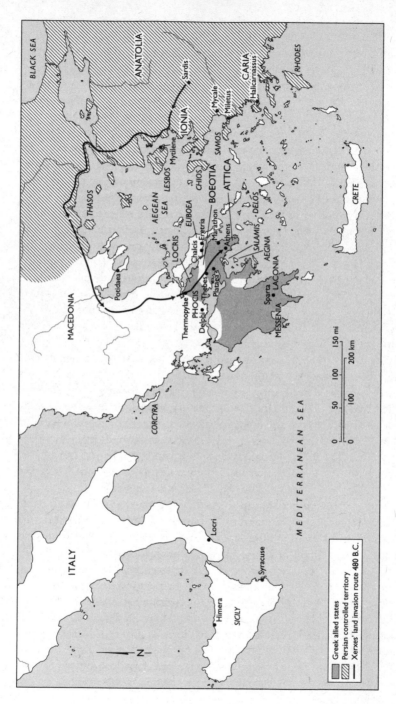

Map 5. The Persian Wars

Greek allied states
Persian controlled territory
Xerxes' land invasion route 480 B.C.

FULL-SCALE PERSIAN INVASION

This newly won confidence helped steel the population of Athens to join in the resistance to the gigantic Persian invasion of Greece that arrived in 480 B.C. Darius had vowed the invasion as revenge for the defeat at Marathon, but it took so long to assemble forces from all over the far-flung Persian kingdom that he died before his retaliatory strike could be launched. His son, Xerxes I (ruled 486–465), therefore led the massive invasion force of infantry and ships against the Greek mainland. So huge was Xerxes' army, the Greeks later claimed, that it required seven days and seven nights of continuous marching on a temporary bridge lashed together from boats and pontoons to cross the Hellespont, the narrow passage of sea between Anatolia and mainland Greece. Xerxes expected the Greek states simply to surrender without a fight once they realized the size of his forces. The city-states in northern and central Greece did just that because their location placed them directly in the line of the invading Persian forces, while the small size of their populations left them without any hope of effective defense. The important Boeotian city-state of Thebes, about forty miles north of Athens, also supported the Persian invasion, probably hoping to gain an advantage over its Athenian neighbors in the aftermath of the expected Persian victory; Thebes and Athens had of course long been hostile to one another over whether Plataea should be free of Theban dominance.

Thirty-one Greek states, most of them located in central and southern Greece, formed a military coalition to fight the Persian invasion; they chose Sparta as their leader because it fielded Greece's most formidable hoplite army. The coalition also sought aid from Gelon, the tyrant of Syracuse, the most powerful Greek city-state on Sicily. The appeal failed, however, when Gelon demanded command of the Greek forces in return for his assistance, a price the Spartan and Athenian leaders were unwilling to meet. In this same period Gelon was engaged in a struggle with Carthage, a powerful Phoenician city on the coast of North Africa, over territory in Sicily. In 480 B.C. Gelon's forces defeated a massive Carthaginian expedition in battle at Himera, on the island's northern coast. It is possible that the Carthaginian expedition to Sicily and the Persian invasion of mainland Greece were purposely coordinated to embroil the Greek world simultaneously in a two-front war in the west and the east.

The Spartans showed their courage this same year when three hundred of their men led by Leonidas, along with a number of other Greeks, held off Xerxes' huge army for several days at the narrow pass called Thermopylae ("warm gates") on the eastern coast of central Greece. Xerxes was

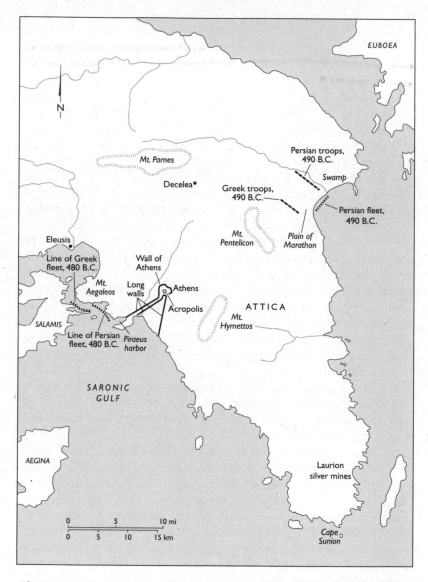

Plan 1. Attica Showing Battle of Marathon (490 B.C.) and Battle of Salamis (480 B.C.)

flabbergasted that this paltry force did not immediately retreat when confronted with his magnificent army. The Spartan troops characteristically refused to be intimidated. When one of Xerxes' scouts was sent ahead to observe the situation at the pass, he reported that the Spartans were standing casually in front of their fortification, leisurely combing their long hair. The Persians were astonished at this behavior, but it was in fact customary for Spartan soldiers to fix their flowing locks as a mark of pride before proceeding into battle. Their defiant attitude was summed up by the reputed response of a Spartan hoplite to the remark that the Persian archers were so numerous that their arrows darkened the sky in battle. "That's good news," said the Spartan; "we'll get to fight in the shade" (Herodotus, *The Histories* 7.226). The pass was so narrow that the Persians could not employ their superior numbers to overwhelm the Greek defenders, who were more skilled at close-in fighting. Only when a local Greek, hoping for a reward from the Persian king, revealed to him a secret route around the choke point was the invading army able to massacre the Greek defenders by attacking them from the front and the rear simultaneously. The Persian army then continued its march southward into Greece; the "Three Hundred" had failed to stop the Persians, but they had demonstrated that they would die before surrendering.

The Athenians soon proved their resolve and courage, too. Rather than surrender when Xerxes arrived in Attica with his army, they abandoned their city. Women, children, and noncombatants packed up their belongings as best they could and evacuated to the northeast coast of the Peloponnese. Xerxes then sacked and burned Athens as punishment for their defiance. The destruction of Athens frightened the Peloponnesian Greeks in the alliance, and their desire to retreat southward with the fleet to defend their peninsula threatened to destroy the unity of the resistance. The Greek warships at this point were anchored off the west coast of Athenian territory, where the Athenian commander Themistocles (c. 528–462) realized they could use to their advantage the topography of the narrow channel of water between the coast and the island of Salamis, close offshore. As in the infantry battle at the pass at Thermopylae, the confined space of the channel would prevent the vastly larger Persian navy from attacking with all its ships at once and overwhelming the Greeks with their smaller number of warships. He therefore compelled his disheartened colleagues in the alliance to do battle with the Persian fleet in the battle of Salamis in 480 B.C. by sending a message to the Persian king to block both ends of the channel to prevent the Peloponnesians from sailing away.

Athens supplied the largest contingent to the Greek navy at Salamis because the assembly had been financing the construction of warships ever

since a rich strike of silver had been made in Attica in 483. The proceeds
from the silver mines went to the state, and, at the urging of Themistocles,
the assembly had voted to use the financial windfall to build a navy for
defense, rather than to disburse the money to all the citizens. The warship
of the time was an expensive vessel called a trireme, a name derived from
its having three stacked banks of oarsmen on each side for propulsion in
battle. Built for speed, these specialized weapons were so cramped and
unstable that they had to be pulled up on shore every night; there was
no room for anyone to sleep or eat on board. One hundred and seventy
rowers were needed to propel a trireme, which fought by smashing into
enemy ships with a metal-clad ram attached to the bow. Most of the row-
ers could not see out and never knew from moment to moment if they
were about to be skewered by an enemy attack, and anxiety was so raw
that men could lose control of their bowels onto the heads of their col-
leagues below as they rowed into battle, facing the prospect of an enemy
ram smashing through their ship's side to crush them to death at any mo-
ment. Triremes also usually carried a complement of ten hoplite warriors
and four archers on their decks to engage the enemy crews in combat
when the ships became entangled. Officers and other crew brought the
total of men on board to two hundred.

The tight space of the Salamis channel not only prevented the Persians
from using all their warships at once but also minimized the advantage of
their ships' greater maneuverability. The heavier Greek ships could employ
their underwater rams to sink the less-sturdy Persian craft, whose rams did
not have as much mass behind them. When Xerxes observed that the most
energetic of his naval commanders appeared to be the one woman among
them, Artemisia, the ruler of Caria (today the southwest corner of Turkey),
he reportedly remarked, "My men have become women, and my women,
men" (Herodotus, *The Histories* 8.88).

The Greek victory at Salamis in 480 induced Xerxes to return to Persia;
it was now clear that a quick victory over the Greeks was not going to hap-
pen, especially at sea, where the Greek fleet had proved it was better than
his. It was not wise for the Great King to be away too long from the court
and its potential rivals for his throne if he wished to keep a firm grip on his
power. So Xerxes went home, but he left behind an enormous land army
under his best general, Mardonius, as well as a startling (to the Greeks)
strategic move: Early in 479 he extended an offer to the Athenians to make
peace with them (and only them). If they came to terms, he would leave
them in freedom (meaning no tyrant ruling as a Persian stooge), pay to
rebuild the Athenian sanctuaries that his troops had burned, and give the
Athenians another land to rule in addition to their own. The Greeks should

not have been surprised; after all, the Persian king had reversed his policy in Ionia after having crushed the rebels, replacing the puppet tyrants there with democracies to ensure more peaceful conditions in his dealings with the Ionian city-states. Xerxes made this offer because he recognized that, with the Athenian fleet on his side, the rest of the Greeks would have no chance except to submit to Persian control.

Xerxes' offer was genuine, and it was seductive; as the king's ally, the Athenians could have reconstructed their wrecked city with his endless supply of money and enjoyed his support in dominating their rivals and enemies in Greece. The Spartans were frantic with fear when they heard about the offer; they realized how tempting it was. They probably acknowledged, to themselves in secret, that they would have taken it if it had been made to them. Astonishingly, however, the Athenian assembly refused to take the Persian deal. They told the Spartans that there was no pile of gold large enough and no territory beautiful enough to bribe them to collaborate with the Persians to bring "slavery" to their fellow Greeks. No, they said, we insist on fighting for retribution from our enemies who burned the images and houses of our gods. Our Greekness, they continued, pledges us to reject this temptation: "We all share the same ancestry and language, we have sanctuaries and sacrifices to the gods that we share, and we share a common way of life" (Herodotus, *The Histories* 8.144). This definition of Greek identity meant so much to them, then, that they were willing to risk complete destruction—the massive Persian land army remained close by—rather than abandon their sense of who they were and what their place in the world was. Their refusal to compromise their ideals deserves recognition as a decisive moment in ancient Greek history.

Mardonius then marched the Persian army into Attica—and sent the offer again. When Lycidas, a member of the Athenian Council of Five Hundred, recommended that it be accepted, his fellow council members and the men gathered around to listen to the debate stoned him to death. When the women in the city heard about what Lycidas had proposed, they banded together to attack his home and stone his wife and children. Emotions were raw because everyone knew how high the stakes were. The people of Athens then evacuated their city and land for the second time, and, with the offer rejected again, Mardonius then laid waste to everything left standing in the urban center and the countryside of Athens.

Meanwhile, the Spartans had built a wall across the isthmus that connected the Peloponnese peninsula to central Greece, planning to hunker down there to block the Persians from advancing into their territory; they were ready to abandon the rest of the Greeks beyond the isthmus. They decided to leave their wall behind and march north to face the enemy

only after being bluntly reminded by the Athenians that Athens could still accept the Persian king's offer even at this point and add their intact fleet to his to become the rulers of Greece. Reluctantly, the Spartans sent their infantry, commanded by a royal son named Pausanias (c. 520–470 B.C.), to join the other Greeks still in the alliance to face the much larger Persian land army on the plains of Boeotia north of Athens; Mardonius had chosen to take up a position near Plataea because the terrain was favorable to the disposition of his forces. There, the Greeks and the Persians met in the final great land battle of the Persian Wars in 479. The sight of so many Persians in battle array at first dismayed the majority of the Spartan infantry, and to avoid meeting these frightening troops directly, the Spartan commanders asked to switch positions in the line with the Athenians so that they could face the Persians' allies instead. The Athenians agreed. In the end, however, one stubborn band of Spartan warriors refused to leave their place despite the imminent danger to their lives from Persian attacks, inspiring their wavering comrades to stand and fight the numerically superior and visually intimidating enemy. When Mardonius, the Persian commander, was killed, his army lost heart, and the Greeks won a tremendous victory at the battle of Plataea. In an amazing coincidence, on the same day (so the Greeks later remembered it) the Greek fleet stationed off the coast of southwestern Anatolia at a place called Mycale caught the Persian fleet unprepared for battle. The Greeks courageously disembarked their crews to attack the disorganized Persians on shore. The surprise succeeded, and the Persians were routed at the battle of Mycale.

The battles of Plataea and Mycale in 479 proved the tipping points in expelling the invasion forces of the Persian Empire from Greece. The Persian army and navy could have recovered from the losses of men and materiel; their empire was too large and too rich to be seriously disabled by these setbacks for very long. The loss of morale seems to have been the key. The Greeks, despite the fears and disagreements that nearly overcame them at critical moments, had summoned the dedication and determination not to give in; they broke the spirit of the enemy, the secret to winning wars in the hand-to-hand conditions of the killing zones of ancient warfare.

The coalition of thirty-one Greek city-states had stunned their world: Despite the huge difficulties they constantly created for themselves in cooperating with one another, in the end they fought together to protect their homeland and their independence from the strongest power in the world. The Greek fighters' superior weapons and armor and their commanders' insightful use of topography to counterbalance their enemy's greater numbers help to explain their victories on the military level. What

is truly memorable about the Persian Wars, however, is the decision of the citizen militias of the thirty-one Greek city-states to fight in the first place—and their determination never to quit in the face of doubts and temptations. They could easily have surrendered and agreed to become Persian subjects to save themselves. Instead, these Greek warriors chose to strive together against apparently overwhelming odds. Their bravery found support in the encouragement to fight, even the demand not to give up, offered by noncombatants in their communities, such as the women of Corinth, who as a group offered public prayers to the goddess Aphrodite for the Greek cause. Since the Greek forces included not only the wealthiest men and hoplites but also thousands of poorer men, who fought as light-armed troops and rowed the warships, the effort against the Persians cut across social and economic divisions. The Greek decision to fight the Persian Wars demonstrated courage inspired by a deep devotion to the ideal of political freedom, which had emerged in the preceding Archaic Age. The Athenians, who twice allowed the Persians to ravage and burn their homes and property rather than make a deal with the Persian king, showed a determination that filled their enemies—and everyone else—with awe.

THE ESTABLISHMENT OF THE ATHENIAN EMPIRE

The struggle against the Persian invasion had generated a rare interval of interstate cooperation in ancient Greek history. The two most powerful city-states, Athens and Sparta, had, with difficulty, put aside their mutual suspicions stemming from their clash at the time of the reforms of Cleisthenes to share the leadership of the united Greek military forces. Their attempt to continue this cooperation after the repulse of the Persians, however, ended in failure, despite the lobbying of pro-Spartan Athenians who believed that the two city-states should be partners rather than rivals. Out of this failure arose the so-called Athenian Empire, a modern label invented to indicate the military and financial dominance Athens eventually came to exercise over numerous other Greek states in an alliance that had originated as a voluntary coalition against Persia.

Following its victories in 479 B.C., the members of the Greek coalition decided to continue as a naval alliance aimed at expelling the Persian outposts that still existed in far northern Greece and western Anatolia, especially Ionia. The Spartan Pausanias, the victor of the battle of Plataea, was chosen to lead the first expedition in 478. He was soon accused of arrogant and violent behavior toward both his allies and local Greek citizens in Anatolia, especially women. Some modern scholars believe that he

was framed by his personal and political enemies; whatever the truth, contemporaries evidently found it easy to believe that such outrageous conduct was a threat from Spartans in positions of power, now that they were spending long periods away from home on distant military campaigns. What does seem true is that Spartan men's long years of harshly regimented training often left them poorly prepared to operate humanely and effectively once they had been freed from the constraints imposed by their way of life at home, where they were always under the scrutiny of the entire Spartan community. In short, there seems to have been a real danger that Spartan men would put aside their respect for their society's traditional restraint and self-control once they left behind the borders of their city-state and were operating on their own.

By 477, the Athenian leader Aristides (c. 525–465 B.C.) had successfully persuaded the other Greeks in the alliance to demand Athenian leadership of the continuing fight against the Persians in the Aegean region. The leaders at Sparta decided to give up their position at the head of the alliance without protest because, in the words of the Athenian historian Thucydides (c. 460–400 B.C.), "They were afraid any other commanders they sent abroad would be corrupted, as Pausanias had been, and they were glad to be relieved of the burden of fighting the Persians. . . . Besides, at the time they still thought of the Athenians as friendly allies" (The Peloponnesian War 1.95). The Spartans' ongoing need to keep their army at home most of the time to guard against helot revolts also made it risky for them to keep up prolonged operations outside the Peloponnese.

The Greek alliance against Persia now took on a permanent organizational structure under Athenian leadership. Member states swore a solemn oath never to desert the coalition. The members were predominantly located in northern Greece, on the islands of the Aegean Sea, and along the western coast of Anatolia—the areas most exposed to Persian attack. Most of the independent city-states of the Peloponnese, on the other hand, remained in their long-standing alliance with the Spartans, an arrangement that had been in existence since well before the Persian Wars. Thus, Athens and Sparta each now dominated a separate coalition of allies. Sparta and its allies, whose coalition modern historians refer to as the Peloponnesian League, had an assembly to set policy, but no action could be taken unless the Spartan leaders agreed to it. The alliance headed by Athens also had an assembly of representatives to make policy. Members of this alliance were in theory supposed to make decisions in common, but in practice Athens was in charge because it furnished the greatest number of warships in the alliance's navy. The special arrangements made to finance the Athenian-led alliance's naval operations promoted Athenian domination. Aristides set

the different levels of dues (today called "tribute") that the various member states were to pay each year, based on their size and prosperity. The alliance's funds were kept on the Aegean island of Delos, in the temple of Apollo, to whom the whole island was sacred, and consequently the alliance is today customarily referred to as the Delian League.

Over time, more and more of the members of the Delian League paid their dues in cash rather than by going to the trouble of furnishing warships. Most members of the alliance preferred this option because it strained their capacities to maintain the construction infrastructure required to build ships as specialized and expensive as triremes, and it was exhausting to train crews to the high level of teamwork required to work triple banks of oars as they drove the ships forward, back, and obliquely in complicated tactical formations. Athens, far larger than most of the allies, had the shipyards and skilled workers to build triremes in large numbers, as well as a large population of men eager to endure tough training so that they could earn pay as rowers. Therefore, Athens built and manned most of the alliance's warships, using the dues of allies to supplement its own contribution. The Athenian men serving as rowers on these warships came from the poorest social class, that of the laborers (thetes), and their invaluable contribution to the navy earned them not only money but also additional political importance in Athenian democracy, as naval strength increasingly became the city-state's principal source of military power. Athens continued to be able to muster larger numbers of hoplite infantry than many smaller city-states, but over time its fleet became its most powerful force.

Since most allies eventually had only limited naval strength or no warships of their own at all, many individual members of the Delian League had no effective recourse if they disagreed with decisions made for the league as a whole under Athenian leadership. By dispatching the superior Athenian fleet to compel discontented allies to adhere to league policy and to continue paying their annual dues, the men of the Athenian assembly came to exercise the dominant power. The modern reference to allied dues as tribute is meant to indicate the compulsory nature of these payments. As Thucydides observed, rebellious allies "lost their independence," making the Athenians as the league's leaders "no longer as popular as they used to be" (The Peloponnesian War 1.98–99).

The most egregious instance of Athenian compulsion of a reluctant ally was the case of the city-state of the island of Thasos in the northern Aegean Sea. Thasos in 465 B.C. unilaterally withdrew from the Delian League after a dispute with Athens over control of gold mines on the neighboring mainland. To force the Thasians to keep their sworn agreement to stay in

the league forever, the Athenians led allied forces against them in a protracted siege, which ended in 463 with the island's surrender. As punishment, the league forced Thasos to pull down its defensive walls, give up its warships, and pay enormous tribute and fines.

The Delian League did accomplish its principal strategic goal: Within twenty years after the battle of Salamis in 480, league forces had expelled almost all the Persian garrisons that had continued to hold out in city-states along the northeastern Aegean coast and had driven the Persian fleet from the Aegean Sea, ending the direct Persian military threat to Greece for the next fifty years. Athens meanwhile grew stronger from its share of the spoils captured from Persian outposts and the dues paid by its members. By the middle of the fifth century B.C., league members' annual payments totaled the equivalent of perhaps $300 million in contemporary terms (assuming $120 as the average daily pay of an ordinary worker today).

The male citizens meeting in the assembly decided how to spend the city-state's income, and for a state the size of Athens (around thirty to forty thousand adult male citizens) the annual income from the alliance combined with other revenues from the silver mines at Laurion and taxes on international commerce meant general prosperity. Rich and poor alike had a self-interested stake in keeping the fleet active and the allies paying for it. Privately wealthy leaders such as Cimon (c. 510–450 B.C.), the son of Miltiades, the victor of Marathon, enhanced their prestige by commanding successful league campaigns and then spending their share of the spoils on benefactions to the people of Athens. Cimon, for example, reportedly paid for the foundations of the massive defensive walls that eventually connected the city's urban core with its harbor at Piraeus several miles away. Such financial contributions to the common good were expected of wealthy and prominent men. Political parties did not exist in ancient Athens, and political leaders formed informal circles of friends and followers to support their ambitions. Disputes among these ambitious leaders often stemmed more from competition for election to the highest public offices of the city-state and influence in the assembly than from disagreements over political or financial policy. Arguments tended to concern how Athens should exercise its growing power internationally, not whether it should refrain from interfering with the affairs of the other members of the Delian League in the pursuit of Athenian interests. The numerous Athenian men of lesser means who rowed the Delian League's ships came to depend on the income they earned on league expeditions. Since these men represented the numerically largest group in the male population eligible to vote in the assembly of Athens, where decisions were rendered

by majority vote, they could make certain that assembly votes were in their interest. If the interests of the allies did not coincide with theirs, the allies were given no choice but to acquiesce to official Athenian opinion concerning league policy. In this way, alliance was transformed into empire, despite Athenian support of democratic governments in some allied city-states previously ruled by oligarchies. From the Athenian point of view, this transformation was justified because it kept the alliance strong enough to continue to carry out the overall mission of the Delian League: protecting Greece from the Persians.

THE DEMOCRATIC REFORM OF THE ATHENIAN SYSTEM OF JUSTICE

Poorer men of the *thete* class powered the Athenian fleet, and as a result of their essential role in national defense, both their military and their political importance grew in the decades following the Persian War. As these poorer citizens came to recognize that they provided the foundation of Athenian security and prosperity, they apparently felt the time had come to make the administration of justice at Athens just as democratic as the process of making policy and passing laws in the assembly, which was open to all male citizens over eighteen years old. Although at this time the assembly could serve as a court of appeals, most judicial verdicts were rendered by the nine annual magistrates of the city-state—the archons—and the Areopagus council of ex-archons. The nine archons had been chosen by lottery rather than by election since 487 B.C., thus making access to those offices a matter of random chance and not liable to domination by wealthy men from Solon's highest income level, who could afford expensive electoral campaigns. Filling public offices by lottery was felt to be democratic because it gave an equal chance to all eligible contestants; the gods were thought to oversee this process of random selection to make sure the choices were good ones. But even democratically selected magistrates were susceptible to corruption, as were the members of the Areopagus. A different judicial system was needed if those men who decided cases were to be insulated from pressure by socially prominent people and from bribery by those rich enough to buy a favorable verdict. That laws were enacted democratically at Athens meant little if they were not applied fairly and honestly.

The final impetus to a reform of the judicial system came from a crisis in foreign affairs. The change had its roots in a tremendous earthquake near Sparta in 465 B.C. The tremors of the earth killed so many Spartans that the helots of Messenia, the Greeks in the western Peloponnese who had long ago been subjugated by the Spartans, instigated a massive re-

volt against their weakened masters; as previously mentioned, the Spartan citizen population never recovered from the losses. By 462 the revolt had become so serious that the Spartans appealed to Athens for military help, despite the chill that had fallen over relations between the two city-states since the days of their cooperation against the Persians. The tension between the former allies had arisen because rebellious members of the Delian League had received at least promises of support from the leaders at Sparta, who felt that Athens was growing powerful enough to someday threaten Spartan interests in the Peloponnese. Cimon, the hero of the Delian League's campaigns, marshaled all his prestige to persuade a reluctant Athenian assembly to send hoplites to help the Spartans defend themselves against the Messenian helots. Cimon, like many among the Athenian elite, had always been an admirer of the Spartans, and he was well known for signaling his opposition to proposals in the assembly by saying, "But that is not what the Spartans would do" (Plutarch, Cimon 16). His Spartan friends let him down, however, by soon changing their minds and sending him and his army in disgrace back to Athens. Spartan leaders feared that the democratically inclined Athenian rank and file might decide to help the helots escape from Spartan domination, even over Cimon's opposition.

The humiliating Spartan rejection of their help outraged the Athenian assembly and provoked openly hostile relations between the two states. The disgrace it brought to Cimon carried over to the elite in general, thereby establishing a political climate ripe for further democratic reforms. A man named Ephialtes promptly seized the moment in 461 B.C. and convinced the assembly to pass measures limiting the power of the Areopagus. The details are obscure, but it appears that up to this time the Areopagus council had held authority to judge accusations of misconduct brought against magistrates, a competence referred to as "guardianship of the laws." The Areopagus was constituted by ex-magistrates, who would presumably have been on generally good terms with current magistrates, the very ones whom they were supposed to punish when the officeholders acted unjustly or made corrupt decisions. This connection created at least the appearance of a conflict of interest, and instances of illegal conduct by magistrates being whitewashed or excused by the Areopagus no doubt had occurred. The reforms apparently removed the guardianship of the laws from the Areopagus, although the council remained the court for premeditated murder and wounding, arson, and certain offenses against the religious cults of the city-state.

The most significant of Ephialtes' reforms was the establishment of a judicial system of courts manned by juries of male citizens over thirty years

old, chosen by lottery to serve in trials for a one-year term. Previously, judicial power had belonged primarily to the archons and the Areopagus council of ex-archons, but now that power was largely transferred to the jurors, a randomly chosen cross section of the male citizen body, six thousand men in all, who were distributed into individual juries as needed to handle the case load. Under this new judicial system, the magistrates were still entitled to render verdicts concerning minor offenses, the Areopagus had its few special judicial competencies, and the council and assembly could take action in certain cases involving the public interest. Otherwise, the citizen-manned courts were given wide jurisdiction. Their juries in practice defined the most fundamental principles of Athenian public life because they interpreted the law by deciding on their own how it should be applied in each and every case. There were no judges to instruct the jurors and usually no prosecutors or defense lawyers to harangue them, although a citizen could be appointed to speak for the prosecution when a magistrate was on trial for misconduct in office, or when the case explicitly involved the public interest.

In most cases citizens brought the charges, and the only government official in court was a magistrate to keep fights from breaking out during the trial. All trials were concluded in a single day, and jurors made up their own minds after hearing speeches by the persons involved. They swore an oath to pay attention and judge fairly, but they were the sole judges of their own conduct as jurors and did not have to undergo a public examination of their actions at the end of their term of service, as other officials in Athenian democracy regularly did. Improperly influencing the outcome of cases by bribing jurors was made difficult because juries were so large, numbering from several hundred to several thousand. Nevertheless, jury tampering apparently was a worry, because in the early fourth century B.C. the system was revised to assign jurors to cases by lottery and not until the day of the trial.

Since few, if any, criminal cases could be decided by scientific or forensic evidence of the kind used in modern trials, persuasive speech was the most important element in the legal proceedings. The accuser and the accused both had to speak for themselves in Athenian court, although they might pay someone else to compose the speech that they would deliver, and they frequently asked others to speak in support of their arguments and as witnesses to their good character. The characters and civic reputations of defendants and plaintiffs were therefore always relevant, and jurors expected to hear about a man's background and his conduct as a citizen as part of the information necessary to discover where truth lay. A majority vote of the jurors ruled. No higher court existed to overrule their

decisions, and there was no appeal from their verdicts. The power of the court system after Ephialtes epitomized the power of Athenian democracy in action. As a trial-happy juror boasts in Aristophanes' comic play of 422 B.C. about the Athenian judicial system, "Our power in court is the equivalent of a king's!" (*Wasps*, pp. 548–549).

The structure of the new court system reflected underlying principles of what scholars today call the "radical" democracy of Athens in the mid-fifth century B.C. This system involved widespread participation by a cross section of male citizens, selection of the participants by lottery at random for most public offices, elaborate precautions to prevent corruption, equal protection under the law for individual citizens regardless of wealth, and the authority of the majority over any minority or individual when the vital interests of the state were at stake. This last principle appears most dramatically in the official procedure for exiling a man from Athens for ten years, called ostracism. Every year the assembly voted on whether to go through this procedure, which gets its name from the word *ostraca*, meaning "pieces of broken pottery"; these shards were inscribed with names of candidates for expulsion and used as ballots. If the vote on whether to hold an ostracism in a particular year was affirmative, all male citizens on a predetermined day could cast a ballot on which they had scratched the name of the man they thought should be exiled. If six thousand ballots were cast, whichever man was named on the greatest number was compelled to go live outside the borders of Attica for ten years. He suffered no other penalty, and his family and property could remain behind undisturbed. Ostracism was not a criminal penalty, and men returning from their period of exile enjoyed undiminished rights as citizens.

Ostracism existed because it helped protect the Athenian system from real or perceived threats. At one level, it provided a way of removing a citizen who seemed extremely dangerous to democracy because he was totally dominating the political scene, whether because he was simply too popular and thus a potential tyrant by popular demand, or whether he was genuinely subversive. This point is made by a famous anecdote concerning Aristides, who set the original level of dues for the members of the Delian League. Aristides had the nickname "the Just" because he was reputed to be so fair-minded. On the day of the balloting for an ostracism, an illiterate man from the countryside handed Aristides a potsherd, asking him to carve on it the name of the citizen he wanted to ostracize. "Certainly," said Aristides. "Which name should I write?" "Aristides," replied the countryman. "All right," remarked Aristides as he proceeded to inscribe his own name. "But tell me, why do you want to ostracize Aristides? What has he done to you?" "Oh, nothing. I don't even know him," sputtered the man.

"I'm just sick and tired of hearing everybody refer to him as 'the Just'" (Plutarch, *Aristides* 7).

In most cases, ostracism served to identify a prominent man who could be made to take the blame for a failed policy that the assembly had originally approved but that was now causing extreme political turmoil. Cimon, for example, was ostracized after the disastrous attempt to cooperate with Sparta during the helot revolt of 462 B.C. There is no evidence that ostracism was used frivolously, despite the story about Aristides, and probably no more than several dozen men were actually ostracized before the practice fell into disuse after about 416, when two prominent politicians colluded to have a nonentity ostracized instead of one of themselves. Ostracism is significant for understanding Athenian democracy because it symbolizes the principle that the interest of the group must prevail over that of the individual citizen when the freedom of the group and the freedom of the individual come into conflict in desperate and dangerous cases. Indeed, the first ostracisms had taken place in the 480s, after the ex-tyrant Hippias had appeared with the Persians at Marathon in 490 and some Athenians feared he would again become tyrant over the community.

Although Aristides was indeed ostracized in 482 and recalled in 480 to fight the Persians, the anecdote about his encounter with the illiterate citizen sounds apocryphal. Nevertheless, it makes a valid point: The Athenians assumed that the right way to protect democracy was always to trust the majority vote of freeborn adult male citizens, without any restrictions on a man's ability to say what he thought was best for democracy. This conviction required making allowances for irresponsible types like the kind of man depicted in the story about Aristides. It rested on the belief that overall the cumulative political wisdom of the majority of voters would outweigh the eccentricity and irresponsibility of the few.

THE LEADERSHIP OF PERICLES

The idea that democracy at Athens was best served by involving a cross section of the male citizenry received further backing in the 450s B.C. from Pericles (c. 495–429 B.C.), whose mother was the niece of the democratic reformer Cleisthenes and whose father had been a prominent leader. Like Cleisthenes before him, Pericles was a man of privilege who became the most influential leader in the Athens of his era by devising innovations to strengthen the egalitarian tendencies of Athenian democracy. In the 450s he successfully proposed that state revenues be used to pay a daily stipend to men who served on juries, on the Council of Five Hundred established by Cleisthenes, and in other public offices filled by lottery. Before these

stipends were mandated, poorer men found it hard to leave their regular work to serve in these time-consuming positions. The amount that jurors and other officials received was a living allowance, not a high rate of pay, certainly no more than an ordinary laborer could earn in a day. Nevertheless, providing this money to them enabled poorer Athenians to serve in government. On the other hand, the most influential public officials—the annual board of ten generals who had responsibility both for military and civil affairs, especially public finances—received no stipends. They were elected by the assembly rather than chosen by lottery, because their posts required expertise and experience; they were not paid because mainly rich men like Pericles, who had received the education required to handle this top job and enjoyed the free time to fill it, were expected to win election as generals. Generals were compensated only by the status and prestige that their office brought them.

Pericles and others of his economic status had inherited enough wealth to spend their time in politics without worrying about money, but remuneration for public service was essential for Athenian democracy if it were truly going to be open to the mass of men who depended on farming or earning wages to feed their families. Pericles' proposal for state stipends for jurors made him overwhelmingly popular with ordinary citizens. Consequently, beginning in the 450s, he was able to introduce dramatic changes in both Athenian foreign and domestic policy. On the latter front, for instance, Pericles sponsored a law in 451 stating that from then on citizenship would be conferred only on children whose mother and father both were Athenians. Previously, the offspring of Athenian men who married non-Athenian women had been granted citizenship. Wealthy Athenian men from the social elite had regularly married rich foreign women, as Pericles' own maternal grandfather had done. The new law not only solidified the notion of Athenian identity as special and exclusive but also emphatically recognized the privileged status of Athenian women as possessors of citizenship, putting their citizenship on a par with that of men in the crucially important process of establishing the citizenship of new generations of Athenians. Not long after the passage of the citizenship law, a review of the citizenship rolls of Athens was conducted to expel any persons who had claimed citizenship fraudulently. The advantages of citizenship included, for men, the rights to participate in politics and juries, to influence decisions that directly affected their lives and the lives of their families, to have equal protection under the law, and to own land and houses in Athenian territory. Citizen women had fewer direct rights because they were excluded from politics, had to have their male legal guardian speak for them in court, and were not legally entitled to make

large financial transactions on their own. They did, however, enjoy the fundamental guarantees of citizenship: the ability to control property and to have the protection of the law for their persons and their property. Female and male citizens alike experienced the advantage of belonging to a city-state that was enjoying unparalleled material prosperity and an enhanced sense of pride in its communal identity and international power.

The involvement of Pericles in foreign policy in the 450s B.C. is less clear, and we cannot tell how he felt about the massive Athenian intervention in support of a rebel in Egypt trying to overthrow Persian rule there. This expedition, which began perhaps in 460, ended in utter disaster in 454 with the loss of perhaps two hundred ships and their crews, an overwhelming death toll given that each ship had approximately two hundred men on board. Some of these men would have been allies, not Athenians, but the loss of manpower to Athens must have been large regardless. In the aftermath of this catastrophe, the treasury of the Delian League was moved from Delos to Athens, ostensibly to insure its safety from possible Persian retaliation and not simply to make it easier for the Athenian assembly to use the funds. Whatever the real motive behind this change, it signified the overwhelming dominance that Athens had achieved as leader of the league by this time.

The 450s were a period of intense military activity by Athens and its allies. At the same time that Athenian and Delian League allies were fighting in Egypt, they were also on campaign on the eastern Mediterranean seacoast against Persian interests. In this same decade, Pericles also supported an aggressive Athenian foreign policy against Spartan interests in Greece. Athens's forces were defeated by the Peloponnesians at the battle of Tanagra in Boeotia in central Greece in 457, but its troops subsequently gained control of that region and neighboring Phocis as well. The Athenians won victories over the nearby island of Aegina as well as Corinth, the powerful city-state in the northeastern Peloponnese. When Cimon, who had returned from ostracism, died in 450 while leading a naval force against the Persians on the island of Cyprus, the assembly finally decided to end military campaigns directed at Persian interests and sent no more fleets to the eastern Mediterranean.

Athenian military operations in Greece failed to secure enduring victory over Sparta's allies in central Greece, and Boeotia and Phocis threw off Athenian control in 447 B.C. In the winter of 446–445, Pericles engineered a peace treaty with Sparta designed to freeze the balance of power in Greece for thirty years and thus preserve Athenian dominance in the Delian League. He was then able to turn his attention to his political rivals at Athens, who were jealous of his influence over the board of ten

generals. Pericles' overwhelming political prominence was confirmed in 443 when he managed to have his chief rival, named Thucydides (not the historian), ostracized instead of himself. Pericles was subsequently elected one of Athens's generals for fifteen years in a row. His ascendancy was challenged, however, after he rashly took sides in a local political crisis on the island of Samos, which led to a war with that valuable Delian League ally from 441 to 439. The war with Samos was not the first break between Athens and its Delian League allies in the period since 450, when action against the Persians—the main goal of the league in its early years after 478—had ceased to be an active part of the league's mission. Strains developed between Athens and several allied city-states that wished to leave the league and end their tribute payments, which were no longer paying for open war with Persia, only for defensive power in case of attack, which now seemed unlikely. Pericles' position apparently was that the league was indeed fulfilling its primary mission of keeping the allies safe from Persia: That no Persian fleet ever ventured far from its eastern Mediterranean home base was proof that the allies had no cause for complaint. Inscriptions from the 440s B.C., in particular, testify to the unhappiness of various Athenian allies and to Athenian determination to retain control over its unhappy partners in the alliance.

When the city-state of Chalcis on the island of Euboea rebelled against the Delian League in 446 B.C., for example, the Athenians soon put down the revolt and forced the Chalcidians to swear to a new set of arrangements. Copies of the terms inscribed on stone were then set up in Chalcis and Athens. The differences in the oaths exchanged by the two sides as recorded in this copy of the inscription found at Athens reveal the imperiousness of Athens's dominance over its Greek allies in this period:

> The Athenian Council and all the jurors shall swear the oath as follows: "I shall not deport Chalcidians from Chalcis or lay waste the city or deprive any individual of his rights or sentence him to a punishment of exile or put him in prison or execute him or seize property from anyone without giving him a chance to speak in court without (the agreement of) the People [that is, the assembly] of Athens. I shall not cause a vote to be held, without due notice to attend trial, against either the government or any private individual whatever. When an embassy [from Chalcis] arrives [in Athens], I shall see that it has an audience before the Council and People within ten days when I am in charge of the procedure, so far as I am able. These things I shall guarantee to the Chalcidians if they obey the People of Athens." The Chalcidians shall swear the oath as follows: "I shall not rebel against the People of Athens

either by trickery or by plot of any kind either by word or by action. Nor shall I join someone else in rebellion and if anyone does start a rebellion, I shall denounce him to the Athenians. I shall pay the dues to the Athenians which I persuade them [to assess], and I shall be the best and truest possible ally to them. And I shall send assistance to the People of Athens and defend them if anyone attacks the People of Athens, and I shall obey the People of Athens."

—(Crawford and Whitehead no. 134 = IG 3rd ed., no. 40)

While it is clear that the Athenians with this imposed agreement bound themselves to follow rules in dealing with their allies, it is equally unmistakable that the relationship was not on equal terms: Their formerly independent allies were explicitly required to "obey."

Pericles in the mid-430s B.C. faced an even greater challenge than restive and rebellious allies when Athenian relations with Sparta greatly worsened despite the provisions of the peace that had been struck in 446–445. A stalemate developed when the Spartans finally threatened war unless the Athenians ceased their interference in the affairs of the Corinthian colonies of Corcyra and Potidaea, but Pericles prevailed upon the assembly to refuse all compromises. His critics claimed he was sticking to his hard line against Sparta and insisting on provoking a war in order to revive his fading popularity by whipping up a jingoistic furor in the assembly. Pericles retorted that no accommodation to Spartan demands was possible, because Athenian freedom of action was at stake. By 431, the thirty-years' peace between Athens and Sparta made in 445 had been shattered beyond repair. The Peloponnesian War (as modern historians call it) between Athens and its allies and Sparta and its allies broke into open hostilities in 431; at that point no one could know that its violence would drag on for twenty-seven years.

PROSPEROUS ATHENS

Athens reached the height of its power and prosperity in the decades of the mid-fifth century B.C. preceding the Peloponnesian War, the period accordingly referred to today as the city-state's Golden Age. Private homes, whether in the city or in the countryside, retained their traditionally modest size even during this period of communal abundance. Farmhouses were usually clustered in villages, while homes in the urban center were wedged tightly against one another along narrow, winding streets. Even the residences of rich people followed the same basic design, which grouped bedrooms, storerooms, workrooms, and dining rooms around

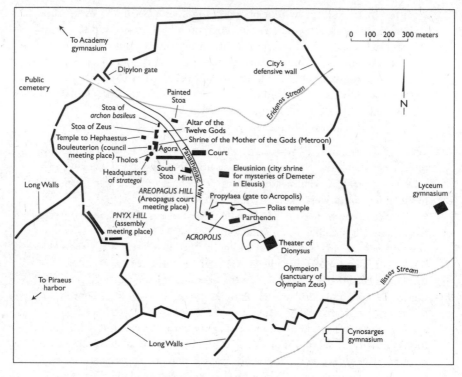

Plan 2. Athens near the End of the Fifth Century B.C.

the one constant in every decent-sized Greek house: an open-air courtyard in the center. The courtyard was walled off from the street, thereby insuring privacy, a prime goal of Greek domestic architecture. Wall paintings or works of art were as yet uncommon as decoration in private homes, with sparse furnishings and simple furniture the rule. Toilet facilities usually consisted of a pit dug just outside the front door, which was emptied by collectors paid to dump manure outside the city at a distance set by law. Poorer people rented houses or small apartments.

Benefactions donated by the rich provided some public improvements, such as the landscaping with shade trees and running tracks that Cimon paid to have installed in open areas in the city. On the edge of the agora, the central market square and open gathering spot at the heart of the urban area, Cimon's brother-in-law paid for the construction of the renowned building known as the Painted Stoa. Stoas were narrow buildings open along one side, designed to provide shelter from sun or rain. The crowds of men who came to the agora daily for conversation about

politics and local affairs would cluster inside the Painted Stoa, whose walls were decorated with paintings of great moments in Greek history commissioned from the most famous painters of the time, Polygnotus and Mikon. It was appropriate that one of the stoa's paintings portrayed the battle of Marathon in 490 B.C., in which Cimon's father, Miltiades, had won glory, because the husband of Cimon's sister had donated the building to the city. The social values of Athenian democracy called for leaders like Cimon and his brother-in-law to provide such gifts for public use to show their goodwill toward the city-state and thereby earn increased social eminence as their reward. Wealthy citizens were also expected to fulfill costly liturgies (public services), such as providing theatrical entertainment at city festivals or fitting out a fully equipped warship and then serving on it as a commander. This liturgical system for wealthy men compensated to a certain extent for the lack of any regular income or property taxes in peacetime after the reign of the tyrant Pisistratus. (The Assembly could vote to institute a temporary levy on property, the *eisphora*, to pay war costs.)

Athens received substantial public revenues from harbor fees, sales taxes, its silver mines, and the dues paid by the allies. Buildings paid for by public funds from these sources constituted the most conspicuous architecture in the city of the Classical period of the fifth and fourth centuries B.C. The scale of these public buildings was usually no greater than the size required to fulfill their function, such as the complex of buildings on the agora's western edge in which the Council of Five Hundred held its meetings and the public archives were kept. Since the assembly convened in the open air on a hillside above the agora, it required no building at all except for a speaker's platform. In 447, however, at Pericles' instigation, a great project began atop the Acropolis, the mesalike promontory at the center of the city that towered over the agora. Over the next fifteen years, the Athenians financed the construction of a mammoth gate building with columns, the Propylaea, which straddled the broad entrance to the Acropolis at its western end, and a new Athena temple, the Parthenon, to house a towering image of the goddess (fig. 6.2). These buildings together cost easily more than the equivalent of the total of several years' dues from the allies, a phenomenal sum to spend for an ancient Greek city-state, regardless of whether the money came from domestic or foreign sources of revenue. The program was so expensive that the political enemies of Pericles blasted him in the assembly for squandering public funds. Scholars disagree about how much, if any, of the finances for this building program came from Athens's income from the Delian League, as the financial records of the period are incomplete and ambiguous. Some funds cer-

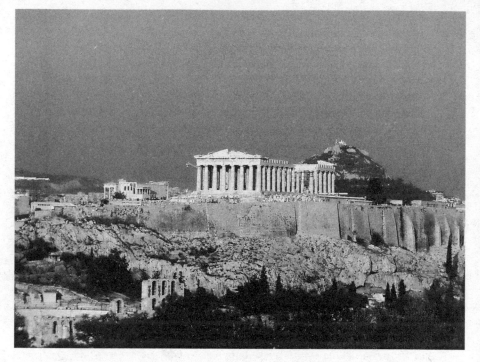

Fig. 6.2: In the mid-fifth century B.C., the Athenians built the very expensive Parthenon temple on their city-state's citadel (the Acropolis) as a second temple honoring their patron goddess Athena and proclaiming their prosperity and military success. The older Athena temple sits to the left of the larger Parthenon in the photo. Wikimedia Commons.

tainly were taken from the financial reserves of the goddess Athena, whose sanctuaries, like those of the other gods throughout Greece, received both private donations and public support. However they were paid for, the new buildings made a spectacular impression not only because they were expensive but also because their large scale, decoration, and surrounding open spaces contrasted so vividly with the private architecture of Athens in the fifth century B.C.

Parthenon, the name of the new temple built for Athena on the Acropolis, meant "the house of the virgin goddess." As the patron deity of Athens, Athena had long had another sanctuary on the Acropolis honoring her in her role as Athena Polias ("guardian of the city"). The focus of this earlier shrine was an olive tree regarded as the sacred symbol of the goddess,

who in this capacity provided for the agricultural and thus the essential prosperity of the Athenians. The temple in the Athena Polias sanctuary had largely been destroyed by the Persians when they sacked and burned Athens in 480 and 479 B.C. For thirty years, the Athenians purposely left the Acropolis in ruins as a memorial to the sacrifice of their homeland in that war. When at Pericles' urging the assembly decided to rebuild the temples on the Acropolis, it conspicuously turned first not to reconstruction of the olive-tree sanctuary but rather to building the Parthenon. This spectacular new temple was constructed to honor Athena in her capacity as a warrior serving as the divine champion of Athenian military power. Inside the Parthenon was placed a gold-and-ivory statue over thirty feet high portraying the goddess in battle armor and holding in her outstretched hand a six-foot statue of the figure of Victory (nikē in Greek).

Like all Greek temples, the Parthenon was meant as a house for its divinity, not as a gathering place for worshippers. In its general design, the Parthenon was representative of the standard architecture of Greek temples: a rectangular box with doors on a raised platform, a plan that the Greeks probably derived from the stone temples of Egypt. The box was fenced in by columns all around. The columns were carved in the simple style called Doric, in contrast to the more elaborate Ionic or Corinthian styles that have often been imitated in modern buildings (for example, in the Corinthian-style facade of the Supreme Court Building in Washington, DC). Only priests and priestesses could enter the temple, but public religious ceremonies took place around the altar outside its east end.

The Parthenon was extraordinary in its great size and expense, but it was truly remarkable in the innovation of its refined architecture and elaborate sculptural decoration. Constructed from twenty thousand tons of Attic marble, it stretched nearly 230 feet in length and 100 feet in width, with eight columns across the ends instead of the six normally employed in Doric style, and seventeen instead of thirteen along the sides. These dimensions gave it a massive look conveying an impression of power. One speculation to explain the more subtle features of its construction, which not all scholars accept, is that perfectly rectilinear architecture appears curved to the human eye. According to this theory, subtle curves and inclines were built into the Parthenon to produce an optical illusion of completely straight lines: The columns were given a slight bulge in their middles; the corner columns were installed at a slight incline and closer together; and the platform was made slightly convex. These technical refinements made the Parthenon appear ordered and regular in a way a building built entirely on straight lines would not. By overcoming the

distortions of nature, the Parthenon's sophisticated architecture made a confident statement about human ability to construct order out of the entropic disorder of the natural world.

The sculptural decoration of the Parthenon also boldly proclaimed Athenians' high confidence about their city-state's close relationship with the gods and the divine favor that they fervently believed they enjoyed. The Parthenon had sculptured panels along its exterior above the columns, and groups of sculptures in the triangular spaces (pediments) underneath the line of the roof at either end of the building. These decorations were part of the Doric style, but the Parthenon also presented a unique sculptural feature. A continuous band of figures was carved in relief around the top of the walls inside the porch formed by the columns along the edges of the building's platform. This sort of continuous frieze was usually put only on Ionic-style buildings. Adding an Ionic frieze to a Doric temple was a startling departure from architectural tradition, which was designed to attract notice to its subject, even though the frieze itself was difficult to see clearly from ground level. The Parthenon's frieze probably depicted the Athenian religious ritual in which a procession of citizens paraded to the Acropolis to present to Athena in her olive-tree sanctuary a new robe woven by specially selected Athenian girls, although it has also been suggested that the frieze refers to the myth of the sacrifice of the daughters of the legendary Erechtheus to save the city in a time of crisis. Depicting the procession in motion, like a filmstrip in stone, the frieze showed men riding spirited horses, women walking along carrying sacred implements, and the gods gathering at the head of the parade to observe their human worshippers. As usual in the sculptural decoration on Greek temples, the frieze sparkled with shiny metal attachments, serving, for example, as the horsemen's reins and brightly colored paint enlivening the figures and the background.

No other city-state had ever gone beyond the traditional function of temples—glorifying and paying honor to the community's special deities—by adorning a temple with representations of its citizens. The Parthenon frieze made a unique statement about the relationship between Athens and the gods by showing its citizens in the company of the gods, even if the assembled deities carved in the frieze were understood to be separated from and perhaps invisible to the humans in the procession. A temple adorned with pictures of citizens, even if idealized citizens of perfect physique and beauty, amounted to a claim of special intimacy between the city-state and the gods and a statement of confidence that these honored deities favored the Athenians. Presumably, this claim reflected the Athenian interpretation of their success in helping to turn back the Persians and thus playing their role as the defenders of Greek civilized life, in achiev-

ing leadership of a powerful naval alliance, and in controlling a public income from their commercial taxes, silver mines, and the allies' dues, which made Athens richer than all its neighbors in mainland Greece. The Parthenon, like the rest of the Periclean building program, paid honor to the gods with whom the city-state was identified, and expressed the Athenian view that the gods looked favorably on their empire. Their success, the Athenians would have said, proved that the gods were on their side.

REPRESENTING THE BODY

Like the design of the sculpture attached to the outside of the Parthenon, the enormous size and expense of the freestanding figure of Athena placed inside the temple expressed the innovative and confident spirit of Athens in the mid-fifth century B.C. The statue's creator, the Athenian Phidias, gained such fame that he became a close friend of Pericles and was invited by other Greek states to make great statues for their temples, such as a giant seated Zeus for the main temple at Olympia.

Other Greek artists as well as sculptors were experimenting with new techniques and artistic approaches in this period, but freestanding sculpture provides the clearest demonstration of the innovation and variety in the representation of the human body that characterized Greek art in the fifth century B.C. Such sculptures could either be public in the sense of having been paid for with state funds, as was the case with those on the Parthenon, or private and therefore paid for by individuals or families, but the latter did not serve as pieces of private art in the modern sense. Greeks who ordered statues privately from sculptors had not yet developed the custom of using them to decorate the interior of their homes. Instead, they set them up on public display for a variety of purposes. Privately commissioned statues of gods could be placed in a sanctuary as proof of devotion. In the tradition of offering lovely crafted objects to divinities as commemorations of important personal experiences, such as economic success or victories in athletic contests, people also donated sculptures of physically beautiful human beings to the sanctuaries of the gods as gifts of honor. Wealthy families would commission statues of their deceased members, especially if they had died young, to be placed above their graves as memorials of their excellence. In every case, private statues were meant to be seen by other people. In this sense, then, private sculpture in the Golden Age served a public function: It broadcast a message to an audience.

Archaic Age statues had been characterized by a stiff posture imitating the style of standing figures from Egypt. Egyptian sculptors had gone on

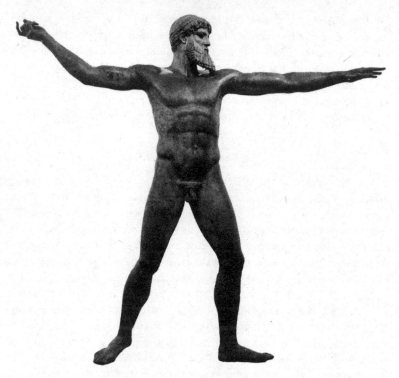

Fig. 6.3: In the Classical Age, Greek artists produced their most spectacular and costly statues by casting them in bronze, such as this depiction of the god Zeus hurling a thunderbolt (which is missing from his right hand), or the god Poseidon wielding a trident. The naturalistic rendering of the well-toned body and the pose suggesting motion were characteristic of sculpture in this period. Wikimedia Commons.

producing this style unchanged for centuries. Greek artists, on the other hand, had begun to change their style by the time of the Persian Wars, and the fifth century B.C. saw new poses become prevalent in freestanding sculpture, continuing an earlier evolution toward movement visible in the sculpture attached to temples. Human males were still being generally portrayed nude as athletes or warriors, while women were still clothed in fine robes. But their postures and their physiques were evolving toward ever more naturalistic renderings. While Archaic Age male statues had been positioned striding forward with their left legs, arms held rigidly at their sides, male statues in the Classical Age might now have bent arms or the body's weight balanced on either leg. Their musculature was anatomically correct rather than sketchy and almost impressionistic, as

had been the style in the sixth century B.C. Female statues, too, now had more-relaxed poses and clothing, which hung in such a way as to hint at the shape of the body underneath instead of disguising it. The faces of Classical Age sculptures, however, reflected an impassive calm rather than the smiles that had characterized Archaic Age figures.

Bronze was the preferred material of the sculptors who devised these daring new styles, although marble was also popular. Creating bronze statues, which were cast in molds made from clay models, required a well-equipped workshop with furnaces, tools, and foundry workers skilled in metallurgy. Because sculptors and artists labored with their hands, the wealthy elite regarded them as workers of low social status, and only the most famous ones, like Phidias, could move in high society. Properly prepared bronze had the tensile strength to allow outstretched poses of arms and legs, which could not be done in marble without supports (fig. 6.3). This is the reason for the intrusive tree trunks and other such supporting members introduced in the marble imitations of Greek statues in bronze that were made in Roman times. The Roman imitations of the sort commonly seen in modern museums are often the only surviving examples of the originals.

The strength and malleability of bronze allowed innovative sculptors like the Athenian Myron and Polyclitus of Argos to push the development of the freestanding statue of the human form to its physical limits. Myron, for example, sculpted a discus thrower crouched at the top of his backswing, a pose far from the relaxed and serene symmetry of early Archaic Age statuary. The figure not only assumes an asymmetrical pose but also seems to burst with the tension of the athlete's effort. Polyclitus's famous statue of a walking man carrying a spear is posed to give a different impression from every angle of viewing and to impart a powerful sensation of motion. The same is true of the famous statue by an unknown sculptor of a female figure (perhaps the goddess of love, Aphrodite) adjusting her see-through robe with one upraised arm. The message these statues conveyed to their ancient audience was one of energy, motion, and asymmetry in delicate balance. Archaic Age statues impressed viewers with their appearance of stability; not even a hard shove looked likely to budge them. Statues of the Classical Age, by contrast, showed greater range with a variety of poses and impressions. The spirited movement of some of these statues suggests the energy of the times but also the possibility of change and instability that underlies even a Golden Age.

Culture and Society in Classical Athens

As mentioned in the previous chapter, the prosperity and cul-
tural achievements of Athens in the mid-fifth century B.C. have
led to this period being called a Golden Age in the city-state's
history. The state of the surviving ancient evidence, which
consistently comes more from Athens than from other city-
states, and the focus of modern popular interest in ancient
Greece, which has traditionally remained on the magnificent
architectural remains of Athens, have resulted in Greek history
of this period being centered almost exclusively on just Athe-
nian history. For these reasons, we really are talking mostly
about Athens when we speak of the Golden Age of Greece.

That being said, it seems fair to point out that Athenian
prominence in the story of Classical Greece is no accident and
reflects the unprecedented changes that characterized the cul-
ture and society of Athens in the fifth century B.C. At the same
time, central aspects of Athenian life remained unchanged.
The result was a mix of innovation and continuity that created
tensions that sometimes proved productive and sometimes
detrimental. Tragic drama developed as a publicly supported
art form performed before mass audiences, which explored
troubling ethical issues relevant both to the life of individu-
als and of the community. Also emerging in the fifth century
was a new and—to traditionalists—upsetting form of educa-
tion for wealthy young men with ambitions in public life. For
upper-class women, public life remained constrained by the
limitations of modesty and their exclusion from the political

500–323 B.C.: The Greek Classical Age.

458 B.C.: Aeschylus's trilogy of tragedies, *The Oresteia* (*Agamemnon, The Libation Bearers, The Eumenides*), produced at Athens.

c. 450 B.C.: The sophist Protagoras makes his first visit to Athens.

c. 447 B.C.: Sophocles' tragedy *Ajax* probably produced at Athens.

444 B.C.: Protagoras makes laws for colony of Athenians and others being sent to Thurii in southern Italy.

c. 441 B.C.: Sophocles' tragedy *Antigone* probably produced at Athens.

431 B.C.: Euripides' tragedy *Medea* produced at Athens.

affairs that filled the days of many of their husbands. Women of the poorer classes, on the other hand, could have more contact with the public, male world because they had to work and therefore interact with strangers to earn money to help support their families. The interplay of continuity and change created tensions that were tolerable until the pressure of conflict with Sparta in the Peloponnesian War strained Athenian society to the breaking point. All these changes took place against the background of traditional Greek religion, which remained prominent in public and private life because most people never lost their faith that the gods' will mattered in their lives as citizens and as individuals.

CLASSICAL GREEK RELIGION

As the Ionic frieze on the Parthenon revealed so dramatically, the Athenians in the mid-fifth century B.C. believed they enjoyed the favor of the gods and were willing to spend public money—and lots of it—to erect beautiful and massive monuments in honor of the deities protecting them. This belief corresponded to the basic tenet of Greek religion: Human beings both as communities and as individuals paid honors to the gods to thank them for blessings received and to receive blessings in return. Those honors consisted of public sanctuaries, sacrifices, gifts to the sanctuaries, and festivals of songs, dances, prayers, and processions. A seventh-century B.C. bronze statuette in the Boston Museum of Fine Arts, which a man named Mantiklos gave to a sanctuary of Apollo to honor the god, makes clear why individuals gave such gifts. On its legs Mantiklos inscribed his understanding of the transaction: "Mantiklos gave this from his share to the Far Shooter of the Silver Bow [Apollo]; now you, Apollo, do something beneficial for me in return" (BMFA accession number 03.997). This idea

of reciprocity between gods and humans defined the Greek understanding of the divine. Gods did not love human beings, except sometimes literally in mythological stories of gods choosing particular favorites or taking earthly lovers and producing half-divine children. Rather, they supported humans who paid them honor and avoided offending them. If human beings angered the gods, the deities could punish the offenders by sending such calamities as famines, earthquake, epidemic disease, or defeat in war. Disaster and vengeance could also be inflicted on people from the action of the natural order of the universe, of which the gods were a part but not necessarily the guarantors. For example, death, including murder, created a state of pollution (*miasma*). Corpses had to receive purification and proper burial to remove the pollution before life around it could return to normal; murderers had to receive just punishment for their crimes, or the entire community—not just the criminal—would experience dire consequences, such as infertility or the births of monstrous offspring, starvation from bad harvests, and illness and death from epidemic disease.

The greatest religious difficulty for human beings lay in anticipating what specific actions might make a god angry. By definition, mortals could not fully understand the gods: The gap between the mortal and the divine was just too great. A few standards of behavior that people believed the gods demanded of them were codified in a traditional moral order with clear rules to follow. For example, the Greeks believed that the gods demanded hospitality for strangers and proper burial for family members and that the gods punished acts of murder and instances of exceptional or violent arrogance (*hybris*). Otherwise, when things went wrong in their lives, people consulted oracles, analyzed dreams, conducted divination rituals, and studied the prophecies of seers to seek clues as to what they might have done to anger a divinity. Offenses could be acts such as forgetting a sacrifice, blasphemy (explicitly denying the power of the gods), failing to keep a vow to pay an honor to a particular god, or violating the sanctity of a temple area. The gods were regarded as especially concerned with certain human transgressions that disrespected their divine majesty, such as people breaking agreements that they had sworn to others while invoking the gods as witnesses that they would keep their word. The gods were seen as generally uninterested in common crimes, which humans had to police for themselves.

The Greeks believed their gods lived easy lives, exposed to pain sometimes in their dealings with one another or sometimes sad at the misfortunes of favored humans, but essentially carefree in their immense power and immortality. The twelve most important of the gods, headed by Zeus as king of the gods, were envisioned assembling for banquets atop

Mount Olympus, the highest peak in mainland Greece at nearly 10,000 feet. Hera, the wife of Zeus, was queen of the gods; Zeus's brother Poseidon was god of the sea; Athena was born directly from the head of Zeus as goddess of wisdom and war; Ares was the male god of war; Aphrodite was goddess of love; Apollo was the sun god, while Artemis was the moon goddess; Demeter was goddess of agriculture; Hephaestus was god of fire and technology; Dionysus was god of wine, pleasure, and disorder; Hermes was the messenger of the gods. Hades, god of the underworld, was also a brother of Zeus, but he was not strictly speaking an Olympian deity, because he spent his time under the earth presiding over the world of the dead.

Like the prickly warriors of the stories of Homer, who became enraged at any acts or words of disrespect to their status, the gods were always alert for insults to their honor. "I am well aware that the gods are envious of human success and prone to disrupt our affairs," is Solon's summary of their nature in one famous anecdote in which he is portrayed as giving advice to another famous person, in this case Croesus, before the Lydian king lost his kingdom to the Persians (Herodotus, The Histories 1.32).

To show respect for a god, worshippers prayed, sang hymns of praise, offered sacrifices, and presented offerings at the deity's sanctuary as part of the system of worship and rituals forming the particular god's cult; each divine being had a separate cult with its specific practices and traditions, and major divinities could have more than one cult. In the sanctuary of a god or goddess, a person could honor and thank the deity for blessings and seek to propitiate him or her when serious troubles, which were understood as indications of divine anger at human behavior, had struck the petitioner. Private individuals offered sacrifices at home with the household gathered around, and often the family's slaves were allowed to join the gathering. The sacrifices of public cults of gods and goddesses were conducted by priests and priestesses, who were in most cases chosen from the citizen body as a whole but otherwise existed as ordinary citizens. The priests and priestesses of Greek cults were usually attached to a certain sanctuary or shrine and did not seek to influence political or social matters. Their special knowledge consisted of knowing how to perform the gods' rites in a particular location in accordance with ancestral tradition. They were not guardians of theological orthodoxy, because Greek religion had no systematic theology or canonical dogma; it also lacked any groups or hierarchies comparable to today's religious leaders and institutions that oversee and enforce correct doctrine.

The ritual of sacrifice provided the primary occasion of contact between the gods and their worshippers, symbolizing the reciprocal, if un-

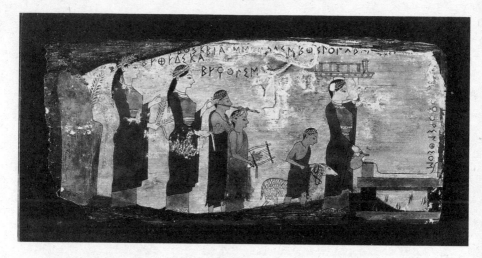

Fig. 7.1: Painting was the favorite form of ancient Greek art, but little has survived. This picture painted in vivid colors on wood shows the preparations, including playing music, for the sacrifice of a sheep to a divinity. Gianni Dagli Orti / The Art Archive at Art Resource, NY.

equal, relations between divine and human beings (fig. 7.1). The great majority of sacrifices took place as regularly scheduled events on the community's civic calendar. At Athens the first eight days of every month were marked by specified demonstrations of the citizens' piety toward the deities of the city-state's official cults. The third day of each month, for example, was celebrated as Athena's birthday and the sixth as that of Artemis, the goddess of wild animals, who was also the special patroness of the Athenian Council of Five Hundred. Artemis's brother, Apollo, was honored on the following day. Athens boasted of having the largest number of religious festivals in all of Greece, with nearly half the days of the year featuring one, some large and some small. Not everyone attended all the festivals, and hired laborers' contracts stated how many days off they received to attend religious ceremonies. Major occasions such as the Panathenaic festival, whose procession probably was portrayed on the Parthenon frieze, attracted large crowds of women and men. The Panathenaic festival honored Athena not only with sacrifices and parades but also with contests in music, dancing, poetry, and athletics. Valuable prizes were awarded to the winners. Some religious rituals were for women only; one famous women-only gathering was the three-day festival for married women in honor of the goddess Demeter, the protector of agriculture and life-giving fertility.

Despite different cults having many differing rituals, sacrifice served as

their centering experience. Sacrifices ranged from the slaughter of large animals to bloodless offerings of fruits, vegetables, and small cakes. It seems possible that the tradition of animal sacrifice had its deepest roots in the lives of prehistoric hunters, for whom such rites might have expressed their uneasiness about the paradox of having to kill other living beings so that they themselves could eat and survive. The Greeks of the Classical Age sacrificed valuable and expensive domesticated animals such as cattle, which their land supported in only small numbers, to express their reverence for the majesty of the gods, to ask for good fortune for themselves and their community, to symbolize their control over the animal world, and to have a rare meal of meat. The sacrifice of a large animal provided an occasion for the community to reassemble to reaffirm its ties to the divine world and, by sharing the roasted meat of the sacrificed beast, for the worshippers to benefit personally from a good relationship with the gods. Looking back on fifth-century B.C. Athens, the orator Lysias explained the tradition—and the necessity—of public sacrifice: "Our ancestors handed down to us the most powerful and prosperous community in Greece by performing the prescribed sacrifices. It is therefore proper for us to offer the same sacrifices as they, if only for the sake of the success which has resulted from those rites" (*Orations* 30.18).

Procedures for sacrificing animals specified strict rules meant to ensure the purity of the occasion, and the elaborate requirements for conducting a blood sacrifice show how seriously and solemnly the Greeks regarded the sacrificial killing of animals. Sacrifices were performed at altars placed outside in front of temples, where large groups of worshippers could gather; the inside of the building was reserved for the god and the priests. The victim had to be an unblemished domestic animal, specially decorated with garlands and induced to approach the altar as if of its own will. The assembled crowd had to maintain a strict silence to avoid possibly impure remarks. The sacrificer sprinkled water on the victim's head so it would, in shaking its head in response to the sprinkle, appear to consent to its death. After washing his hands, the sacrificer scattered barley grains on the altar fire and the victim's head, and then cut a lock of the animal's hair to throw on the fire. Following a prayer, he swiftly cut the animal's throat while musicians played flutelike pipes and while female worshippers screamed to express the group's ritual sorrow at the victim's death. The carcass was then butchered, with some portions thrown on the altar fire so their aromatic smoke could waft upward to the god of the cult. The rest of the meat was then distributed among the worshippers.

Greek religion included many activities besides those of the cults of the twelve Olympian deities. Families marked important private moments

such as birth, marriage, and death with prayers, sacrifices, and rituals. In the fifth century B.C. it became increasingly common for ordinary citizens, not just members of the elite, to make offerings at the tombs of their relatives. Nearly everyone consulted seers about the meanings of dreams and omens and sought out magicians for spells to improve their love lives, or curses to harm their enemies. Particularly important both to the community and to individuals were what we call hero cults, whose rituals were performed at the tomb of a man or woman, usually from the distant past, whose remains were thought to retain special power. Athenian soldiers in the battle of Marathon in 490 B.C., for example, had reported having seen the ghost of the hero Theseus leading the way against the Persians. When Cimon in 475 brought back to Athens bones agreed to be those of Theseus, who was said to have died on a distant island, the people of Athens celebrated the occasion as a major triumph for their community and had the remains installed in a special shrine at the center of the city. The power of a hero's remains was local, whether for revealing the future through oracles, for healing injuries and disease, or for providing assistance in war. The strongman Heracles (Hercules) was the only Greek hero to whom cults were established internationally, all over the Mediterranean world. His superhuman feats in overcoming monsters and generally doing the impossible gave him an appeal as a protector in many city-states.

International in a different sense was the cult of Demeter and her daughter Korē (or Persephone), whose headquarters were located at Eleusis, a settlement on the west coast of Attica. The central rite of this cult was called the Mysteries, a series of ceremonies of initiation into the secret knowledge of the cult, whose name is derived from the Greek word mystēs ("initiate"). Those initiated into these Eleusinian Mysteries became members of a group with special knowledge unavailable to the uninitiated. All free people who spoke Greek, from anywhere in the world—women and men, adults and children—were eligible for initiation, if they were free of pollution. Some slaves who worked in the sanctuary were also eligible for initiation. The process of becoming an initiate proceeded in several stages. The main rituals took place during an annual festival lasting almost two weeks. This mystery cult became so important that the states of Greece honored an international agreement specifying a period of fifty-five days for guaranteed safe passage through their territories for travelers going to and from the festival. Prospective initiates participated in a complicated set of ceremonies that culminated in the revelation of Demeter's central secret after a day of fasting. The revelation was performed in an initia-

tion hall constructed solely for this purpose. Under a roof fifty-five yards square supported on a forest of interior columns, the hall held three thousand people standing around its sides on tiered steps. The most eloquent proof of the sanctity attached to the Mysteries of Demeter and Korē is that throughout the thousand years during which the rites were celebrated, we know of no one who ever revealed the secret. To this day, all we know is that it involved something done, something said, and something shown. It is certain, however, that initiates expected to fare better in their lives on earth and—this is highly significant for ancient Greeks' views of the afterlife—were also promised a better fate after death. "Richly blessed is the mortal who has seen these rites; but whoever is not an initiate and has no share in them, that one never has an equal portion after death, down in the gloomy darkness," are the words describing the benefits of initiation in a sixth-century B.C. poem from the collection called Homeric Hymns (Hymn to Demeter 480–482).

A similar concern over what awaited human beings after death lay at the heart of other mystery cults, whose sanctuaries were located elsewhere in the Greek world. Most of them were also believed to bestow protection on initiates in their daily lives, whether against ghosts, illness, poverty, shipwrecks, or the countless other mundane dangers of life. This divine protection given worshippers was provided, however, only as a reward for appropriate conduct, not just for an abstract belief in the gods. For the ancient Greeks, gods expected honors and rites, and Greek religion required action and proper behavior from human beings. Greeks had to say prayers and sing hymns honoring the gods, perform sacrifices, support festivals, and undergo purifications. These rites represented an active response to the precarious conditions of human life in a world in which early death from disease, accident, or war was commonplace. Furthermore, the Greeks believed the same gods were responsible for sending both good and bad into the world. As Solon warned Croesus, "In all matters look to the end, and to how it turns out. For many people have enjoyed prosperous happiness as a divine gift, only afterwards to be uprooted utterly" (Herodotus, The Histories 1.32). As a result, the Greeks of the Classical Age had no automatic expectation that they would achieve paradise at some future time when evil forces would finally be vanquished forever through divine love. Their assessment of existence made no allowance for change in the relationship between the human and the divine. That relationship encompassed sorrow as well as joy, punishment in the here and now, with the hope for divine favor both in this life and in an afterlife for initiates of the Eleusinian Mysteries and other similar mystery cults.

TRAGIC DRAMA AND PUBLIC LIFE

The problematic relationship between gods and humans formed the basis of Classical Athens's most enduring cultural innovation: the tragic dramas performed over three days at the major festival of the god Dionysus held in the late spring every year. These plays, still read and produced on stage today, were presented in ancient Athens as part of a contest for the authors of plays, in keeping with the deeply competitive spirit characteristic of Greek society. Athenian tragedy reached its peak as a dramatic form in the fifth century B.C., as did comedy, the other equally significant type of public drama of Athens (which will be discussed in the next chapter).

Each year, one of Athens's magistrates chose three authors to present four plays each at the festival of Dionysus. Three were tragedies and one a satyr play, so named from the actors portraying the half-human, half-animal (horse or goat) satyrs who were featured in this theatrical blend of drama and farce. The term *tragedy*—derived, for reasons now lost, from two Greek words meaning "goat" and "song"—referred to plays with plots involving fierce conflicts and characters representing powerful human and divine forces. Playwrights composed their tragedies in poetry with elevated, solemn language and frequently based their stories on imaginative reinterpretations of the violent consequences of the interaction between gods and people. The play often ended with a resolution to the trouble— but only after terrible suffering, emotional turmoil, and traumatic deaths.

The performance of ancient Greek plays bore little resemblance to conventional modern theater productions. Dramas were produced during the daytime in outdoor theaters (fig. 7.2). At Athens, the theater was located on the slope of the southern hillside of Athens's Acropolis. This theater sacred to Dionysus held around fourteen thousand spectators overlooking an open circular area in front of a slightly raised stage platform. Seating was temporary in the fifth century B.C.; the first stone theater was not installed until the following century. To ensure fairness in the competition, all tragedies were required to have the same-size cast, all of whom were men: three actors to play the speaking roles of all male and female characters, and fifteen chorus members, who performed songs and dances in the circular area in front of the stage, called the orchestra. The chorus had a leader who periodically engaged in dialogue with the other characters in the play. Since all the actors' lines were in verse with special rhythms, the musical aspect of the chorus's role was an elaboration of the overall poetic nature of Athenian tragedy and the dancing was part of its strongly visual impact on spectators.

Even though scenery on the stage was sparse, a well-written and pro-

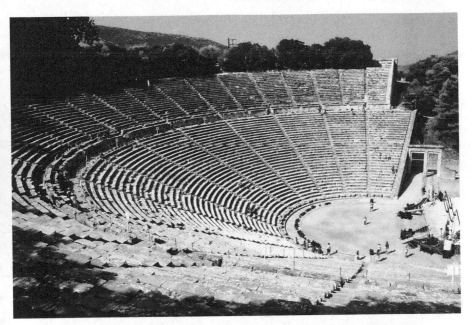

Fig. 7.2: The prosperity stemming from its internationally famous sanctuary of the healing god Asclepius allowed the city-state of Epidaurus in the Peloponnese to build a theater in the fourth century B.C. for fifteen thousand spectators to view plays and festival performances. Its acoustics are famous: A word softly spoken on its stage in quiet conditions can be heard in the top row of seats. Wikimedia Commons.

duced tragedy presented a vivid spectacle to its huge outdoor audience. The chorus wore elaborate decorative costumes and trained for months to perform intricate dance routines. The actors, who wore masks, used broad gestures to be seen as far away as the last row of seats and could project their voices with force, to be understood over wind blowing through the outdoor auditorium and over the crowd noise that inevitably arose from such large audiences; this incidental audio interference could overwhelm the good acoustics of the carefully built theaters in major city-states. A good voice and precise enunciation were crucial to a tragic actor because words represented the heart of a tragedy, in which dialogue and long speeches were more significant for conveying meaning than physical action. Special effects were, however, part of the spectacle. For example, a crane allowed actors playing the roles of gods to fly suddenly onto the stage, like superheroes in a modern movie. The actors playing the lead roles, called the protagonists ("first competitors"), were also competing against each other for the designation of best actor. So important was it to

have a first-rate lead actor to be able to put on a successful tragedy in the authors' competition that protagonists were assigned by lot to the competing playwrights of the year to give all three of them an equal chance to have the finest cast. Great protagonists became enormously popular figures, although, unlike many authors of plays, they were not usually members of the social elite.

The author of a slate of tragedies in the festival of Dionysus also served as director, producer, musical composer, choreographer, and sometimes even one of the actors. Only men with private wealth could afford the endless amounts of time such work demanded, because the prizes in the tragedy competition were probably modest and intense rehearsals lasted for months before the festival. As citizens, playwrights also fulfilled the normal military and political obligations of an Athenian man. The best-known Athenian tragedians—Aeschylus (525–456 B.C.), Sophocles (c. 496–406 B.C.), and Euripides (c. 485–406 B.C.)—all served in the army, held public office at some point in their careers, or did both. Aeschylus fought at Marathon and Salamis; the epitaph on his tombstone, which says nothing of his great success as a dramatist, reveals how highly he valued his contribution to his city-state as a citizen-soldier: "Under this stone lies Aeschylus the Athenian, son of Euphorion. . . . The grove at Marathon and the Persians who landed there were witnesses to his courage" (Pausanias, *Guide to Greece* 1.14.5).

Aeschylus's pride in his military service to his homeland points to a fundamental characteristic of Athenian tragedy: It was a public art form, an expression of the polis that explored the ethical dilemmas of human beings caught in conflict with the gods and with one another in a polis-like community. The plots of most tragedies were based on stories set in ancient times, before the creation of the polis, when myth said that kings ruled in Greece; tales from the era of the Trojan War were very popular subjects. Nevertheless, the moral issues embedded in the playwrights' re-interpretations of these old legends always pertained to the society and obligations of citizens in the contemporary polis. For example, Sophocles presented, probably in 447, a play entitled *Ajax*, the name of the second-best warrior (Achilles had been number one) in the Greek army fighting the Trojans. When the other fighters encamped before Troy voted to award the armor of the now-dead Achilles to the clever and glib Odysseus rather than to the physically more-imposing but mentally less-sharp Ajax, losing this competition of honor drove Ajax to madness and set him on a berserk rampage against his former friends in the Greek army. The goddess Athena thwarted Ajax because he had once arrogantly rejected her help in battle. Disgraced by his failure to secure revenge, Ajax committed suicide

despite the pleas of his wife, Tecmessa, not to abandon his family to the tender mercies of his enemies. Odysseus then used his verbal skills to convince the hostile Greek chiefs to bury Ajax because the future security of the army and the obligations of friendship demanded that they obey the divine injunction always to bury the dead, regardless of how badly the person had behaved while living. Odysseus's arguments in favor of burying Ajax anachronistically treat the army as if it were a polis, and his use of persuasive speech to achieve accommodation of conflicting individual interests to the benefit of the community corresponds to the way in which disputes in fifth-century Athens were supposed to be resolved.

In *Antigone* (probably produced in 441 B.C.), Sophocles presented a drama of bitter conflict between the family's moral obligation to bury its dead in obedience to divine command and the male-dominated city-state's need to preserve order and defend its communal values. Antigone, the daughter of Oedipus, the now-deceased former king of Thebes, comes into conflict with her uncle, the new ruler Creon, when he prohibits the burial of one of Antigone's two brothers on the grounds that he was a traitor. This brother had attacked Thebes after the other brother had broken an agreement to share the kingship. Both brothers died in the ensuing battle, but Antigone's uncle allowed the burial only of the brother who had remained in power at Thebes. When Antigone defies her uncle by symbolically burying the allegedly traitorous brother, her uncle the ruler condemns her to die. He realizes his error only when religious sacrifices go spectacularly wrong, indicating that the gods have rejected his decision and were expressing their anger at his outrage against the ancient tradition requiring proper burial of everyone. Creon's decision to punish Antigone ends in personal disaster when his son, who was in love with Antigone, kills himself, and then his wife, distraught at the loss of their son, commits suicide. In this horrifying story of anger, pride, and death, Sophocles deliberately exposes the right and wrong on each side of the conflict. Although Antigone's uncle eventually acknowledges a leader's responsibility to listen to his people, the play offers no easy resolution of the competing interests of divinely sanctioned moral tradition upheld by a woman and the political rules of the state enforced by a man.

A striking aspect of Greek tragedies is that these plays written and performed by men frequently portray women as central, active figures in their plots. At one level, the frequent depiction of women in tragedy allowed men accustomed to spending most of their time with other men to peer into what they imagined the world of women must be like. But the heroines portrayed in fifth-century Athenian tragedies also served to explore the tensions inherent in the moral code of contemporary society by strongly

reacting to men's violations of that code, especially as it pertained to the family and their status and honor as women. Sophocles' Antigone, for example, confronts the male ruler of her city because he deprived her family of its traditional prerogative to bury its dead. Antigone is remarkable in fearlessly criticizing a powerful man in a public debate about right and wrong. Sophocles, in other words, shows a woman who can express herself with the freedom of speech of an Athenian male citizen, who believed that he had the right to say things publicly that he knew other people did not want to hear and that would even enrage them. In this way and many others, heroines such as Antigone display through their actions and words on stage as characters in tragedies the qualities of courage and fortitude that men strove to achieve in their daily lives as politically engaged citizens.

Another heroine of tragedy equal to any man in resolve and action was Clytemnestra, the wife of Agamemnon, the leader of the Greek army in the Trojan War, in the drama *Agamemnon* by Aeschylus (produced in 458 B.C.). In the story as told in this play, Clytemnestra takes a lover and rules her city in her husband's place when Agamemnon subverts his marriage by sacrificing their daughter to appease an angry goddess who is holding up the Greek army sailing against Troy. Agamemnon then stays away from home for ten years during the war, and finally brings back home with him a captive Trojan princess whom he intends to install as a concubine alongside his legitimate spouse in their house. Enraged by her husband's betrayal of her and his public disrespect for her status as wife, mother, and queen, Clytemnestra arranges the murder of Agamemnon, avenging her honor but also motivating her children to seek deathly revenge on her and her lover for the slaughter of their father.

Of the three best-known authors of Athenian tragedies, Euripides depicts the most sensational heroines. His heroine Medea, the main character in the play *Medea* produced in 431 B.C., reacts with a shattering violence when Jason, her husband, proposes to divorce her in order to marry a richer, more-prominent woman. Jason's plans flout the social code governing marriage: A husband had no moral right to divorce a wife who had fulfilled her primary duty by bearing legitimate children, especially sons. To gain revenge, Medea uses magic to kill their children and Jason's new bride. Medea's murder of her own offspring destroys her proper role as wife and mother, yet she argues forcefully for a reevaluation of that role. She insists that women who bear children are due respect at least commensurate with that granted men who fight as hoplites: "People say that we women lead a safe life at home, while men have to go to war. What fools they are! I would much rather fight in the phalanx three times than give birth to a child only once" (*Medea*, lines 248–251).

Despite their often-gloomy outcomes, Sophocles' plays were overwhelmingly popular, and he earned the reputation as the Athenians' favorite author of tragedies. In a sixty-year career as a playwright, he competed in the dramatic festival about thirty times, winning at least twenty times and never finishing with less than second prize. Since the winning plays were selected by a panel of ordinary male citizens who were apparently influenced by the audience's reaction, Sophocles' record clearly means his works appealed to the large number of citizens attending the drama competition of the festival of Dionysus. These audiences most likely included women as well as men, and the issues raised by the plays certainly gave prominence to gender relations both in the family and in the community. We cannot know the spectators' precise understanding of Sophocles' messages and those of other authors' tragedies, but the audience must have been aware that the central characters of the plays were figures who fell from positions of power and prestige into violent disasters. These awful reversals of fortune come about not because the characters are absolute villains but because, as human beings, they are susceptible to a lethal mixture of error, ignorance, and hubris that the gods punish.

The Athenian Empire was at its height when audiences at Athens were seeing the plays of Sophocles. The presentation of the plays at the festival of Dionysus was preceded by a procession in the theater to display the revenues of Athens received from the dues paid by the allies in the Delian League. All the Athenian men in the audience were actual or potential combat veterans in the citizen-militia of the city-state and thus personally acquainted with the possibility of having to endure or inflict deadly violence in the service of their community. Thoughtful spectators would have perhaps reflected on the possibility that Athens's current power and prestige, managed as it was by human beings in the democratic assembly, remained hostage to the same forces that the playwrights taught controlled the often-bloody fates of the heroes and heroines of tragedy. Tragedies certainly had appeal because they were engrossing purely as entertainment, but they also had an educative function: to remind citizens, especially those who cast votes to make policy for the polis, that success and the force needed to maintain it engendered problems of a moral complexity too formidable to be fathomed casually or arrogantly.

ATHENIAN LIFE FOR WOMEN

Athenian women earned status and acquired power in both private and public life through their central roles in the family and religion, respectively. Their formal absence from politics, however, meant that their

contributions to the city-state might be overlooked by men. Melanippe, another heroine in a tragedy by Euripides, vigorously expresses this judgment in a famous speech denouncing men who denigrate women, expressing sentiments that have a modern echo: "Empty is the slanderous blame men place on women; it is no more than the twanging of a bowstring without an arrow; women are better than men, and I will prove it: women make agreements without having to have witnesses to guarantee their honesty. . . . Women manage the household and preserve its valuable property. Without a wife, no household is clean or happily prosperous. And in matters pertaining to the gods—this is our most important contribution—we have the greatest share. In the oracle at Delphi we propound the will of Apollo, and at the oracle of Zeus at Dodona we reveal the will of Zeus to any Greek who wishes to know it. Men cannot rightly perform the sacred rites for the Fates and the Anonymous Goddesses, but women make them flourish. . . ." (*Melanippe the Captive*, Fragment 13a).

Greek drama sometimes emphasized the areas in which Athenian women most obviously and publicly contributed to the polis: by acting as priestesses, by bearing and raising legitimate children to be the future citizens of the city-state, and by serving as managers of their households' property. Women's property rights in Classical Age Athens reflected both the importance of the control of property by women and the Greek predisposition to promote the formation and preservation of households headed by property-owning men. Under Athenian democracy, women could control property, even land—the most valued possession in their society—through dowry and inheritance, although they faced more legal restrictions than men did when they wanted to sell their property or give it away as gifts. Like men, women were supposed to preserve their property to be handed down to their children. If a family had any living sons, then daughters did not inherit from their father's property, instead receiving a portion of the family's wealth in their dowries at marriage. Similarly, a son whose father was still alive at the time of the son's marriage might receive a share of his inheritance ahead of time to allow him to set up a household. Perhaps one household in five had only daughters living, in which case the father's property then passed by inheritance to the daughters. Women could also inherit from other male relatives without male children. A bride's husband had legal control over the property in his wife's dowry, and their respective holdings frequently became commingled. In this sense husband and wife were co-owners of the household's common property, which had to be formally allotted between its separate owners only if the marriage were dissolved. The husband was legally responsible for preserving the dowry and using it for the support and comfort of his

wife and any children she bore him, and a groom often had to put up valuable land of his own as collateral to guarantee the safety of his bride's dowry. Upon her death, the dowry became the inheritance of her children. The expectation that a woman would have a dowry tended to encourage marriage within groups of similar wealth and status. As with the rules governing women's rights to inheritances, customary dowry arrangements supported the society's goal of enabling males to establish and maintain households—because daughters' dowries were usually smaller in value than their brothers' inheritances—and therefore kept the bulk of a father's property attached to his sons.

The same goal shows up clearly in Athenian law concerning heiresses. If a father died leaving only a daughter to survive him, his property passed to her as his heiress, but she did not own it in the modern sense of being able to dispose of it as she pleased. Instead, Athenian law (in the simplest case) required her father's closest male relative—her official guardian after her father's death—to marry her himself, with the aim of producing a son. The inherited property then belonged to that son when he reached adulthood. As a disputant in a fourth-century B.C. court case about an heiress said, "We think that the closest kin should marry her and that the property should belong to the heiress until she has sons, who will take it over two years after coming of age" (Isaeus, *Orations*, Fragment 25).

The law on heiresses served to keep the property in their fathers' families, and, theoretically at least, it could require major personal sacrifices from the heiress and her closest living male relative. That is because the law applied regardless of whether the heiress was already married (so long as she had not given birth to any sons) or whether the male relative already had a wife. The heiress and the male relative were both supposed to divorce their present spouses and marry each other, which they might well not be at all willing to do. In practice, therefore, people often found ways to get around this requirement by various technical legal maneuvers. In any case, the law was intended to prevent rich men from getting richer by bribing wealthy heiresses' guardians to marry the woman and therefore merge their estates, and, above all, to stop property from piling up in the hands of unmarried women. At Sparta, Aristotle reported, precisely this agglomeration of wealth outside men's control took place as women inherited land or received it in their dowries without—to Aristotle's way of thinking—adequate regulations requiring the women to remarry. He claimed that women in this way had come to own 40 percent of Spartan territory. The law at Athens was evidently more successful at regulating women's control over property in the interests of promoting the formation of households headed by property-owning men.

In Euripides' play bearing her name, Medea's comment to the effect that men said women led a safe life at home reflected the expectation in Athenian society that a woman from the propertied class would avoid frequent or close contact with men who were not members of her own family or its circle of friends. Women of this socioeconomic level were therefore supposed to spend much of their time in their own homes or in the homes of women friends. There, women dressed, slept, and worked in interior rooms and in the central open courtyard characteristic of Greek houses. Male visitors from outside the family were banned from entering the rooms in a house designated as women's space, which did not mean an area to which women were confined but rather the places where they conducted their activities in a flexible use of domestic space varying from house to house. In the rooms women controlled, they would spin wool for clothing while chatting with female friends over for a visit, play with their children, and direct the work of female slaves. In the courtyard at the center of the house, where men and women could interact, they would offer their opinions on family matters and pubic politics to male family members as they came and went. One room in a house was usually set aside as the men's dining room (andrōn), where the husband could entertain male friends, reclining on couches set against the wall in Greek fashion, without their coming into contact with the women of his family except for slaves. Poor women had much less time for domestic activities, because they, like their husbands, sons, and brothers, had to leave their homes—often only a crowded rental apartment—to find work. As small-scale entrepreneurs, they set up stalls to sell bread, vegetables, simple clothing, or trinkets. Their male relatives had more freedom to work in a variety of jobs, especially as laborers in workshops, foundries, and construction sites.

Expectations of female modesty dictated that a woman with servants who answered the door of her house herself would be reproached as careless of her reputation. So too a proper woman went out only for an appropriate reason, usually covering her head with a scarflike veil. Fortunately, Athenian life offered many occasions for women to go out in the city: religious festivals, funerals, childbirths at the houses of relatives and friends, and trips to workshops to buy shoes or other articles. Sometimes a woman's husband would escort her, but more often she was accompanied only by a servant or female friends and had more opportunity for independent action. Social protocol demanded that men not speak the names of respectable women in public conversations and speeches in court unless practical necessity demanded it.

Since women stayed inside or in the shade so much, those rich enough not to have to work maintained very pale complexions. This pallor was

much admired as a sign of an enviable life of leisure and wealth, much as an even, all-over tan is valued today for the same reason. Women regularly used powdered white lead as makeup to give themselves a suitably pallid look. Presumably, many upper-class women valued their life of limited contact with men outside the household as a badge of their superior social status. In a gender-divided society such as that of the wealthy at Athens, the primary opportunities for personal relationships in an upper-class woman's life probably came in her contact with her children and the other women with whom she spent most of her time.

The social restrictions on women's freedom of movement served men's goal of avoiding uncertainty about the paternity of children by limiting opportunities for adultery among wives and protecting the virginity of daughters. Given the importance of citizenship as the defining political structure of the city-state and of a man's personal freedom, an Athenian husband, like other Greeks and indeed everyone else, felt it crucially important to be certain a boy truly was his son and not the offspring of some other man, who could conceivably even be a foreigner or a slave. Furthermore, the preference for keeping property in the father's line meant that the boys who inherited a father's property needed to be his legitimate sons. In this patriarchal system, citizenship and property rights therefore led to restrictions on women's freedom of movement in society. Women who did bear legitimate children, however, immediately earned a higher status and greater freedom in the family, as explained, for example, by an Athenian man in his remarks before a jury when he was on trial for having killed an adulterer whom he had caught with his wife: "After my marriage, I initially refrained from bothering my wife very much, but neither did I allow her too much independence. I kept an eye on her. . . . But after she had a baby, I started to trust her more and put her in charge of all my things, believing we now had the closest of relationships" (Lysias, *Orations* 1.6). Bearing male children brought special honor to a woman because sons meant security for parents. Adult sons could appear in court in support of their parents in lawsuits and protect them in the streets of the city, which for most of its history had no regular police force. By law, sons were required to support their parents in old age, a necessity in a society with no state-sponsored system for the support of the elderly, such as Social Security in the United States. So intense was the pressure to produce sons that stories were common of barren women who smuggled in babies born to slaves to pass them off as their own. Such tales, whose truth is hard to gauge, were credible only because husbands customarily stayed away at childbirth.

Men, unlike women, had sexual opportunities outside marriage that

carried no penalties. "Certainly you don't think men beget children out of sexual desire?" wrote the upper-class author Xenophon. "The streets and the brothels are swarming with ways to take care of that" (Memorabilia 2.2.4). Besides having sex with female slaves, who could not refuse their masters, men could choose among various classes of prostitutes, depending on how much money they had to spend. A man could not keep a prostitute in the same house as his wife without causing trouble, but otherwise he incurred no disgrace by paying for sex. The most expensive female prostitutes the Greeks called "companions" (hetairai). Usually from another city-state than the one in which they worked, companions supplemented their physical attractiveness with the ability to sing and play musical instruments at men's dinner parties, to which wives were not invited (fig. 7.3). Many companions lived precarious lives, subject to exploitation or even violence at the hands of their male customers. The most accomplished companions, however, could attract lovers from the highest levels of society and become sufficiently rich to live in luxury on their own. Their independent existence and earned income strongly distinguished them from well-off married women, as did the freedom to control their own sexuality. Equally distinctive was their cultivated ability to converse with men in public. Like the geisha of Japan, companions in ancient Greece entertained men especially with their witty, bantering conversation. Their characteristic skill at clever taunts and verbal snubs endowed companions with a power of speech ordinarily denied to most proper women. Only very rich citizen women of advanced years, such as Elpinike, the sister of the famous military commander Cimon, could enjoy a similar freedom of expression. She, for example, once publicly rebuked the political leader Pericles for having boasted about the Athenian conquest of the city-state on Samos after its rebellion. When other Athenian women were praising Pericles for his success, Elpinike sarcastically remarked, "This really is wonderful, Pericles, . . . that you have caused the loss of many good citizens, not in battle against Phoenicians or Persians, like my brother Cimon, but in suppressing an allied city of fellow Greeks" (Plutarch, Pericles 28).

A man speaking in a lawsuit succinctly described the theoretical purposes assigned the different categories of women by Athenian men: "We have 'companions' for the sake of pleasure, ordinary prostitutes for daily attention to our physical needs, and wives to bear legitimate children and to be faithful guards inside our households" (Demosthenes, Orations 59.122). In practice, of course, the roles filled by women did not necessarily correspond to this idealized scheme; a husband could expect his wife to perform all of them. The social marginality of companions—they

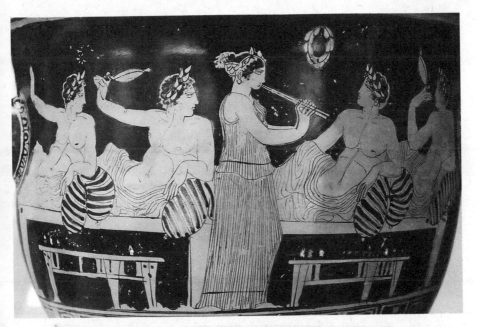

Fig. 7.3: This red-figure style vase depicts a symposium (men's drinking party) at which a female "companion" (*hetaira*) is entertaining the guests by playing music on the *aulos*, a reed instrument with finger holes. Two of the men are playing *kottabos*, a messy party game in which they flung the dregs of their wine from their shallow drinking cups. Marie-Lan Nguyen / Wikimedia Commons.

were often not citizens; they could not legally marry; they had unsavory reputations—empowered them in speech and in sexuality because by definition they were expected to break the norms of respectability. Other women, by contrast, earned respect and social status by obeying these norms.

TRAINING FOR PUBLIC LIFE

Athenians learned the norms of respectable behavior for both women and men not in school but in their families and from the countless social interactions of everyday life. Formal education in the modern sense hardly existed because schools subsidized by the state did not exist. Only well-to-do families could afford to pay the fees charged by private teachers, to whom they sent their sons to learn to read, to write, perhaps to learn to sing or play a musical instrument, and to train for athletics and military

service. Physical fitness was considered so important for men, who could be called on for military service in the militia from the age of eighteen until sixty, that the city-state provided open-air exercise facilities for daily workouts. These gymnasia were also favorite places for political conversations and the exchange of news. The daughters of well-to-do families often learned to read, write, and do simple arithmetic, presumably from being instructed at home, because a woman with these skills would be better prepared to manage the household finances and supplies for the husband of property whom she was expected to marry and partner with in overseeing their resources.

Poorer girls and boys learned a trade and perhaps some rudiments of literacy by helping their parents in their daily work, or, if they were fortunate, by being apprenticed to skilled crafts producers. As mentioned earlier, a law of Solon required fathers to teach their sons a skill for making a living; otherwise, the children would be freed from the duty of supporting their parents when as senior citizens they became too old to work themselves. The level of literacy in Athenian society outside the ranks of the prosperous was probably quite low by modern standards, with only a small minority of the poor able to do much more than perhaps sign their names. The inability to read presented few insurmountable difficulties for most people, who could find someone to read aloud to them any written texts they needed to understand. The predominance of oral rather than written communication meant that people were accustomed to absorbing information by ear (those who could read usually read out loud), and Greeks were very fond of songs, speeches, narrated stories, and lively conversation, and their memories were trained to recall what they heard by ear. Like the son of the famous Athenian general Nicias, people were known to memorize the entire *Iliad* and *Odyssey*, for example.

Young men from prosperous families traditionally acquired the advanced skills required for successful participation in the public life of Athenian democracy by observing their fathers, uncles, and other older men as they participated in the assembly, served on the council or as magistrates, and made speeches in court cases. The most important skill to acquire was the ability to speak persuasively in public. In many cases, an older man would choose an adolescent boy as his special favorite to educate. The boy would learn about public life by spending his time in the company of the older man and his adult friends. During the day, the boy would observe his mentor talking politics in the agora or giving speeches in the assembly or courts, help him perform his duties in public office, and work out with him in a gymnasium. Their evenings would be spent at a symposium, a drinking party for men and companions, which could

encompass a range of behavior from serious political and philosophical discussion to riotous partying.

Such a mentor-protégé relationship commonly implied homosexual love as an expression of the bond between the boy and the older male, who would normally be married. As mentioned in the discussion of Sparta, it is difficult to apply modern categories and judgments to ancient Greek sexuality and sexual norms; contemporary judgments range from acceptance to condemnation and imputations of pederasty. In any case, Greeks by this period found it natural for an older man to be excited by the physical beauty of a boy (as also of a lovely girl). The love between the older "lover" (*erastēs*) and the younger "beloved" (*erōmenos*) implied more than just desire, however. The eroticism of the relationship had to be played out as a type of contest for status, with the younger man wishing to appear desirable but sufficiently in control to reject or modify his older pursuer's demands, and the older man wishing to demonstrate his power and ability to overcome resistance by winning a physical relationship with the young object of his pursuit. Although male homosexuality outside a mentor-protégé relationship and female homosexuality in general incurred disgrace, the special homosexuality between older mentors and younger protégés was accepted as appropriate behavior in many—but not all—city-states, so long as the older man did not exploit his younger companion purely for physical gratification or neglect the youth's education in public affairs. Plato portrayed a plain-thinking fifth-century B.C. Athenian man summing up what was apparently a common opinion about appropriate male homosexual love: "I believe that the greatest good for a youth is to have a worthy lover from early on and, for a lover, to have a worthy beloved. The values that men need who want to live lives of excellence lifelong are better instilled by love than by their relatives or offices or wealth or anything else. . . . I mean the values that produce feelings of shame for disgraceful actions and ambition for excellence. Without these values neither a city-state nor a private person can accomplish great and excellent things. . . . Even a small army of such men, fighting side by side, could defeat, so to speak, the entire world because a lover could more easily endure everyone else rather than his beloved seeing him desert his post or throw down his weapons. He would die many times over before allowing that to happen" (*Symposium* 178c–179a).

In the second half of the fifth century, a new brand of self-proclaimed teachers appeared, offering more organized instruction to young men seeking to develop the skills in public speaking and argumentation needed to excel in democratic politics. These instructors were called sophists ("wise men"), a label that acquired a pejorative sense (preserved in the

English word *sophistry*) because they were so clever at public speaking and philosophic debates. Sophists were detested and even feared by many traditionally minded men, whose political opinions and influence they threatened. The earliest sophists arose in parts of the Greek world other than Athens, but from about 450 B.C. on they began to travel to Athens, which was then at the height of its material prosperity and cultural reputation, to search for pupils who could pay the hefty prices the sophists charged for their instruction. Wealthy young men flocked to the dazzling demonstrations that these itinerant teachers put on to showcase their ability to speak persuasively, an ability that they claimed to be able to impart to students. The sophists were offering just what every ambitious young man wanted to learn, because the greatest single skill that a man in democratic Athens could possess was to be able to persuade his fellow citizens in the debates of the assembly and the council or in lawsuits before large juries. For those unwilling or unable to master the new rhetorical skills of sophistry, the sophists (for stiff fees) would compose speeches to be delivered by the purchaser as his own composition. The overwhelming importance of persuasive speech in an oral culture like that of ancient Greece made the sophists frightening figures to many, for the new teachers offered an escalation of the power of speech that seemed potentially destabilizing to political and social traditions.

The most famous sophist was Protagoras, a contemporary of Pericles, from Abdera in northern Greece. Protagoras moved to Athens around 450 B.C., when he was about forty, and spent most of his career there. His oratorical ability and his upright character so impressed the men of Athens that they chose him to devise a code of laws for a new Panhellenic colony founded in Thurii in southern Italy in 444. Some of Protagoras's ideas, however, shocked traditional-minded citizens, who feared their effects on the community. One was his agnostic opinion concerning the gods: "Whether the gods exist I cannot discover, nor what their form is like, for there are many impediments to knowledge, [such as] the obscurity of the subject and the brevity of human life" (Diogenes Laertius, *Lives of Eminent Philosophers* 9.51 = D.-K. 80B4). It is easy to see how people might think that the gods would take offense at this view and therefore punish the city-state that permitted Protagoras to teach there.

Equally controversial was Protagoras's denial of an absolute standard of truth, his assertion that every issue has two, irreconcilable sides. For example, if one person feeling a breeze thinks it is warm, while a different person judges the same wind to be cool, Protagoras said there is no way to decide which judgment is correct because the wind simply is warm to the

one person and cool to the other. Protagoras summed up his subjectivism (the belief that there is no absolute reality behind and independent of appearances) in the much-quoted opening of his work entitled Truth (most of which is now lost): "Man is the measure of all things, of the things that are that they are, and of the things that are not that they are not" (Plato, Theaetetus 151e = D.-K. 80B1). "Man" in this passage (anthrōpos in Greek, hence our word anthropology) seems to refer to the individual human being, both male and female, whom Protagoras makes the sole judge of his or her own impressions. Protagoras's critics denounced him for these views, accusing him of teaching his students how to make the weaker argument the stronger and therefore how to deceive and bamboozle other people with seductively persuasive but dangerous arguments. This, they feared, was a threat to their democracy, which depended on persuasion based on truth and employed for the good of the community.

THE IMPACT OF NEW IDEAS

The ideas and techniques of argumentation that sophists such as Protagoras taught made many Athenians nervous or even outraged, especially because leading citizens such as Pericles flocked to hear this new kind of teacher. Two related views taught by sophists aroused special controversy: (1) that human institutions and values were not products of nature (physis) but rather only the artifacts of custom, convention, or law (nomos), and (2) that, since truth was relative, speakers should be able to argue either side of a question with equal persuasiveness. The first idea implied that traditional human institutions were arbitrary rather than grounded in immutable nature, and the second idea made rhetoric into an amoral technique for persuasion. The combination of the two ideas seemed exceptionally dangerous to a society so devoted to the spoken word, because it threatened the shared public values of the polis with unpredictable changes. Protagoras himself insisted that his intellectual doctrines and his techniques for effective public speaking were not hostile to democracy, especially because he argued that every person had an innate capability for excellence and that human survival depended on people respecting the rule of law based on a sense of justice. Members of the community, he argued, should be persuaded to obey the laws not because they were based on absolute truth, which did not exist, but because it was in people's own interests to live according to society's agreed-upon standards of behavior. A thief, for instance, who might claim that in his opinion a law against stealing had no value or validity, would have to be persuaded that laws against theft

worked to his advantage because they protected his own property and promoted the well-being of the community in which he, like everyone else, had to live in order to survive and flourish.

The instruction that Protagoras offered struck some Athenian men as ridiculous hair splitting. One of Pericles' sons, for example, who had become estranged from his father, made fun of him for disputing with Protagoras about the accidental death of a spectator killed by a javelin thrown by an athlete in a competition. The politician and the sophist had spent an entire day debating whether the javelin itself, the athlete, or the judges of the contest were responsible for the tragic death. Such criticism missed the point of Protagoras's teachings, however. He never meant to help wealthy young men undermine the social stability of the traditional city-state. Some later sophists, however, had fewer scruples about the uses to which their instruction in arguing both sides of a case might be put. An anonymous handbook compiled in the late fifth century B.C., for example, provided examples of how rhetoric could be used to stand common-sense arguments on their heads:

> Greeks interested in philosophy propose double arguments about the good and the bad. Some of them claim that the good is one thing and the bad something else, but others claim that the good and the bad are the same thing. This second group also says that the identical thing might be good for some people but bad for others, or at a certain time good and at another time bad for the same individual. I myself agree with those holding the latter opinion, which I shall investigate by taking human life as my example and its concern for food, drink, and sexual pleasures: these things are bad for a man if he is ill but good if he is healthy and has need of them. Furthermore, overindulgence in these things is bad for the person who gets too much of them but good for those who profit by selling these things to those who overindulge. Here is another point: illness is a bad thing for the patient but good for the doctors. And death is bad for those who die but good for the undertakers and sellers of grave monuments. . . . Shipwrecks are bad for the ship-owners but good for the shipbuilders. When tools become blunt and worn down it is bad for their owners but good for the toolmaker. And if a piece of pottery gets broken, this is bad for everyone else but good for the pottery maker. When shoes wear out and fall apart it is bad for others but good for the shoemaker. . . . In the stadion race for runners, victory is good for the winner but bad for the losers.
> —(Dissoi Logoi [Double Arguments] 1.1–6)

Skill in arguing both sides of a case and a relativistic approach to such fundamental issues as the moral basis of the rule of law in society were

not the only aspects of these new intellectual developments that disturbed many Athenian men. Fifth-century B.C. thinkers and philosophers, such as Anaxagoras of Clazomenae in Ionia and Leucippus of Miletus, propounded unsettling new theories about the nature of the cosmos in response to the provocative physics of the earlier Ionian thinkers of the sixth century. Anaxagoras's general theory postulating an abstract force that he called "mind" as the organizing principle of the universe probably impressed most people as too obscure to worry about, but the details of his thought could offend those who held to the assumptions of traditional religion. For example, he argued that the sun was in truth nothing more than a lump of flaming rock, not a divine entity. Leucippus, whose doctrines were made famous by his pupil Democritus of Abdera, invented an atomic theory of matter to explain how change was possible and indeed constant. Everything, he argued, consisted of tiny, invisible particles in eternal motion. Their endless collisions caused them to combine and recombine in an infinite variety of forms. This physical explanation of the source of change, like Anaxagoras's analysis of the nature of the sun, seemed to deny the validity of the entire superstructure of traditional religion, which explained events as the outcome of divine forces and the will of the gods.

Many Athenians feared that the teachings of the sophists and philosophers could offend the gods and therefore destroy the divine favor and protection that they believed their city-state enjoyed. Just like a murderer, a teacher spouting doctrines offensive to the gods could bring pollution and therefore divine punishment on the whole community. So deeply felt was this anxiety that Pericles' friendship with Protagoras, Anaxagoras, and other controversial intellectuals gave his rivals a weapon to use against him when political tensions came to a head in the 430s B.C. as a result of the threat of war with Sparta: His opponents criticized him as being sympathetic to dangerous new ideas as well as to being autocratic in his leadership.

Sophists were not the only thinkers to emerge with new ideas in the mid-fifth century B.C. In historical writing, for example, Hecataeus of Miletus, born in the later sixth century, had earlier opened the way to a broader and more critical vision of the past. He wrote both an extensive guidebook to illustrate his map of the world as he knew it and a treatise criticizing mythological traditions. The Greek historians writing immediately after him concentrated on the histories of their local areas and wrote in a spare, chroniclelike style that made history into little more than a list of events and geographical facts. As mentioned in chapter 1, Herodotus, who was from Halicarnassus (c. 485–425 B.C.), opened an entirely new perspective on the possibilities for history writing by compos-

ing his enormous, wide-ranging, and provocative work *The Histories*. His narrative broke new ground with its vast geographical scope, critical approach to historical evidence, complex interpretation of the innately just nature of the cosmos, and respectful exploration of the culture and ideas of diverse peoples, both Greek and barbarian. To describe and explain the clash between East and West that exploded in the Persian Wars, Herodotus searched for the origins of the conflict both by delving deep into the past and by examining the traditions and assumptions of all the peoples involved. With his interest in ethnography, he recognized the importance and the delight of studying the cultures of others as a component of historical investigation. His subtle examination of what he saw as the evidence for the retributive justice imposed by the natural order of the universe expressed a profound and sometimes disturbing analysis of the fate of human beings on this earth.

Just as revolutionary as the ideas of Herodotus in history were those in medicine by Hippocrates, a younger contemporary whose name became the famous one in the long history of ancient Greek medical theories and treatments. Details are sketchy about the life and thought of this influential doctor from the Aegean island of Cos, but the works preserved under his name show that he took innovative and influential strides toward putting medical diagnosis and treatment on a scientific basis. Hippocrates' contribution to medicine is remembered today in the oath bearing his name, which doctors customarily swear at the beginning of their professional careers. Earlier Greek medical ideas and treatments had depended on magic and ritual. Hippocrates took a completely new approach, regarding the human body as an organism whose parts must be seen as part of an interrelated whole and whose functioning and malfunctioning must be understood as responses to physical causes. Even in antiquity, however, medical writers disagreed about the underlying theoretical foundation of Hippocrates' medicine. Some attributed to him the view, popular in later times, that four fluids, called humors, make up the human body: blood, phlegm, black bile, and yellow bile. Being healthy meant being in "good humor." This intellectual system corresponded to the division of the inanimate world into the four elements of earth, air, fire, and water.

What is certain is Hippocrates' crucial insistence that doctors should base their knowledge and decisions on careful observation of patients and the responses of sick people to remedies and treatments. Empirically grounded clinical experience, he taught, was the best guide to medicines and therapies that would above all, as his oath said, "abstain from doing the patient harm." Medical treatments, he knew, could be powerfully injurious as well as therapeutic: Drugs could as easily poison as heal. Treat-

ments administered without reliable evidence of their positive effects were irresponsible. The most startling innovation of Hippocrates' medical doctrine was that it apparently made little or no mention of a divine role in sickness and its cures. This repudiated the basis of various medical cults in Greek religion, most famously that of the god Asclepius, which offered healing to patients who worshipped in his sanctuaries. It was a radical break with tradition to take the gods out of medicine, but that is what Hippocrates did, for the good of his patients, he believed.

There is unfortunately little direct evidence for the impact on ordinary people of the new developments in history and medicine, but their worries and even anger about the new trends in education, oratory, and philosophy with which Pericles was associated are recorded. These novel intellectual developments helped fuel tensions in Athens in the 430s B.C. They had a wide-ranging effect because the political, intellectual, and religious dimensions of life in ancient Athens were so intricately connected. A person could feel like talking about the city-state's foreign and domestic policies on one occasion, about novel theories of the nature of the universe on another, and on every occasion about whether the gods were angry or pleased with the community. By the late 430s B.C., Athenians had new reasons to feel deep anxiety about each of these topics that mattered so deeply to their lives as citizens and individuals.

The Peloponnesian War and Its Aftermath at Athens

Athens and Sparta had cooperated in the fight against Xerxes' great invasion of Greece in 480–479 B.C., but by the middle of the fifth century B.C. relations between the two most powerful states of mainland Greece had deteriorated to such a point that open hostilities erupted. The peace they made in 446–465 to end these battles was supposed to endure for thirty years, but the conflicts between them in the 430s led once again to an insupportably high level of tension. The resulting Peloponnesian War lasted twenty-seven years, from 431 to 404, engulfing most of the Greek world at one time or another during its generation-long extent. Extraordinary in Greek history for its protracted length, the deaths and expenses of this bitter Greek-on-Greek conflict shattered the social and political harmony of Athens, sapped its economic strength, decimated its population, and turned its citizens' everyday lives upside down. The war exposed sharp divisions among Athenian citizens over how to govern the city-state and whether to keep fighting as the bodies and the bills piled up higher than they could handle. Their homegrown disagreements were expressed most eloquently and bitingly in the comedies that Aristophanes (c. 455–385 B.C.) produced during the war years. There were other fifth-century comic authors whose plays also exposed the stresses of war at Athens, but Aristophanes is the only one for whom we have comic

433 B.C.: Athens and Corinth clash over former Corinthian ally.

432 B.C.: Athens imposes economic sanctions on Megara.

431 B.C.: War begins with first Spartan invasion of Attica and Athenian naval raids on the Peloponnese.

430–426 B.C.: Epidemic strikes Athens.

429 B.C.: Pericles dies in epidemic.

425 B.C.: Athenians commanded by Cleon capture Spartan hoplites at Pylos; Aristophanes' comedy *The Acharnians* produced at Athens.

424 B.C.: Aristophanes' comedy *The Knights* produced at Athens.

422 B.C.: Cleon and Brasidas killed in battle of Amphipolis.

421 B.C.: Peace of Nicias reestablishes prewar alliances.

418 B.C.: Athenians defeated at Mantinea; war with Sparta resumes.

416 B.C.: Athens attacks the island of Melos.

415 B.C.: Athenian expedition launched against Syracuse on the island of Sicily; Alcibiades defects to Sparta.

414 B.C.: Aristophanes' comedy *The Birds* produced at Athens.

413 B.C.: Destruction of Athenian forces in Sicily; establishment of Spartan base at Decelea in Attica.

411B.C.: Athenian democracy temporarily abolished; Aristophanes' comedy *Lysistrata* produced at Athens.

410 B.C.: Alcibiades commands an Athenian naval victory over the Spartans at Cyzicus; democracy is restored at Athens.

404 B.C.: Athens surrenders to Spartan army commanded by the Spartan general Lysander.

404–403 B.C.: Reign of terror of the Thirty Tyrants at Athens.

403 B.C.: Overthrow of the Thirty Tyrants in civil war and restoration of Athenian democracy.

399 B.C.: Trial and execution of Socrates at Athens.

By 393 B.C.: Rebuilding of Long Walls of Athens completed.

dramas whose texts have survived intact. Even after the active bloodshed of the war died out with Athens's surrender in 403, the trial and execution of the philosopher Socrates in 399 revealed that the bitterness and recriminations dividing Athenians lived on.

The losses that Athens suffered in the Peloponnesian War show the sad,

if unanticipated, consequences of the repeated unwillingness of the male voters in the city-state's democratic assembly to negotiate peace terms with the enemy: By insisting on total victory they lost everything. The other side of the coin, so to speak, is the remarkable resilience that Athenians demonstrated in recovering from their wartime defeats and severe losses of manpower. The magnitude of the conflict and the unprecedented, if controversial, contemporary analysis of it provided by Thucydides justify the high level of attention that modern historians and political scientists have devoted to studying this conflict and its effects on the people who fought it.

THE CAUSES OF THE PELOPONNESIAN WAR

Most of our knowledge of the causes and the events of this long and bloody war depends on the history written by the Athenian Thucydides (c. 460–400 B.C.). Thucydides served as an Athenian commander in northern Greece in the early years of the war. In 424 B.C., however, the assembly exiled him for twenty years as punishment for failing to protect a valuable northern outpost, Amphipolis, from defecting to the Spartan side. During his exile, Thucydides was able to interview witnesses from both sides of the conflict. Unlike Herodotus, Thucydides concentrated on contemporary history and presented his account of the events of the war in an annalistic framework—that is, according to the years of the war, with only occasional divergences from chronological order. Like Herodotus, however, he included versions of direct speeches in addition to the description of events. The speeches in Thucydides' annals, usually longer and more complex than those in Herodotus's, vividly describe and analyze major events and issues of the war in complex and dramatic language. Their contents usually present the motives of the participants in the war. Scholars disagree about the extent to which Thucydides has put words and ideas into the mouths of his speakers, but it seems indisputable that the speeches deal with the moral and political issues that Thucydides saw as central for understanding the Peloponnesian War as well as human conflict in general. Thucydides' own comments offer broad, often-pessimistic interpretations of human nature and behavior. His perceptive chronicle of events and disturbing interpretation of human motivations made his book a pioneering work of history as the narrative of disturbing contemporary events and power politics.

The Peloponnesian War, like most wars, had a complex origin. Thucydides reveals that the immediate causes centered on disputes between Athens and Sparta in the 430s concerning whether they could each set

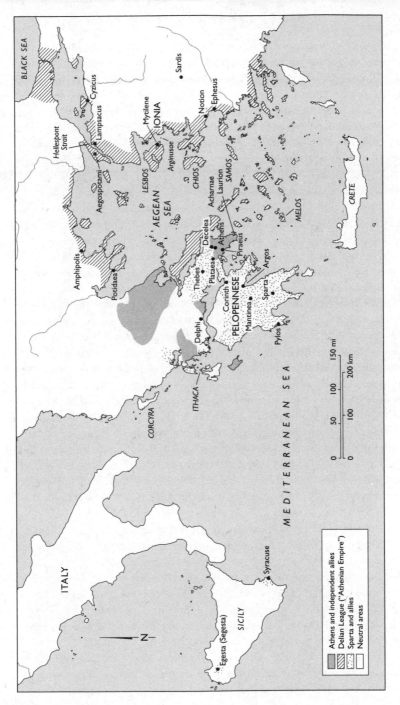

Map 6. The Peloponnesian War

BLACK SEA

Cyzicus
Lampsacus
Hellespont
Strait
Aegospotami
Amphipolis
Potidaea
LESBOS
Myrilene
IONIA
Notion
Ephesus
Sardis
Arginusae
CHIOS
SAMOS
Acharnae
Laurion
AEGEAN
SEA
Decelea
Athens
Piraeus
MELOS
CRETE
Delphi
Thebes
Plataea
Corinth
Argos
PELOPENNESE
Mantinea
Sparta
Pylos
ITHACA
CORCYRA
ITALY
SICILY
Egesta (Segesta)
Syracuse
MEDITERRANEAN SEA
N

0 50 100 150 mi
0 100 200 km

Athens and independent allies
Delian League ("Athenian Empire")
Sparta and allies
Neutral areas

their own independent courses in dealing with the city-states allied to the other. Violent disputes broke out concerning Athenian aid to Corcyra (an island naval power in conflict with Corinth, a principal Spartan ally), the economic sanctions imposed by Athens against the neighboring city-state of Megara (a Spartan ally located immediately west of Athenian territory), and the Athenian blockade of Potidaea (a strategically positioned city-state in northern Greece formerly allied to Athens but now in revolt and seeking help from Corinth). The deeper causes involved the antagonists' ambitions for hegemony in Greece, fears of each other's power, and determination to remain free from interference by a strong and hostile rival.

The outbreak of the war came when the Spartans issued ultimatums to Athens that the Athenian assembly rejected at the urging of Pericles. The Spartans threatened open warfare unless Athens lifted its economic sanctions against Megara and stopped its military blockade of Potidaea. The Athenians had prohibited the Megarians from trading in all the harbors of the Athenian Empire, a severe blow for Megara, which depended on the revenue from seaborne trade. The Athenians had imposed the sanctions in retaliation for alleged Megarian encroachment on sacred land along the border between Megara and Athens. Potidaea retained ties to Corinth, the city that had originally founded it, and Corinth, a Spartan ally, had protested the Athenian blockade of its colony. The Corinthians were by this time already angry with the Athenians for supporting the city-state of Corcyra in its earlier quarrel with Corinth and for making an alliance with Corcyra and its formidable navy. The Spartans issued their ultimatums in order to placate the Megarians and, more importantly, the Corinthians with their powerful naval force. The Corinthians had bluntly informed the Spartans that they would withdraw from the Peloponnesian League and add their ships to the Athenian alliance if the Spartans delayed any longer in backing them in their dispute with the Athenians over Potidaea; this threat forced the Spartans to draw a line in the sand with Athens.

That line was drawn when the Spartans demanded that the Athenians rescind the Megarian Decree, as the economic sanctions are called today, or face war. In answer to this demand, Pericles is said to have replied frostily that the Athenian assembly had passed a law barring anyone from taking down the inscribed panel on which the text of the sanctions against Megara had been publicly displayed. "All right, then," exploded the head of the Spartan delegation, "you don't have to take the panel down. Just turn its inscribed side to the wall. Surely you have no law prohibiting that!" (Plutarch, *Pericles* 30). This anecdote about the Megarian Decree bluntly exposes the rancor that had come to characterize Spartan-Athenian relations in the late 430s. In the end, then, the actions of lesser powers pushed

the two great powers, Athens and Sparta, over the brink to open conflict in 431.

The dispute over Athenian sanctions against Megara, as well as over its use of force against Potidaea and alliance with Corcyra, reflected the larger issues of power motivating the hostility between Athens and Sparta. The Spartan leaders feared that the Athenians would use their superiority in long-distance offensive weaponry—the naval forces of the Delian League—to destroy Spartan control of the Peloponnesian League. The majority in the Athenian assembly, for their part, resented Spartan interference in their freedom of action. For example, Thucydides portrays Pericles as making the following arguments in a speech to his fellow male citizens: "If we do go to war, harbor no thought that you went to war over a trivial affair. For you this trifling matter is the assurance and the proof of your determination. If you yield to the enemy's demands, they will immediately confront you with some larger demand, since they will think that you only gave way on the first point out of fear. But if you stand firm, you will show them that they have to deal with you as equals. . . . When our equals, without agreeing to arbitration of the matter under dispute, make claims on us as neighbors and state those claims as commands, it would be no better than slavery to give in to them, no matter how large or how small the claim may be" (The Peloponnesian War 1.141).

Thucydides' rendition of Pericles' strongly worded "slippery slope" argument, to the effect that compromise inevitably leads to "slavery," certainly has a ring of truth. (It is no accident that historians criticize the English prime minister Neville Chamberlain for giving in to Adolf Hitler's demand in A.D. 1938 to annex Czechoslovakia's Sudetenland, because it only encouraged the Nazi dictator to undertake even bolder takeovers.) People still quote the saying "Give 'em an inch and they'll take a mile!" because that is often the reality. At the same time, surely there are times and places when compromise with an opponent makes sense as a way to avoid a destructive and unpredictable war. But is that dishonorable, even if prudent? Would it matter if it was? Were the Athenians, when they were persuaded by Pericles in 431 B.C. to reject the Spartan ultimatum, remembering their reply to the Spartans during the Persian Wars in 479, when they said there was no offer from the Persian king that could induce them to collaborate in reducing the Greeks to "slavery"? If so, were the circumstances actually analogous? Was the notion of "slavery" the right metaphor to characterize what would have resulted if the Athenians had negotiated one more time in 431? Or did the Spartans truly give them no option except to go to war? The ambiguity of the circumstances leading up to the outbreak of the Peloponnesian War and Thucydides' brilliant

dramatization of the motives of the Athenians and the Spartans provide, it seems to me, a fascinatingly provocative example of how ancient Greek history can be "good to think with" on the enduring issue of when we can compromise with our opponents and when we cannot.

In assigning formal blame for the war, it is important to remember that the Athenians had offered to submit to arbitration to resolve the Spartan complaints, the procedure officially mandated under the sworn terms of the peace treaty of 446–445 B.C. Despite the oath they had taken then, the Spartans nevertheless refused arbitration because they could not risk the defection of Corinth from their alliance if the decision went against them. The Spartans needed Corinth's sizable fleet to combat Athens's formidable naval power. The Spartan refusal to honor an obligation imposed by an oath amounted to sacrilege. Although the Spartans continued to argue that the Athenians were at fault for having refused all concessions, they felt deeply uneasy about the possibility that the gods might punish them for breaking their sworn word. The Athenians, on the other hand, exuded confidence that the gods would favor them in the war because they had respected their obligation under the treaty.

PERICLEAN STRATEGY

Athens's large fleet and stone fortifications made its urban center and main harbor at Piraeus impregnable to direct attack. Already by the 450s B.C. the Athenians had encircled the city with a massive wall and fortified a broad corridor with a wall on both sides leading all the way to Piraeus some four miles to the west (see plan 1 in chapter 6). In the late 460s Cimon had spent great sums to lay the foundations for the first two Long Walls, as they were called, and Pericles had seen to their completion in the early 450s, using public funds. A third wall was added about 445. The technology of military siege machines in the fifth century B.C. was not advanced enough to break through fortifications of stone with the thickness of Athens's Long Walls. Consequently, no matter what level of damage Spartan invasions inflicted on the agricultural production of Attica in the farm fields outside the walls around the city center, the Athenians could feed themselves by importing food on cargo ships through their fortified port; they could guard the shipping lanes with their incomparable fleet. They could pay for the food and its transportation with the huge financial reserves they had accumulated from the dues of the Delian League and the revenue from their silver mines at Laurion; they minted that silver into coins that were highly desired as an internationally accepted currency (fig. 8.1). The Athenians could also retreat safely behind their walls when the

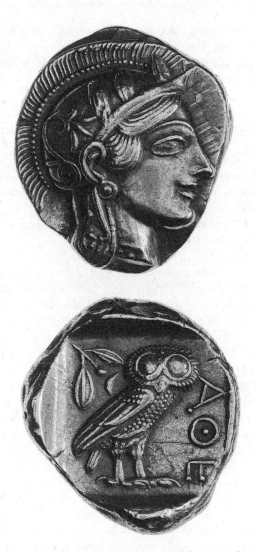

Fig. 8.1: Silver coins minted at Athens became a widely accepted currency because people everywhere trusted the quality of their precious metal; as a reassurance to the international market, the Athenians did not change the design for centuries. This fifth-century B.C. example, like all the rest, features a profile of Athena on the front and an owl, her sacred bird, on the back; in slang, the coins were called "owls." Courtesy of the American Numismatic Society.

Spartan infantry attacked their own less-powerful land army. From their unassailable position, they could launch surprise attacks against Spartan territory by sending warships from the fortified harbor to land troops behind enemy lines. Like aircraft in modern warfare before the invention of radar warning systems, Athenian warships could swoop down unexpectedly on their enemies before they could prepare to defend themselves. Pericles therefore devised a two-pronged war strategy for Athens: Avoid set battles on land with the Spartans' infantry, even when they ravaged Athenian territory, but use the fleet to attack the Spartans' countryside and that of their allies. In the end, he predicted, the superior resources of Athens in money and men would enable it to win a war of attrition. What was required was consistent guidance from Athens's leaders and firm dedication from its people. They would all suffer, but they would survive to prevail in the end—if they had the will to stay the course.

The gravest difficulty in carrying out Pericles' strategy was that it required the many Athenians who resided outside the city center to abandon their homes and fields to be pillaged and burned by the Spartan army during its regular invasions of Attica each year. As Thucydides reports, people hated coming in from the countryside, where "most Athenians were born and bred; they grumbled at having to move their entire households [into Athens] . . . and abandoning their normal way of life, leaving behind what they regarded as their true city" (The Peloponnesian War 2.16). In 431 B.C. the Spartans opened hostilities by invading Attica for the first time and proceeded to destroy property in the countryside, hoping to force the Athenians into an infantry battle. The country dwellers of Attica became fiercely angry when, standing safely on Athens's walls, they watched the smoke rise from their homes and fields as they burned. The men of Acharnae, the most populous deme of Attica and visible just to the north from the city walls, were particularly furious; Pericles barely managed to stop the citizen-militia from rushing out in a rage to take on the Spartan hoplites in a land battle. Somehow he managed to prevent the assembly from meeting to authorize this change in strategy; Thucydides does not reveal precisely how Pericles blocked normal democratic procedures at this critical moment. The Spartan army returned home from this first attack on Athenian territory after staying only about a month in Attica because it lacked the structure for resupply over a longer period and could not risk being away from Sparta too long from fear of a helot revolt. For these reasons, the annual invasions of Attica that the Spartans sent in the early years of the war never lasted longer than forty days. Even in this short time, however, the Spartan army could inflict losses on the countryside, which the citizens of Athens, holed up in their walled city, felt personally and painfully.

UNFORESEEN DISASTER

The innate unpredictability of war soon undermined Pericles' strategy for Athenian victory when an epidemic began to ravage Athens's population in 430 B.C. and raged on for several years with disastrous consequences. The disease struck while the Athenians from the countryside were jammed together with the city's usual residents in unsanitary conditions behind the city walls. The failure to provide adequate housing and sanitation for this new influx of population into the city was a devastating oversight by Pericles and his fellow leaders. The symptoms of the disease, described in detail by Thucydides, were gruesome: vomiting, convulsions, painful sores, uncontrollable diarrhea, and fever and thirst so extreme that sufferers threw themselves into water tanks vainly hoping to find relief in the cold water. The rate of mortality was so high that it crippled Athenian ability to man the naval expeditions that Pericles' wartime strategy demanded. Pericles himself died of the disease in 429. He apparently had not anticipated the damage to Athens's conduct of the war that the loss of his firm leadership would mean. The epidemic also seriously hampered the war effort by destroying the Athenians' confidence in their relationship with the gods. "As far as the gods were concerned, it seemed not to matter whether one worshipped them or not because the good and the bad were dying indiscriminately," Thucydides wrote (The Peloponnesian War 2.53).

The epidemic hurt the Athenians materially by devastating their population, politically by removing their foremost leader, Pericles, and psychologically by damaging their self-confidence and weakening communal social and religious norms. Nevertheless, they refused to give up. Despite the loss of manpower inflicted by the deadly disease, Athenian military forces proved effective in several locations. Potidaea, the ally whose rebellion had worsened the hostility between Athens and Corinth, was compelled to surrender in 430 B.C. The Athenian navy won two major victories in 429 off Naupactus in the western Gulf of Corinth under the general Phormio. A serious revolt in 428–427 of allies on the island of Lesbos, led by the city-state of Mytilene, was forcefully put down. One of the most famous passages in Thucydides is the set of vivid speeches on the fate of the people of Mytilene presented by the Athenian orators Cleon and Diodotus (The Peloponnesian War 3.37–48). The opposing speeches respectively argued for capital punishment based on justice and clemency based on expediency. Their arguments represent stirring and provocative positions that bear on larger political and ethical questions about the effectiveness of punishment as a deterrent more than on the immediate issue of what to do about the rebels of Mytilene.

Equally impressive and even more disturbing is Thucydides' report of the civil war that broke out on the island of Corcyra in 427 B.C., when the opposing factions in the city-state there, one supporting Athens and one Sparta, tried to gain advantage by appealing to these major powers in the Peloponnesian War. Thucydides' blunt analysis describes how civil war can bring out the worst features of human nature and inflame deadly emotions, even among people who have lived all their lives as neighbors:

[The citizens supporting democracy in the civil war in the city-state of Corcyra] captured and executed all their enemies whom they could find. . . . They then proceeded to the sanctuary of Hera and persuaded about fifty of the suppliants [from the opposing faction] who had sought sacred refuge there to agree to appear in court. The democrats thereupon condemned every last one of the erstwhile suppliants to death. When the other suppliants who had refused to go to trial comprehended what was going on, most of them killed each other right there in the sanctuary. Some hanged themselves from trees, while others found a variety of ways to commit suicide. [For a week] the members of the democratic faction went on slaughtering any fellow citizens whom they thought of as their enemies. They accused their victims of plotting to overthrow the democracy, but in truth they killed many people simply out of personal hatred or because they owed money to the victims. Death came in every way and fashion. And, as customarily occurs in such situations, the killers went to every extreme and beyond. There were fathers who murdered their sons; men were dragged out of the temples to be put to death or simply butchered on the very altars of the gods; some people were actually walled up in the temple of Dionysus and left there to die [of starvation].

In numerous Greek cities these factional struggles produced many catastrophes—as happens and always will happen while human nature remains what it is. . . . During periods of peace and prosperity, cities and individuals alike adhere to more demanding standards of behavior, because they are not forced into a situation where they have to do what they do not want to do. But war is a violent teacher; in stealing from people the ability to fulfill their ordinary needs without undue difficulty, it reduces most people's temperaments to the level of their present circumstances.

So factional conflicts erupted in city after city, and in cities where the struggles took place at a later date than in other cities, the knowledge of what had already happened in other places led to even more inventiveness in attacking rivals and to unprecedented atrocities of revenge. In

accordance with the changes in conduct, words, too, exchanged their customary meanings to adapt to people's purposes. What had previously been described as a reckless act of aggression was now seen as the courage demanded of a loyal co-conspirator in a faction; to give any thought to the future and not take immediate action was simply another way of calling someone a coward; any suggestion of moderation was just an attempt to cover up one's cowardice; ability to understand different sides of an issue meant that one was wholly unsuited to take action. Fanatical enthusiasm was the defining characteristic of a real man. . . . Ties of family were weaker obligations than belonging to a faction, since faction members were more prepared to go to any extreme for any reason whatsoever.

—(The Peloponnesian War 3.81–82)

The manpower losses caused by the great epidemic prevented Athens from launching as many naval expeditions as would have been needed to make Periclean strategy effective, and the annual campaigns of the war in the early 420s B.C. brought additional losses to both sides without any significant opportunity for one side to overcome the other decisively. In 425, however, Athens stumbled upon a golden chance to secure an advantageous peace, when the Athenian general Cleon won an unprecedented victory by capturing some 120 Spartan warriors and about 170 allied Peloponnesian troops after a protracted struggle on the tiny island of Sphacteria at Pylos in the western Peloponnese. No Spartan soldiers had ever before surrendered under any circumstances. They had always taken as their soldiers' creed the sentiment expressed by the legendary advice of a Spartan mother handing her son his shield as he went off to war: "Come home either with this or on it" (Plutarch, Moralia 241F), meaning that he should return either as a victor or as a corpse. By this date, however, the population of Spartan male citizens was so diminished that to lose even such a small group was perceived as intolerable. The Spartan leaders therefore offered the Athenians favorable peace terms if they would return the captured warriors. Cleon's unexpected success at Pylos had vaulted him into a position of political leadership, and he advocated a hard line toward Sparta. Thucydides, who apparently had no love for Cleon, called him "the most violent of the citizens" (The Peloponnesian War 3.36). At Cleon's urging, the Athenian assembly refused to make peace with Sparta: He convinced his fellow citizens that they could win even more, and they took the gamble.

The lack of wisdom in the Athenian decision became clear with the next unexpected development of the war: a sudden reversal in the tra-

ditional Spartan policy against waging extended military expeditions far from home. In 424 B.C. the Spartan general Brasidas led a land army on a daring campaign against Athenian strongholds in far northern Greece hundreds of miles from Sparta. His most important move came when he succeeded in getting the defection to the Spartan side of the strategic city Amphipolis, an important Athenian colony near the coast that the Athenians regarded as essential to their strategic position. This coup by Brasidas robbed Athens of access to gold and silver mines and a major source of timber for warships. Even though Thucydides was not directly responsible for Athens's having lost Amphipolis, the Athenian assembly stripped him of his command and forced him into exile because he had been the commander in charge of the region when this catastrophe took place.

A FIGHTING PEACE

Cleon, the most prominent and influential leader at Athens after the Athenian victory at Pylos in 425 B.C., was dispatched to northern Greece in 422 to try to stop Brasidas. As events turned out, both he and Brasidas were killed at Amphipolis in 422 in a battle won by the Spartan army. Their deaths deprived each side of its most energetic military commander and opened the way to negotiations. Peace came in 421, when both sides agreed to resurrect the balance of forces as it had been in 431. The agreement made in that year is known as the Peace of Nicias, after the Athenian general who was instrumental in convincing the Athenian assembly to agree to a peace treaty. The Spartan agreement to the peace revealed a fracture in the coalition of Greek states allied with Sparta against Athens and its allies, because the Corinthians and the Boeotians refused to join the Spartans in signing the treaty.

The Peace of Nicias failed to quiet those on both sides of the conflict who were pushing for a decisive victory. A brash, rich, and young Athenian named Alcibiades (c. 450–404 B.C.) was especially active in agitating against the uneasy peace. He was a member of one of Athens's wealthiest and most distinguished families, and he had been raised in the household of Pericles after his father had died in battle against allies of Sparta in 447, when Alcibiades was only about three years old. By now in his early thirties—a very young age at which to have achieved political influence, by Athenian standards—Alcibiades rallied support in the Athenian assembly for action against Spartan interests in the Peloponnese. Despite the formal agreement of peace between Sparta and Athens, he managed to cobble together a new alliance among Athens, Argos, and some other Peloponnesian city-states that were hostile to Sparta. He evidently believed

that Athenian power and security, as well as his own career, would be best served by a continuing effort to weaken Sparta. Since the geographical location of Argos in the northeastern Peloponnese placed it astride the principal north–south route in and out of Spartan territory, the Spartans had reason to fear the alliance created by Alcibiades. If the alliance held, Argos and its allies could virtually pen the Spartan army inside its own borders. Nevertheless, support for the coalition seems to have been shaky in Athens, perhaps because the memory of the ten years of war just concluded was still vivid. The Spartans, recognizing the threat to themselves, met and defeated the forces of the coalition in battle at Mantinea in the northeastern Peloponnese in 418. The Peace of Nicias was now a dead letter, even if the war was not yet formally recommenced. When an Athenian force later raided Spartan territory, it flared into the open once again. Thucydides remarked that in his opinion the Peloponnesian War had never really ceased, despite the Peace of Nicias; the hostility between Athens and Sparta had grown too deep and too fierce to be resolved by a treaty. Someone had to win for the war truly to be over.

In 416 B.C. an Athenian force besieged the tiny city-state situated on the island of Melos in the Mediterranean Sea southeast of the Peloponnese. The Melians were sympathetic to Sparta but had taken no active part in the war, although an inscription has been interpreted to mean that they had made a monetary contribution to the Spartan war effort. (It is possible, however, that this text in fact refers to events after the fall of the city in this siege, at a time when refugees from Melos gave small amounts of money to try to win Spartan favor.) In any case, Athens had long considered Melos an enemy because Nicias had led an unsuccessful attack on the island in 426. The Athenians now once again demanded that the Melians support their anti-Spartan alliance voluntarily or face destruction, but the Melians refused to submit despite the overwhelming superiority of the Athenian force. What the Athenians hoped to gain by this campaign is not clear, because Melos had neither much property worth plundering nor a strategically crucial location. At bottom, the Athenians simply may have been infuriated by the Melians' refusal to join their alliance and comply with their wishes. When Melos eventually had to surrender to the besieging army of Athenian and allied forces, its men were killed and its women and children sold into slavery. An Athenian community was then established on the island. Thucydides portrays Athenian motives in the siege of Melos as concerned exclusively with the amoral politics of the use of force, while the Melians he shows as relying on an expedient concept of justice that they insisted should govern relations between states. He represents the leaders of the opposing sides as participating in a private meeting to dis-

cuss their views of what issues are at stake. This passage in his history (*The Peloponnesian War* 5.84–114), called the Melian Dialogue, offers a chillingly realistic insight into the clash between ethics and power in international politics and remains timeless in its insight and its bluntness.

THE SICILIAN EXPEDITION

There was no question about the war being on again when in 415 B.C. Alcibiades convinced the Athenian assembly to launch a massive naval campaign against the city-state of Syracuse, a Spartan ally on the large and prosperous island of Sicily. This wealthy city near the southeastern corner of the island represented both the richest prize and the largest threat to Athenian success in the war if the Syracusans sent aid to the Spartans. With this expedition, the Athenians and their allies would pursue the great riches awaiting conquerors in Sicily and prevent any cities there from supporting their enemies. In launching the Sicilian expedition, the Athenians' stated reason for acting was that they were responding to a request for military protection from the Sicilian city of Egesta (also known as Segesta), with which the Athenians had previously made an alliance. The Egestans encouraged the Athenians to prepare a naval expedition to Sicily by misrepresenting the extent of the financial resources that they would be able to contribute to the military campaign against Athens's enemies on the island.

In the debate preceding the vote on the expedition, Alcibiades and his supporters argued that the numerous warships in the fleet of Syracuse represented an especially serious potential threat to the security of the Athenian alliance because they could sail from Sicily to join the Spartan alliance in attacks on Athens and its allies. Nicias led the opposition to the proposed expedition, but his arguments for caution failed to counteract the enthusiasm for action that Alcibiades generated with his speeches. The latter's aggressive dreams of the glory to be won in battle appealed especially to young men who had not yet experienced the brutal realities of war for themselves. The assembly resoundingly backed his vision by voting to send to Sicily the greatest force ever to sail from Greece.

The arrogant flamboyance of Alcibiades' private life and his blatant political ambitions had made him many enemies in Athens, and the hostility to him reached a crisis point at the very moment of the expedition's dispatch, when Alcibiades was suddenly accused of having participated in sacrilegious events on the eve of the sailing. One incident involved the herms of Athens. Herms, stone posts with a sculpted set of erect male genitals and a bust of the god Hermes, were placed throughout the city as

guardians of doorways, boundaries, and places of transition. A herm stood at nearly every street intersection, for example, because crossings were, symbolically at least, zones of special danger. Unknown vandals outraged the public by knocking off the statues' phalluses just before the fleet was to sail. When Alcibiades was accused of having been part of the vandalism, his enemies immediately upped the ante by reporting that he had earlier staged a mockery of the Eleusinian Mysteries. This was an extremely serious charge of sacrilege and caused an additional uproar. Alcibiades pushed for an immediate trial while his popularity was at a peak and the soldiers who supported him were still in Athens, but his enemies cunningly got the trial postponed on the excuse that the expedition must not be delayed. Alcibiades therefore set off with the rest of the fleet, but it was not long before a messenger was dispatched telling him to return alone to Athens for trial. Alcibiades' reaction to this order was dramatic and immediate: He defected to Sparta.

The defection of Alcibiades left the Athenian expedition against Sicily without a strong and decisive leader. The Athenian fleet was so large that it won initial victories against Syracuse and its allies even without brilliant leadership, but eventually the indecisiveness of Nicias undermined the attackers' successes. The Athenian assembly responded to the setbacks by authorizing large reinforcements led by its general Demosthenes, but these new forces proved incapable of defeating Syracuse, which enjoyed effective military leadership to complement its material strength. Alcibiades had a decisive influence on the quality of Syracusan military leadership because the Spartans followed his suggestion to send an experienced Spartan commander to Syracuse to combat the invading expedition. In 414 B.C. they dispatched Gylippus, who proved himself the tactical superior to the Athenian commanders on the scene. As what the Spartans called a *mothax* ("someone who doesn't stick to his place in society"), Gylippus was a self-made man, so to speak, a member of a special class of "half-caste" citizens born to a Spartan father and a helot (or desperately poor citizen) mother. The population decline at Sparta had become so critical during the Peloponnesian War that the Spartans were allowing wealthier citizens to sponsor talented boys from these mixed backgrounds in joining the common messes, to bolster the number of men being raised as warriors and potential commanders.

The Spartans and their allies in Sicily eventually trapped the Athenian forces in the harbor of Syracuse, completely crushing them in a climactic naval battle in 413 B.C. When the survivors of the attacking force tried to flee overland to safety, they were either slaughtered or captured, almost to a man, including Nicias. The Sicilian expedition ended in inglorious de-

feat for the Athenian forces and the crippling of their navy, the city-state's main source of military power. When the news of this catastrophe reached Athens, the citizens wept and wailed in horror.

TEN MORE YEARS OF WAR

Despite their fears, the Athenians did not give up, even when more troubles confronted them in the wake of the disaster in Sicily. Alcibiades' defection caused Athens yet more problems when he advised the Spartan commanders to establish a permanent base of operations in the Attic countryside; in 413 B.C. they at last acted on his advice. Taking advantage of Athenian weakness in the aftermath of the enormous losses in men and equipment sustained in Sicily, the Spartans installed a garrison at Decelea in northeastern Attica, in sight of the walls of Athens itself. Spartan forces could now raid the Athenian countryside year-round; previously, the annual invasions dispatched from Sparta could never stay longer than forty days at time in Athenian territory, and only during the months of good weather. Now the presence of a permanent enemy garrison in Athenian territory made agricultural work in the fields dangerous and forced the Athenians huddling behind the city's fortification walls to rely even more heavily than in the past on food imported by sea. The damage to Athenian fortunes increased when twenty thousand slaves sought refuge in the Spartan camp. Some of these fugitives seem to have come from the silver mines at Laurion, which made it harder for Athens to keep up the flow of revenue from this source. So immense was the distress caused by the crisis that an extraordinary change was made in Athenian government: A board of ten officials was appointed to manage the affairs of the city. The stresses of a seemingly endless war had convinced the citizens that the normal procedures of their democracy had proved sadly inadequate to the task of keeping them safe. They had lost confidence in their founding principles. As Thucydides observed, "War is a violent teacher" (The Peloponnesian War 3.82).

The disastrous consequences of the Athenian defeat in Sicily in 413 B.C. became even worse when Persia once again took a direct hand in Greek affairs on the side of Sparta. Athenian weakness seemed to make this an opportune time to reassert Persian dominance in western Anatolia by stripping away Athens's allies in that region. The satraps governing the Persian provinces in the area therefore began to supply money to help the Spartans and their allies construct and man a fleet of warships. At the same time, some disgruntled allies of Athens in Ionia took advantage of the depleted strength of their alliance's leader to revolt from the Delian

League, instigated by the powerful city-state of the island of Chios in the eastern Aegean. Once again it was Alcibiades who was getting his revenge on his countrymen: He had urged the Ionians to rebel from Athens when the Spartans had sent him there in 412 to stir up rebellion. Since Ionia provided bases for attacking the shipping lanes by which the Athenians imported the grain from the fertile shores of the Black Sea to the northeast and from Egypt to the southeast, which they needed to survive, losing their Ionian allies threatened them with starvation.

Even in the face of these mounting hardships and dangers, the Athenians continued to demonstrate a strong communal will and refusal to stop fighting for their independence. They devoted their scarce resources to rebuilding their fleet and training new crews to row the triremes, drawing on the emergency reserve funds that had been stored on the Acropolis since the beginning of the war. Astonishingly, by 412–411 Athenian naval forces had revived sufficiently that they managed to prevent a Corinthian fleet from sailing to aid Chios, to lay siege to that rebellious island ally, and to win other battles along the Anatolian coast. "Never say die" was evidently their national motto.

Despite this military recovery, the bitter turmoil in Athenian politics and the steep decline in revenues caused by the Sicilian disaster opened the way for a group of men from the social elite, who had long harbored contempt for the broad-based direct democracy of their city-state, to stage what amounted to an oligarchic coup d'état. They insisted that a small group of elite leaders was now needed to manage Athenian policy in response to the obvious failures of the democratic assembly. Alcibiades furthered their cause by sending messages home that he could make an alliance with the Persian satraps in western Anatolia and secure funds from them for Athens—but only on the condition that the democracy abolish itself and install an oligarchy. He apparently hoped that this abrupt change in government would pave the way for him to return to Athens. Alcibiades had reason to want to return, because his negotiations with the satraps had by now aroused the suspicions of the Spartan leaders, who rightly suspected that he was intriguing in his own interests rather than theirs. He had also made Agis, one of Sparta's two kings, into a powerful enemy by seducing his wife.

By holding out the lure of Persian gold, Alcibiades' promises helped the oligarchic sympathizers in Athens to play on the assembly's fears and hopes. In 411 B.C. the Athenian oligarchs succeeded in having the assembly members turn over all power to a group of four hundred men; the voters had been persuaded that this smaller body would provide better guidance for foreign policy in the war and, most importantly, boost

Athens's finances by doing a deal with the Persian king. These four hundred Athenians were supposed in turn to choose a group of five thousand men to act as the city's ultimate governing body, creating a broad rather than a narrow oligarchy. In fact, however, the four hundred kept all power in their own hands, preventing the five thousand from having any effect on government. This duplicitous regime soon began to fall apart, however, when the oligarchs struggled with each other for dominance; none of them could tolerate appearing to bow to the superior wisdom of a fellow oligarch. The end for this revolutionary government came when the crews of the Athenian war fleet, which was stationed in the harbor of the friendly island city-state of Samos in the eastern Aegean, threatened to sail home to restore democracy by force unless the oligarchs stepped aside. In response, a mixed democracy and oligarchy, called the Constitution of the Five Thousand, was created, which Thucydides praised as "the best form of government that the Athenians had known, at least in my time" (The Peloponnesian War 8.97). This new government voted to recall Alcibiades and other prominent Athenians who were in exile, hoping that these experienced men could improve Athenian military leadership and carry the war to the Spartans.

With Alcibiades as one of its commanders, the revived Athenian fleet won a great victory over the Spartans in early 410 B.C. at Cyzicus, in Anatolia, south of the Black Sea. The victorious Athenians intercepted the plaintive and typically brief dispatch sent by the defeated Spartans to their leaders at home: "Ships lost. Commander dead. Men starving. Do not know what to do" (Xenophon, Hellenica 1.1.23). The pro-democratic fleet demanded the restoration of full democracy at Athens, and within a few months after the victory at Cyzicus, Athenian government returned to the form and membership that it had possessed before the oligarchic coup of 411. It also returned to the uncompromising bellicosity that had characterized the decisions of the Athenian assembly in the mid-420s. Just as they had after their defeat at Pylos in 425, the Spartans offered to make peace with Athens after their defeat at Cyzicus in 410. The Athenian assembly once again refused the terms, however. Athens's fleet then proceeded to reestablish the safety of the grain routes to the port at Piraeus and to compel some of the allies who had revolted to return to the alliance.

Unfortunately for the Athenians, their successes in battle did not lead to victory in the war. The aggressive Spartan commander Lysander ultimately doomed Athenian hopes by using Persian money to rebuild the Spartan fleet and by ensuring that this new navy had expert commanders. When in 406 B.C. he inflicted a defeat on an Athenian fleet at Notion, near Ephesus on the Anatolian coast, the Athenians blamed Alcibiades for the loss, even

though he had been away on a mission at the time. He was forced into exile for the last time. The Athenian fleet won a victory later in 406 off the islands of Arginusae, south of the island of Lesbos, but a storm prevented the rescue of the crews of wrecked ships. Emotions at the loss of so many men ran so high at Athens that the commanders were put on trial as a group, even though that decision contradicted the normal legal guarantee of individual trials. They were condemned to death for alleged negligence. And then the assembly again rejected a Spartan offer of peace, guaranteeing the current state of things. Lysander thereupon secured more Persian funds, strengthened the Spartan naval forces further, and finally and decisively defeated the Athenian fleet in 405 in a battle at Aegospotami, near Lampsacus on the coast of Anatolia. Athens was now defenseless. Lysander blockaded the city and compelled its citizens to surrender in 404; they had no other choice but starvation. After twenty-seven years of near-continuous war, the Athenians found themselves at the mercy of their enemies.

Fortunately for the Athenians, the Spartan leaders resisted the demand made by their allies the Corinthians, the bitterest enemy of Athens, that the defeated city be totally destroyed. The Spartans feared that Corinth, with its large fleet and strategic location on the isthmus, potentially blocking access to and from the Peloponnese, might grow too strong if Athens were no longer in existence to serve as a counterweight. Instead of ruining Athens, Sparta installed a regime of anti-democratic Athenian collaborators to rule the conquered city. This group became known as the Thirty Tyrants. These Athenians came from the wealthy elite, which had always included a faction admiring oligarchy and despising democracy. Brutally suppressing the opposition from their fellow Athenians and stealing shamelessly from people whose only crime was to possess valuable property, these oligarchs embarked on an eight-month-long period of terror in their homeland during 404–403 B.C. The metic and famous speechwriter-to-be Lysias, for example, whose father had earlier moved his family from their native Syracuse at the invitation of Pericles, reported that the henchmen of the Thirty seized his brother for execution as a way to steal the family's valuables. The plunderers even ripped the gold earrings from the ears of his brother's wife in their pursuit of loot.

The rule of the Thirty Tyrants became so violent and disgraceful that the Spartans did not interfere when a pro-democracy resistance movement came to power in Athens after a series of street battles during a civil war between democrats and oligarchs in 403 B.C. To put an end to the internal strife that threatened to tear Athens apart, the newly restored democracy proclaimed a general amnesty, the first known in Western history. Under

this agreement, all legal charges and official recriminations concerning crimes committed during the reign of terror were forbidden from that time onward. Athens's government was once again a functioning democracy. Its financial and military strength, however, was shattered, and its society preserved the memory of a lethal divisiveness among its own citizens that no amnesty could completely dispel.

HARDSHIP AND COMEDY IN WARTIME ATHENS

The Peloponnesian War drained the state treasury of Athens, splintered its political harmony, and devastated its military power. But that was not all the damage that it did. The nearly thirty years of war also exacted a heavy toll on Athenians' domestic life. Many people both from the city and the countryside found their livelihoods threatened by the economic dislocations of the war. Women without wealth whose spouses or male relatives were killed in the war experienced particularly difficult times because dire necessity forced them to do what they had never done before: look for work outside the home to support themselves and their children.

The many people who made their homes outside the walls of the urban center suffered the most ruinous personal losses and disruptions during the war. These country dwellers periodically had to take refuge inside the city walls while the Spartan invaders wrecked their houses and barns and damaged the crops in their fields. If they did not also own a house in the city or have friends who could take them in, these families had to camp in public areas in Athens in cramped and unsanitary conditions, looking for shelter, food, cooking facilities, and water every day on the fly. The load that their presence put on Athens's limited urban infrastructure inevitably caused friction between the refugees and the residents who were full-time city dwellers.

The war meant drastic changes in the ways that many households in Athens made their livings. The changes affected both those whose incomes depended on agriculture and those who operated their own small businesses. Wealthy families that had money and valuable goods stored up could weather the crisis by spending their savings, but most people had no financial cushion to fall back on. When the enemy destroyed harvests in the countryside, farmers used to toiling in their own fields outside the walls had to scrounge for work as day laborers in the city. Such jobs became increasingly scarce as the pool of men looking for them swelled. Men who rowed the ships of the Athenian fleet could earn wages for the time the ships were at sea, but they had to spend long periods away from their families in uncomfortable conditions and faced death in every battle

and storm. Men and women who worked as crafts producers and small merchants or business owners in the city still had their livelihoods, but their income levels suffered because consumers had less money to spend.

The pressure of war on Athenian society became especially evident in the severe damage done to the prosperity and indeed the very nature of the lives of many comfortably well-off women whose husbands and brothers died during the conflict. Women of this socioeconomic level had traditionally done weaving at home for their own families and supervised the work of household slaves, but the men had earned the family's income by farming or practicing a trade. With no working male to provide for them and their children, these women were now forced to take the only jobs open to them in such low-paying occupations as wet nurse, weaver, or even vineyard laborer, when there were not enough men to meet the need in the fields. These circumstances involved more women in activities conducted outside their homes and brought them into more contact with strangers than ever before, but this change did not lead to a woman's movement in the modern sense or to any inclusion of women in Athenian political life. After the war, Aristophanes produced a comedy, The Assembly-women (c. 392 B.C.), that portrayed women disguising themselves as men to take over the assembly and revolutionize Athenian government to spend its resources prudently, following the principles of financial planning that women used to manage their families' household accounts. In the play, most of the men of Athens in the end have to admit that the women will do a better job running the city-state than they have. In real life, this vision of politically empowered women remained a fantasy confined to the comic stage.

The financial stability of the city-state of Athens declined to a desperate state during the later stages of the Peloponnesian War as a result of the many interruptions to agriculture and from the reduction of income from the state's silver mines, which occurred after the Spartan army took up a permanent presence in 413 B.C. in Athenian territory in a fortified base at Decelea. Now that the enemy was present year-round, the lucrative mining, so important to the city-state's treasury, could not operate as reliably, because the mines and smelting facilities were at Laurion, which was located within easy raiding distance of the invader's position. Some public building projects in the city itself were kept going, like the Erectheum, a temple to Athena on the Acropolis, to demonstrate the Athenian will to carry on and also as a device for infusing some money into the crippled economy by paying construction workers. But the demands of the war depleted the funds available for many nonmilitary activities. The great annual dramatic festivals, for example, had to be cut back. The financial situation

had become so critical by the end of the war that Athenians were required to exchange their silver coins for an emergency currency of bronze thinly plated with silver to be used in local circulation. The regular silver coins, along with gold coins that were minted from golden objects borrowed from Athens's temples, were then used to pay war expenses. This creation of what could be called a "scrip" currency, which has no intrinsic worth, to replace in the domestic economy the precious-metal coins that did have intrinsic value, signaled that Athens was very nearly a bankrupt political state.

The plots and characters of Athenian comedies produced during the Peloponnesian War reflected the growing stresses of everyday life during these three decades of death, destruction, and despair. Comedy was very popular in ancient Greece, as in every other human society, and it existed in various forms (fig. 8.2). At Athens, comic plays were the other main form of public dramatic art besides tragedies. Like tragic plays, comedies were composed in verse and had been presented annually in the city since early in the fifth century B.C. They formed a separate competition in the Athenian civic festivals in honor of Dionysus in the same outdoor theater used for tragedies. The ancient evidence does not make clear whether women could attend the performances of comedies, but if they could see tragedies, it seems likely that they could attend comedies as well. The all-male casts of comic productions consisted of a chorus of twenty-four members in addition to regular actors. Unlike tragedy, comedy was not restricted to having no more than three actors with speaking parts on stage at the same time. The beauty of the soaring poetry of the choral songs of comedy was matched by the ingeniously imaginative fantasy of its plots, which almost always ended with a festive resolution of the problems with which they had begun. For example, the story of Aristophanes' comedy The Birds, produced in 414 B.C. as the war in Sicily raged on, has two men trying to escape the wrangles and disappointments of current everyday life at Athens and the regulations of the Athenian Empire by running away to seek a new life in a world called Cloudcuckooland that is inhabited by talking birds, portrayed by the chorus in colorful bird costumes. Unfortunately for the avian residents of this paradise, the human immigrants turn out to be eager to take over for their own pleasure and advantage, which can include bird sacrifices.

The author's immediate purpose in writing a comic play was to create beautiful poetry and raise laughs at the same time, in the hope of winning the award for the festival's best comedy. The plots of fifth-century Athenian comedies primarily dealt with contemporary issues and personalities, while much of their humor had to do with explicit references to sex

Fig. 8.2: This deep vase, for mixing wine with water at drinking parties, is decorated with a painting of a comic actor from Magna Graecia wearing a mask with prominent facial features and a padded costume with an exaggerated shape. Ancient Greek comedy took various forms, with parody, farce, and criticism of politicians being popular features of the shows. Image copyright © The Metropolitan Museum of Art. Image source: Art Resource, NY.

and bodily functions, and much of their dialogue included uncensored and highly colorful profanity. Insulting verbal attacks on prominent men, such as Pericles or Cleon, the victor of Pylos, were a staple of the comic stage. Pericles apparently tried to impose a ban on this sort of comic criticism in response to scathing treatment that he received in the dialogues

of comedies produced after the revolt of Samos in 441–439 B.C., but the measure was soon rescinded. Cleon later was so outraged by the way he was portrayed on the comic stage by Aristophanes that he sued the playwright. When Cleon lost the case, Aristophanes responded by pitilessly parodying him as a degenerate foreign slave in The Knights, of 424 B.C. Even prominent men who were not portrayed as characters on stage could nevertheless fall prey to insults in the dialogue of comedies as sexually effeminate and cowards. Women characters who are made figures of fun and ridicule in comedy, however, seem to have been fictional and not avatars of actual women from Athenian society.

Slashing satire directed against the mass of ordinary citizens seems to have been unacceptable in Athenian comedy, but fifth-century comic productions often criticized governmental policies by blaming individual political leaders for decisions that the assembly as a whole had in fact voted to implement. The strongly critical nature of comedy was never more evident than during the war. Several of the popular comedies of Aristophanes had plots in which characters arranged peace with Sparta, even though the comedies were produced while the war was still being fiercely contested and the assembly had rejected all such proposals. In The Acharnians of 425 B.C., for example, the protagonist arranges a separate peace treaty with the Spartans for himself and his family while humiliating a character who portrays one of Athens's prominent military commanders of the time. In other words, the triumphant hero in this play was a traitor who got away with betraying Athens. The play won first prize in competition for comedies that year, a fact that underlines the strength of the freedom of public speech in Classical Age Athens and suggests just how much many citizens yearned to end the war and return to "normal" life.

The most striking of Aristophanes' comedies are those in which the main characters, the heroes of the plot, are women, who use their wits and their solidarity with one another to compel the men of Athens to overthrow basic policies of the city-state. Most famous of Aristophanes' comedies depicting powerfully effectual women is Lysistrata of 411 B.C., named after the female lead. It portrays the women of Athens compelling their husbands to end the Peloponnesian War. The women first use force to blockade the Acropolis, where Athens's financial reserves are kept, and prevent the men from squandering the city-state's money any further on the war. The women then beat back an attack on their position by the old men who have remained in Athens while the younger men are out on campaign in the war. When their husbands return from the battlefield, the women refuse to have sex with them. Teaming with the women of Sparta on this sex strike, which is portrayed in a series of sexually explicit comic

episodes, they finally coerce the men of Athens and Sparta to agree to a peace treaty.

Lysistrata presents women acting bravely, aggressively, and with international cooperation against men who seem bent both on destroying their family life by staying away from home for long stretches while on military campaign and on ruining their city-states by prolonging a pointless war. In other words, the play's powerful women take on masculine roles to preserve the traditional way of life of the community. Lysistrata herself emphasizes this point in the very speech in which she insists that women have the intelligence and judgment to make political decisions. She came by her knowledge, she says, in the traditional way: "I am a woman, and, yes, I have brains. And I'm not badly off for judgment. Nor has my education been bad, coming as it has from my listening often to the conversations of my father and the elders among the men" (Lysistrata, lines 1124–1127). Lysistrata is here explaining that she was educated in the traditional way, by learning from older men. Her old-fashioned training and good sense allowed her to see what needed to be done to protect the community. Like the heroines of tragedy, Lysistrata is a reactionary: She wants to put things back the way they were in the past when everything was better. To do that, however, she has to act like a revolutionary. The play's message that Athenians should concern themselves with preserving the old ways before all was lost evidently failed to impress the male voters in the assembly, as they failed to end the war despite Lysistrata's having shown them how to make that happen. Somehow, we can guess, the desire to maintain the city-state's political independence and international power trumped the wish for peace. We can also wonder what role notions of pride and honor played in the decision to not work toward a negotiated settlement. History shows over and over how important those sentiments are to human beings, for better or for worse.

POSTWAR ATHENIAN SOCIETY

The losses of population, the ravages of epidemic disease, and the financial damage caused by the war created ongoing problems for Athenians. Not even the amnesty that accompanied the restoration of Athenian democracy in 403 B.C. could quench all the social and political hatreds that the war and the rule of the Thirty Tyrants had enflamed. Socrates, the famous philosopher, became the most prominent casualty of this divisive bitterness. His trial for impiety in 399 ended with him being sentenced to death. Through it all, however, the traditional institution of the Athenian household—the family members and their personal slaves—survived

the war as the fundamental unit of the city-state's society and economy. Gradually, postwar Athens recovered much of its former prosperity and its role as leader of other Greek city-states, but in the end it never recovered fully. Athens's lesser financial and military power in the fourth century B.C. was going to prove extremely consequential for the city-state's freedom and its place in the world when the threat of domination by the kingdom of Macedonia seemingly came out of nowhere during the reign of Philip II in mid-century, as we will see in the next chapter.

Many Athenian households lost fathers, sons, or brothers in the Peloponnesian War, but resourceful families in the opening decades of the fourth century B.C. following the end of the war found ways to compensate for the economic strain that these family tragedies created. An Athenian named Aristarchus, for example, is reported by the writer Xenophon (c. 428–354 B.C.) to have experienced financial difficulty because the turmoil of the war had severely reduced his income and also caused his sisters, nieces, and female cousins to come live with him. He found himself unable to support this expanded household of fourteen plus slaves. Aristarchus's friend Socrates thereupon reminded him that his female relatives knew quite well how to make men's and women's cloaks, shirts, capes, and smocks, "the work considered the best and most fitting for women" (*Memorabilia* 2.7.10). Previously, the women had always just made clothing for their families and never had to try to sell what they made for profit. But other people did make a living by selling such clothing or by baking and selling bread, Socrates pointed out, and Aristarchus could have the women in his house do the same. The plan was a financial success, but the women complained that Aristarchus was now the only member of the household who ate without working. Socrates advised his friend to reply that the women should think of him as sheep did a guard dog: He earned his share of the food by keeping the wolves away from the sheep.

Most Athenian manufactured goods were produced in households like that of Aristarchus or in small shops, although a few larger businesses did exist. Among these were metal foundries, pottery workshops, and the shield-making factory employing 120 slaves owned by the family of Lysias (c. 459–380 B.C.); commercial enterprises larger than this were apparently unknown at this period. The metic Lysias had to use his education and turn to writing speeches for others to make a living after the Thirty Tyrants seized his property in 404 B.C. Metics could not own land in Athenian territory without special permission, but they enjoyed legal rights in Athenian courts that other foreigners lacked. In return, they paid taxes and served in the army when called upon. Lysias lived near the harbor of Athens, Piraeus, where many metics took up residence because they played a

central role in the international trade in such goods as grain, wine, pottery, and silver from Athens's mines, which passed through Piraeus. The safety of Athenian trade was restored to prewar conditions when the Long Walls that connected the city with the port, demolished after the war as punishment, were rebuilt by 393. Another sign of the improving economic health of Athens was that by the late 390s the city had resumed the minting of its famous and valuable silver coins to replace the worthless emergency coinage produced during the last years of the war.

The importation of grain through Piraeus continued to be crucial for meeting the food needs of the population of Athens. Even before the war, Athenian farms had been unable to produce enough of this dietary staple to feed the whole population. The damage done to farm buildings and equipment during the Spartan invasions of the Peloponnesian War made the situation worse. The Spartan establishment of a year-round base at Decelea near Athens from 413 to 404 B.C. had given these enemy forces an opportunity to do much more severe damage in Athenian territory than the usually short campaigns of Greek warfare allowed. The invaders had probably even had time to cut down many Athenian olive trees, the source of olive oil, which was widely used at home and also provided a valuable export commodity. Olive trees took a generation to replace because they grew so slowly. Athenian property owners after the war worked hard to restore their land and businesses to production, not only to rebuild their incomes but also to provide for future generations, because Athenian men and women felt strongly that their property, whether in land, money, or belongings, represented resources to be preserved for their descendants. For this reason, Athenian law allowed prosecution of men who squandered their inheritance.

Most working people probably earned little more than enough to clothe and feed their families. Athenians usually ate only two meals a day, a light lunch in midmorning and a heavier meal in the evening. Bread baked from barley or, for richer people, wheat, constituted the main part of the diet. A family could buy its bread from small bakery stands, often run by women, or make it at home, with the wife directing and helping the household slaves to grind the grain, shape the dough, and bake it in a pottery oven heated by charcoal. Those few households wealthy enough to afford meat often grilled it over coals on a pottery brazier shaped much like modern portable barbeques. Vegetables, fruit, olives, and cheese provided the main variety in their diet for most people, with meat available to them only from the large animal sacrifices paid for by the state or wealthy citizens. The wine that everyone drank, usually much diluted with water, came mainly from local vineyards. Water from public fountains had to be car-

ried into the house in jugs, a task that the women of the household had to perform themselves or see that the household slaves did. The war had hurt the Athenian state economically by giving a chance for escape to many of the slaves who worked in the silver mines in the Attic countryside, but few privately owned domestic slaves tried to run away, perhaps because they realized that they would simply be resold by the Spartans if they managed to escape their Athenian masters. All but the poorest Athenian families, therefore, continued to have at least a slave or two to do chores around the house and look after the children. If a mother did not have a slave to serve as a wet nurse to suckle her infants, she would hire a poor free woman for the job, if her family had money for the expense.

THE CAREER OF SOCRATES

The most infamous episode in Athenian history in the aftermath of the Peloponnesian War consisted of the trial, conviction, and execution of Socrates (469–399 B.C.), the most famous philosopher of the fifth century B.C. Socrates had devoted his life to combating the idea that justice should be equated with the power to work one's will over others. His passionate concerns to discover valid guidelines for leading a just life and to prove that justice is better than injustice under all circumstances gave a new direction to Greek philosophy: an emphasis on ethics. Although other thinkers before him, especially the poets and dramatists, had dealt with moral issues, Socrates was the first philosopher to make ethics and morality his central concern. Coming as it did during a time of social and political turmoil after the war, his death indicated the fragility of the principles of Athenian justice when put to the test in the crucible of lingering hatred and bitterness over the crimes of the Thirty Tyrants.

Compared to the financially most successful sophists, Socrates lived in poverty and publicly disdained material possessions, but he nevertheless managed to serve as a hoplite in the army and support a wife and several children. He may have inherited some money, and he also received gifts from wealthy admirers. Nevertheless, he paid so little attention to his physical appearance and clothes that many Athenians regarded him as eccentric. Sporting, in his words, a stomach "somewhat too large to be convenient" (Xenophon, Symposium 2.18), Socrates wore the same cheap cloak summer and winter and went without shoes no matter how cold the weather (fig. 8.3). His physical stamina was legendary, both from his tirelessness when he served as a soldier in Athens's army and from his ability to outdrink anyone at a symposium.

Whether participating at a symposium, strolling in the agora, or watch-

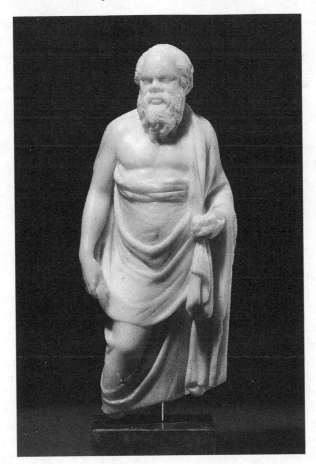

Fig. 8.3: This statuette portrays the controversial Athenian philosopher Socrates. He was famed for, among various other prominently idiosyncratic behaviors, wearing the same clothes all year round and going barefoot. Erich Lessing / Art Resource, NY.

ing young men exercise in a gymnasium, Socrates spent almost all his time in conversation and contemplation. In the first of these characteristics he resembled his fellow Athenians, who placed great value on the importance and pleasure of speaking with each other at length. He wrote nothing; our knowledge of his ideas comes from others' writings, especially those of his pupil Plato (c. 428–347 B.C.). Plato's dialogues, so called because they present Socrates and others in extended conversations about philosophy, portray Socrates as a relentless questioner of his fellow citizens, foreign

friends, and various sophists. Socrates' questions had the unsettling aim of provoking those with whom he spoke to examine the basic assumptions of their way of life. Employing what has come to be called the Socratic method, Socrates never directly instructed his conversational partners; instead, he led them to draw conclusions in response to his probing questions and refutations of their cherished but unexamined assumptions.

Socrates typically began one of his conversations by asking someone for a definition of an abstract quality, such as happiness, or an excellence, such as courage. For instance, in the dialogue *Laches*, named after the Athenian general who appears as one of the speakers in the dialogue, Socrates asks Laches and another distinguished military commander what makes a citizen a brave soldier. Socrates then proceeds by further questioning to show that the definitions of courage and instances of courageous behavior that they are now presenting actually contradict their other beliefs about what sort of behavior constitutes courage. In other words, he shows them that they really do not know what they are talking about, even though it concerns the very center of their expertise as military leaders.

This indirect but pitiless method of searching for the truth often left Socrates' conversational partners in a state of puzzlement and unhappiness because they were forced to admit that they were ignorant of what at the start of the conversation they had assumed they knew perfectly well. They were forced to the uncomfortable admission that the principles by which they said they lived could not withstand close examination. Socrates insisted that he too was ignorant of the best definition of excellence but that his wisdom consisted of knowing that he did not know. He was trying to improve rather than undermine his companions' personal values and their beliefs in morality, even though, as one of them put it, a conversation with Socrates made a man feel numb, just as if he had been stung by a stingray. Socrates wanted to discover through reasoning the universal standards that justified morality. He especially attacked the sophists' view of conventional morality as the "shackles that bind nature" (Plato, *Protagoras* 337d), asserting that it equated human happiness with power and "getting more."

Socrates passionately believed that just behavior was literally better for human beings than injustice: It created genuine happiness and well-being. Essentially, he seems to have argued that just behavior, which he saw as true excellence, was identical to knowledge, and that true knowledge of justice would inevitably lead people to choose good over evil and therefore to have truly happy lives, regardless of their level of financial success or physical comfort. In his view, the poor could be genuinely happy, too, perhaps more easily than the rich could, with their inevitable concerns for managing and increasing their wealth, none of which contributed to

a life lived with real justice. Since Socrates believed that knowledge itself was sufficient for happiness, he asserted that no one knowingly behaved unjustly, and that behaving justly was always in the individual's interest. It might appear, he maintained, that individuals could promote their interests by cheating or using force on those weaker than themselves, but this appearance was deceptive. It was in fact ignorance to believe that the best life was the life of unlimited power to pursue whatever one desired. Instead, the most desirable human life was concerned with excellence and guided by rational reflection about justice. This pure moral knowledge was all one needed for the good life, as Socrates defined it.

THE PROSECUTION AND EXECUTION OF SOCRATES

Despite Socrates' laserlike focus on justice and his refusal, unlike the sophists, to offer courses and take fees for teaching young men, his effect on many people was as perturbing as had been the impact of the relativistic doctrines of the sophists. Indeed, Socrates' refutation of his fellow conversationalists' most treasured beliefs made some of them extremely upset. Unhappiest of all were the fathers whose sons, after listening to Socrates reduce someone to utter bewilderment, came home to try the same technique on their parents. Men who experienced this reversal of the traditional hierarchy of education between parent and child—the father was supposed to educate the son, not the other way round—had cause to feel that Socrates' effect, even if it was not his intention, was to undermine the stability of society by questioning Athenian traditions and inspiring young men to do the same with the hot-blooded enthusiasm of their youth.

We cannot say with certainty what Athenian women thought of Socrates, or he of them. His views on human capabilities and behavior could be applied to women as well as to men, and he perhaps believed that women and men had the same basic capacity for justice. Nevertheless, the realities of Athenian society meant that Socrates circulated primarily among men and addressed his ideas to them and their situations. Xenophon reports, however, that Socrates had numerous conversations with Aspasia, the courtesan who lived with Pericles for many years. Plato has Socrates attribute his ideas on love to a woman, the otherwise unknown priestess Diotima of Mantinea. Whether these contacts were real or fictional remains uncertain.

The suspicion of many people that Socrates presented a danger to the traditions that held conventional society together gave Aristophanes the inspiration for his comedy The Clouds, of 423 B.C., so named from the role played by the chorus. In the play Socrates is presented as a cynical sophist,

who for a fee offers instruction in his school in the Protagorean technique of making the weaker argument the stronger. When the protagonist's son is transformed by Socrates' instruction into a rhetorician able to argue that a son has the right to beat his parents—and then proceeds to do just that to his father, the protagonist ends the comedy by burning down Socrates' "Thinking Shop."

Athenians anxious about Socrates' effect on people found confirmation of their fears in the careers of the outrageous Alcibiades and, especially, Critias, one of the Thirty Tyrants. Socrates' critics blamed him for Alcibiades' contempt for social conventions because Alcibiades had been one of Socrates' most devoted followers; Critias, another prominent follower, had played a leading role in the murder and plunder perpetrated by the Thirty Tyrants in 404–403 B.C. Critias was also notorious for having argued that the gods and moral codes linked to religion were just cynical inventions by lawmakers to keep people in line and make them obey laws by teaching them that deities knew what human beings were doing even when no one else was watching and would punish wrongdoers. In blaming Socrates for the crimes and ideas of Critias, Socrates' detractors chose to overlook his defiance of the Thirty Tyrants when they had tried to involve him in their violent schemes and his rejection of the immorality that Critias had displayed and proclaimed.

The hostility some Athenians felt toward Socrates after the violence of the Thirty Tyrants was brought to a head by a distinguished Athenian citizen named Anytus, a supporter of democracy whom Alcibiades had mocked and whose son had defied him by listening to Socrates. Anytus joined with two other men of lesser prominence to prosecute Socrates in 399 B.C. Since the amnesty prevented the accusers from bringing any charges directly related to the period of tyranny in 404–403, they accused Socrates of failing, in his actions and his words, to respect the gods of the city-state (a charge of "impiety"). Impiety ranked as an extremely serious crime because the gods were believed to punish the entire city-state if it harbored impious individuals. Athenian law, however, did not state precisely what specific actions or words constituted this crime. The accusers therefore had to convince the jurors chosen for the case that what Socrates had done and how he had behaved and what he believed and said amounted to a punishable offense. As usual in Athenian trials, no judge presided to rule on what evidence was admissible or how the law should be applied. Speaking for themselves as prosecutors, as also required by Athenian law, the accusers argued their case against Socrates before a jury of 501 men who had been assembled by lot from that year's pool of eligible jurors, drawn from the male citizens over thirty years old.

The prosecution of Socrates had both a religious and a moral component. Religiously, the prosecutors accused Socrates of not believing in the gods of the city-state and of introducing new divinities. Morally, they charged, he had led the young men of Athens away from Athenian standards and ideals. After the conclusion of the prosecutors' remarks, Socrates spoke in his own defense, as required by Athenian legal procedure. Plato presents Socrates as not using his remarks to rebut all the charges or to try to curry favor or beg for sympathy, as jurors expected defendants to do in serious cases like this one. Instead, he bluntly reiterated his unyielding dedication to goading his fellow citizens into examining their preconceptions. The unexamined life, he famously stated, was not worth living. His irritating process of constant questioning, he maintained, would help his fellow citizens learn to live lives of excellence, and he would never stop doing that, no matter what penalty he might experience as a result. Furthermore, they should care not about their material possessions but about making their true selves—their souls—as good as possible. Nothing else should take priority. If he were to be acquitted, he baldly stated, he vowed to remain their stinging gadfly no matter what the consequences to himself.

After the jury narrowly voted to convict, standard Athenian legal procedure required the jurors to decide between alternative penalties proposed by the prosecutors and the defendant. Anytus and his associates proposed death. In such instances the defendant was then expected to offer exile as the alternative, which the jury would usually accept. Socrates, however, replied to the prosecutors' proposal of the death penalty with the brash claim that he deserved a reward rather than a punishment, until his friends at the trial in horror prevailed upon him to propose a fine as his penalty. The jury chose death, by a wider margin than for the conviction. Socrates accepted his sentence with equanimity because, as he put it in a famous paradox, "No evil can befall a good man either in life or in death" (Plato, *Apology* 41d). In other words, nothing can take away the knowledge that constitutes excellence, and only the loss of that wisdom can count as a true evil.

After his sentencing, Socrates had to wait in prison for some time before his execution because the city-state had a sacred delegation on the Cycladic island of Delos to honor Apollo and did not allow executions to be carried out while such official religious activity was in progress. While he waited, Socrates was visited regularly by a wealthy follower named Crito, who tried to convince Socrates to escape from his cell and flee Attica to his friends in other regions. Crito was confident that he and his associates could safely secure Socrates' freedom through bribery. Socrates refused to go, explaining his reasons by imagining that the laws of Athens were brought to life and held a dialogue with him as the interlocutor, a conver-

sation in which they based their arguments on the concept of a voluntary, implicit social contract between citizens and the state:

> Consider, Socrates [the Laws would most likely say], whether we are correct in saying that you are now trying to do something to us that is wrong [that is, to escape from prison and execution]. Although we brought you into this world and reared you and educated you and gave you and all your fellow citizens a share in all the good things that we could, nevertheless by the very fact of granting our permission we openly proclaim this principle: that any Athenian, once he becomes an adult and understands the political organization of the city and us its Laws, is allowed, if he is dissatisfied with us, to move away to wherever he likes and take his family property with him. If any citizen who is unhappy with us and with the city decides to go to one of our colonies or to emigrate to any other country, not one of us Laws hinders or stops him from going to wherever he pleases, without being penalized by any loss of property. On the other hand, if any one of you stays here once he understands how we administer justice and the rest of the official organization of our city, we claim that the fact of his remaining here means that he has agreed to follow any order that we may give him; and we further believe that anyone in this situation who disobeys us is guilty of wrongdoing on three separate counts: first because we are his parents, and second because we are his guardians, and third because, after promising us obedience, he neither obeys us nor persuades us to change our decision if we are in any way in the wrong; and although we issue all our orders as proposals, not as fierce commands, and we give him the choice either to persuade us or to carry out our order, he in fact does neither.
> —(Plato, Crito 51cd)

Spurning his friends' pleas to escape with arguments such as these, Socrates was executed in a normal way, by being given a poisonous drink concocted from powdered hemlock. The intellectual controversy that Socrates provoked in his life continued after his death, as philosophers and sophists churned out work after work in the genre called "Socratic conversations," arguing both for and against the positions on a wide variety of issues that they ascribed to Socrates. Xenophon, in a memoir on Socrates perhaps written decades after the philosopher's execution, summed up the feelings of his admirers: "All those who knew what sort of person Socrates was and who aim at excellence in their lives continue even now to long for him most of all because he was the most helpful of all in learning about excellence" (Memorabilia 4.8.11).

From the Peloponnesian War
to Alexander the Great

The tragic outcome of the Peloponnesian War did not stop the long-standing tendency of the prominent Greek city-states to battle for power over one other. In the fifty years following the war, Sparta, Thebes, and Athens struggled militarily to win a preeminent position over their rivals. In the end, however, they achieved nothing more than weakening themselves and creating a vacuum of power in Greece. That void was filled by the unexpected rise to military and political power of the kingdom of Macedonia during the reign of Philip II (ruled 359–336 B.C.). Philip's reorganization of the Macedonian army saved the kingdom from invasion by northern enemies and gave him the power to extend his influence eastward and southward into Greek territory. His victory over an alliance of Greek city-states in the battle of Chaeronea in 338 B.C. led to his forming and commanding the League of Corinth, whose forces of Greeks and Macedonians he planned to lead in a war of invasion against the Persian Empire as retribution for the Persians' attacks on mainland Greece 150 years earlier.

Philip never achieved his goal of conquering Persia, because he was murdered in 336, before he could begin that quest. It was his son, Alexander the Great (ruled 336–323 B.C.), who astonished the world by making Philip's dream come true. Alexander's awe-inspiring conquests reached from Greece to the western border of India and convinced him that he had

c. 400–380 (early fourth century) B.C.: Plato founds his school, the Academy, in Athens.

395–386 B.C.: The Corinthian War between Sparta and other Greek states.

390s–370s B.C.: Spartans campaign first in Anatolia and then in Greece.

386 B.C.: King's Peace between Sparta and Persia.

377 B.C.: Athens reestablishes a naval alliance.

371 B.C.: Spartans defeated at battle of Leuctra in Boeotia.

370 B.C.: Jason, tyrant of Pherae in Thessaly, assassinated.

369 B.C.: The Theban army commanded by Epaminondas liberates Messenia from Spartan control.

362 B.C.: Spartans defeated by Thebans in the battle of Mantinea in the Peloponnese; the great Theban general Epaminondas is killed.

359 B.C.: Philip II becomes king of Macedonia.

357–355 B.C.: Athenian-led naval alliance dissolves in internal war.

338 B.C.: Philip II defeats Greek alliance at Chaeronea in Boeotia and founds League of Corinth.

336 B.C.: Philip murdered; his son Alexander ("the Great") takes over as king.

335 B.C.: Aristotle founds the Lyceum at Athens.

334 B.C.: Alexander begins attack against the Persian Empire; wins victory at the Granicus River in northwest Anatolia.

333 B.C.: Alexander wins victory at Issus in southeastern Anatolia.

332 B.C.: Walled city of Tyre (on an island off the coast of Lebanon) falls to Alexander's siege.

331 B.C.: Alexander takes Egypt and founds Alexandria; victory over Persian king at Gaugamela.

329 B.C.: Alexander reaches Bactria (modern Afghanistan).

327 B.C.: Alexander marries the Bactrian princess Roxane.

326 B.C.: Alexander's army mutinies at the Hyphasis River in India.

324 B.C.: Alexander returns to Persia after difficult march through the Gedrosian Desert (in modern southern Iran).

323 B.C.: Alexander dies in Babylon (in modern Iraq).

achieved the status of a god. Alexander died unexpectedly in 323, before he had a mature heir to succeed him as king of Macedonia and without having put into place a permanent restructuring of governance in Greece to suit the new political conditions of the world in the late fourth century B.C. Thus, his brilliant success as a conqueror left unresolved the problem of how to structure international power in a Greek world in which the citizen-militias of the city-states could not withstand the mercenary armies of the ambitious commanders from Alexander's army who made plans to rule the world as self-appointed kings. The long-term consequences of Alexander's expedition simultaneously brought the Greek and Near Eastern worlds into more direct contact than ever before, while also demonstrating that the city-states of mainland Greece, the Aegean, and Anatolia were no longer strong enough to set their own foreign policy. In international affairs, they were from now on going to be ultimately subordinate to monarchs.

CONFLICT AFTER THE WAR

Athens after the Peloponnesian War never regained the level of economic and military strength that it had enjoyed at the height of its prosperity in the fifth century B.C., perhaps because its silver mines were no longer producing at the same level. Xenophon wrote an essay offering a plan for increasing the production of ore by investing in more publicly purchased slaves, but it was never adopted, perhaps because the city-state no longer had the funds to invest in the up-front capital cost of the purchases. Nevertheless, following the reestablishment of democracy in 403 B.C., Athens did recover enough of its previous strength to became a force in Greek international politics once again. In particular, Athens and other city-states reacted with diplomatic and military actions meant to counteract Sparta's blatant attempts to extend its power over other Greeks in the decades following the Peloponnesian War. But even their initial hostility to Sparta could not keep these city-states unified. Therefore the first half of the fourth century saw frequently shifting alliances among the numerous city-states in Greece. In short, whichever city-states found themselves weaker at any point would temporarily join together against whichever city-state happened to be strongest at that moment, even if that meant allying with Sparta, only to lose their unity once the common enemy of the moment had been humbled.

Shortly after the war, in 401 B.C., the Persian satrap Cyrus hired a mercenary army to try to unseat the current Persian king, Artaxerxes II, who had ascended the throne in 404. Cyrus was the son of a previous Great

King, and he wanted that position for himself. Xenophon, the Athenian author and, it turned out, adventurer, enlisted as an officer on the side of the rebel satrap in this civil war. Xenophon's narrative (*Anabasis*) detailing the story of his adventures offers an exciting account of the challenges of the long march and many battles of the Greek soldiers paid to fight in Cyrus's army. Disastrously defeated at Cunaxa, near Babylon in Iraq, and left without a commander or sponsor because Cyrus had been killed, the now unemployed and leaderless Greek mercenaries had to organize themselves as a city-state on the move to fight their way out of the enemies surrounding them in the desert, and then make the skirmish-filled trek home through hundreds of miles of hostile territory, even pushing their thinly clad bodies through chest-high snow as they crossed the mountains into Anatolia. The demonstration of the Greek hoplites' skill and courage in surviving reminded the Persian king, if a reminder was needed, that Greeks could form a fearsome threat to his army if they ever found a way to unite their forces. He took away the lesson that it was in his interest to do what he could to keep the Greeks fractured and fighting one another so that they could never focus their ambitions on his empire and riches.

That threat almost materialized in the 390s B.C. During that period, the Spartan general Lysander and the Spartan king Agesilaus tried to capitalize on Sparta's victory in the Peloponnesian War by pursuing an aggressive policy in Anatolia and northern Greece; other Spartan commanders tried to extend their city-state's power in Sicily. Agesilaus, the most successful commander that Sparta ever fielded, was so successful that he was poised to continue on to conquer the Persian Empire. He had to give up this dream, however, when the political leaders at Sparta called him home to defend the homeland against its Greek enemies. As a loyal Spartan, he obeyed. If he had been allowed to keep going in Asia, we might today talk about "Agesilaus the Great" instead of Alexander as the conqueror of the Persians.

In response to the Spartan efforts to win dominance in Greece, the city-states of Thebes, Athens, Corinth, and Argos had put aside their usual hostility to one another to form an anti-Spartan military coalition; they were naturally fearful that this expansionist Spartan policy threatened their own security at home and their interests abroad. In a reversal of the alliances of the end of the Peloponnesian War, the Persian king initially allied with Athens and the other Greek city-states against Sparta in the so-called Corinthian War, which lasted from 395 to 386 B.C.; he was betting that the anti-Spartan city-states had less of a chance to threaten his territories in the long run than the Spartans did. His goal was to create a stalemate in Greece and thereby remove any potential danger to Persia. This alliance

fell apart, however, when his Greek allies realized that he was not going to help them crush Sparta. The war ended when the Persian king imposed a settlement that acknowledged his right to control the Greek city-states of Anatolia but guaranteed autonomy for the mainland Greeks. The Spartans tried to make this treaty sound like a defense of Greek freedom, which they had promoted, but in reality they looked forward to the king's promise as a way for them to win a free hand pursuing dominance in Greece. The King's Peace of 386, as the agreement is called, effectively returned the Greeks of Anatolia to their status as Persian subjects from a century earlier, before the Greek victory in the Persian Wars of 490–479 B.C. had freed them from Persian domination. Sparta, as at the end of the Peloponnesian War, had cut a deal with Persia for support against its enemies in Greece, blatantly ignoring their long-standing claim to be the liberators of the Greek city-states and the defenders of Greek political independence.

Spartan forces attacked city-states all over Greece in the years following the King's Peace of 386. Athens, meanwhile, had restored its invulnerability to invasion by rebuilding the Long Walls connecting the city and the harbor. The Athenian general Iphicrates also devised effective new tactics for light-armed troops, who were called peltasts, from the name of the smaller shield they carried. To enable these mobile soldiers to fight longer and more effectively against heavy infantry, he lengthened their weapons, replaced metal chest protectors with lightweight but tightly woven linen vests, and designed better battlefield footwear. Athens also rebuilt its navy to a substantial level, and by 377 the city had again become the leader of a naval alliance of Greek states. This time, however, the members of the league had their rights specified in writing and posted in public inscriptions for all to see; they wanted to prevent the high-handed Athenian treatment of allies that had characterized the so-called Athenian Empire in the fifth-century B.C.

Spartan hopes of achieving lasting power in these decades of turmoil after the Peloponnesian War were crushed in 371 B.C., when a resurgent Theban army commanded by the great general Epaminondas defeated the Spartan army at Leuctra in Boeotia. The Spartans lost the battle when their cavalry was pushed back into their infantry ranks, disrupting the phalanx, and then their king and battlefield commander Cleombrotus was killed. So many Spartan hoplites were killed and wounded that their army finally had to retreat. The victors then invaded the Spartan homeland in the Peloponnese, a fate that Laconia had never before experienced. At this point, the rampaging Thebans seemed likely to challenge Jason, tyrant of Pherae in Thessaly and an ambitious commander, for the position as the dominant military power in Greece.

The threat from Thessaly disappeared suddenly with Jason's assassination in 370 B.C., but in 369 Epaminondas led another invasion of Spartan territory. Following up on what he had started after the battle of Leuctra, he succeeded in freeing Messenia from Spartan control. This was a turning point in Spartan history: Being deprived of the economic output from the helots of that large and fertile region struck a devastating blow to the Spartan's strength, from which they would never fully recover. The Thebans now seemed likely to seize the position of the most powerful mainland city-state, so the former enemies Sparta and Athens now allied against Thebes; this conflict culminated in the epochal battle of Mantinea in the Peloponnese in 362 B.C. It became famous because Thebes won the battle but lost the war when Epaminondas was killed there. His death seriously compromised the quality of the Theban military leadership. Over the next two decades Thebes saw its power decline as it continued to fight neighboring Greeks and then the rising power of Macedonia under Philip II. In this same period, Athens and Sparta once again became openly hostile to one another. When the naval alliance led by Athens dissolved in the mid-350s B.C., after its member states rebelled and the Athenians proved too weak to compel them to obey, this loss of power shattered any dreams that Athenians clung to about dominating Greece as they had in their Golden Age a century earlier.

Xenophon bleakly summed up the situation in Greece as it developed in the aftermath of the battle of Mantinea: "Everyone had supposed that the winners of this battle would become Greece's rulers and its losers would become their subjects . . . but there was only more confusion and disturbance in Greece after it than before" (Hellenica 7.5.26–27). He was right: All the efforts of the various major Greek city-states to extend their hegemony over mainland Greece in the first half of the fourth century B.C. ended in failure. By the 350s and 340s, no Greek city-state had the power to rule more than itself. The struggle for supremacy in Greece that had begun eighty years earlier with the outbreak of the Peloponnesian War had finally ended in a stalemate of military and political exhaustion on the international level. In the midst of this violent impasse, Greece remained culturally productive, however; this period saw some of the most famous and influential intellectual developments in all of ancient Greek history.

THE CAREER OF PLATO

The most famed Greek in the first half of the fourth century B.C. was not a general or a politician but Socrates' most brilliant follower, the philosopher Plato of Athens (c. 428–347 B.C.). His writings are without doubt the

most influential intellectual legacy of this period for later times. Although his status as a member of the social elite propelled him into politics as a young man, he withdrew from Athenian public life after 399. The trial and execution of Socrates had apparently convinced Plato that citizens in a democracy were incapable of rising above narrow self-interest to cultivate knowledge of universal truth, the goal of a worthwhile life in his view. In his works theorizing about the best way to organize human society, Plato bitterly rejected democracy as a justifiable system of government, calling it the "worst form of rule under law" (*Statesman* 303a). He said that Pericles' establishment of pay for service in public office, the linchpin of broad citizen participation in democracy, had made the Athenians "lazy, cowardly, gabby, and greedy" (*Gorgias* 515e). As he portrayed Socrates saying at his trial, Plato concluded that an honorable man committed to excellence could take no part in Athenian public life without incurring hatred and mortal danger (*Apology* 32e).

Against the background of this fierce criticism of his own city-state, Plato went on to describe an ideal for political and social organization headed by leaders nurtured and guided by philosophical wisdom. His utopian vision had virtually no effect on the actual politics of his time, however, and his attempts to advise Dionysius II (ruled 367–344 B.C.), tyrant of Syracuse in Sicily, on how to rule as a true philosopher ended in utter failure. But political philosophy formed only one portion of Plato's interests, which ranged widely in astronomy, mathematics, and metaphysics (theoretical explanations for phenomena that cannot be understood through direct experience or scientific experiment). After Plato's death in the middle of the fourth century B.C., his ideas continued to remain influential even as philosophers moved in new directions; they later became vitally important to Christian theologians contemplating the nature of the soul and other complex ideas about the relationship between human beings and God. The sheer intellectual power of Plato's difficult thought and the controversy it has engendered ever since his lifetime have won him fame as one of the world's greatest philosophers.

Plato did not compose philosophical treatises based on abstractions of the kind familiar from more-recent academic study of philosophy; instead, he composed works called dialogues from their form as conversations, or reported conversations. Almost as if they were plays or scripts, the dialogues have particular settings and casts of conversationalists, often including Socrates, who talk about philosophical issues. Divorcing the philosophical content of a Platonic dialogue from its literary form is surely a mistake; a dialogue of Plato demands to be understood as a whole, and any interpretation of a dialogue has to take into account both its form and

its content. The plots, so to speak, of the dialogues and their often indirect and inconclusive treatments of their philosophical subjects were intended to provoke readers into thoughtful reflection rather than to spoon-feed them a circumscribed set of doctrines.

Furthermore, Plato's views seem to have changed over time, and he nowhere sets out in one place a unified set of ideas. He does seem to have disagreed with Socrates' insistence that fundamental knowledge meant moral knowledge based on personal experience and reflection. Plato concluded that knowledge meant discovering truths that are independent of the individual or the observer of the visible world and can be taught to others. In the early fourth century he acted on this belief by establishing a school at a site called Academy, just outside the walls of Athens, a shady location named after the legendary hero Academos, whose shrine was nearby (fig. 9.1). Plato's school, referred to as the Academy, was not a college or research institute in the modern sense but rather an informal association where adults interested in studying philosophy, mathematics, and theoretical astronomy could gather, exercise, and spend time talking, with Plato as their guide. The Academy became so famous as a gathering place for intellectuals that it continued to operate for nine hundred years after Plato's death, with periods in which it was directed by distinguished philosophers and others during which it lapsed into mediocrity under lackluster leaders.

Although it is risky to try to summarize Plato rather than to read his dialogues as complete works, it is perhaps not too misleading to say that his dialogues as a whole indicate that human beings cannot define and understand absolute excellences, such as Goodness, Justice, Beauty, or Equality, by the concrete evidence of their experience of those qualities in their lives. Any earthly examples will in another context display the opposite quality. For instance, always returning whatever one has borrowed might seem to be just. But what if a person who has borrowed a weapon from a friend is confronted by that friend who wants the weapon back to commit a murder? In this case, returning the borrowed item would be unjust. Examples of equality are also only relative. The equality of a stick two feet long, for example, is evident when it is compared with another two-foot stick. Paired with a three-foot stick, however, it displays inequality. In the world that human beings experience with their senses, every example of the excellences or of every quality is relative in some aspect of its nature.

Plato refused to accept the relativity of the excellences as reality, and his spirited rejection of relativism attacked the doctrines of the sophists. Plato developed the theory that the excellences cannot be discovered through experience; rather, excellences as qualities are absolutes that can be ap-

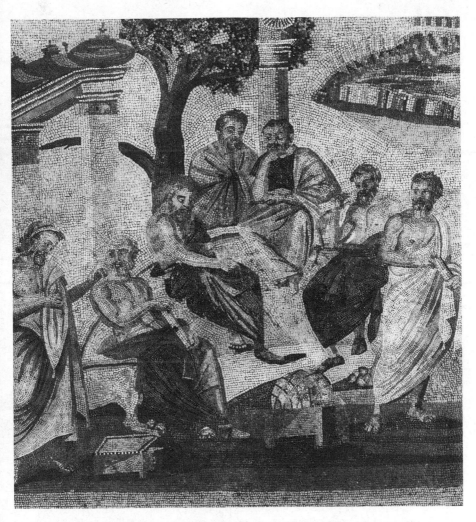

Fig. 9.1: This later mosaic from the Roman town of Pompeii imagines a scene at the Academy of Plato in Athens, where male students gathered to discuss that philosopher's difficult ideas about the true nature of reality and knowledge and how human beings should live as a result. Plato's "school" apparently did not charge tuition, relying instead on his private wealth and contributions from members. Wikimedia Commons.

prehended only by reasoning and that somehow exist independently of human existence. In some of his dialogues, Plato refers to the ultimate realities of the pure excellences as "Forms" or "Ideas." The Forms, he says, are nonmaterial universals that exist separately and are not perceptible by direct human experience. They are invisible, invariable, perfect, and eternal entities located in a higher realm beyond the empirical world of human beings. Among the Forms are Goodness, Justice, Beauty, and Equality. The Forms are, according to Plato, the only true reality; what humans experience with their senses are the mere shadows or imitations of these archetypes. Plato's concept of nonmaterial Forms requires the further belief that knowledge of them comes not through the human body but rather the soul, which must be immortal. When a soul is incarnated in its current body, it brings with it from its former existence knowledge of the Forms. The soul then uses reason in argument and proof, not empirical observation through the senses, to recollect its preexistent knowledge. Plato was not consistent throughout his career in his views on the nature or the significance of Forms, and his later works seem even distant from the theory. Nevertheless, Forms provide a good example of both the complexity and the depth of Platonic thought.

Plato's idea that humans possess immortal souls distinct from their bodies established the concept of dualism, positing a separation between spiritual and physical being. This notion of the separateness of soul and body would play an influential role in later philosophical and religious thought. In a dialogue written late in his life, the Timaeus, Plato says the preexisting knowledge possessed by the immortal human soul is in truth the knowledge known to the supreme deity. Plato calls this god the Demiurge ("craftsman") because the deity used knowledge of the Forms to craft the world of living beings from raw matter. According to this doctrine of Plato, a knowing, rational god created the world, and the world therefore has order. Furthermore, its beings have goals, as evidenced by animals adapting to their environments in order to flourish. The Demiurge wanted to reproduce in the material world the perfect order of the Forms, but the world as crafted turned out not to be perfect because matter is necessarily imperfect. Plato suggested that human beings should seek perfect order and purity in their own souls by making rational desires control their irrational desires. The latter cause harm in various ways. The desire to drink wine to excess, for example, is irrational because the drinker fails to consider the hangover to come the next day. Those who are governed by irrational desires thus fail to consider the future of both body and soul. Finally, since the soul is immortal and the body is not, our present, impure existence is only one passing phase in our cosmic existence.

Plato employs his theory of Forms not only in metaphysical speculation about the original creation of the everyday world in which people live, but also to explain how an ideal human society should be structured. One version of Plato's utopian vision is found in his most famous dialogue, The Republic. This work, whose Greek title (Politeia) would more accurately be rendered as System of Government, primarily concerns the nature of justice and the reasons that people should be just instead of unjust. Justice, Plato argues, is advantageous; it consists of subordinating the irrational to the rational in the soul. By using the truly just and therefore imaginary city-state as a model for understanding this notion of proper subordination in the soul, Plato presents a vision of the ideal structure for human society as an analogy for understanding what the individual should do to have a just and moral soul. Like a just soul, the just society would have its parts in proper hierarchy, parts that Plato presents in The Republic as three classes of people, as distinguished by their ability to grasp the truth of Forms. The highest class constitutes the rulers, or "guardians" as Plato calls them, who are educated in mathematics, astronomy, and metaphysics. Next come the "auxiliaries," whose function it is to defend the city-state. The lowest class is that of the "producers," who grow the food and make the objects required by the whole population. Each part contributes to society by fulfilling its proper function.

In Plato's utopia, women as well as men qualify to be guardians because they possess the same excellences and abilities as men, except for a disparity in physical strength between the average woman and the average man. The axiom justifying the inclusion of women—that excellence is the same in women as in men—is perhaps an idea that Plato derived from Socrates. The inclusion of women in the ruling class of Plato's utopian city-state represented a startling departure from the actual practice of his times. Indeed, never before in Western history had anyone proposed—even in fantasy, which the imaginary city of The Republic certainly is—that work be allocated in human society without regard to gender. Almost equally radical were the specifications for how guardians are required to live: To minimize distraction from their duties, they can have neither private property nor nuclear families. Male and female guardians are to live in shared houses, eat in the same mess halls, and exercise in the same gymnasiums. Their children are to be raised as a group in a common environment by special caretakers. Although this scheme is meant to free women guardians from child-care responsibilities and enable them to rule equally with men, Plato fails to consider that women guardians would in reality have a much tougher life than the men because they would have to be pregnant frequently and undergo the strain and danger of giving birth. At

the same time, he evidently does not believe that they should be disqualified from ruling on this account. The guardians who achieved the highest level of knowledge in Plato's ideal society would qualify to rule over this ideal state as philosopher-kings.

To become a guardian, a person must be educated from childhood for many years in mathematics, astronomy, and metaphysics to gain the knowledge that Plato in *The Republic* presented as necessary for the common good. Plato's specifications for the education of guardians in fact make him the first thinker to argue systematically that education should be the training of the mind and of character rather than simply the acquisition of information and practical skills. A state based on such education would necessarily be authoritarian because only the ruling class would possess the knowledge to determine its policies. They would determine even the nature of reproduction by deciding who is allowed to mate with whom, with the goal of producing the best children.

The severe regulation of life from work to eugenics that Plato proposed for his ideally just state in *The Republic* was a reflection of his tight focus on the question of a rational person's true interest and his identification of morality as the key to answering this question. Furthermore, he insisted that politics and ethics are fields in which objective truths can be found by the use of reason. Despite his harsh criticism of existing governments, such as Athenian democracy, and his scorn for the importance of rhetoric in its functioning, Plato also recognized the practical difficulties in implementing radical changes in the way people actually lived. Indeed, his late dialogue *The Laws* shows him wrestling with the question of improving the real world in a far less radical, though still authoritarian, way than in the imagined community of *The Republic*. Plato hoped that, instead of ordinary politicians, the people who know truth and can promote the common good would rule because their rule would be in everyone's real interest. For this reason above all, he passionately believed that the study of philosophy mattered to human life.

THE SCIENCE AND PHILOSOPHY OF ARISTOTLE

Greece in the later fourth century B.C. produced a second thinker whose intellectual legacy achieved monumental proportions. Aristotle (384–322 B.C.), Plato's most brilliant follower, earned his enduring reputation in science and philosophy from his groundbreaking work in promoting scientific investigation of the natural world and developing rigorous systems of logical argument. The enormous influence of Aristotle's works on scholars in later periods, especially in medieval Europe, has made him a central

figure in the history of Western science and philosophy, rivaling—or, in the opinion of some, even surpassing—the achievements of Plato.

The son of a wealthy doctor from Stagira in northern Greece, who worked at the royal court of Macedonia, Aristotle came to Athens at the age of seventeen to study in Plato's Academy. In 335 B.C., Aristotle founded his own philosophical school in Athens, named the Lyceum, later called the Peripatetic School after the covered walkway (*peripatos*) in which its students carried on conversations while strolling out of the glare of the Mediterranean sun. Aristotle lectured on nearly every branch of learning: biology, medicine, anatomy, psychology, meteorology, physics, chemistry, mathematics, music, metaphysics, rhetoric, political science, ethics, and literary criticism. He also worked out a sophisticated system of logic for precise argumentation. Creating a careful system to identify the forms of valid arguments, Aristotle established grounds for distinguishing a logically sound case from a merely persuasive one. He first gave names to contrasts, such as the universal *versus* the particular, and premise *versus* conclusion, which have been commonplaces of thought and speech ever since. He also studied the process of explanation itself, formulating the influential doctrine of four causes. According to Aristotle, four different categories of explanation exist that are not reducible to a single, unified whole: form (defining characteristics), matter (constituent elements), origin of movement (similar to what we commonly mean by "cause"), and *telos* (aim or goal). The complexity of this analysis exemplifies Aristotle's concern to never oversimplify the nature of reality.

Apparently an inspiring teacher, Aristotle encouraged his followers to conduct research in numerous fields of specialized knowledge. For example, he had student researchers compile reports on the systems of government of 158 Greek states. Much of Aristotle's philosophical thought reflected the influence of Plato, but he also refined and even rejected ideas that his teacher had advocated. He denied the validity of Plato's theory of Forms, for example, on the grounds that their existence separate from the world that Plato postulated for them failed to make sense. This position typified Aristotle's general preference for explanations based on logical reasoning and on observation rather than derived from metaphysics. By modern standards, his scientific thought paid relatively limited attention to mathematical models of explanation and quantitative reasoning, but mathematics in his time had not yet reached the level of sophistication appropriate for such work. His method also differed from that of modern scientists because it did not include controlled experimentation. Aristotle believed that investigators had a better chance of understanding objects and beings by observing them in their natural setting than under the ar-

tificial conditions of a laboratory. His coupling of detailed investigation with perceptive reasoning served especially well in such physical sciences as biology, botany, and zoology. For example, as the first scientist to try to collect all the available information on the animal species and to classify them, Aristotle recorded information about more than five hundred different kinds of animals, including insects. Although his human gynecology was particularly inaccurate, many of his descriptions represented significant advances in learning. For example, his recognition that whales and dolphins were mammals, a biological fact that later writers on animals overlooked, was not rediscovered for another two thousand years.

In his research on animals Aristotle set forth his teleological view of nature—that is, he believed organisms developed as they did because they had a natural goal (*telos*), or what we might call an end or a function. To explain a phenomenon, Aristotle said that one must discover its goal—to understand "that for the sake of which" the phenomenon in question existed. A simple example of this kind of explanation is the duck's webbed feet. According to Aristotle's reasoning, ducks have webbed feet for the sake of swimming, an activity that supports the goal of a duck's existence, which is to find food in the water so as to stay alive. Aristotle argued that the natural goal of human beings was to live in the society of a city-state, and that the city-state came into existence to meet the human need to live together, since individuals living in isolation cannot be self-sufficient. Furthermore, existence in a city-state made possible an orderly life of excellence for its citizens. The means to achieve this ordered life were the rule of law and the process of citizens' ruling and being ruled in turn.

Some of Aristotle's most influential discussions concentrated on understanding qualitative concepts that human beings tend to take for granted, such as time, space, motion, and change. Through careful argumentation he probed the philosophical difficulties that lie beneath the surface of these seemingly familiar concepts, and his views on the nature of things exercised an overwhelming influence on later thinkers.

Aristotle was conventional for his times in regarding slavery as natural, on the argument that some people were by nature bound to be slaves because their souls lacked the rational part that should rule in a human being. Thinkers supporting the contrary view were rare but did exist; one fourth-century B.C. orator, Alcidamas, argued that "god has set all men free; nature has made no one a slave" (Fragment 3 = scholium to Aristotle, *Rhetorica* 1373b). Also in accordance with the majority view of his times was Aristotle's conclusion that women were by nature inferior to men. His view of the inferiority of women was based on faulty notions of biology. He wrongly believed, for example, that in procreation the male

with his semen actively gave the fetus its form, while the female had only the passive role of providing the baby's matter. His assertion that females were less courageous than males was justified by dubious evidence about animals, such as the report that a male squid would stand by as if to help when its mate was speared, but that a female squid would swim away when the male was impaled. Although his erroneous biology led Aristotle to evaluate females as incomplete males, he believed that human communities could be successful and happy only if they included the contributions of both women and men. Aristotle argued that marriage was meant to provide mutual help and comfort, but that the husband should rule. In his views on slavery and women, it seems necessary to say, Aristotle failed to meet the high standards of reasoning and observation that he taught his students. It seems to me a humbling warning to everyone who cares about justice that even such a brilliant scientist and philosopher as Aristotle could fall short in analyzing hot-button issues concerning which human differences can be used to justify treating people differently and which cannot.

Aristotle sharply departed from the Socratic idea that knowledge of justice and goodness was all that was necessary for a person to behave justly. He argued that people in their souls often possess knowledge of what is right but that their irrational desires overrule this knowledge and lead them to do wrong. People who know the evils of hangovers still get drunk, for instance. Recognizing a conflict of desires in the human soul, Aristotle devoted special attention to the issue of achieving self-control by training the mind through habituation to win out over the instincts and passions. Self-control did not mean denying human desires and appetites; rather, it meant striking a balance between suppressing and heedlessly indulging physical yearnings, of finding "the mean." Observing the mean was the key to a properly lived life, he taught. Aristotle claimed that the mind should rule in determining this balance in all the aspects of life because intelligence is the finest human quality and the mind is the true self, indeed the godlike part of a person. He specifically warned young people to be extraordinarily careful about how they habituated themselves to live: There will probably come a time later in life, he said, when you will want to accomplish new things or behave differently, but it will be almost impossible to change at that point if in your youth you developed habits that are now holding you back.

Aristotle regarded science and philosophy not as abstract subjects isolated from the concerns of ordinary existence but rather as the disciplined search for knowledge in every aspect of life. That search epitomized the kind of rational human activity that alone could bring the good life and

genuine happiness. Some modern critics have charged that Aristotle's work lacks a clear moral code, but he did the study of ethics a great service by insisting that standards of right and wrong have merit only if they are grounded in character and aligned with the good in human nature and do not simply consist of lists of abstract reasons for behaving in one way rather than another. An ethical system, that is, must be relevant to the actual moral situations that human beings continually experience in their lives. In ethics, as in all his scholarship, Aristotle distinguished himself by the insistence that the life of the mind and experience of the real world were inseparable components in the quest to define a worthwhile existence for human beings.

Aristotle believed that human happiness, which was not to be equated with the simpleminded pursuit of pleasure, stems from fulfilling human potentialities. These potentialities can be identified by rational choice, practical judgment, habituation to excellence, and recognition of the value of choosing the mean instead of extremes. The central moral problem is the nearly universal human tendency to want to "get more," to act unjustly whenever one has the power to do so. The aim of education is to dissuade people from this inclination, which has its worst effects when it is directed at acquiring money or honor. In this context Aristotle was thinking of men in public life outside the home, and he says that the dangerous disorder caused by men's desire for "getting more" occurs both in democracies and oligarchies. Like Plato, he criticized democracy because he saw it as rule by the majority and the poor, not by the educated and elite. Athens served as Aristotle's home for many years, but its radically direct democracy never won his approval. The goal of democracy, he said, was living exactly as one likes, which could never be a valid principle for organizing the best government. True freedom, he stressed, consisted in ruling and being ruled in turn and not always insisting on fulfilling one's desires.

ISOCRATES ON RHETORIC AND SOCIETY

Despite his interest in subjects relevant to politics, such as the history of the constitutions of states and the theory and practice of rhetoric, Aristotle remained a theoretician in the mold of Plato. He was opposed to the kind of democracy open to all male citizens that distinguished Athens, in which persuasive public speaking was the most valued skill. These characteristics set him apart from the major educational trend of the fourth century B.C., which emphasized practical wisdom and training with direct application to the public lives of male citizens in a democratic city-state. The most

important subject in this education was rhetoric, the techniques of public speaking and argumentation. Effective rhetoric required not only oratorical expertise but also knowledge of the world and of human psychology.

Influential believers in the value of practical knowledge and rhetoric were to be found even among the followers of Socrates, himself no admirer of democracy or rhetorical techniques. Xenophon, for example, knew Socrates well enough to write extensive memoirs recreating many conversations with the great philosopher. But he also wrote a wide range of works in history, biography, estate management, horsemanship, and the public revenues of Athens. The subjects of these treatises reveal the many topics that Xenophon considered essential to the proper education of young men.

The works of Isocrates (436–338 B.C.) did the most to emphasize the importance of rhetoric as a practical skill. Born to a rich family, he studied both with sophists and Socrates. The Peloponnesian War destroyed his property and forced him to seek a living as a writer and teacher. Since he lacked a strong enough voice to address large gatherings and preferred quiet scholarly work to political action, Isocrates composed speeches for other men to deliver and sought to influence public opinion and political leaders by publishing treatises on education and politics. Seeing education as the preparation for a useful life doing good in matters of public importance, he strove to develop an educational middle ground between theoretical study of abstract ideas and practical training in rhetorical techniques. In this way, Isocrates as an educator staked out a position between the unattainable ideals of Plato as a theorist and the sophists' alluring promises to teach persuasive oratory as a tool for individuals to promote their own private advantage. Isocrates on occasion criticized Athenian democracy because it allowed anyone at all to participate, but his pride in his city-state never waned. In his nineties he composed a long treatise, *Panathenaicus*, praising Athens for its leadership in Greece and insisting on its superiority to Sparta in the cutthroat arena of international politics.

Rhetoric was the skill that Isocrates sought to develop, but that development, he insisted, could come only through natural talent honed by practical experience of worldly affairs. This experience was necessary to train orators both to understand public issues and the psychology of the people whom they had to persuade for the common good. Isocrates saw rhetoric therefore not as a device for cynical self-aggrandizement but as a powerful tool of persuasion for human betterment, if it was used by properly gifted and trained men with developed consciences. Women were excluded from participation because they could not take part in politics. The Isocratean emphasis on rhetoric and its application in the real world

of politics won many more adherents among men in Greek and, later, Roman culture than did the Platonic vision of the philosophical life, and it had great influence when revived in Renaissance Europe two thousand years later.

Throughout his life Isocrates tried to recommend solutions to the most pressing problems of his era. He was particularly worried by the growing social unrest created by friction between the rich and the poor in communities throughout Greece. Athens was more fortunate than many city-states in avoiding conflict between social classes in the fourth century B.C., perhaps because its democracy required wealthier men to spend money on benefactions to the community as a whole, especially through the liturgical system. Such men from the elite had to fulfill liturgies by paying for and sometimes also personally participating in activities that supported the city-state, such as buying the equipment for warships and serving on them as commanders, or financing the costumes and training of choruses for plays produced in the public dramatic festivals. These benefactions won their sponsors public gratitude (charis, the source of the modern word charity) on the grounds that they were putting their wealth to use in an appropriately democratic fashion. Any rich man involved in a court case would try to win sympathy from the jury, which as a randomly selected group would include many men of moderate means, by citing all the liturgies that he and his family had performed. Indeed, in all their public speaking wealthy citizens had to signal their allegiance to democratic principles in order to win popular support. The politics of charis, then, helped to lessen tensions between rich and poor in Athens.

Elsewhere in Greece hostility between rich and poor was evidently worse. The tension was only heightened by the city-states' traditional tendency toward hostility and rivalry toward one another; they rarely could find ways to cooperate to solve their social problems. For Isocrates, the state of affairs in Greece had become so unstable that only a radical remedy would do: Panhellenism—political harmony among the Greek states— which would be put into action not by Greeks but under the leadership of Philip II, king of Macedonia. Philip would unite the Greeks in a crusade against Persia, recalling the glorious success of the wars of a century and a half earlier. This alliance, as Isocrates imagined it, would end war among the city-states and also relieve the impoverished population by establishing new Greek colonies on conquered land carved out of Persian-held territory in Anatolia. That a prominent and proud Athenian would openly appeal for a Macedonian king to save the Greeks from themselves reflected the startling new political and military reality that had emerged in the Greek world by the second half of the fourth century B.C.

THE MACEDONIAN KINGDOM AND PHILIP II

The rise to international power of the kingdom of Macedonia filled the power vacuum that had been created by the fruitless wars of the Greek city-states with each other in the early fourth century B.C., the void that Xenophon had so acutely summed up at the end of his *Hellenica* with his bleak assessment of the consequences of the battle of Mantinea. Macedonia was a rough land of mountains and lowland valleys just to the north of Greece, and everyday life there was harder than in Greece because the climate was colder; it was more dangerous because the Macedonians' western and northern neighbors periodically launched devastating raids into Macedonian territory. The Macedonian population was especially vulnerable to such raids because they generally lived in small villages and towns without protective walls. Macedonia had more natural resources than Greece did, especially in timber and precious metals, but that this formerly minor kingdom become the supreme power in Greece in the 350s and 340s B.C. and then conquered the vast Persian Empire in the 330s and 320s ranks as one of the major surprises in ancient military and political history.

The power of the king of the Macedonian state was limited by the tradition that he was supposed to listen to his people, who were accustomed to addressing their monarch with a blunt freedom of speech. Above all, the king could govern effectively only as long as he maintained the support of the most powerful families in Macedonia, whose leaders ranked as his social equals and controlled large bands of followers. Fighting, hunting, and heavy drinking were the favorite pastimes of these men. The king was expected to demonstrate his prowess in these activities to show that he was a man's man capable of heading the state. Macedonian queens and royal mothers received respect in this male-dominated society because they belonged to powerful families of the Macedonian social elite or the ruling houses of lands bordering Macedonia and they bore their husbands the male heirs needed to carry on royal dynasties. In the king's absence, these royal women could compete with the king's designated representative for power at the royal court.

Macedonians had their own language related to Greek, but the members of the elite that dominated Macedonian society routinely learned to speak Greek because they thought of themselves, and indeed all Macedonians, as Greek by descent. At the same time, Macedonians looked down on the Greeks to the south as a soft bunch unequal to the adversities of life in Macedonia. The Greeks reciprocated this scorn. The famed Athenian orator Demosthenes (384–322 B.C.) lambasted the Macedonian king Philip

II (382–336 B.C.) as "not only not a Greek nor related to the Greeks, but not even a barbarian from a land worth mentioning; no, he's a pestilence from Macedonia, a region where you can't even buy a slave worth his salt" (*Orations* 9.31). Barbed verbal attacks like this one characterized Demosthenes' speeches on foreign and domestic policy to the Athenian assembly, where he consistently tried to convince his fellow Athenians to oppose the expansion of Macedonian power in Greece. His exceptional rhetorical skill also made him the foremost man of his time in the writing of speeches for other men to deliver in court cases.

Demosthenes spoke so forcefully against Philip II because he recognized how ambitious was this king, the person most responsible for making Macedonia into an international power and doing so against heavy odds. For one thing, strife in the royal family and disputes among the leading families had always been so common that Macedonia before Philip's reign had never been sufficiently united to mobilize its full military strength. So real was the fear of violence from their own countrymen that Macedonian kings stationed bodyguards at the door to the royal bedroom. Moreover, Macedonian princes married earlier than did most men, soon after the age of twenty, because the instability of the kingship demanded the production of male heirs as soon as possible.

Macedonian royal politics therefore reached a crisis in 359 B.C., when the Macedonian king Perdiccas and four thousand Macedonian troops were slaughtered in battle with the Illyrians, hostile neighbors to the north of Macedonia. Philip was only in his early twenties. Despite his relative youth, in this moment of national emergency he had the charisma to persuade the most important Macedonian leaders to recognize him as king in place of his infant nephew, for whom he was now serving as regent after the death of Perdiccas in battle. Philip soon restored the army's confidence by teaching the infantrymen an unstoppable new tactic. He convinced Macedonian troops to carry thrusting spears sixteen to eighteen feet long, which they had to hold with two hands. Philip drilled his men to handle these long weapons in a phalanx formation, whose front line bristled with outstretched spears like a lethal porcupine. With the cavalry deployed as a strike force to soften up the enemy and protect the infantry's flanks, Philip's reorganized army promptly routed Macedonia's northern enemies—and also suppressed local rivals to the young new king.

Philip next embarked on a whirlwind of diplomacy, bribery, and military action to make the states of Greece acknowledge his political superiority. He financed his ambition by prodigious spending of the gold and silver coinage he had minted from the mines of Macedonia and those that he captured in Thrace. Not even a grave battlefield wound that cost him

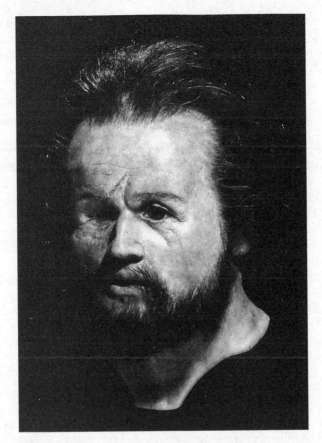

Fig. 9.2: Forensic anthropology has produced this reconstruction of the head of Philip II, king of Macedonia and father of Alexander the Great. Philip had an eye destroyed by an arrow shot by a defender stationed atop the fortification wall of the city of Methone, which the Macedonian ruler was besieging in 354 B.C. The Manchester Museum, The University of Manchester / Created by Richard Neave.

an eye could stop Philip (fig. 9.2). A Greek contemporary, the historian Theopompus of Chios, labeled Philip "insatiable and extravagant; he did everything in a hurry. . . . A soldier, he never spared the time to reckon up his income and expenditure" (Athenaeus, *The Learned Banqueters* [*Deipnoso-phistae*] 4.166f–167a = FGrH 115 F224). Philip achieved a great political coup in the 350s B.C. by convincing the most powerful leaders in Thessaly, the prosperous region of central Greece just over the mountains south of Macedonia, to elect him hegemonial commander of their confederacy,

thereby investing him with legitimacy as a leader of Greeks chosen by consent. The Thessalian barons apparently justified the choice of a Macedonian to lead their alliance by asserting that Philip was their kin as a descendant of the legendary Heracles and therefore qualified for the post by his famous ancestry.

In the mid-340s B.C. Philip intervened militarily in a bitter dispute over alleged sacrilege at the oracle of Apollo at Delphi, committed by the Phocians, the Greeks located just south of the Thessalians and their traditional bitter enemies. This so-called Sacred War pitted Philip and his Greek allies against the Phocians and their allies, among whom were the Athenians. Philip and his side gained the upper hand in this conflict, and by the late 340s Philip had cajoled or forced most of northern and central Greece to follow his lead in foreign policy. His goal then became to lead a united Macedonian and Greek army in his quest to defeat the Persian Empire. His announced reason sprang from a central theme in Greek understanding of the past: the need to exact retribution for the Persian invasion of Macedonia and Greece of 480. Philip also feared the potentially destabilizing effect on his kingdom if his reinvigorated army were left with nothing to do. To launch his ambitious invasion, however, he needed to strengthen his alliance by adding to it the forces of southern Greece.

At Athens, Demosthenes used his stirring rhetoric to scorch the Greeks for their failure to resist Philip: They stood by, he thundered, "as if Philip were a hailstorm, praying that he would not come their way, but not trying to do anything to head him off" (*Orations* 9.33). The Athenians were divided over whether to resist Philip or collaborate, and they were unable to form a consensus to direct all their now-limited public financial resources to military preparedness. Finally, however, Athens joined its traditional enemy Thebes in heading a coalition of southern Greek states to try to block Philip's plans by pooling their armies. It was not enough. In 338 B.C., Philip and his Greek allies trounced the coalition's forces at the battle of Chaeronea in Boeotia.

The defeated Greek states retained their internal political freedom, but they were compelled to join an alliance under Philip's undisputed leadership, called by modern scholars the League of Corinth, after the location of its headquarters. Sparta managed to stay out of the League of Corinth, but its days as an important power in its own right were over because its population had shrunk so dramatically. The battle of Chaeronea was a decisive turning point in Greek history: Never again would the states of Greece make foreign policy for themselves without considering, and usually following, the wishes of outside powers. This change marked the end of the Greek city-states as independent actors in international politics, although

they unquestionably retained their significance as the basic economic and social units of the Greek world. They had to fulfill a subordinate role now, however, either as subjects or allies of the kingdom of Macedonia or, after the death of Alexander the Great in 323 B.C., of the kingdoms subsequently created by Alexander's former generals. The Hellenistic kingdoms, as these new monarchies are called, like the Roman provinces that eventually replaced them as political masters of the Greeks, depended on the local leaders of the Greek city-states to collect taxes for the imperial treasuries and to insure the loyalty and order of the rest of the citizens. In this way, the city-states remained important constituent elements of the political organization of the Greek world and maintained a vital public life for their citizens, but they were never again to be fully in charge of their own fates.

Whether the Greeks could have avoided this degradation if they had acted differently is a question worth asking. Were they simply overcome by the accident of facing an enemy with better leadership and more access to natural resources to finance its power? Or could the Greek city-states have turned back Philip if they had not been weakened and divided by spending so many decades and so much treasure fighting one another? Could they have done better at compromising with other city-states when disputes arose, or would doing so have been a slippery slope leading to "slavery," as Pericles had argued to the Athenians in persuading them not to compromise with Sparta even if it meant war? These questions, which certainly have their analogues in our history today, seem to me to mark one of the numerous places where ancient Greek history is "good to think with."

THE CONQUESTS OF ALEXANDER THE GREAT

A Macedonian holding a grudge for a violent insult assassinated Philip in 336 B.C. Unconfirmed rumors circulated that the murder had been instigated by one of his several wives, Olympias, a princess from Epirus to the west of Macedonia and mother of Philip's son, Alexander (356–323 B.C.). When his father was killed, Alexander promptly liquidated potential rivals for the throne and won recognition as king while barely twenty years old. In several lightning-fast campaigns, he subdued Macedonia's traditional enemies to the west and north. Next, he compelled the city-states in southern Greece that had rebelled from the League of Corinth at the news of Philip's death to rejoin the alliance. (As in Philip's reign, Sparta remained outside the league.) To demonstrate the price of disloyalty, Alexander destroyed Thebes in 335 as punishment for its rebellion.

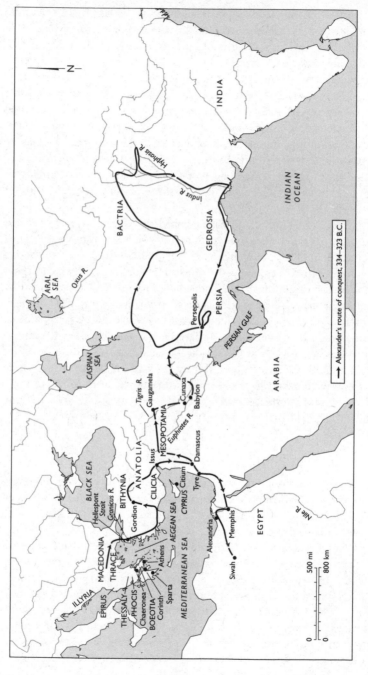

Map 7. Alexander's Route of Conquest, 334–323 B.C.

This lesson in terror made it clear that Alexander might claim to lead the Greek city-states by their consent (the kind of leader called a *hegemon* in Greek) but that the reality of his power rested on his superior force and his unwavering willingness to employ it. Alexander would always reward those who acknowledged his power, even if they had previously been his enemies, but he ruthlessly punished anyone who betrayed his trust or defied his ambitions.

With Greece cowed into peaceful if grudging allegiance, Alexander in 334 B.C. led a Macedonian and Greek army into Anatolia to fulfill his father's plan to obtain retribution for Greece by subduing Persia. Alexander's astounding success in the following years in conquering the entire Persian Empire while still in his twenties earned him the title "the Great" in later ages. In his own time, his greatness consisted of his ability to inspire his men to follow him into hostile, unknown regions where they were reluctant to go, beyond the borders of civilization as they knew it, and his genius for adapting his tactics to changing military and social circumstances as he marched farther and farther away from the land and people that he knew from his youthful years. Alexander inspired his troops with his reckless disregard for his own safety; often he plunged into the enemy at the head of his men and shared the danger of the common soldier in the front of the battle line. No one could miss him in his plumed helmet, vividly colored cloak, and armor polished to reflect the sun. So intent on conquering distant lands was Alexander that he had rejected advice to delay his departure from Macedonia until he had married and fathered an heir, to forestall instability in case of his death. He had further alarmed his principal advisor, an experienced older man, by giving away almost all his land and property in order to strengthen the army, thereby creating new landowners who would furnish troops. "What," the advisor asked, "do you have left for yourself?" "My hopes," Alexander replied (Plutarch, *Alexander* 15). Those hopes centered on constructing a heroic image of himself as a warrior as glorious as the incomparable Achilles of Homer's *Iliad*. Alexander always kept a copy of *The Iliad* under his pillow, along with a dagger. Alexander's aspirations and his behavior represented the ultimate expression of the Homeric vision of the glorious conquering warrior striving "always to be the best" and to win the immortal reputation that only such achievements could convey.

Alexander cast a spear into the earth of Anatolia when he crossed the Hellespont Strait from Europe to Asia, thereby claiming the Asian continent for himself in Homeric fashion as territory "won by the spear" (Diodorus Siculus, *Library of History* 17.17.2). The first battle of the campaign, at the Granicus River in western Anatolia, proved the worth of Alexander's

Macedonian and Greek cavalry, which charged across the river and up the bank to rout the opposing Persians. A Persian came within a split second of cutting Alexander's head in two with a sword as the king led his cavalry against the enemy, but a Macedonian commander saved the charging king by slicing off the attacker's arm. Alexander went on to visit the legendary King Midas's capital of Gordion in Phrygia, where an oracle had promised the lordship of Asia to whoever could loose a seemingly impenetrable knot of rope that was tying the yoke of an ancient chariot preserved in the city. The young Macedonian, so the story goes, cut the Gordion knot with his sword. In 333 B.C. the Persian king Darius finally faced Alexander in battle at Issus, near the southeastern corner of Anatolia. Alexander defeated his more-numerous opponents with a characteristically bold strike of cavalry through the left side of the Persian lines, followed by a flanking maneuver against the king's position in the center. Darius had to flee from the field to avoid capture, leaving behind his wives and daughters, who had accompanied his campaign in keeping with royal Persian tradition. Alexander's scrupulously chivalrous treatment of the Persian royal women after their capture at Issus reportedly boosted his reputation among the peoples of the king's empire.

When Tyre, a heavily fortified city on the coast of what is now Lebanon, refused to surrender to him in 332 B.C., Alexander employed the assault machines and catapults developed by his father to breach the walls of its formidable offshore fortress after a long siege. The capture of Tyre revealed that walled city-states were no longer impregnable to siege warfare. Although successful sieges remained difficult after Alexander because well-constructed city walls still presented formidable barriers to attackers, Alexander's success against Tyre increased the terror of a siege for a city's general population. No longer could its citizens confidently assume that their defensive system could indefinitely withstand the technology of their enemy's offensive weapons. The now-present fear that a siege might actually breach a city's walls made it much harder psychologically for city-states to remain united in the face of threats from enemies like aggressive kings.

Alexander next took over Egypt, where hieroglyphic inscriptions exist that scholars have suggested are evidence the Macedonian presented himself as the successor to the Persian king as the land's ruler, not as an Egyptian pharaoh. This conclusion is not certain, however, and in Egyptian art Alexander is depicted in the traditional guise of rulers of that ancient state. For all practical purposes, Alexander became pharaoh, an early sign that he was going to adopt whatever foreign customs and institutions he found useful for controlling his conquests and proclaiming his superior status.

On the coast, to the west of the Nile river, Alexander in 331 B.C. founded a new city, named Alexandria after himself, the first of many cities he would later establish as far east as Afghanistan. During his time in Egypt, Alexander also paid a mysterious visit to the oracle of the god Ammon, whom the Greeks regarded as identical to Zeus, at the oasis of Siwah, far out in the western Egyptian desert. Alexander told no one the details of his consultation of the oracle, but the news got out that he had been informed that he was the son of the god and that he joyfully accepted the designation as true.

In 331 B.C., Alexander crushed the Persian king's main army at the battle of Gaugamela in northern Mesopotamia, near the border of modern Iraq and Iran. He subsequently proclaimed himself king of Asia in place of the Persian king; never again would he be merely the king of the Macedonians and hegemon of the Greeks. For the heterogeneous populations of the Persian Empire, the succession of a Macedonian to the Persian throne meant essentially no change in their lives. They continued to send the same taxes to a remote master, whom they rarely if ever saw. As in Egypt, Alexander left the local administrative system of the Persian Empire in place, even retaining some Persian governors. His long-term aim seems to have been to forge an administrative corps composed of Macedonians, Greeks, and Persians working together to rule the territory he conquered with his army. Alexander was quick to recognize excellence when he saw it, and he began to rely more and more on "barbarians" as supporters and administrators. His policy seems to have been to create strength and stability by mixing ethnic traditions and personnel. As he had learned from Aristotle, his tutor when he was a teenager in Macedonia, mixed natures were the strongest and best.

TO INDIA AND BACK

Alexander next led his army farther east into territory hardly known to the Greeks. He pared his force to reduce the need for supplies, which were difficult to find in the arid country through which they were marching. Each hoplite in Greek armies customarily had a personal servant to carry his armor and pack. Alexander, imitating Philip, trained his men to carry their own equipment, thereby creating a leaner force by cutting the number of army servants dramatically. As with all ancient armies, however, a large number of noncombatants trailed after the fighting force: merchants who set up little markets at every stop; women whom soldiers had taken as mates along the way and their children; entertainers; and prostitutes. Although supplying these hangers-on was not Alexander's responsibility,

their foraging for themselves made it harder for Alexander's quartermasters to find what they needed to supply the army proper.

An ancient army's demand for supplies usually left a trail of destruction and famine for local inhabitants in the wake of its march. Hostile armies simply took whatever they wanted. Friendly armies expected local people to sell or donate food to its supply officers and also to the merchants trailing along. These entrepreneurs would set up markets to resell locally obtained provisions to the soldiers. Since most farmers in antiquity had practically no surplus to sell, they found this expectation—which was in reality a requirement—a terrific hardship. The money the farmers received was of little use to them because there was nothing to buy with it in the countryside, where their neighbors had also had to participate in the forced marketing of their subsistence.

From the heartland of Persia in 329 B.C., Alexander marched northeastward into the trackless steppes of Bactria (modern Afghanistan). When he proved unable to completely subdue the highly mobile locals, who avoided pitched battles in favor of the guerrilla tactics of attack and retreat, Alexander settled for an alliance sealed by his marriage to the Bactrian princess Roxane in 327. In this same period, Alexander completed the cold-blooded suppression of both real and imagined resistance to his plans among the leading men in his officer corps. As in past years, he regarded accusations of treachery or disloyalty as justification for the execution of those Macedonians he had come to distrust. These executions, like the destruction of Thebes in 335, demonstrated Alexander's appreciation of terror as a disincentive to rebellion.

From Bactria Alexander pushed on eastward to India. He probably intended to march all the way through to China in search of the edge of the farthest land on the earth, which Aristotle had taught was a sphere. Seventy days of marching through monsoon rains, however, finally shattered the nerves of Alexander's soldiers. In the spring of 326 B.C., they mutinied on the banks of the Hyphasis River (the modern Beas) in northwestern India. Alexander was forced to agree to lead them in the direction of home. When his men had balked before, Alexander had always been able to shame them back into action by sulking in his tent like Achilles in *The Iliad*. This time the soldiers were beyond shame.

Blocked from continuing eastward, Alexander now proceeded south down the Indus River. Along the way he took out his frustration at being stopped in his push to the east by conquering the Indian tribes who resisted him and by risking his life more flamboyantly than ever before. As a climax to his frustrated rage, he flung himself over the wall of an Indian town to face the enemy alone like a Homeric hero. His horrified officers

were barely able to rescue him in time; even so, he received near-fatal wounds. At the mouth of the Indus on the Indian Ocean, Alexander turned a portion of his army west through the fierce desert of Gedrosia. He sent another group on an easier route inland, while a third group sailed westward along the coast to explore for possible sites for new settlements and harbors to connect Mesopotamia and India. Alexander himself led the contingent that braved the desert, planning to surpass earlier famous leaders by marching through territory that they had found nearly impassable. The environment along the way was punishing. A flash flood wiped out most of the noncombatants following the army when they camped in a dry riverbed that filled up after a sudden inundation. Many soldiers died on the burning sands of the desert, expiring from lack of water and the heat, which has been recorded at 127 degrees in the shade in that area. Alexander, as always, shared his men's hardships. In one legendary episode from this horrible ordeal, a patrol was said to have brought him a helmet containing some water that had been found on their scouting expedition. Alexander spilled the water out onto the sand rather than drink when his men could not. They loved him for this gesture more than anything else, it is reported. The remains of the army finally reached safety in the heartland of Persia in 324 B.C. Alexander promptly began plans for an invasion of the Arabian Peninsula and, to follow that, North Africa west of Egypt.

By the time Alexander returned to Persia, he had dropped all pretense of ruling over the Greeks as anything other than an absolute monarch. Despite his earlier promise as hegemon to respect the internal freedom of the Greek city-states, he now impinged on their autonomy by sending a peremptory decree ordering them to restore to citizenship the large number of exiles wandering homeless in the Greek world. The previous decades of war in Greece had created many of these unfortunate wanderers, and their status as stateless persons was creating unrest. Even more striking was Alexander's communication to the city-states that he wished to receive the honors due a god. Initially dumbfounded by this request, the leaders of most Greek states soon complied by sending honorary delegations to him as if he were a god. The Spartan Damis pithily expressed the only prudent position on Alexander's deification open to the stunned Greeks: "If Alexander wishes to be a god, we agree that he be called a god" (Plutarch, *Moralia* 219e).

Scholarly debate continues over Alexander's motive for desiring the Greeks to acknowledge him as a god, but few now accept a formerly popular theory that he did not really think that he was divine and only claimed that status because he believed the city-states could then save face by obeying his orders because the commands originated from a divinity, whose authority of course superseded that of all earthly regimes. Personal rather

than political motives best explain Alexander's request. He certainly had come to believe that he was the son of Zeus; after all, Greek mythology told many stories of Zeus producing children by mating with a human female. Most of those legendary offspring were mortal, but Alexander's conquest showed that he had surpassed them. His feats must be superhuman, it would have seemed to him, because they exceeded the bounds of human possibility. In other words, Alexander's accomplishments demonstrated that he had achieved godlike power and therefore must be a god himself, even while still a man. This new kind of divinity achieved by Alexander emerged, in his view, as a natural consequence of his power and achievements. We have to take seriously the ancient evidence that Alexander believed he was a god and a man at the same time; that was an idea that, later history shows, was going to have a long future.

Alexander's political and military goals can best be explained as interlinked goals: the conquest and administration of the known world, and the exploration and possible colonization of new territory beyond. Conquest through military action was a time-honored pursuit for ambitious Macedonian leaders such as Alexander. He included non-Macedonians in his administration and army because he needed their expertise, not because he had any dream of promoting an abstract notion of what was once called "the brotherhood of man." Alexander's explorations benefited numerous scientific fields, from geography to botany, because he took along scientifically minded writers to collect and catalogue the new knowledge that they encountered. The far-flung new cities that he founded served as loyal outposts to keep the peace in conquered territory and provide warnings to headquarters in case of local uprisings. They also created new opportunities for trade in valuable goods, such as spices, that were not produced in the Mediterranean region.

Alexander's plans to conquer Arabia and North Africa were extinguished by his premature death in Babylon on June 10, 323 B.C. He died from a fever worsened by dehydration from drinking wine, which Greeks believed had medicinal qualities for the sick. He had already been suffering for months from depression brought on by the death of his best friend, Hephaistion. Close since their boyhoods, Alexander and Hephaistion are believed by some to have been lovers, though the major surviving ancient sources do not make this claim explicitly. They do suggest, however, that Alexander, like other men of his time and place, had a more expansive view of appropriate erotic desire and sexual practice for men than is usual today; for one thing, he is said to have had a beautiful eunuch who provided him with intimate services. In any case, when Hephaistion died in a bout of excessive drinking, Alexander went wild with grief. The depth

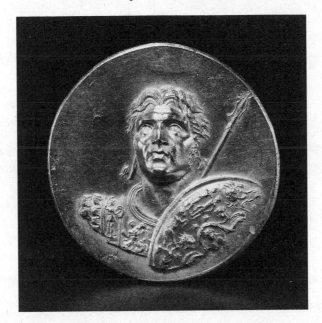

Fig. 9.3: This gold medallion made in the time of the Roman Empire commemorates Alexander the Great, outfitted in decorated armor, though without a helmet so that his face could be clearly seen. His head is depicted gazing upward, with Alexander scanning the sky, a pose that the Macedonian conqueror was said to have chosen for his official portrait in sculpture. The Walters Art Museum, Baltimore.

of his emotion was evident when he planned to build an elaborate temple to honor Hephaistion as a god. Meanwhile, Alexander threw himself into preparing for his Arabian campaign by exploring the marshy lowlands of southern Mesopotamia. Perhaps it was on one of these trips that Alexander contracted the malarialike fever that killed him when he was only thirty-two years old. Alexander had made no plans about what should happen if he should die unexpectedly. His wife Roxane gave birth to their first child only some months after Alexander's death. When at Alexander's deathbed his commanders asked him to whom he left his kingdom, he replied, "to the most powerful" (Arrian, *Anabasis* 7.26.3).

The Athenian orator Aeschines (c. 397–322 B.C.) well expressed the bewildered reaction of many people to the events of Alexander's lifetime: "What strange and unexpected event has not occurred in our time? The life we have lived is no ordinary human one, but we were born to be an object of wonder to posterity" (*Orations* 3.132). Alexander himself attained a fabulous level of fame that persisted in later times (fig. 9.3). Sto-

ries of awe-inspiring exploits attributed to him became popular folktales throughout the ancient world, even reaching distant regions where Alexander had never gone, such as deep in sub-Saharan Africa. The popularity of the legend of Alexander as the narrative of the height of achievement for a masculine warrior-hero served as one of his most enduring and powerful legacies to later ages. That the worlds of Greece and the Near East had been brought into closer contact than ever before represented another long-lasting effect of his astonishing career. Its immediate political and military consequences, however, were the violent struggles among his generals that led to the creation of the kingdoms of the Hellenistic Age.

The Hellenistic Age

The term Hellenistic ("Greek-like") was invented in the nineteenth century A.D. to designate the period of Greek and Near Eastern history from the death of Alexander the Great in 323 B.C. to the death of Cleopatra VII, the last Macedonian ruler of Egypt, in 30 B.C. The early Hellenistic period saw the emergence of a new form of kingship that, compounded from Macedonian and Near Eastern traditions, became the dominant political structure in the eastern Mediterranean after Alexander's premature death. The men who founded the Hellenistic kingdoms were generals from Alexander's forces, who made themselves into self-proclaimed monarchs although they had neither a blood relationship to any traditional royal family line nor any historical claim to a particular territory. Their military power, their prestige, and their ambition were their only justifications for transforming themselves into kings.

Hellenistic also conveys the idea that a mixed, cosmopolitan form of social and cultural life combining Hellenic (that is, Greek) traditions with indigenous traditions emerged in the eastern Mediterranean region in the aftermath of Alexander's conquests. The Hellenistic kings spurred this development by bringing Greeks to live in the midst of long-established indigenous communities and also by founding new cities on Greek lines. Since these imported Greeks primarily lived in cities, Greek ideas and customs had their greatest impact on the urban populations of Egypt and southwestern Asia. The great number of people farming the Near Eastern countryside, who rarely

c. 320–301 B.C.: Macedonian generals Antigonus and his son Demetrius fight the other "successor kings" to reestablish Alexander's empire but only succeed in maintaining a kingdom in Macedonia and Greece.

310 B.C.: Murder of Alexander's son, the last member of the Macedonian royal house; Zeno founds the Stoic philosophical school at Athens.

307 B.C.: Epicurus establishes his philosophical school at Athens.

306–304 B.C.: "Successors" of Alexander declare themselves kings.

303 B.C.: Seleucus cedes eastern territory of his kingdom to the Indian king Chandragupta.

301 B.C.: Antigonus defeated and killed at battle of Ipsus in Anatolia.

300 B.C.: King Ptolemy I establishes the Museum in Alexandria.

c. 284–281 B.C.: Foundation of Achaean League in southern Greece.

279 B.C.: Gauls invade Macedonia and Greece.

256 B.C.: Mauryan king Aśoka in India proclaims his Buddhist mission to Greeks.

239–130 B.C.: Independent Greek kingdom in Bactria (modern Afghanistan).

238–227 B.C.: Attalid king Attalus I defeats the Gauls and confines them to Galatia.

167 B.C.: Antiochus IV forcibly introduces a statue of the Syrian god Baal into the temple of the Jews in Jerusalem.

30 B.C.: Death of Cleopatra VII, queen of Egypt, the last Macedonian monarch of the Hellenistic period.

visited the cities, had much less contact with Greek ways of life. Since the kings favored Greek culture, there was never any doubt that it would be adopted by the elite of the Hellenistic kingdoms, whatever their own origins. At the same time, the relocations of Greek culture to so many new places outside the Greek homeland inevitably, if often unintentionally, reconfigured what it meant to be Greek, or at least to live in a "Greek-like" way.

CREATING HELLENISTIC KINGDOMS

After Alexander's death, his mother, Olympias, fought for several years to establish her infant grandson, Alexander's son by Roxane, as the Macedonian king under her protection. Her plan failed because Alexander's former commanders were willing to do whatever it took to seize power for themselves, and within twenty years three of the most powerful of

them had established new kingdoms carved from parts of Alexander's empire: Antigonus (c. 382–301 B.C.) and his son Demetrius (c. 336–283 B.C.) took over in Macedonia and Greece, Seleucus (c. 358–281 B.C.) in Syria and the old Persian Empire (extending to Afghanistan and western India), and Ptolemy (c. 367–282 B.C.) in Egypt. Since these men took over the largest sections of Alexander's conquests as if they had been his heirs (though they had no blood relationship to him), they were referred to as the "successor kings."

The first Hellenistic kings faced the same challenge shared by all new regimes: to establish political legitimacy for their rule. Legitimacy in the eyes of the population was essential if these former generals of Alexander were to create royal families of their own that had any chance of enduring beyond their lifetimes. As a result, Hellenistic queens enjoyed a high social status as the offspring of distinguished families who gave birth to a lineage of royal descendants. Ultimately, the successors' positions rested on their personal ability and their power; they had no automatic claim to be acknowledged as legitimate rulers. The city of Ilion in northwest Anatolia summed up the situation in the words it used in an inscription conveying honors on Seleucus's son and heir, Antiochus I (ruled 281–261 B.C.), in the 270s: "He has made his kingdom prosperous and brilliant mostly through his own excellence but also with the good will of his friends and his forces" (Austin, The Hellenistic World no. 162 = OGIS 219). In sum, Hellenistic kingship had its origins in the personal attributes of the king instead of inherited privileges and perquisites. For this reason, it is often described as "personal monarchy."

It took decades after Alexander's death for the territorial boundaries of the new kingdoms to be settled. Antigonus tried to expand his personal monarchy into a large empire by attacking the kingdoms of the other successors, but they in response temporarily banded together to defeat and kill him at the battle of Ipsus in Anatolia in 301 B.C. His son, Demetrius, regained the Macedonian throne from about 294 to 288 B.C., but later defeats forced Demetrius to spend his last years in luxurious captivity as a helpless guest under the power of Seleucus. Demetrius's son, Antigonus Gonatas (c. 320–239 B.C.), reestablished the Antigonid kingdom, centered in Macedonia, by about 276. The Seleucid kingdom traded its easternmost territory early in its history to the Indian king Chandragupta (ruled 323–299 B.C.), founder of the Mauryan dynasty, for five hundred war elephants. Later on, most of Persia was lost to the Parthians, a north Iranian people. Even after these reductions, the territory of the Seleucid kingdom covered a huge area. The Ptolemaic kingdom was able to retain continuous control of the rich land of Egypt, which was easier to defend

because the deserts on its borders made invasions by land difficult. By the middle of the third century B.C., the three successor kingdoms had in practice reached a balance of power that kept them from expanding much beyond their core territories. Nevertheless, the Hellenistic monarchs, like the Greek city-states before them, remained competitive with one another, especially in conflicts over contested border areas. The Ptolemies and the Seleucids, for example, periodically engaged in violent tugs-of-war over Palestine and Syria.

Some smaller regional kingdoms also formed in the Hellenistic period. Most famous among them was the kingdom of the Attalids in Anatolia, with the wealthy city of Pergamum as its capital. The Attalids were strong enough to defeat a large band of Celtic people called Gauls, who invaded the Pergamene kingdom from northern Europe in the third century B.C.; the Attalid army succeeded in confining the Gauls to an area in Anatolia thereafter known as Galatia, from their name. As far away as central Asia, in what is today Afghanistan, a new kingdom formed when Diodotos I led a successful rebellion of Bactrian Greeks from the Seleucid kingdom in the mid-third century. These Greeks, whose ancestors Alexander the Great had settled in Bactria, had flourished because their land was the crossroads for overland trade in luxury goods between India and China and the Mediterranean world. By the end of the first century B.C., the Bactrian kingdom had fallen to Asian invaders from north of the Oxus River (now the Amu Daria), but the region continued to serve as a cauldron for the interaction of the artistic, philosophical, and religious traditions of East and West, including Buddhism.

All the Hellenistic kingdoms in the eastern Mediterranean region eventually fell to the Romans. Diplomatic and military blunders by the kings of Macedonia beginning in the third century B.C. first drew the Romans into Greece, where they became dominant by the middle of the second century. Thereafter, Greek history became part of Roman history. Smaller powers, such as the city-state of Rhodes and the Attalid kings in Pergamum that were seeking protection from more-powerful rivals, encouraged the Romans to intervene in the eastern Mediterranean. Despite the Seleucid kingdom's early losses of territory and later troubles from both internal uprisings and external enemies, it remained a major power in the Near East for two centuries. Nevertheless, it too fell to the Romans in the mid-first century B.C. The Ptolemaic kingdom survived the longest. Eventually, however, its growing weakness forced the Egyptian kings in the first century to request Roman support, which the Romans characteristically extended only under the condition that the protected would conduct themselves in the future according to Roman wishes. When Queen Cleopatra chose the

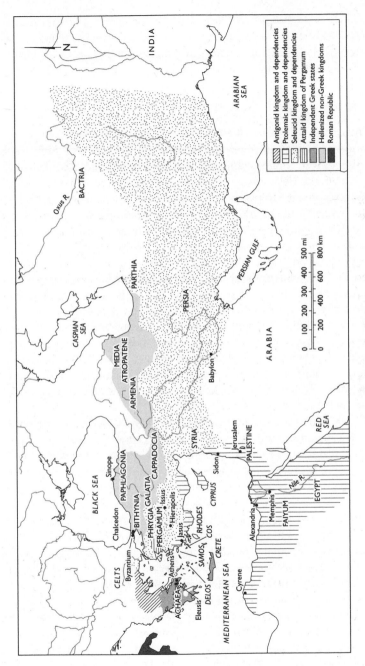

Map 8. The Hellenistic World, c. 240 B.C.

INDIA

ARABIAN
SEA

Antigonid kingdom and dependencies
Ptolemaic kingdom and dependencies
Seleucid kingdom and dependencies
Attalid kingdom of Pergamum
Independent Greek states
Hellenized non-Greek kingdoms
Roman Republic

N

Oxus R.

BACTRIA

CASPIAN
SEA

PARTHIA

PERSIAN GULF

MEDIA
ATROPATENE
ARMENIA

PERSIA

ARABIA

Babylon

500 mi
0 100 200 300 400
0 200 400 600 800 km

BLACK SEA

Sinope

PAPHLAGONIA

BITHYNIA

Chalcedon

Byzantium

CELTS

PHRYGIA GALATIA

CAPPADOCIA

SYRIA

Jerusalem

PALESTINE

Sidon

CYPRUS

RED
SEA

Nile R.

EGYPT

FAIYUM

Memphis

Alexandria

PERGAMUM

Hierapolis

Issus

Jasus

RHODES

COS

SAMOS

CRETE

DELOS

Athens

Eleusis

ACHAEA

Cyrene

MEDITERRANEAN SEA

losing side in the Roman civil war of the late first century, a Roman inva-
sion in 30 B.C. ended her reign and the long succession of Ptolemaic rul-
ers; Egypt became Roman territory, making its conqueror, Octavian (the
future Augustus, the first emperor of Rome), the richest man in the world.

DEFENDING AND ADMINISTERING HELLENISTIC KINGDOMS

The armies and navies of Hellenistic kingdoms provided security not
only against foreign enemies but internal rebellion as well. Hellenistic
royal forces were composed of professional soldiers, and even the Greek
city-states in the Hellenistic period increasingly hired mercenaries instead
of calling up citizens as troops. To develop their military might, the Seleu-
cid and Ptolemaic kings vigorously promoted immigration by Greeks and
Macedonians, who received grants of land in return for military service.
When this source of people later dried up, the kings had to recruit soldiers
from the local populations, employing indigenous troops to do military
service. The kingdoms' military expenses rose because the kings faced ongo-
ing pressure to pay their mercenaries regularly and because technology had
developed more-expensive artillery, such as catapults capable of flinging a
projectile weighing 170 pounds a distance of nearly 200 yards. Hellenistic
navies were hugely expensive, too, because warships were larger, with
some dreadnoughts requiring hundreds of men as crews. War elephants,
popular weapons in Hellenistic arsenals for their shock effect on enemy
troops, also required large expenses for upkeep: The beasts ate a lot, all
year-round.

To administer their kingdoms at the highest levels, Hellenistic kings ini-
tially depended on immigrant Greeks and Macedonians. The title "King's
Friends" identified the inner circle of advisors and courtiers. Like Alex-
ander before them, however, the Seleucids and the Ptolemies necessarily
also employed indigenous men throughout the middle and lower levels
of their administrations. Nevertheless, social discrimination persisted be-
tween Greeks and non-Greeks, and local men who made successful careers
in government employ were only rarely admitted to the highest ranks of
royal society, such as the rank of King's Friends. Greeks (and Macedo-
nians) generally saw themselves as too superior to mix socially with locals.
The most valuable qualification local men could acquire for a governmen-
tal career was to learn to read and write Greek in addition to their native
languages. They would then be able to fill positions communicating the
orders of the highest-ranking officials, who were almost all Greeks and
Macedonians, to the local farmers, builders, and crafts producers, whose
job it was to carry out these commands. The Greek that these administra-

tors learned was koinē ("common Greek"), a standardized and simplified form of the language based on the Athenian dialect. For centuries, Koine was the common language of commerce and culture all the way from Sicily to the border of India. It is the language in which the New Testament was written during the early Roman Empire and became the parent of Byzantine and Modern Greek.

The principal duties of administrators in the Hellenistic kingdoms were to maintain order and manage the direct and indirect tax systems that provided a main source of revenue to the kings. In many ways, the goals and the structures of Hellenistic royal administration recalled those of the earlier Assyrian, Babylonian, and Persian empires. These institutions kept order among the kingdom's subjects by arbitrating between disputing parties whenever possible, but their administrators could, if necessary, call on troops to perform police functions. Overseeing the collection of taxes could be complicated. For instance, in Ptolemaic Egypt, the most tightly organized of the Hellenistic kingdoms, royal officials collected customs duties of 50, 33 1/3, 25, or 20 percent, depending on the type of goods. The central planning and control of the renowned Ptolemaic organization were inherited from much earlier periods of Egyptian history. Officials enforced royal monopolies, such as on the production of vegetable oil, intended to maximize the king's revenue. Ptolemaic administrators, in a system much like modern schemes of centralized agriculture, decided how much royal land was to be sown in oil-bearing plants, supervised production and distribution of the vegetable oil extracted from the crops, and set all prices for every stage of the oil business. The king, through his officials, also often entered into partnerships with private investors to produce more revenue.

Cities were the economic and social centers of the Hellenistic kingdoms. In Greece, some cities tried to increase their strength to counterbalance that of the monarchies by banding together into new federal alliances, such as the Achaean League in the Peloponnese, established in the 280s B.C. Making decisions for the members of the league in a representative assembly, these cities agreed on shared systems, such as coinage, weights and measures, and legal protections for citizens. Many Greeks and Macedonians also now lived in new cities founded by Alexander and the successors in the Near East. Hellenistic kings refounded existing cities to bring honor on themselves and to introduce new immigrants and social practices supporting their policies. The new settlements were built with the traditional features of Classical Greek city-states, such as gymnasiums and theaters. Although these cities often also possessed such traditional political institutions of the city-state as councils and assemblies for citizen

men, the limits of their independence depended strictly on the king's will. When writing to the city's council, the king might express himself in the form of a polite request, but he expected his wishes to be fulfilled as if they were commands. In addition, the cities often had to pay taxes directly to the king.

The kings needed the goodwill of the wealthiest and most influential city dwellers—the Greek and Macedonian urban elites—to keep order in the cities and ensure a steady flow of tax revenues. These wealthy people had the crucial responsibility of collecting the kingdom's taxes from the surrounding countryside as well as their cities, and then sending the money safely to the royal treasury. The kings in return honored and flattered these members of the cities' upper class to secure their goodwill and cooperation. Favored cities would receive financial grants from the king to pay for expensive public works such as theaters and temples, or rebuilding projects after earthquakes. The wealthy men and women of the urban upper classes did their loyal service by helping to keep the general population content; these rich members of the social elite provided donations and loans to ensure a reliable supply of grain to feed the urban populations, subsidized the pay of teachers and doctors in the cities, and paid for the construction of public works. The Greek tradition that the wealthy elite of a city-state should make benefactions for the common good was therefore continued in a new way, through the social interaction of the kings and the urban upper classes in their kingdoms.

Well-to-do members of the indigenous populations also mattered to the kings. Since non-Greek cities had long been powerful in Syria and Palestine, for example, the kings had to develop cordial relations with their leading members. Non-Greeks and non-Macedonians from eastern regions also moved westward to Hellenistic Greek cities in increasing numbers. Jews in particular moved away from Palestine into Anatolia, Greece, and Egypt. The Jewish community eventually became an influential minority in Alexandria in Egypt, the most important Hellenistic city. In Egypt, the Ptolemaic kings also had to come to terms with the priests who controlled the temples of that land's traditional gods, because the temples owned large tracts of productive agricultural land worked by tenant farmers; the Macedonian rulers evidently tried to express their respect for Egypt's antiquity by having themselves represented in art in Egyptian style (fig. 10.1). The linchpin in the organization of the Hellenistic kingdoms was the system of mutual rewards by which the kings and their leading subjects—Greeks, Macedonians, and indigenous elites—became, as it were, senior and junior partners in government and public finance.

The successor kingdoms nevertheless amounted to foreign rule over

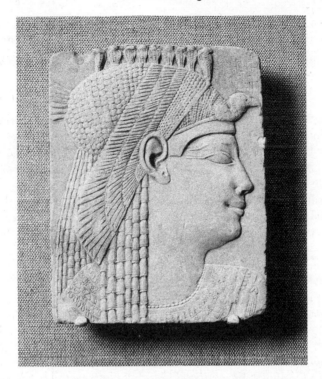

Fig. 10.1: This sculpture from Egypt in the Hellenistic Age portrays a queen, or perhaps a goddess, wearing a vulture headdress. The Greek family (the Ptolemies) who seized the rule of Egypt after the death of Alexander the Great had themselves portrayed in official art in a style recalling that of the ancient pharaohs of dynastic Egypt. The Walters Art Museum, Baltimore.

indigenous populations by kings and queens of Greco-Macedonian descent. Monarchs had to respect and cultivate the cooperation of the urban elites and the favored immigrants in their kingdoms, but royal power ultimately determined the safety and security of the lives of the kingdoms' subjects, above all in the system of justice. Seleucus, for one, claimed this right as a universal truth: "It is not the customs of the Persians and other peoples that I impose upon you, but the law which is common to everyone, that what is decreed by the king is always just" (Appian, *Roman History* 11. 61 [*The Syrian Wars*]). Even the successors of Antigonus, who claimed to lead the Greeks in a voluntary alliance that allegedly reestablished Philip's League of Corinth, frequently interfered in the internal affairs of the Greek city-states. Like the other kings, they regularly installed their own gover-

nors and garrisons in cities where loyalty was suspect. Never again would ancient Greeks live their lives free of the shadow of monarchy, sometimes faint in the distance, sometimes looming near.

ECONOMY AND SOCIETY IN THE HELLENISTIC KINGDOMS

Hellenistic society in the eastern Mediterranean world was firmly divided into separate layers. At the top of the hierarchy came the royal family, followed by the King's Friends. The Greek and Macedonian elites of the major cities ranked next in social status. Then came the wealthy elites of the indigenous cities, the leaders of large minority urban populations, and the traditional lords and princes of indigenous groups maintaining their ancestral domains in more rural regions. Lowest ranking of the free population were the masses of small merchants, crafts producers, and laborers. Slaves remained where they had always been, outside the bounds of social ranking, although those who worked at court could live materially comfortable lives.

Poor people performed the overwhelming bulk of the labor required to support the economies of the Hellenistic kingdoms. Agriculture remained the economic base, and conditions for farmers and field workers changed little over time. Many of them worked on the huge agricultural estates belonging to the royal family, but city-states that retained their rural territories still had free peasants working small plots, as well as larger farms belonging to wealthy landowners. Rural people rose early to begin work before the heat of the day, cultivating the same kinds of crops and animals as their ancestors, using the same simple hand-tools and beasts of burden. The relatively limited level of mechanical technology meant that perhaps as many as 80 percent of all adult men and women, free as well as slave, had to do manual labor on the land to produce enough food to sustain the population. Along certain international routes, however, trade by sea thrived. Tens of thousands of amphoras (large ceramic jars used to transport commodities such as olive oil and wine) made on the Greek island of Rhodes, for example, have been found in Ptolemaic Egypt. Consortiums of foreign merchants turned the Aegean island of Delos into a busy transportation hub for the cross-shipping of goods, such as the ten thousand slaves a day the port could handle. In the cities, poor women and men continued to work as merchants, peddlers, and artisans producing goods such as tools, pottery, clothing, and furniture. Men could sign on as deckhands on the merchant ships that sailed the Mediterranean and Indian oceans in pursuit of profits from trade. By the later Hellenistic Age, merchant ships

were regularly sailing to India and back along the route that Alexander the Great had had his fleet scout out during the return from India.

In the Seleucid and Ptolemaic kingdoms, a large section of the rural population existed in a state of dependency between free and slave. The "peoples," as they were called, farmed the estates belonging to the king, who was the kingdom's greatest landowner. The king theoretically claimed title to all his kingdom's land because it had been, following Alexander's terminology of conquest, "won by the spear." In reality, however, Hellenistic kings ceded a significant amount of territory to cities, temples, and favored individuals. The peoples, by contrast, were not landowners but compulsory tenants. Although they could not be sold like chattel slaves, they were not allowed to move away or abandon their tenancies. They had to pay a certain quota of produce per area of land to the king, much like paying rent to a landlord. The amount was sufficiently high that the "peoples" had virtually no chance to improve their economic lot in life.

Women at the pinnacle of the social pyramid in the Hellenistic world— the female members of the royal families—commanded influence and riches unprecedented in Greek history. Hellenistic queens usually exercised political and military power only to the extent that they could influence their husbands' decisions, but they ruled on their own when no male heir existed. Since the Ptolemaic royal family permitted brother-sister marriage for dynastic purposes, royal daughters as well as sons were in line to rule. For example, Arsinoë II (c. 316–270 B.C.), the daughter of Ptolemy I, first married the Macedonian successor king Lysimachus, who gave her four towns as her personal domain and sources of revenue. After Lysimachus's death, she married her brother, Ptolemy II of Egypt, and exerted at least as much influence on policy as he did. The excellences publicly praised in a queen reflected traditional Greek values for women. When, around 165 B.C., the city of Hierapolis passed a decree in honor of Queen Apollonis of Pergamum, for instance, she was praised for her piety toward the gods, her reverence toward her parents, her distinguished conduct toward her husband, and her harmonious relations with her "beautiful legitimate children" (Austin, The Hellenistic World, no. 240 = OGIS no. 308).

Some queens paid special attention to the condition of women. About 195 B.C., for example, the Seleucid queen Laodice gave a ten-year endowment to the city of Iasus in southwestern Anatolia to provide dowries for needy girls. Her endowing a foundation to help less-fortunate women reflected the increasing concern on the part of the wealthy for the welfare of the less-fortunate during the Hellenistic period. The royal families led the way in this tendency toward greater philanthropy, seeking to cultivate

an image of the level of magnanimous generosity befitting glorious kings and queens, in accordance with the long Greek tradition of the social elite making benefactions for the good of the community. That Laodice funded dowries shows that she recognized the importance to women of owning property, the surest guarantee of a certain respect and a measure of power in their households.

The lives of most women in the Hellenistic Age nevertheless remained under the influence of decisions made by men. "Who can judge better than a father what is in his daughter's interest?" (Isaeus, *Orations* 3.64) remained the dominant creed of the fathers of daughters. Upper-class women remained largely separated from men not members of their families; poor women still worked in public. Greeks continued to abandon infants they could not or would not raise, and girls were abandoned more often than boys. Other peoples, however, such as the Egyptians and the Jews, did not practice abandonment, or "exposure," as it is often called. Exposure differed from infanticide because the expectation was that someone else would find the child and bring it up, though usually as a slave and not as an adopted child. The third-century B.C. comic poet Posidippus overstated the truth but pointed to the undeniable tendency to favor males by saying, "A son, one always raises even if one is poor; a daughter, one exposes, even if one is rich" (Stobaeus, *Anthology* 77.7 = CAF, Fragment 11). Daughters of the wealthy were of course usually not abandoned, but as many as 10 percent of other infant girls may have been.

In some limited ways, however, women did achieve greater control over their own lives in the Hellenistic period. A woman of exceptional wealth could enter public life, for example, by making donations or loans to her city and then being rewarded with an official post in the government of her community. Of course, such positions were now less prestigious and important than in the days of the independent city-states because real power in this era resided in the hands of the king and his top administrators. In Egypt, women acquired greater say in the conditions of marriage because marriage contracts, now a standard procedure, gradually evolved from an agreement between the groom and the bride's parents to one between the bride and groom themselves.

Even with social influence and financial power based in the cities, most of the population continued to live where people always had, in small villages in the countryside. There, different groups of people lived side by side, though usually without mingling. In one region of Anatolia the different groups spoke twenty-two different languages. Life in the new and refounded Hellenistic cities developed largely independently of indigenous rural society. Urban life acquired special vitality because the

Greek and Macedonian residents of these cities, surrounded by the non-Greek countryside, tended to remain in the urban centers more than had their predecessors in the Classical city-state, whose habit it was to go back and forth frequently between city and countryside to attend to their rural property, participate in local festivals, and worship in local shrines. Now the activities of city dwellers were more and more centered on and in the city. Residents became attached to their cities also because the wealthy, following the tradition of the elites in the Classical city-states, increasingly gave their cities benefactions that endowed urban existence with new advantages over country life. On the island of Samos, for example, wealthy contributors endowed a foundation to finance free distribution of grain every month to all the citizens so that shortages of food would no longer trouble their city. State-sponsored schools for universal education of the young also sprang up in various Hellenistic cities, often financed by wealthy donors. In some places girls as well as boys went to school. Many cities also began ensuring the availability of doctors by financially sponsoring their practices. Patients still had to pay for medical attention, but at least they could count on finding a doctor when they needed one. The wealthy whose donations and loans made many of the cities' new advantages possible were paid back by the respect and honor they earned from their fellow citizens. Philanthropy even affected international relations. For example, when an earthquake devastated Rhodes, many other cities joined kings and queens in sending donations to help the Rhodians recover from the disaster. The Rhodians in turn showered public recognition and honors on their benefactors.

Wealthy non-Greeks more and more adopted Greek habits of life in the process of accommodating themselves to the new social hierarchy. Diotimus of Sidon, in Lebanon, for example, although not a Greek by birth, used a Greek name and pursued the premier Greek sport, chariot racing. He traveled to Nemea in the Peloponnese to enter his chariot in the race at the prestigious festival of Zeus there. When he won, he put up an inscription in Greek to announce that he was the first Sidonian to do so. He announced his victory in Greek because, much like English in today's world, Koine Greek had become the international language of the eastern Mediterranean coastal lands. The explosion in the use of Greek by non-Greeks is certainly the best indication of the emergence of an international culture based on Greek models, which was adopted by rulers and their courts, the urban upper classes, and intellectuals during the Hellenistic period. The most striking evidence of the spread of Greeks and Greek throughout the Hellenistic world comes from Afghanistan. There, Aśoka (ruled c. 268–232 B.C.), third king of the Mauryan dynasty and a convert to Bud-

dhism, used Greek as one of the languages in his public inscriptions that announced his efforts to introduce his subjects to Buddhist traditions of self-control, such as abstinence from eating meat. Even in far-off Afghanistan, non-Greeks used Greek to communicate with Greeks with whom they were now in contact.

THE GREEK LITERATURE AND ART OF A NEW AGE

As knowledge of the Greek language became more common throughout the Hellenistic world, literature in Greek also began to reflect the new conditions of life. At Athens, the focus on contemporary affairs and the fierce attacks on political leaders that had characterized the comedies of the fifth century B.C. soon disappeared as the city-state's freedom from outside interference was lost to the kings. Instead, comic dramatists like Menander (c. 342–289 B.C.) and Philemon (c. 360–263 B.C.) now presented timeless plots concerning the trials and tribulations of fictional lovers, in works not unlike modern soap operas. These comedies of manners proved so popular that they were closely imitated in later times by Roman authors of comic plays.

Poets such as Theocritus from Syracuse in Sicily (born c. 300 B.C.) and Callimachus from Cyrene in North Africa (c. 305–240 B.C.), both of whom came to Alexandria to be supported by the patronage of the Ptolemaic kings, made individual emotions a central theme in their work. Their poetry broke new ground in demanding great intellectual effort from the audience, as well as personal emotional engagement. Only the erudite could fully appreciate the allusions and complex references to mythology that these poets employed in their elegant poems, which could be quite short, in contrast to Homeric epics. Theocritus was the first Greek poet to express a cultural split between the town and the countryside, a poetic stance corresponding to a growing reality. His pastoral poems in a collection called Idylls emphasized the discontinuity between the environment of the city and the bucolic life of the country dweller, although the rural people depicted in Theocritus's poetry were Greeks in idealized landscapes rather than the actual workers of the Egyptian fields. Nevertheless, his literary pose as a sophisticated author reflected the fundamental social division of the Ptolemaic kingdom between the food consumers of the town and the food producers of the countryside.

The themes of Callimachus's prolific output underlined the division in Hellenistic society between the intellectual elite and the uneducated masses. "I hate the common crowd and keep them at a distance," as the Roman poet Horace expressed it (Odes 3.1), could stand for Callimachus's

authorial stance toward poetry and its audience. A comparison between Callimachus's work and that of his fierce literary rival, Apollonius of Rhodes, emphasizes the Hellenistic development of intellectually demanding poetry suited only for an educated elite. Even though Apollonius wrote a long epic about Jason and the Argonauts instead of short poems like those of Callimachus, Apollonius's verses too displayed an erudition that only readers with a literary education could share. Like the earlier lyric poets, who in the sixth and fifth centuries B.C. had often written to please rich patrons, these Hellenistic authors necessarily had to take into account the tastes of the royal patrons who were paying the bills. In one poem expressly praising his patron, Ptolemy II, Theocritus spelled out the quid pro quo of Hellenistic literary patronage: "The spokesmen of the Muses [that is, poets] celebrate Ptolemy in return for his benefactions" (Idylls 17.115–116).

The Hellenistic kings promoted intellectual life principally by offering scholars financial support to move to the royal capitals, as human proofs of the rulers' royal magnanimity and grandeur. The Ptolemies won this particular form of competition with their fellow monarchs by making Alexandria the leading intellectual center of the Hellenistic world. There they established the world's first scholarly research institute. Its massive library had the daunting goal of collecting all the books (that is, manuscripts) in the world; it grew to hold half a million scrolls, an enormous number for the time. Linked to it was a building in which the hired scholars dined together and produced encyclopedias of knowledge, such as The Wonders of the World and On the Rivers of Europe by Callimachus, whose more than 800 works included detailed prose works like these (neither of which has survived) in addition to erudite poetry. The name of this learned society maintained by the Ptolemaic kings in Alexandria was the Museum (meaning "place of the Muses," the Greek goddesses of learning and the arts), a term that endures to this day as a designation for cultural institutions for the preservation and promotion of knowledge. The output of the Alexandrian scholars was prodigious. Their champion was Didymus (c. 80–10 B.C.), nicknamed "Bronze Guts" for his stamina in writing nearly four thousand books.

None of the women poets known from the Hellenistic period seems to have received royal patronage. Nevertheless, they earned fame for excelling in composing epigrams, a style of short poems originally used for funerary epitaphs and for which Callimachus was famous. In this era, the epigram was transformed into a vehicle for the expression of a wide variety of personal feelings, love above all. Elegantly worded epigrams survive from the pens of women from diverse regions of the Hellenistic world, such as Anyte of Tegea in the Peloponnese, Nossis of Locri in southern

Italy, and Moiro of Byzantium at the mouth of the Black Sea. Women, from courtesans to respectable matrons, figured as frequent subjects in their poems. No Hellenistic literature better conveyed the depth of human emotion than their epigrams, such as Nossis's poem on the power of Eros (Love, regarded as a divinity): "Nothing is sweeter than Eros. All other delights are second to it—from my mouth I spit out even honey. And this Nossis says: whoever Aphrodite has not kissed knows not what sort of flowers are her roses" (*Palatine Anthology* 5.170).

Like their literary contemporaries, Hellenistic sculptors and painters brought the emotions of the individual to the forefront in their art (fig. 10.2). Artists of the Classical Age had usually portrayed the faces of their subjects with a serene calm that represented an ideal rather than the reality of life. Hellenistic sculptors, by contrast, strove for a more naturalistic depiction of emotion in a variety of artistic genres. In portrait sculpture, Lysippus's famous bust of Alexander the Great captured the passionate dreaminess of the young commander. A sculpture from Pergamum by an unknown artist commemorated the third-century B.C. Attalid victory over the plundering Gauls by showing a defeated Gallic warrior stabbing himself after having killed his wife to prevent her enslavement by the victors. This scene dramatically represented the pain and sacrifice demanded by a code of honor requiring noble suicide rather than disgraceful surrender. A large-scale painting of Alexander in battle against the Persian king Darius similarly portrayed Alexander's intense concentration and Darius's horrified expression. The artist, who was probably either Philoxenus of Eretria or a Greek woman from Egypt named Helena (one of the first female artists known), used foreshortening and strong contrasts between shadows and highlights to accentuate the emotional impact of the picture.

To appreciate fully the appeal of Hellenistic sculpture, we must remember that, like earlier Greek sculpture, it was painted in bright colors. The fourth-century B.C. sculptor Praxiteles, in fact, reportedly remarked that his best statues were "the ones colored by Nicias," a leading painter of the time (Pliny, *Natural History* 35.133). Hellenistic art differed from Classical art, however, in its social context. Works of Classical art had been commissioned by the city-states as a whole for public display, or by wealthy individuals to present to their city-state. Now sculptors and painters created their works more and more as commissions from royalty and from the urban elites who wanted to demonstrate that they had artistic taste aligned with that of their social superiors in the royal family. To be successful, the artists had to please their rich patrons, and so the increasing diversity of subjects that emerged in Hellenistic art presumably represented a trend approved by kings, queens, and the elites. Sculpture best reveals this new

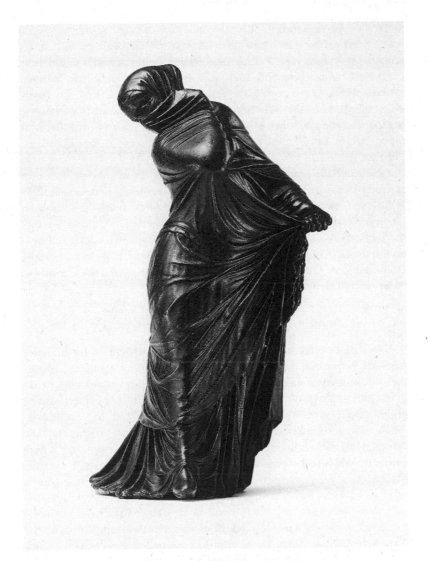

Fig. 10.2: This bronze statue made in the Hellenistic Age depicts a veiled and masked female dancer in motion. Dance performances featured prominently in ancient Greek culture, both for entertainment in the theater and as part of the worship of divinities in religious rituals. Image copyright © The Metropolitan Museum of Art. Image source: Art Resource, NY.

preference for depictions of human beings in a wide variety of poses, many from private life, again in contrast with Classical art. Hellenistic sculptors portrayed subjects unknown in that earlier period: foreigners as paragons of noble behavior (such as a dying Gaul), drunkards, battered athletes, wrinkled old people. The female nude became a particular favorite. A naked Aphrodite, which Praxiteles sculpted for the city of Cnidos, became so renowned that Nicomedes, king of Bithynia in Anatolia, later offered to pay off Cnidos's entire public debt if he could have the statue. The Cnidians refused.

One especially popular subject in Hellenistic art was the depiction of abstract ideas as sculptural types. Such statues were made to represent ideas as diverse as Peace and Insanity. Modern sculptures such as the Statue of Liberty in New York harbor belong in this same artistic tradition. So, too, modern neoclassical architecture imitates the imaginative public architecture of the Hellenistic period, whose architects often boldly combined the Doric and Ionic orders on the same building and energized the Corinthian order with exuberant decoration.

NEW IDEAS IN PHILOSOPHY AND SCIENCE

Greek philosophy in the Hellenistic period reached a wider audience than ever before. Although the mass of the working poor as usual had neither the leisure nor the resources to attend the lectures or read the works of the philosophers, the more affluent members of the population studied philosophy in growing numbers. Theophrastus (c. 370–285 B.C.), Aristotle's most accomplished pupil, lectured to crowds of two thousand in Athens. Most of the students of philosophy continued to be men, but now women could also become members of the groups attached to certain philosophers. Kings competed to attract famous thinkers to their courts, and Greek settlers brought their interest in philosophy as the guide to life with them even to the most remote of the new Hellenistic cities. Archaeological excavation of a city located thousands of miles from Greece on the Oxus River in Afghanistan, for example, has turned up a Greek philosophical text, as well as inscriptions of moral advice attributed to Apollo's oracle at Delphi.

Fewer thinkers now concentrated on metaphysics. Instead, philosophers concerned themselves with philosophical materialism, denying the concept of soul described by Plato and ignoring any other entities asserted to be beyond the reach of the senses. The goal of much philosophical inquiry was now centered on securing human independence from the effects of Chance or other worldly troubles. Scientific investigation of the

physical world also tended to become a specialty separate from philosophy. Hellenistic philosophy itself was regularly divided into three related areas: logic (the process for discovering truth), physics (the fundamental truth about the nature of existence), and ethics (the way human beings should achieve happiness and well-being as a consequence of logic and physics). The most significant new philosophical schools of thought to arise were Epicureanism and Stoicism, and Epicurean and Stoic doctrines later proved exceptionally popular among upper-class Romans.

The various philosophies of the Hellenistic period were in many ways focused on the same question: What is the best way for human beings to live? Different philosophies recommended different paths to the same answer: individual human beings must attain personal tranquility to achieve freedom from the turbulence of outside forces. This philosophic goal had special emotional impact for Greeks experiencing the changes in political and social life that accompanied the rise to dominance of the Macedonian and later Hellenistic kingdoms. Outside forces in the persons of aggressive kings had robbed the city-states of their previous freedom of action internationally, and the fates and fortunes of city-states as well as individuals now often resided in the hands of distant, sometimes fickle monarchs. More than ever before, human life and opportunities for free choice seemed inclined to spin out of the control of individuals. It therefore made sense, at least for those people wealthy enough to spend time philosophizing, to study with philosophers to look for personal and private solutions to the unsettling new conditions of life in the Hellenistic Age.

Epicureanism took its name from its founder, Epicurus (341–271 B.C.), who settled his followers in Athens in a house set in a verdant garden (hence the Garden as the name of his informal school). Under the direction of Epicurus, the study of philosophy represented a new social form in opposition to previous traditions because he admitted women and slaves as regular members of his group. His lover, Leontion, became notorious for her treatise criticizing the views of Theophrastus. Epicurus believed that human beings should pursue pleasure, by which he did not mean what other people might expect. He insisted that true pleasure consisted of an "absence of disturbance" from pain and from the continuing, everyday turbulence, passions, and desires of an ordinary human existence. A quiet life lived in the society of friends apart from the cares of the common world could best provide this essential peace of mind. This teaching represented a serious challenge to the ideal of Greek citizenship, which required men of means to participate in the politics of the city-state and for women of the same class to participate in public religious cults.

Human beings should above all be free of worry about death, Epicurus

taught. Since all matter consisted of microscopic atoms in random movement, as Democritus and Leucippus had earlier theorized, death was nothing more than the painless disassociation of the body's atoms. Moreover, all human knowledge must be empirical, that is, derived from experience and perception. Phenomena that most people perceive as the work of the gods, such as thunder, do not result from divine intervention in the world. The gods live far away in perfect tranquility, taking no notice of human affairs. Human beings therefore have nothing to fear from gods, in life or in death.

The Stoics recommended a different, much more activist path for individuals. Their name derived from the Painted Stoa in Athens, where they discussed their doctrines. Zeno of Citium on Cyprus (c. 333–262 B.C.) founded stoicism, but Chrysippus from Cilicia in Anatolia (c. 280–206 B.C.) did the most to make it a comprehensive guide to life. Stoics believed that human beings should make their goal the pursuit of excellence. This, they said, consisted of putting oneself in harmony with universal Nature, the rational force of divine providence that directed all existence under the guise of Fate. Reason as well as experience should be used to discover the way to that harmony, which required the "perfect" excellences of good sense, justice, courage, and temperance. According to the Stoics, the doctrines of Zeno and Chrysippus applied to women as well as men. In his controversial work The Republic (Politeia), which survives only in fragments, Zeno even proposed that in an ideal, philosophically governed society, unisex clothing should be worn as a way to obliterate unnecessary distinctions between women and men.

The Stoics' belief that fate was responsible for everything that happened gave rise to the question of whether human beings truly have free will. Employing some of the subtlest reasoning ever brought to bear on this fundamental issue, Stoic philosophers concluded that purposeful human actions did have significance. A Stoic should therefore take action against evil, for example, by participating in politics. Nature, itself good, did not prevent vice from occurring because otherwise moral excellence would have no meaning. What mattered in life, indeed, was the striving for good, not the result. In addition, to be a Stoic meant to shun desire and anger while enduring pain and sorrow calmly, an attitude that informs the meaning of the word "stoic" today. Through endurance and self-control, a Stoic attained tranquility. Death was not to be feared because, Stoics believed, we will all live our lives over and over again an infinite number of times in a fashion identical with our present lives. This repetition will occur as the world is periodically destroyed by fire and then reformed after the conflagration.

Other schools of thought carried on the work of earlier philosophi-

cal leaders such as Plato and Pythagoras. Still others like the Sceptics and the Cynics struck out in idiosyncratic directions. Sceptics aimed at the same state of personal imperturbability as did Epicureans, but from a completely different premise. Following the doctrines of Pyrrho of Elis in the Peloponnese (c. 360–270 B.C.), they believed that secure knowledge about anything was impossible because the human senses yield contradictory information about the world. All human beings can do, they insisted, is to depend on the appearances of things while suspending judgment about their reality. Pyrrho's thought had been influenced by the Indian ascetic wise men that he met as a member of Alexander the Great's entourage. The basic premise of skepticism inevitably precluded any unity of doctrine.

Cynics ostentatiously rejected every convention of ordinary life, especially wealth and material comfort. Human beings should instead aim at a life of complete self-sufficiency. Whatever was natural was good and could be done without shame before anyone; even public defecation and intercourse, for example, were acceptable, according to this idea. Women and men alike were free to follow their sexual inclinations. Above all, Cynics should disdain the comforts and luxuries of a comfortable life. The name Cynic, which meant "like a dog," reflected the common evaluation of this ascetic and unconventional way of life. The most famous early Cynic, Diogenes from Sinope on the Black Sea (c. 400–c. 325 B.C.), was reported to go around wearing borrowed clothing, and very little of that, and to sleep outside in a big storage jar. Almost as notorious was Hipparchia, a female Cynic of the late fourth century B.C. She once bested an obnoxious philosophical opponent named Theodorus the Atheist with the following argument, which recalled the climactic episode between father and son in Aristophanes' Clouds: "That which would not be considered wrong if done by Theodorus would also not be considered wrong if done by Hipparchia. Now if Theodorus strikes himself, he does no wrong. Therefore, if Hipparchia strikes Theodorus, she does no wrong" (Diogenes Laertius, Lives of Eminent Philosophers 6.97).

Science benefited from its widening divorce from philosophy during the Hellenistic Age. Indeed, historians have called this era the Golden Age of ancient science. Various factors contributed to this flourishing of thought and discovery: the expeditions of Alexander and his support of scientific investigators had encouraged curiosity and increased knowledge about the extent and differing features of the world; royal patronage provided Hellenistic scientists with financial support; and the gathering together of scientists in Alexandria promoted an ongoing scholarly exchange of ideas that could not otherwise take place because travel and communication were so difficult. The greatest advances came in geom-

etry and mathematics. Euclid, who taught at Alexandria around 300 B.C., made revolutionary progress in the analysis of two-and three-dimensional space. The fame and utility of Euclidean geometry endures to this day. Archimedes of Syracuse (287–212 B.C.) was an arithmetical polymath, who calculated the approximate value of pi and devised a way to manipulate very large numbers. He also invented hydrostatics (the science of the equilibrium of a fluid system) and mechanical devices such as a screw for lifting water to a higher elevation. The modern expression "Eureka!" immortalizes Archimedes' shout of delight "I have found it" (heurēka in Greek) when the solution to a problem came to him as he immersed himself into a bathing pool (Vitruvius, On Architecture 9, preface 10).

The sophistication of Hellenistic mathematics yielded benefits in fields of research that required complex computations. Aristarchus of Samos early in the third century B.C. first proposed the correct model of the solar system by theorizing that the earth revolved around the sun, which he also identified as being far larger and far more distant than it appeared. Later astronomers rejected Aristarchus's heliocentric model in favor of the traditional geocentric one because calculations based on the orbit he postulated for the earth failed to correspond to the observed positions of celestial objects. Aristarchus had made a simple mistake: he had postulated a circular orbit instead of an ellipse. It was to be another eighteen hundred years before the correctness of the heliocentric system would be recognized by the Polish astronomer Copernicus (A.D. 1473–1543), the founder of modern astronomy. Eratosthenes of Cyrene (c. 275–194 B.C.) pioneered mathematical geography. He calculated the circumference of the earth with astonishing accuracy by having measurements made of the length of the shadows of widely separated but identically tall structures at the same moment. Ancient scientists in later periods, especially the astronomer and geographer Ptolemy, who worked in Alexandria in the second century A.D., improved and refined the description of the natural world elaborated by Hellenistic researchers, but their basic ideas remained dominant in scientific thought until the advent of modern science.

Greek science was as quantitative as it could be, given the technological limitations of measurement imposed by the state of ancient technology. Precise scientific experimentation was not possible because no technology existed in ancient times for the precise measurement of very short intervals of time. Measuring tiny quantities of matter was also almost impossible. But a spirit of invention prevailed in spite of these difficulties. Ctesibius of Alexandria, a contemporary of Aristarchus, devised machines operated by air pressure. In addition to this invention of pneumatics, he

built a working water pump, an organ powered by water, and the first ac-
curate water clock. His fellow Alexandrian of the first century A.D., Hero,
continued the Hellenistic tradition of mechanical ingenuity by building
a rotating sphere powered by steam. This invention did not lead to viable
steam engines, perhaps because the metallurgical technology to produce
metal pipes, fittings, and screws was not yet developed. Much of the engi-
neering prowess of the Hellenistic period was applied to military technol-
ogy, as in the modern world. The kings hired engineers to design powerful
catapults, wheeled siege towers many stories high, which were capable of
battering down the defenses of walled cities, and multistoried warships.
The most famous large-scale application of technology for nonmilitary
purposes was the construction of a lighthouse three hundred feet tall (the
Pharos) for the harbor at Alexandria. Using polished metal mirrors to re-
flect the light from a large fire fueled by wood, it shone many miles out
over the sea. Awestruck sailors regarded it as one of the wonders of the
world.

Medicine also shared in the spirit of progress that inspired develop-
ments in Hellenistic science. The increased contact between Greeks and
people of the Near East in this period made the medical knowledge of
the ancient civilizations of Mesopotamia and Egypt better known in the
West and gave an impetus to further understanding of human health and
illness. Around 325 B.C., Praxagoras of Cos discovered the value of mea-
suring the human pulse in diagnosing illness. A bit later Herophilus of
Chalcedon, working in Alexandria, became the first scientist in the West
to study anatomy by dissecting human cadavers. Anatomical terms that
Herophilus coined are still in modern use, such as "duodenum," a section
of the small intestine. Other Hellenistic advances in understanding anat-
omy included the discovery of the nerves and nervous system. Anatomical
knowledge, however, outstripped knowledge of human physiology. The
earlier idea that human health depended on the balance in the body of
four humors or fluids remained the dominant theory in physiology. A
person was healthy—in "good humor"—so long as the correct propor-
tions of the four humors were maintained. Since illness was thought to
be the result of an imbalance of the humors, doctors prescribed various
regimens of drugs, diet, and exercise to restore balance. Physicians also
believed that drawing blood from patients could help rebalance the hu-
mors, a practice that endured in medicine until the nineteenth century
A.D. Many illnesses in women were diagnosed as caused by displacements
of the womb, which was wrongly believed to be able to move around in
the body.

HELLENISTIC RELIGIONS

The expansion and diversification of knowledge that characterized Hellenistic intellectual life found a parallel in the growing diversity of Greek religious practice. The traditional cults of Greek religion remained very popular, but new cults, such as the ones deifying ruling kings, also responded to new political and social conditions. Preexisting cults with previously local significance, such as that of the Greek healing deity Asclepius or the mystery cult of the Egyptian goddess Isis, grew to prominence all over the Hellenistic world. In many cases, Greek cults and indigenous cults from the eastern Mediterranean came to be identified with each other and shared cultic practices in a process of mutual influence. This mixing of traditions came about because originally diverse cults were found to share assumptions about the remedies for the troubles of human life. In other instances, local and Greek cults simply existed side by side. The inhabitants of villages in the Faiyum district of Egypt, for example, went on worshipping their traditional crocodile god and mummifying their dead in the old way while also honoring Greek deities. In accord with the traditions of polytheistic religion, the same people could worship in both old and new cults.

To the extent that diverse new Hellenistic cults had a shared concern, they recalled a prominent theme of Hellenistic philosophy: the relationship between the individual and what seemed the controlling, unpredictable power of Luck or Chance. Greek religion had always addressed this concern at some level, but the chaotic course of Greek history since the Peloponnesian War had made the unpredictable aspects of human existence appear more prominent and frightening than ever. Yet advances in astronomical knowledge revealed the mathematical precision of the celestial sphere of the universe. Religious experience now had to address the apparent disconnection between that observed heavenly uniformity and the apparently shapeless chaos of life on earth. One increasingly popular approach to bridging that gap was to rely on astrology for advice deduced from the movement of the stars and planets, thought of as divinities.

In another approach offering devotees protection from the cruel tricks of Chance or Luck, the gods of popular Hellenistic cults promised salvation of various kinds. One form of security was the safety that powerful rulers were expected to provide, in keeping with the status of gods that they received in what are now known as ruler cults. These forms of worship were established in recognition of great benefactions. The Athenians, for example, deified the living Macedonians Antigonus and his son Demetrius as savior gods in 307 B.C., when they bestowed magnificent gifts on

the city and restored the democracy (which had been abolished fifteen years before by another Macedonian commander). Like most ruler cults, this one expressed both spontaneous gratitude and a desire to flatter the rulers in the hope of obtaining additional favors. Honoring ancient Macedonian customs, the Antigonid kings had no divine cult in their honor in their homeland, but many cities in the Ptolemaic and Seleucid kingdoms instituted ruler cults for their kings and queens. (The Ptolemaic king and queen were also regarded as gods, in keeping with traditions of ancient Egyptian religion.) An inscription put up by Egyptian priests in 238 B.C. concretely described the qualities appropriate for a divine king and queen: "King Ptolemy III and Queen Berenice, his sister and wife, the Benefactor Gods . . . have provided good government . . . and [after a drought] sacrificed a large amount of their revenues for the salvation of the population, and by importing grain. . . . They saved the inhabitants of Egypt" (Austin, The Hellenistic World, no. 271 = OGIS 56).

Healing divinities offered another form of protection to anxious individuals. Scientific Greek medicine had rejected the notion of supernatural causes and cures for disease ever since Hippocrates had established his medical school on the Aegean island of Cos in the late fifth century B.C. Nevertheless, popular support grew in the Hellenistic Age for the cult of Asclepius, son of Apollo, who offered cures for illness and injury at his many shrines. There, suppliants seeking his help would sleep in special dormitories to await dreams from the god in which he prescribed healing treatments. These prescriptions mainly emphasized diet and exercise, but numerous inscriptions set up by grateful patients also testified to miraculous cures and surgery performed by the god while the sufferer slept. The following example is typical: "Ambrosia of Athens was blind in one eye. . . . She . . . ridiculed some of the cures [described in inscriptions in the sanctuary] as being incredible and impossible. . . . But when she went to sleep, she saw a vision; she thought the god was standing next to her. . . . He split open the diseased eye and poured in a medicine. When day came, she left cured" (Austin, The Hellenistic World, no. 146 = IG 4 Sec. ed., 1, no. 121.IV).

Other cults promised secret knowledge as a key to worldly and physical salvation. Since everyday life was full of hazards and so many people died young, protection from physical dangers was a more immediate concern than the care of the soul or the dead person's fate in the afterlife. During the Hellenistic Age, however, moral preparation for life after death became an increasing emphasis in religion. For both these reasons, the Mysteries of Demeter at Eleusis near Athens continued to be popular, but the mystery cults of the Greek god Dionysus and, in particular, of the Egyptian goddess Isis also gained popularity in this period. Isis, like the goddesses

Atargatis from Syria and Cybele (the Great Mother) from Phrygia and Lydia in Anatolia, was a female divinity whose cult achieved near universal distribution in the Hellenistic world. The popularity of Isis received a boost from the patronage of King Ptolemy I, who established an official seat for her cult in Alexandria. He also refashioned the Egyptian deity Osiris in a Greek mold as the new god Sarapis, whose job was to serve as Isis's consort. Sarapis reportedly performed miracles of rescue from shipwreck and illness. The cult of Isis involved extensive rituals and festivals incorporating features of Egyptian religion mixed with Greek elements; she became the most popular female divinity in the Mediterranean world (fig. 10.3). Followers of Isis apparently hoped to achieve personal purification as well as the aid of the goddess in overcoming the demonic influence on human life of Chance and Luck.

That an originally Egyptian deity like Isis could achieve enormous popularity among Greeks (and Romans in later times) alongside the traditional deities of Greek religion, who remained popular themselves, is the best evidence of the cultural cross-fertilization of the Hellenistic world. Equally striking was that many Jews adopted the Greek language and many aspects of Greek culture; this development was most common among those living in the large Jewish communities that had grown up in Hellenistic cities outside Palestine, such as Alexandria. The Hebrew Bible was even translated into Greek in Alexandria in the early third century B.C., reportedly at the request of King Ptolemy II. Hellenized Jews largely retained the ritual practices and habits of life that defined traditional Judaism, and they refused to worship Greek gods, but their lives did become more "Greek-like." Hellenistic politics and culture also affected the Jewish community in Palestine. The region, caught between the great kingdom of the Ptolemies in Egypt and that of the Seleucids in Syria, was controlled militarily and politically by the Ptolemies in the third century and by the Seleucids in the second. Both dynasties allowed the Jews to continue to live their lives according to ancestral tradition under the political leadership of a high priest in Jerusalem. Internal dissension erupted among Jews in second-century Palestine over the amount of Greek influence that was compatible with traditional Judaism. The Seleucid king Antiochus IV (ruled 175–163 B.C.) intervened in the conflict in support of an extreme Hellenizing faction of Jews in Jerusalem, who had taken over the high priesthood. In 167 B.C., Antiochus converted the main Jewish sanctuary there into a temple to the Syrian god Baal Shamen, whom he worshipped, and outlawed the practice of Jewish religious rites, such as the observation of the Sabbath and circumcision. A revolt led by Judah the Maccabee eventually won Jewish independence from the Seleucids after twenty-five years

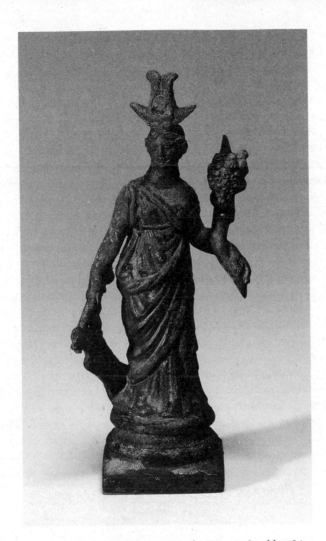

Fig. 10.3: This small bronze statue represents the Egyptian goddess Isis wearing Greek-style clothing. She became a very popular deity among Greeks during the Hellenistic Age; they appreciated her association with love and justice, her requirement that her worshippers live morally upright lives, and the maternal love for human beings that her worship proclaimed. The Walters Art Museum, Baltimore.

of war. The most famous episode of the Maccabean Revolt was the Jewish rebels' retaking of the temple in Jerusalem and its rededication to the worship of the Jewish god, a triumphant moment commemorated by Jews ever since on the holiday of Hanukkah. That Greek culture attracted at least some Jews, whose strong traditions reached far into antiquity, provides a striking example of the transformations that affected many—though far from all—people of the Hellenistic world.

The diversity of the Hellenistic world encompassed much that was new. The creation of kingdoms reconfigured the political map and social dynamics of the Greek world. The queens of its kingdoms commanded greater wealth and status than any women of the city-states of Classical Greece. Its philosophers sought modes of thought and action through which individuals could work to create personal tranquility for themselves despite the turbulence and troubles of the outside world. Its scientists and doctors made new discoveries about the natural world and in mathematics that contributed much to scholarly knowledge, but less to applied technology. The rituals and beliefs of new religious cults were meant to protect worshippers from the dangers of Chance and provide more personal contact with the divine. In the midst of these new developments in the expanded world into which Greek culture had been relocated, the basic characteristics of everyday life for the majority remained the same as they had been throughout the historical period—the physical labor, the poverty, the slavery, and the limited opportunities for material and social self-improvement. Like their ancestors, most people spent most of their time toiling in the fields, vineyards, pastures, craft shops, and markets. This was an abiding continuity in ancient Greek history, a fact that must always be kept in mind as the companion to the tremendous achievements of the ancient Greeks. Any overall evaluation of ancient Greece has to consider both these aspects of the story.

Epilogue
The End as a Beginning

In keeping with the approach to the history of ancient Greece outlined at the start of this book, it seems appropriate to resist the temptation to offer prescriptive conclusions here at the end. For one thing, as also said in chapter 1, Greek history does not end in the Hellenistic Age. For another, the brevity of this overview means that there has not been space to discuss the judgments that the ancient Greeks reached in evaluating their own history. It seems to me that fairness requires historians to pay attention in the first place to what people say about themselves, and only after considering those views to proceed to express their own views in full. This was not the book for me to do that.

Most of all, however, I want to encourage readers to invest the time in reaching their own conclusions by going further than this intentionally brief and selective narrative can. The way to begin that rewarding quest is, to reemphasize what was said in the first chapter, for readers to turn to the ancient sources, to study them as complete works rather than as excerpts removed from their full contexts. Consulting modern secondary sources can then be the next step. As Pausanias memorably observed, almost everything in the history of ancient Greece is a matter of dispute. That seems only fitting for a culture that treated every human activity, from politics to sport to love, as a competition. That was true even of Greeks' conclusions about their own history, as emerges, for example, from Strabo, a famous Greek author on geography and ethnography writing at the beginning of the first century A.D. This date was a turning point in European history, as it was now clear that the Roman Empire was not going to be just a flash

in the pan. Consequently, it was equally clear that Greeks were not going to win back from the Romans the political independence or international status that they had lost in the Hellenistic Age.

There is a passage in which Strabo uses strong and frank language to criticize other Greek authors for what he regards as their inaccurate descriptions of "just and noble barbarians" compared to Greeks, and to present his own account as greatly superior. There, he sums up in strikingly blunt terms what he sees as the corrupting influence that the spread of Greek culture to others created: "Life the way we live it has set up a change for the worse among almost everybody, bringing in luxury and pleasures, and countless deceptive techniques for always getting more and more, to that end" (*Geography* C 301 = 7.3.7). Perhaps Strabo was so critical of his fellow Hellenes because the prospects of Greece's diminished future in the world had embittered him, or perhaps he was just trying to score points in the literary contest in which he saw himself competing with fellow writers. In any case, this passage serves to remind us that ancient Greeks never flinched from expressing critical assessments of their own cultural strengths and weaknesses.

Whatever Strabo's motivation may have been in expressing this negative opinion of the effects of his own culture, that he did it reminds us that ancient Greeks prided themselves on their freedom of speech. For them, the crucial component of freedom of speech was being able to say things to people that you know they will not be happy to hear. This seems to me a concept worth remembering because it is liberating for those willing to do the demanding work of investigating sources, which is the effort that earns them the standing to express judgments worth listening to, because their conclusions will then come from thoughtful and humble reflection about evidence. Doing this work also entitles them to disagree as forthrightly as possible with the conclusions of others that seem mistaken. Many fascinating and enduring questions remain to ask and try to answer about the accomplishments and the failures of the ancient Greeks. That fact should encourage, not discourage, readers to begin to go deeper on their own, competing freely and energetically with Strabo, with me, and with every other author they read on ancient Greece, in reaching and expressing their own persuasive and significant conclusions about a history whose impact lives on in so many ways.

SUGGESTED READINGS

ANCIENT TEXTS

The extensive collection of the Loeb Classical Library (Harvard University Press) provides editions of ancient texts in the original Greek and Latin with facing English translations; some are listed here. The other editions listed are English translations only, when they are available, as these editions can be less expensive than bilingual ones. When the standard title of an author's ancient work as cited in the text differs from the title of the translation listed here, that standard title is given at the end of the translation entry to make clear where readers can find that particular work.

Aeschines. *Aeschines.* Trans. Chris Carey (Austin, TX: University of Texas Press, 2000); includes *Orations.*

Aeschylus. *Oresteia.* Trans. Christopher Collard (Oxford: Oxford University Press, 2002).

———. *The Persians and Other Plays.* Trans. Alan H. Sommerstein (London: Penguin Books, 2010).

Alcaeus. See *Greek Lyric: An Anthology in Translation* (1996); includes fragments.

Alcidamas. *The Works and Fragments.* Trans. J. V. Muir (London: Bristol Classical Press, 2001).

Alcman. See *Greek Lyric: An Anthology in Translation* (1996).

Anaxagoras. See *The First Philosophers* (2000).

Anyte. See *Sappho's Lyre* (1991).

Apollonius of Rhodes. *Jason and the Golden Fleece (The Argonautica).* Trans. Richard Hunter (Oxford: Oxford University Press, 2009).

Appian. *Roman History.* Trans. Horace White. 4 vols. Loeb Classical Library (Cambridge, MA: Harvard University Press, 1912–1913); includes *The Syrian Wars.*

Archilochus. See *Greek Lyric: An Anthology in Translation* (1996); includes fragments.

Aristophanes. *Lysistrata and Other Plays*. Trans. Alan H. Sommerstein. Rev. ed. (London: Penguin Books, 2002); includes *The Acharnians, Lysistrata,* and *The Clouds*.

————. *The Birds and Other Plays*. Trans. David Barrett and Alan H. Sommerstein (London: Penguin Books, 2003); includes *The Birds, The Knights, The Assemblywomen, Peace,* and *Wealth*.

————. *Frogs and other Plays;* includes *The Wasps, The Poet and the Women,* and *The Frogs*. Trans. David Barrett and Shomit Dutta (London: Penguin Books, 2007).

Aristotle. *The Complete Works*. Ed. Jonathan Barnes. 2 vols. (Princeton, NJ: Princeton University Press, 1984); includes *Constitution of the Athenians, Politics*.

————. *Aristotle and Xenophon on Democracy and Oligarchy*. Trans. J. M. Moore. New ed. (Berkeley and Los Angeles: University of California Press, 2010); includes Aristotle's *Constitution of the Athenians* and Xenophon's *Constitution of the Spartans*.

Arrian. *The Landmark Arrian: The Campaigns of Alexander (Anabasis Alexandrou)*. Trans. Pamela Mensch (New York: Pantheon Books, 2010); includes *Anabasis*.

Athenaeus. *The Learned Banqueters (Deipnosophistae)*. Trans. S. Douglas Olsen. 8 vols. Loeb Classical Library (Cambridge, MA: Harvard University Press, 2006–2012).

Atthidographers. *The Story of Athens: The Fragments of the Local Chronicles of Attika*. Trans. Philip Harding (London: Routledge, 2008).

Callimachus. *The Poems of Callimachus*. Trans. Frank Nisetich (Oxford: Oxford University Press, 2001)

Chrysippus. See *The Stoics Reader* (2008).

Clement. *Miscellanies*. *The Ante-Nicene Fathers: Translations of the Fathers Down to* A.D. 325. Vol. 2 Peabody, MA: Hendrickson, 1994; a reprint of the 1885–1897 edition), pp. 299–567.

Critias. See *The Older Sophists* (1972), pp. 241–270.

Curtius Rufus, Quintus. *The History of Alexander*. Trans. John Yardley. Rev. ed. (London: Penguin Books, 2004).

Democritus. See *The First Philosophers* (2000).

Demosthenes. *Demosthenes*. Various translators. 7 vols. Loeb Classical Library (Cambridge, MA: Harvard University Press, 1930–1949); includes *Orations*.

————. *Demosthenes, Speeches 1–17*. Trans. Jeremy Trevett (Austin, TX: University of Texas Press, 2011).

Didymus. *Didymos on Demosthenes*. Trans. Philip Harding (Oxford: Clarendon Press, 2006).

Diodorus Siculus. *Library of History*. Trans. C. H. Oldfather. 12 vols. Loeb Classical Library (Cambridge, MA: Harvard University Press, 1933–1967).

————. *The Persian Wars to the Fall of Athens: Books 11–14.34 (480–401 BCE)*. Trans. Peter Green (Austin, TX: University of Texas Press, 2010).

Diogenes Laertius. *Lives of Eminent Philosophers*. Trans. R. D. Hicks. 2 vols. Loeb Classical Library (Cambridge, MA: Harvard University Press, 1972).

Dissoi Logoi [*Double Arguments*]. See *The Older Sophists* (1972).

Epic of Creation. See Pritchard, *Ancient Near Eastern Texts* (1969), pp. 60–99.

Epicurus. *The Epicurus Reader: Selected Writings and Testimonia*. Trans. Brad Inwood and L. P. Gerson (Indianapolis, IN: Hackett, 1994).

Euclid. *Elements*. Trans. Thomas L. Heath. 2nd ed. (New York: Dover, 1956).

Euripides. *Euripides*. Trans. David Kovacs, Christopher Collard, and Martin Cropp. 7

vols. Loeb Classical Library (Cambridge, MA: Harvard University Press, 1994–2008); includes *Medea*.

———. *Fragments: Aegeus-Meleager.* Trans. Christopher Collard and Martin Cropp. Loeb Classical Library (Cambridge, MA: Harvard University Press, 2008); includes *Melanippe the Captive*.

Excerpta de insidiis. No English translation is available. The Greek text can be found in *Excerpta historica iussu Imp. Constantini Porphyrogeniti confecta.* Ed. C. de Boor. Vol. 3. (Berlin: Weidmann, 1905), available online as a free e-book on Google Books.

The First Philosophers: The Presocratics and the Sophists. Trans. Robin Waterfield (Oxford: Oxford University Press, 2000).

Fragments of Old Comedy. Trans. Ian C. Storey. Loeb Classical Library (Cambridge, MA: Harvard University Press, 2011).

Gorgias. See *The First Philosophers* (2000); *The Older Sophists* (1972).

Greek Elegiac Poetry: From the Seventh to the Fifth Centuries B.C. Trans. Douglas E. Gerber. Loeb Classical Library (Cambridge, MA: Harvard University Press, 1999).

Greek Lyric. Trans. David A. Campbell. 5 vols. Loeb Classical Library (Cambridge, MA: Harvard University Press, 1982–1993).

Greek Lyric: An Anthology in Translation. Trans. Andrew M. Miller (Indianapolis, IN: Hackett, 1996).

Hecataeus. *Brill's New Jacoby.* An online resource available by paid subscription, with Greek text and English translation: http://referenceworks.brillonline.com/browse/brill-s-new-jacoby; no printed English translation is available.

The Hellenistic Philosophers. Vol. 1: *Translations of the Principal Sources, with Philosophical Commentary;* Vol. 2: *Greek and Latin Texts with Notes and Bibliography.* Ed. A. A. Long and D. N. Sedley (Cambridge: Cambridge University Press, 1987); includes fragments of Zeno's *The Republic*.

Hellenistic Poetry: An Anthology. Trans. Barbara Hughes Fowler (Madison, WI: University of Wisconsin Press, 1990).

Herodotus. *The Histories.* Trans. Aubrey de Sélincourt. Ed. John Marincola. Rev. ed. (London: Penguin Books, 1996).

Hesiod. *Theogony and Works and Days.* Trans. Martin West (Oxford: Oxford University Press, 1988).

Hippocrates. *Hippocratic Writings.* Trans. J. Chadwick et al. New ed. (London: Penguin Books, 1983).

Homer. *The Iliad of Homer.* Trans. Richmond Lattimore. New ed. Introduction and Notes by Richard Martin (Chicago: University of Chicago Press, 2011).

———. *The Odyssey of Homer.* Trans. Richmond Lattimore (New York: HarperCollins, 1999).

The Homeric Hymns. Trans. Michael Crudden (Oxford: Oxford University Press, 2001).

Horace. *The Complete Odes and Epodes.* Trans. David West (Oxford: Oxford University Press, 1997).

Isaeus. *Isaeus.* Trans. Michael Edwards (Austin, TX: University of Texas Press, 2007); includes *Orations*.

Isocrates. *Isocrates I*. Trans. David Mirhady and Yun Lee Too (Austin, TX: University of Texas Press, 2000).

————. *Isocrates II*. Trans. Terry L. Papillon (Austin, TX: University of Texas Press, 2004).

Justin, *Cornelius Nepos, and Eutropius*. Trans. John Selbey Watson (London: H. G. Bohn, 1853).

Leucippus. See *The First Philosophers* (2000).

Libanius. *Orations*. No English translation of Oration 25 is available.

Lucian. *Selected Dialogues*. Trans. C. D. N. Costa (Oxford: Oxford University Press, 2005); includes *Timon*.

Lysias. *Lysias*. Trans. S. C. Todd (Austin, TX: University of Texas Press, 2000); includes *Orations*.

Menander. *The Plays and Fragments*. Trans. Peter Brown (Oxford: Oxford University Press, 2001).

Mimnermus. See *Greek Lyric: An Anthology in Translation* (1996); includes fragments.

Moiro. See *Sappho's Lyre* (1991).

Nicolaus of Damascus. *Brill's New Jacoby*. An online resource available by paid subscription, with Greek text and English translation: http://referenceworks.brillonline.com/browse/brill-s-new-jacoby; no printed English translation is available. See also *Excerpta de insidiis*.

Nossis. See *Sappho's Lyre* (1991).

The Older Sophists: A Complete Translation by Several Hands of the Fragments in Die Fragmente der Vorsokratiker edited by Diels-Kranz with a New Edition of Antiphon and Euthydemus. Ed. Rosamund Kent Sprague (Columbia, SC: University of South Carolina Press, 1972).

Palatine Anthology. *The Greek Anthology*. Trans. W. R. Paton. 5 vols. Loeb Classical Library (Cambridge, MA: Harvard University Press, 1925–1927).

Pausanias. *Guide to Greece*. Trans. Peter Levi. 2 vols. (London: Penguin Books, 1971).

Philemon. *The Fragments of Attic Comedy After Meineke, Bergk, and Kock*. Trans. J. M. Edmonds (Leiden, Netherlands: Brill, 1957–1961).

Pindar. See *Greek Lyric: An Anthology in Translation* (1996); includes *Olympian Odes*.

Plato. *The Collected Dialogues*. Ed. Edith Hamilton and Huntington Cairns (Princeton, NJ: Princeton University Press, 1971); includes *Apology, Crito, Gorgias, Protagoras, The Republic, Statesman, Symposium, Theatetus*.

Pliny. *Natural History*. Trans. H. Rackham. 10 vols. Loeb Classical Library (Cambridge, MA: Harvard University Press, 1967–1975).

Plutarch. *The Age of Alexander: Ten Greek Lives*. Trans. Ian Scott-Kilvert and Timothy E. Duff. Rev. ed. (London: Penguin Books, 2011); includes *Alexander*.

————. *On Sparta*. Trans. Richard J. A. Talbert (London: Penguin Books, 2005); includes *Agis and Cleomenenes, Lycurgus*, and Xenophon's *Constitution of the Spartans*.

————. *Greek Lives*. Trans. Robin Waterfield (Oxford: Oxford University Press, 1998); includes *Cimon, Lycurgus, Pericles, Solon*.

————. *Rise and Fall of Athens. Nine Greek Lives*. Trans. Ian Scott-Kilvert (London: Penguin Books, 1960); includes *Aristides, Cimon, Pericles, Solon*.

————. *Moralia*. Trans. Frank Cole Babbitt. 15 vols. Loeb Classical Library (Cambridge, MA: Harvard University Press, 1956–1969).

Pollux. *Onomasticon*. No English translation is available. A nineteenth-century edition of the Greek text, *Iulii Pollucis Onomasticon ex recensione Immanuelis Bekkeri* (Berlin: F. Nikolai, 1846), is available online as a free e-book on Google Books.

Polybius. *The Histories*. Trans. Robin Waterfield (Oxford: Oxford University Press, 2010).

Posidippus. *The Fragments of Attic Comedy After Meineke, Bergk, and Kock*. Trans. J. M. Edmonds (Leiden, Netherlands: Brill, 1957–1961).

Protagoras. See *The First Philosophers* (2000); *The Older Sophists* (1972).

Pseudo-Aristotle. *Oeconomica*. See Aristotle, *The Complete Works* (1984).

Pyrrho. See Diogenes Laertius, *Lives of Eminent Philosophers* (1972).

Sappho. See *Sappho's Lyre* (1991); *Greek Lyric: An Anthology in Translation* (1996); includes fragments.

Sappho's Lyre: Achaic Lyric and Women Poets of Ancient Greece. Trans. Diane Rayor (Berkeley and Los Angeles: University of California Press, 1991).

Solon. See *Greek Elegiac Poetry* (1999); *Greek Lyric: An Anthology in Translation* (1996); includes fragments.

Sophocles. *Electra and Other Plays*. Trans. David Raeburn (London: Penguin Books, 2008).

———. *The Three Theban Plays: Antigone, Oedipus the King, Oedipus at Colonus*. Trans. Robert Fagles. Rev. ed. (London: Penguin Books, 1984).

Stobaeus. *Anthology*. No English translation is available. A nineteenth-century edition of the Greek text, *Ioannis Stobaei Anthologium*. 5 vols. Ed. Curtius Wachsmuth and Otto Hense (Berlin: Weidmann, 1884–1912), is available online as a free e-book on Google Books.

The Stoics Reader: Selected Writings and Testimonia. Trans. Brad Inwood (Indianapolis, IN: Hackett, 2008); includes fragments of Zeno's *The Republic*.

Strabo. *Geography*. Trans. Horace Leonard Jones. 8 vols. Loeb Classical Library (Cambridge, MA: Harvard University Press, 1960–1970).

Theocritus. *Idylls*. Trans. Anthony Verity (Oxford: Oxford University Press, 2002).

Theognis. See *Greek Elegiac Poetry* (1999); includes *Theognidea*.

Theophrastus. *Characters* (with Herodas: Mimes, and Sophron and Other Mime Fragments). Trans. Jeffrey Rusten. Loeb Classical Library (Cambridge, MA: Harvard University Press, 2003).

Theopompus. *Brill's New Jacoby*. An online resource available by paid subscription, with Greek text and English translation: http://referenceworks.brillonline.com/browse/brill-s-new-jacoby; no printed English translation is available.

Thucydides. *The Landmark Thucydides*. Trans. Richard Crawley. Rev. ed. (New York: Free Press, 1996); includes *The Peloponnesian War*.

Tyrtaeus. See *Greek Elegiac Poetry* (1999); includes fragments.

Vitruvius. *Ten Books on Architecture*. Trans. Ingrid D. Rowland (New York: Cambridge University Press, 1999).

Xenophanes. See *The First Philosophers* (2000).

Xenophon. *Xenophon*. Various translators. 7 vols. Loeb Classical Library (Cambridge, MA: Harvard University Press, 1953–1968); includes *Anabasis, Hellenica, Memorabilia, Symposium*.

——. *Aristotle and Xenophon on Democracy and Oligarchy*. Trans. J. M. Moore. New ed. (Berkeley and Los Angeles: University of California Press, 2010); includes Aristotle's *Constitution of the Athenians* and Xenophon's *Constitution of the Spartans*.

Zeno of Citium. See *The Stoics Reader* (2008).

COLLECTIONS OF SOURCES

These books collect translations of ancient sources arranged either according to chronological period or historical topic.

Austin, Michel. *The Hellenistic World from Alexander to the Roman Conquest. A Selection of Ancient Sources in Translation*. 2nd ed. (Cambridge: Cambridge University Press, 2006).

Crawford, Michael, and David Whitehead. *Archaic and Classical Greece: A Selection of Ancient Sources in Translation* (Cambridge: Cambridge University Press, 1983).

Davison, Claire Cullen. *Pheidias: The Sculptures and Ancient Sources* (London: Institute of Classical Studies, 2009).

Dillon, Matthew, and Lynda Garland. *Ancient Greece: Social and Historical Documents from Archaic Times to the Death of Alexander*. 3rd ed. (London: Routledge, 2010).

Emlyn-Jones, C. J. *The Ionians and Hellenism: A Study of the Cultural Achievement of Early Greek Inhabitants of Asia Minor* (London: Routledge & Kegan Paul, 1980).

Irby-Massie, Georgia L., and Paul T. Keyser. *Greek Science of the Hellenistic Era: A Sourcebook* (London: Routledge, 2002).

Kearns, Emily. *Ancient Greek Religion: A Sourcebook* (Malden, MA: Wiley-Blackwell, 2010).

Lefkowitz, Mary R., and Maureen B. Fant. *Women's Life in Greece and Rome: A Source Book in Translation*. 3rd ed. (Baltimore, MD: Johns Hopkins University Press, 2005).

Pollitt, J. J. *The Art of Ancient Greece: Sources and Documents* (Cambridge: Cambridge University Press, 1990).

Pritchard, James B. *Ancient Near Eastern Texts Relating to the Old Testament*. 3rd ed. (Princeton, NJ: Princeton University Press, 1969).

Rhodes, P. J. *The Greek City-States: A Source Book*. 2nd ed. (Cambridge: Cambridge University Press, 2007).

Rhodes, P. J., and Robin Osborne. *Greek Historical Inscriptions: 404–323 BC* (New York: Oxford University Press, 2003).

Robinson, Eric W. *Ancient Greek Democracy: Readings and Sources* (Malden, MA: Blackwell, 2004).

Rusten, Jeffrey, ed. *The Birth of Comedy: Texts, Documents, and Art from Athenian Comic Competitions, 486–280. Trans.* Jeffrey Henderson (Baltimore, MD: Johns Hopkins University Press, 2011).

Samons, Loren J. *Athenian Democracy and Imperialism* (Boston: Houghton Mifflin, 1998).

MODERN STUDIES

Modern scholarship on the history of ancient Greece is vast, international, and multilingual. This limited selection presents works in English related to topics in the narrative of this book. Readers should not assume that these works are the

last word on the subjects they discuss, or that I necessarily agree with their conclusions. The discussions and bibliographies in the more-recent studies in the list can provide pointers to earlier scholarship, much of which remains valuable and worth consulting but is not listed here due to space considerations.

Acton, Lord (John Emerich Edward Dalberg). *Historical Essays and Studies*. Ed. J. N. Figgis and R. V. Laurence (London: Macmillan, 1907).

Adkins, A. W. H. *Moral Values and Political Behaviour in Ancient Greece: From Homer to the End of the Fifth Century* (London: Chatto & Windus, 1972).

Adkins, Lesley, and Roy A. Adkins. *Handbook to Life in Ancient Greece* (New York: Facts on File, 2005).

Balot, Ryan. *Greed and Injustice in Classical Athens* (Princeton, NJ: Princeton University Press, 2001).

Biers, William. *The Archaeology of Greece. An Introduction*. 2nd ed. (Ithaca, NY: Cornell University Press, 1996).

Blundell, Sue. *Women in Ancient Greece* (Cambridge, MA: Harvard University Press, 1995).

Boardman, John. *The Parthenon and Its Sculptures* (Austin, TX: University of Texas Press, 1985).

Boedeker, Deborah, and Kurt A. Raaflaub, eds. *Democracy, Empire, and the Arts in Fifth-Century Athens* (Cambridge, MA: Harvard University Press, 1998).

Borza, Eugene N. *Before Alexander: Constructing Early Macedonia* (Claremont, CA: Regina Books, 1999).

Bosworth, A. B. *Conquest and Empire: The Reign of Alexander the Great* (Cambridge: Cambridge University Press, 1988).

———. *Alexander and the East: The Tragedy of Triumph*. New ed. (Oxford: Oxford University Press, 2004).

Bowden, Hugh. *Mystery Cults of the Ancient World* (Princeton, NJ: Princeton University Press, 2010).

Briant, Pierre. *From Cyrus to Alexander: A History of the Persian Empire* (Winona Lake, IN: Eisenbrauns, 2002).

———. *Alexander the Great and His Empire: A Short Introduction*. Trans. Amélie Kuhrt (Princeton, NJ: Princeton University Press, 2010).

Buckler, John, and Hans Beck. *Central Greece and the Politics of Power in the Fourth Century BC* (Cambridge: Cambridge University Press, 2008).

Bundrick, Sheramy D. *Music and Image in Classical Athens* (Cambridge: Cambridge University Press, 2005).

Burkert, Walter. *Greek Religion: Archaic and Classical*. Trans. Johan Raffan (Oxford: Blackwell, 1985).

Cambridge Ancient History. Vols. 1–7.1. 2nd and 3rd eds. (Cambridge: Cambridge University Press, 1970–1994).

Camp, John McK. *The Athenian Agora: Excavations in the Heart of Classical Athens*. Rev. ed. (London: Thames & Hudson, 1992).

Cartledge, Paul. *The Spartans: The World of the Warrior-Heroes of Ancient Greece* (Woodstock, NY: Overlook Press, 2003).

————. *Alexander the Great: The Hunt for a New Past* (London: Macmillan, 2004).

Castleden, Rodney. *Mycenaeans* (London: Routledge, 2005).

Chadwick, John. *Linear B and Related Scripts* (Berkeley and Los Angeles: University of California Press, 1987).

Cherry, Kevin M. *Plato, Aristotle, and the Purposes of Politics* (New York: Cambridge University Press, 2012).

Cline, Eric H. *The Oxford Handbook of the Bronze Age Aegean* (Oxford: Oxford University Press, 2010).

Cohen, David. *Law, Sexuality, and Society: The Enforcement of Morals in Classical Athens* (Cambridge: Cambridge University Press, 1991).

Cohen, Edward E. *Athenian Economy and Society: A Banking Perspective* (Princeton, NJ: Princeton University Press, 1992).

Cosmopoulos, Michael B., ed. *The Parthenon and Its Sculptures* (Cambridge: Cambridge University Press, 2004).

Crane, Gregory. *Thucydides and the Ancient Simplicity: The Limits of Political Realism* (Berkeley and Los Angeles: University of California Press, 1998).

Cunliffe, Barry, ed. *Prehistoric Europe: An Illustrated History* (Oxford: Oxford University Press, 1998).

Dalby, Andrew. *Siren Feasts: A History of Food and Gastronomy in Greece* (London: Routledge, 1996).

Davidson, James N. *The Greeks and Greek Love: A Radical Reappraisal of Homosexuality in Ancient Greece* (London: Weidenfeld & Nicolson, 2007).

Demand, Nancy H. *The Mediterranean Context of Early Greek History* (Malden, MA: Wiley-Blackwell, 2011).

Dickinson, Oliver. *The Aegean Bronze Age* (Cambridge: Cambridge University Press, 1994).

————. *The Aegean from Bronze Age to Iron Age: Continuity and Change Between the Twelfth and Eighth Centuries BC* (London: Routledge, 2006).

Dillon, Sheila. *Ancient Greek Portrait Sculpture: Contexts, Subjects, and Styles* (New York: Cambridge University Press, 2006).

Donlan, Walter. *The Aristocratic Ideal in Ancient Greece: Attitudes of Superiority from Homer to the End of the Fifth Century B.C.* (Lawrence, KS: Coronado Press, 1980).

Dougherty, Carol. *Prometheus* (London: Routledge, 2006).

Dowden, Ken, and Niall Livingstone. *A Companion to Greek Mythology* (Malden, MA: Wiley-Blackwell, 2011).

Easterling, P. E., and J. V. Muir, eds. *Greek Religion and Society* (Cambridge: Cambridge University Press, 1985).

Ebbinghaus, Susanne. *Gods in Color: Painted Sculpture of Classical Antiquity*. Arthur M. Sackler Museum, Sept. 22, 2007–Jan. 20, 2008 (Cambridge, MA: Harvard University Art Museums, 2007).

Ehrenberg, Margaret. *Women in Prehistory* (Norman, OK: Oklahoma University Press, 1989).

Emerson, Mary. *Greek Sanctuaries: An Introduction* (London: Bristol Classical Press, 2007).

Ferguson, John. *Morals and Values in Ancient Greece* (Bristol, UK: Bristol Classical Press, 1989).

Ferrari, Gloria. *Alcman and the Cosmos of Sparta* (Chicago: University of Chicago Press, 2008).

Figueira, Thomas J. "Mess Contributions and Subsistence at Sparta." *Transactions of the American Philological Association* 114 (1984): 87–109.

Fisher, N. R. E. *Slavery in Classical Greece* (London: Bristol Classical Press, 1993).

Forsyth, Phyllis Young. *Thera in the Bronze Age* (New York: P. Lang, 1999).

Foxhall, Lin. *Olive Cultivation in Ancient Greece: Seeking the Ancient Economy* (Oxford: Oxford University Press, 2007).

Fredal, James. *Rhetorical Action in Ancient Athens: Persuasive Artistry from Solon to Demosthenes* (Carbondale, IL: Southern Illinois University Press, 2006).

Frederiksen, Rune. *Greek City Walls of the Archaic Period, 900–480 BC* (Oxford: Oxford University Press, 2011).

Gagarin, Michael. *Writing Greek Law* (Cambridge: Cambridge University Press, 2008).

Garland, Robert. *Daily Life of the Ancient Greeks*. 2nd ed. (Westport, CT: Greenwood Press, 2009).

Golden, Mark. *Children and Childhood in Classical Athens* (Baltimore. MD: Johns Hopkins University Press, 1990).

Green, Peter. *Alexander the Great and the Hellenistic Age* (London: Weidenfeld & Nicolson, 2007).

———. *The Hellenistic Age: A Short History* (New York: Modern Library, 2008).

Grethlein, Jonas. *The Greeks and Their Past: Poetry, Oratory and History in the Fifth Century BCE* (Cambridge: Cambridge University Press, 2010).

Gruen, Erich S. *Heritage and Hellenism: The Reinvention of Jewish Tradition* (Berkeley and Los Angeles: University of California Press, 1998).

Guthrie, W. K. C. *A History of Greek Philosophy*. 6 vols. (Cambridge: Cambridge University Press, 1962–1981).

Hansen, Mogens Herman. *Polis: An Introduction to the Ancient Greek City-State* (Oxford: Oxford University Press, 2006).

Hanson, Victor Davis. *The Western Way of War: Infantry Battle in Classical Greece*. 2nd ed. (Berkeley and Los Angeles: University of California Press, 2000).

Henderson, Jeffrey. "The Demos and Comic Competition." In *Nothing to Do with Dionysus? Athenian Drama in Its Social Context*. Ed. J. Winkler and F. Zeitlin (Princeton, NJ: Princeton University Press, 1990), pp. 271–313.

Herrmann, John J., and Christine Kondoleon. *Games for the Gods: The Greek Athlete and the Olympic Games* (Boston: MFA Publications, 2004).

Holleran, Claire, and April Pudsey, eds. *Demography and the Graeco-Roman World: New Insights and Approaches* (Cambridge: Cambridge University Press, 2011).

Holt, Frank Lee. *Lost World of the Golden King: In Search of Ancient Afghanistan* (Berkeley and Los Angeles: University of California Press, 2012).

Howe, Timothy. *Pastoral Politics: Animals, Agriculture, and Society in Ancient Greece* (Claremont, CA: Regina Books, 2008).

Hughes, Alan. *Performing Greek Comedy* (Cambridge: Cambridge University Press, 2011).

Hughes, Bettany. *The Hemlock Cup: Socrates, Athens, and the Search for the Good Life* (New York: Knopf, 2011).

Hurwit, Jeffrey M. *The Art and Culture of Early Greece, 1100–480 B.C.* (Ithaca, NY: Cornell University Press, 1987).

————. *The Acropolis in the Age of Pericles* (Cambridge: Cambridge University Press, 2004).

Jouanna, Jacques. *Hippocrates* (Baltimore, MD: Johns Hopkins University Press, 1999).

Kennell, Nigel M. *Spartans: A New History* (New York: Wiley-Blackwell, 2010).

Kraay, Colin M. *Archaic and Classical Greek Coins* (Berkeley and Los Angeles: University of California Press, 1976).

Krentz, Peter. *The Battle of Marathon* (New Haven, CT: Yale University Press, 2010).

Kuhrt, Amélie, and Susan Sherwin-White, eds. *Hellenism in the East: The Interaction of Greek and Non-Greek Civilizations from Syria to Central Asia after Alexander* (Berkeley and Los Angeles: University of California Press, 1987).

Kurke, Leslie. *Coins, Bodies, Games, and Gold: The Politics of Meaning in Archaic Greece* (Princeton, NJ: Princeton University Press, 1999).

Langdon, Susan Helen. *Art and Identity in Dark Age Greece, 1100–700 B.C.E.* (Cambridge: Cambridge University Press, 2008).

Lape, Susan. *Race and Citizen Identity in the Classical Athenian Democracy* (Cambridge: Cambridge University Press, 2010).

Lévi-Strauss, Claude. *Totemism.* Trans. Rodney Needham (Boston: Beacon Press, 1963).

Lewis, John. *Solon the Thinker: Political Thought in Archaic Athens* (London: Duckworth, 2006).

Lissarrague, François. *Greek Vases: The Athenians and Their Images.* Trans. Kim Allen (New York: Riverside Book, 2001).

Llewellyn-Jones, Lloyd, ed. *Women's Dress in the Ancient Greek World* (London: Duckworth, 2002).

Long, A. A. *Hellenistic Philosophy: Stoics, Epicureans, Sceptics.* 2nd ed. (Berkeley and Los Angeles: University of California Press, 1986).

Loomis, William T. *Wages, Welfare Costs, and Inflation in Classical Athens* (Ann Arbor, MI: University of Michigan Press, 1998).

MacDowell, Douglas M. *The Law in Classical Athens* (Ithaca, NY: Cornell University Press, 1978).

Mallory, J. P. *In Search of the Indo-Europeans: Language, Archaeology and Myth* (London: Thames & Hudson, 1989).

Manning, J. G. *The Last Pharaohs: Egypt Under the Ptolemies, 305–30 B.C.* (Princeton, NJ: Princeton University Press, 2010).

Marincola, John, ed. *Greek and Roman Historiography* (Oxford: Oxford University Press, 2011).

Martin, Luther. *Hellenistic Religions: An Introduction* (New York: Oxford University Press, 1987).

Martin, Richard P. *Myths of the Ancient Greeks* (London: Penguin Books, 2003).

Martin, Thomas. R. *Herodotus and Sima Qian: The First Great Historians of Greece and China. A Brief History with Documents* (Boston: Bedford Books, 2009).

Martin, Thomas R., and Christopher W. Blackwell. *Alexander the Great: The Story of an Ancient Life* (New York: Cambridge University Press, 2012).

Middleton, Guy D. *The Collapse of Palatial Society in LBA Greece and the Postpalatial Period* (Oxford: Archaeopress, 2010).

Mikalson, Jon D. *Ancient Greek Religion.* 2nd. ed. (Malden, MA: Wiley-Blackwell, 2010).

Miller, Stephen G. *Ancient Greek Athletics* (New Haven, CT: Yale University Press, 2004).

Mirto, Maria Serena. *Death in the Greek World: From Homer to the Classical Age.* Trans. A. M. Osborne (Norman, OK: University of Oklahoma Press, 2012).

Missiou, Anna. *Literacy and Democracy in Fifth-Century Athens* (Cambridge: Cambridge University Press, 2011).

Mohen, Jean-Pierre, and Christian Eluère. *The Bronze Age in Europe* (New York: Harry N. Abrams, 2000).

Morris, Ian. *Burial and Ancient Society: The Rise of the Greek City-State* (Cambridge: Cambridge University Press, 1989).

Morrison, John S., J. F. Coates, and N. B. Rankov. *The Athenian Trireme: The History and Reconstruction of an Ancient Greek Warship.* 2nd ed. (Cambridge: Cambridge University Press, 2000).

Murray, William M. *The Age of Titans: The Rise and Fall of the Great Hellensitic Navies.* (New York: Oxford University Press, 2012).

Niels, Jenifer. *Women in the Ancient World* (Los Angeles: J. Paul Getty Museum, 2011).

Nielsen, Thomas Heine. *Olympia and the Classical Hellenic City-State Culture* (Copenhagen: Det Kongelige Danske Videnskabernes Selskab, 2007).

Nixon, Lucia, and Simon Price. "The Size and Resources of the Greek Cities." In *The Greek City: From Homer to Alexander.* Oswyn Murray and Simon Price, eds. (Oxford: Clarendon Press, 1990), pp. 137–170.

Nussbaum, Martha C. *The Fragility of Goodness: Luck and Ethics in Greek Tragedy and Philosophy* (Cambridge: Cambridge University Press, 2001).

Oakley, John H., and Rebecca H. Sinos. *The Wedding in Ancient Athens* (Madison, WI: University of Wisconsin Press, 1993).

Ober, Josiah. *Democracy and Knowledge: Innovation and Learning in Classical Athens* (Princeton, NJ: Princeton University Press, 2008).

Osborne, Robin. "Pots, Trade, and the Archaic Greek Economy." *Antiquity* 70 (1996): 31–44.

———. *Greece in the Making, 1200–479 BC.* 2nd ed. (London: Routledge, 2009).

Padgett, Michael J. *The Centaur's Smile: The Human Animal in Early Greek Art* (Princeton, NJ: Princeton University Art Museum, 2003).

Parker, Robert. *Athenian Religion: A History* (Oxford: Clarendon Press, 1996).

———. *On Greek Religion* (Ithaca, NY: Cornell University Press, 2011).

Patterson, Cynthia B. *The Family in Greek History* (Cambridge, MA: Harvard University Press, 1998).

Pomeroy, Sarah B. *Spartan Women* (New York: Oxford University Press, 2002).

Powell, Anton. *Athens and Sparta: Constructing Greek Political and Social History from 478 BC.* 2nd ed. (London: Routledge, 2001).

Preziosi, Donald. *Aegean Art and Architecture* (Oxford: Oxford University Press, 1999).

Price, Simon. *Religions of the Ancient Greeks* (Cambridge: Cambridge University Press, 1999).

Pritchard, David M., ed. *War, Democracy and Culture in Classical Athens* (Cambridge: Cambridge University Press, 2010).

Raaflaub, Kurt A. *The Discovery of Freedom in Ancient Greece.* Trans. Renate Franciscono (Chicago: University of Chicago Press, 2004).

Raaflaub, Kurt A., Josiah Ober, and Robert W. Wallace, eds. *Origins of Democracy in Ancient Greece* (Berkeley and Los Angeles: University of California Press, 2007).

Rawlings, Louis. *The Ancient Greeks at War* (Manchester, UK: Manchester University Press, 2007).

Reden, Sitta von. *Money in Classical Antiquity* (Cambridge: Cambridge University Press, 2010).

Renfrew, Colin. *Before Civilization: The Radiocarbon Revolution and Prehistoric Europe* (Cambridge: Cambridge University Press, 1979).

Rihil, Tracey Elizabeth. *Greek Science* (Oxford: Oxford University Press, 1999).

Robinson, Eric W. *Democracy Beyond Athens: Popular Government in the Greek Classical Age* (Cambridge: Cambridge University Press, 2011).

Roisman, Joseph, ed. *Brill's Companion to Alexander the Great* (Leiden, Netherlands: Brill, 2003).

Ruffell, I. A. *Politics and Anti-Realism in Athenian Old Comedy: The Art of the Impossible* (Oxford: Oxford University Press, 2011).

Sallares, Robert. *The Ecology of the Ancient Greek World* (Ithaca, NY: Cornell University Press, 1991).

Samon, Loren J., ed. *The Cambridge Companion to the Age of Pericles* (Cambridge: Cambridge University Press, 2007).

Sandars, N. K. *The Sea Peoples: Warriors of the Ancient Mediterranean, 1250–1150 B.C.* (London: Thames & Hudson, 1978).

Scarre, Christopher, and Rebecca Stetoff. *The Palace of Minos at Knossos* (New York: Oxford University Press, 2003).

Scheidel, Walter. "Demography and Sociology." In *Oxford Handbook of Hellenic Studies.* George Boys-Stones, Barbara Graziosi, and Phiroze Vasunia, eds. (Oxford: Oxford University Press, 2009), part 4, chap. 54.

Schofield, Louise. *The Mycenaeans* (Los Angeles: J. Paul Getty Museum, 2007).

Schwartz, Adam. *Reinstating the Hoplite: Arms, Armour and Phalanx Fighting in Archaic and Classical Greece* (Stuttgart, Germany: Franz Steiner, 2009).

Scott, Michael. *Delphi and Olympia: The Spatial Politics of Panhellenism in the Archaic and Classical Periods* (Cambridge: Cambridge University Press, 2010).

Seaford, Richard. *Money and the Early Greek Mind: Homer, Philosophy, Tragedy* (Cambridge: Cambridge University Press, 2004).

Shapiro, H. A., ed. *The Cambridge Companion to Archaic Greece* (Cambridge: Cambridge University Press, 2007).

Sherwin-White, Susan, and Amélie Kuhrt. *From Samarkhand to Sardis: A New Approach to the Seleucid Empire* (Berkeley and Los Angeles: University of California Press, 1993).

Shipley, Graham. *The Greek World After Alexander, 323–30 BC* (London: Routledge, 2000).

Sommerstein, Alan H., ed. *Brill's Companion to the Study of Greek Comedy* (Leiden, Netherlands: E. J. Brill, 2010).

Stansbury-O'Donnell, Mark. *Vase Painting, Gender, and Social Identity in Archaic Athens* (New York: Cambridge University Press, 2006).

Steiner, Deborah. *Images in Mind: Statues in Archaic and Classical Greek Literature and Thought* (Princeton, NJ: Princeton University Press, 2001).

Stewart, Andrew F. *Classical Greece and the Birth of Western Art* (Cambridge: Cambridge University Press, 2008).

Stoneman, Richard. *The Ancient Oracles: Making the Gods Speak* (New Haven, CT: Yale University Press, 2011).

Strauss, Barry. *The Battle of Salamis: The Naval Encounter That Saved Greece—and Western Civilization* (New York: Simon & Schuster, 2004).

———. *The Trojan War: A New History* (New York: Simon & Schuster, 2006).

Stuttard, David. *Power Games: Ritual and Rivalry at the Ancient Greek Olympics* (London: British Museum Press, 2011).

Swaddling, Judith. *The Ancient Olympic Games.* 2nd ed. (Austin, TX: University of Texas Press, 2008).

Thorley, John. *Athenian Democracy.* 2nd ed. (London: Routledge, 2004).

Todd, S. C. *The Shape of Athenian Law* (Oxford: Clarendon Press, 1993).

Treister, M. Ju. "Trade in Metals in the Greek World. From the Archaic into the Hellenistic Epoch." *Bulletin of the Metals Museum* 18 (1992): 29–43.

Tsetskhladze, Gocha R., ed. *Greek Colonisation: An Account of Greek Colonies and Other Settlements Overseas.* 2 vols. (Leiden, Netherlands: Brill, 2006–2008).

Valavanes, Panos. *Games and Sanctuaries in Ancient Greece: Olympia, Delphi, Isthmia, Nemea, Athens* (Los Angeles: J. Paul Getty Museum, 2004).

Vasunia, Phiroze. *The Gift of the Nile: Hellenizing Egypt from Aeschylus to Alexander* (Berkeley and Los Angeles: University of California Press, 2001).

Wees, Hans van. *Greek Warfare: Myths and Realities* (London: Duckworth, 2004).

Weiberg, Erika. *Thinking the Bronze Age: Life and Death in Early Helladic Greece* (Uppsala, Sweden: Uppsala Universitet, 2007).

Wickkiser, Bronwen L. *Asklepios, Medicine, and the Politics of Healing in Fifth-Century Greece: Between Craft and Cult* (Baltimore, MD: Johns Hopkins University Press, 2008).

Worman, Nancy. *Abusive Mouths in Classical Athens* (Cambridge: Cambridge University Press, 2008).

Worthington, Ian. *Philip II of Macedonia* (New Haven, CT: Yale University Press, 2008).

Wrenhaven, Kelly L. *Reconstructing the Slave: The Image of the Slave in Ancient Greece* (Bristol, UK: Bristol Classical Press, 2012).

Wycherly, W. E. *How the Greeks Built Cities.* 2nd ed. (New York: Norton, 1976).

INDEX

Page numbers in **bold** refer to illustrations.